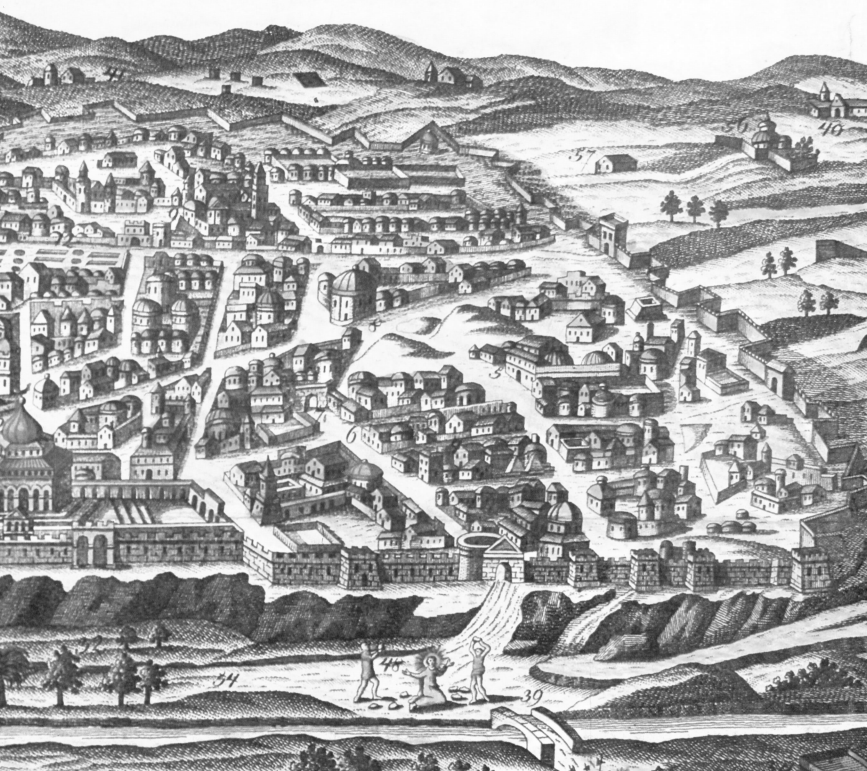

Palestine and Egypt
under
the Ottomans

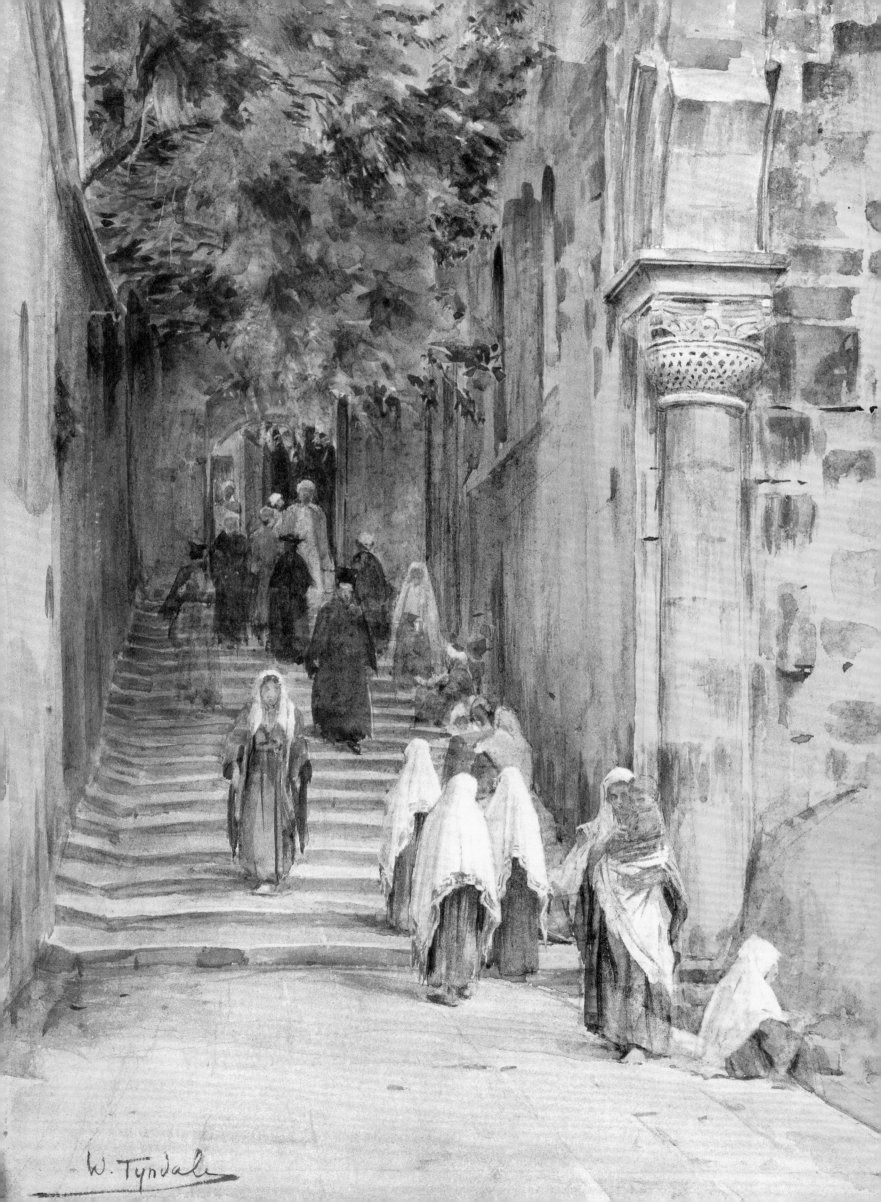

W. Tyndale

Palestine and Egypt under the Ottomans

Paintings, Books, Photographs, Maps and Manuscripts

Hisham Khatib

TAURIS PARKE BOOKS
LONDON • NEW YORK

To the memory of my mother, who loved Jerusalem.

And for my wife Maha; my children Mohamed, Lynn and Isam;

and my sisters Aida, Maha and Ghada.

~

The author wishes to thank the Arab Fund for Economic and Social

Development, Kuwait, for their support of this work

Published in 2003 by Tauris Parke
an imprint of I.B.Tauris & Co Ltd
6 Salem Road, London W2 4BU
175 Fifth Avenue, New York NY 10010
www.ibtauris.com

In the United States of America and in Canada distrib-
uted by Palgrave Macmillan, a division of St. Martin's
Press, 175 Fifth Avenue, New York NY 10010

ISBN 1 86064 888 6

A full CIP record for this book is available from the
British Library.
A full CIP record for this book is available from the
Library of Congress.

Library of Congress catalog card: available.

Designed and typeset in Garamond and Bodoni by
Andrea El-Akshar, Köln

Printed and bound at the National Press, Hashemite
Kingdom of Jordan

*Endpapers: G. Borowsky's perspective view of Jerusalem
 (1710)*
*Page 2: Stairs leading to the Holy Sepulchre, Jerusalem, by
 Walter Tyndale*
Pages 4-5: Lithograph of Jaffa by Charles van de Velde
*Page 8: Detail of one of David Roberts's Studies of
 Palestinian Figures*
Page 11: Sir David Wilkie's Palestinian muleteer

～ Contents ～

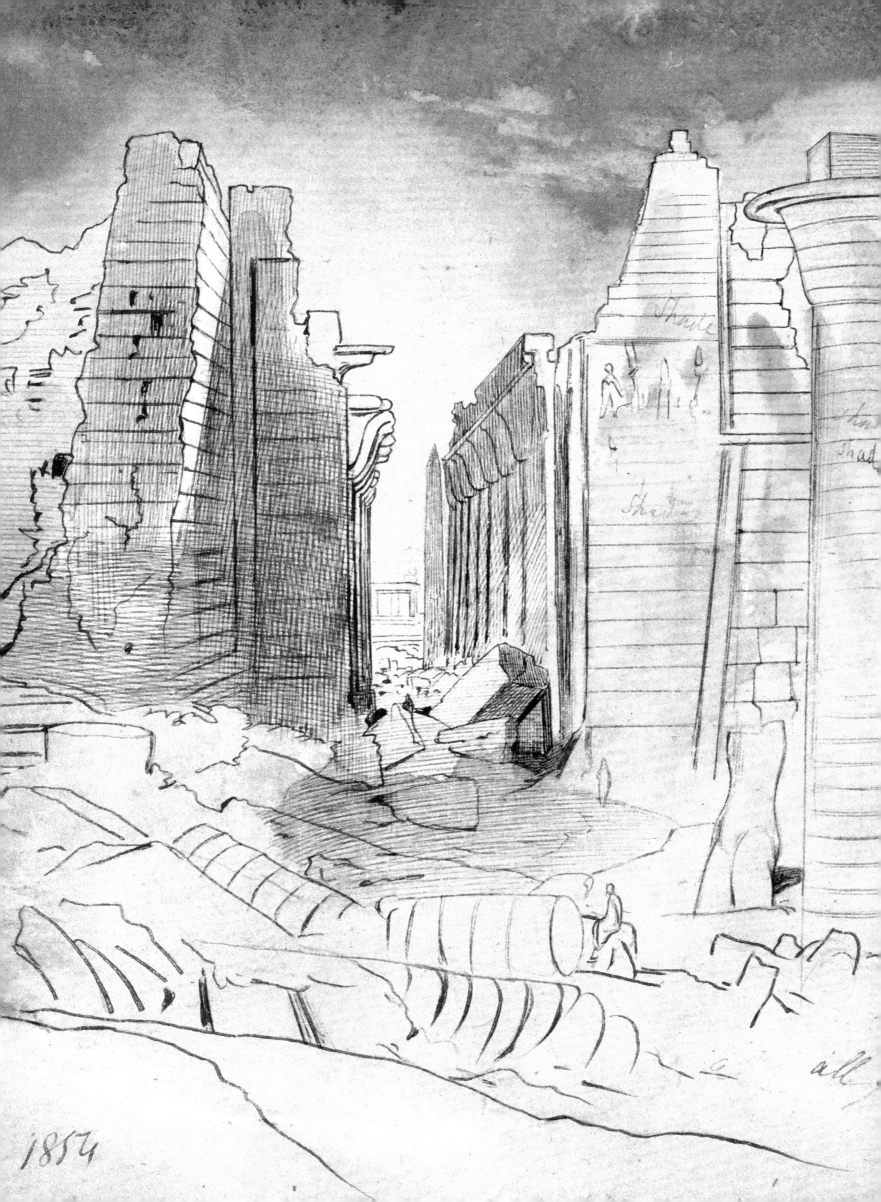

Shade

Shade

Shade

1854

≈ Foreword ≈

This is not a book about the history of the Holy Land or Egypt during the Ottoman era. It is, rather, a record of the perceptions of that region as seen through the eyes of the mainly western travellers and artists who came to Palestine in this period. And because their itineraries in so many instances included Egypt – indeed for most it was the main destination – there is clearly an organic link in the art and writings which these journeys produced.

My source in attempting to portray this perception of Palestine and Egypt has been the collection I have built up over 30 years. The approximately 150 paintings, over 100 travel books, 20 valuable plate books, the many maps and views of Jerusalem and the photographs all featured here are drawn from the several hundred paintings, mostly watercolours, hundreds of travel books, thousands of engravings and rare prints as well as at least 1,000 nineteenth century original photographs and hundreds of postcards which form the collection. The aim has been to record scenes and objects as they existed during the Ottoman period, particularly in the last hundred years of the four centuries of Ottoman rule in the Holy Land (1516-1917). My orientation has always been topographical rather than decorative, so I have generally not collected imaginative scenes of the Orient and its people, particularly those exotic Orientalist scenes of the harem and to a lesser extent the *suqs* and colourful carpet sellers etc.

There are very few collections of historical material on Jerusalem and the Holy Land, and among these even fewer have been accumulated by Arab collectors. Interest in collecting historical material and paintings, antiquarian and travel books, old photographs etc., although growing rapidly, is not yet deeply rooted in our part of the world. I felt that publishing my Collection would contribute towards the recording of Jerusalem and the Holy Land, as well as of Egypt, during the Ottoman

Opposite:
Detail of Edward Lear's drawing of Karnak (see pp. 110-13)

period. I also hope it will encourage and contribute to the growing local as well as international interest in Palestine and its historical background.

Although I can make no claim to having written a history book, I nevertheless felt it would be useful to include a few chapters on the historical background. The first part of the book, therefore, includes short chapters on 'Palestine during the Ottoman Period', 'Jerusalem's Development', and 'Travellers and Explorers of the Holy land'. The remainder of the book is organized into separate sections on paintings, travellers and travel books, atlases, maps and views, as well as on photography and engravings – all from the collection. No writer can cover so wide a scope unaided; I have had to rely to some extent on relevant references and publications listed in an annex on references, as well as in my acknowledgments.

I hope that this book will serve the purpose of its publication: to enrich our knowledge of Jerusalem, the Holy Land and Egypt during the Ottoman period. No writer – particularly, as in my case, a Jordanian Arab who was born in Acre, Palestine, and lived in Jerusalem – can write dispassionately about the Holy Land. While this is only legitimate and human, I have tried to be as unbiased as a biased writer can be.

Hisham Khatib

Amman

September 2002

≈ Acknowledgements ≈

My first thanks must go to the Arab Fund for Economic and Social Development in Kuwait for their support of this work.

I am grateful to many people who assisted in making this book possible. I am particularly indebted to:

Ms Jane Taylor for her very hard work in coordinating all aspects of its production, and for her many suggestions which have greatly enriched its content.

Ms Leonora Navari for allowing me to use some of the material of her *Greece and the Levant: The Catalogue of the Henry Myron Blackmer Collection of Books and Manuscripts* (Blackmer's Collection was auctioned by Sotheby's in 1989).

Ms Briony Llewellyn for allowing me to benefit from her descriptions of the artists who painted the Holy Land and Egypt, and from some of her work on the Rodney Searight Collection (now in the Victoria & Albert Museum, London).

Ms Sarah Searight, daughter of the late Rodney Searight, for her highly professional editing of the typescript.

Ms Judith Eagle, for her sharp proof-reading eye; and also Mrs Elizabeth Wiggans for assembling the index.

Mr Is-haq Rashed Rashid, for his work on the Arabic manuscripts (to be published)

Last but not least I wish to thank my secretary Mrs Tahreer al-Qaq for typing the catalogue manuscripts in both English and Arabic and undertaking the computer work.

Any remaining errors or inconsistencies, as well as ideas and interpretations contained in the book, are entirely my own responsibility.

◁ Abbreviations ▷
used in the Text

AA	Associated Artists in Watercolours, 1808-1812
AJ	Art Journal, 1849-1912
ANWS	Associate of the New Society of Painters in Watercolours
AOWS	Associate of the (Old) Society of Painters in Watercolours
ARA	Associate of the Royal Academy
ARSA	Associate of the Royal Scottish Academy
ARSW	Associate of the Royal Scottish Society of Painters in Watercolours
ARWS	Associate of the Royal Society of Painters in Watercolours
BI	British Institution, 1806-67
BM	British Museum
DNB	Dictionary of National Biography
FRS	Fellow of the Royal Society
FSA	Fellow of the Society of Antiquaries
NWS	'New' Society of Painters in Watercolours, founded in 1831
OWS	'Old' Society of Painters in Watercolours, founded in 1804
RA	Royal Academy, founded in 1768
RBA	Royal Society of British Artists
RCA	Royal College of Art
RI	Royal Institute of Painters in Watercolours
RSA	Royal Scottish Academy
RSW	Royal Scottish Society of Painters in Watercolours
RWS	Royal Society of Painters in Watercolours
SBA	Society of British Artists
VAM	Victoria and Albert Museum

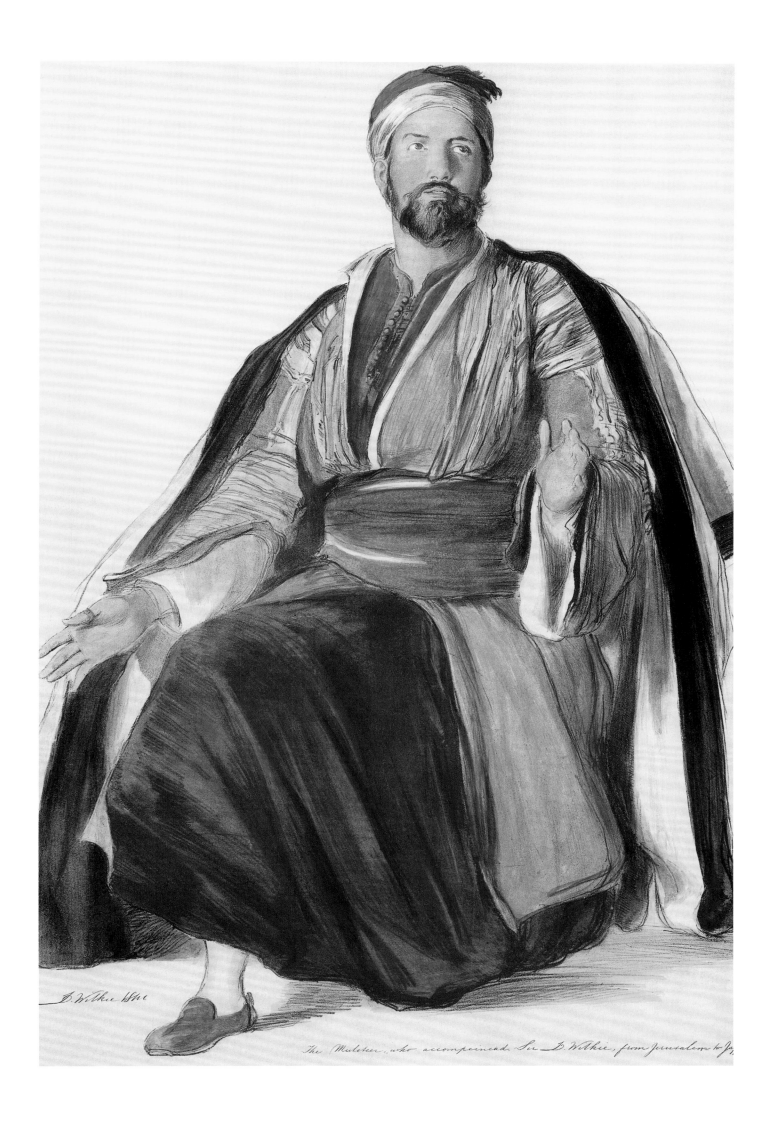

D. Wilkie 1841

The Muleteer who accompanied Sir D. Wilkie from Jerusalem to Ja...

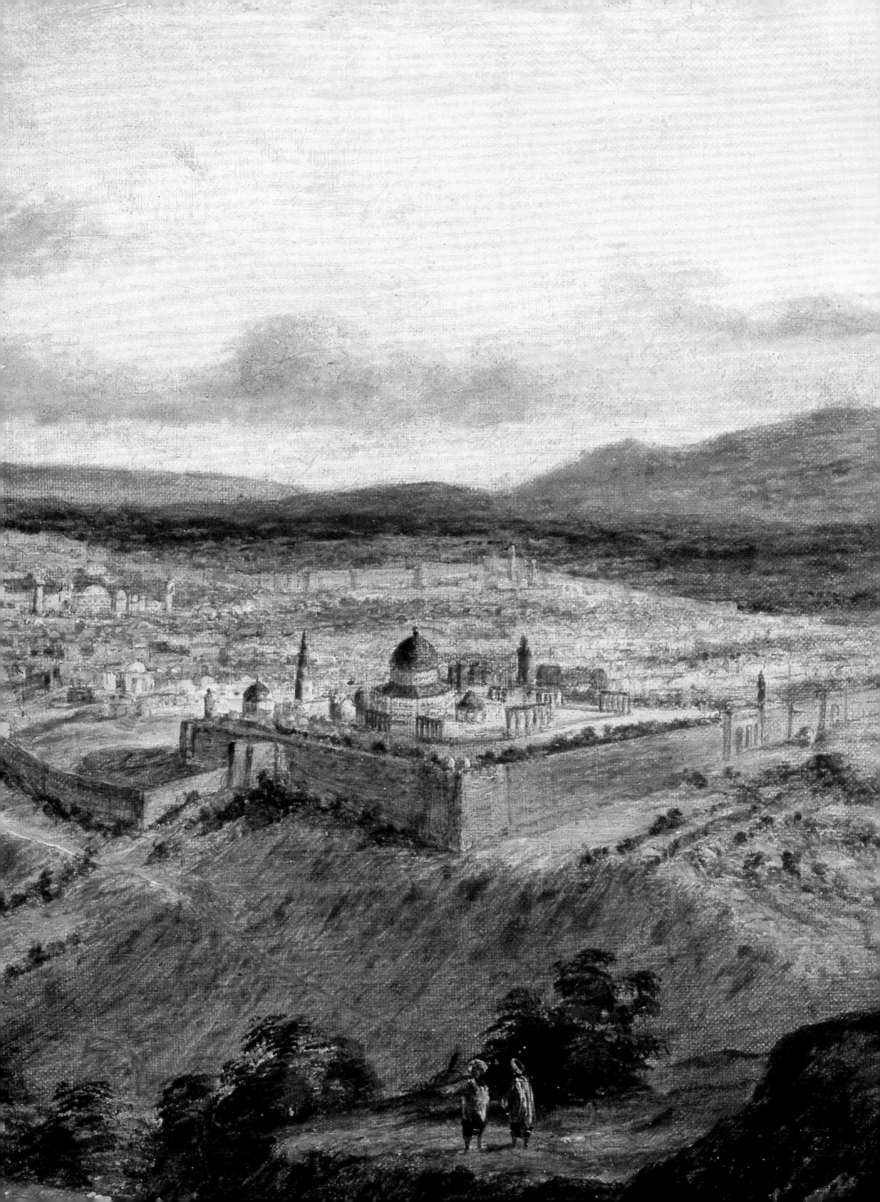

~ Introduction ~

From the late thirteenth century, and throughout the European Renaissance, the Holy Land became *terra incognita* for most westerners. While centres of trade and diplomacy such as Constantinople, Isfahan and Alexandria still attracted Europeans, few people except pilgrims ventured to the Holy Land. Napoleon's campaigns in Egypt and Palestine in 1798-99 heralded a new era: the west's political, historical, archaeological and artistic interest in the Holy Land and Egypt.

Travellers arrived in ever-increasing numbers from the early nineteenth century onwards, the proximity of the Holy Land and Egypt encouraging many to visit both areas. Egypt, with its grand archaeological heritage, tended to be their main focus, but most writers and artists depicted both. By the end of the century Palestine and Egypt had become among the most explored, painted, described and photographed areas on earth – providing rich source material for today's collector.

It is rarely easy to describe why a collector embarks on assembling an impressive collection. Incentives – other than merely to provide a hobby for the productive utilization of time – include the urge to possess, imitating or rivalling other collectors and, of course, an abiding interest in a certain subject. All these motives drew me, once my college years were over, to collect images of Jerusalem and the Holy Land. Seeing others collecting works of art no doubt motivated me to imitate, but more important was my love of the Holy Land, particularly Jerusalem. I lived in Jerusalem for 25 years and I kept links with the city for the next 25 years. Attachment to Jerusalem, its heritage and history is part of my life.

Islamic architecture has always been a central part of my interest, and so too has its representation in art. The magnificent architecture of Mamluk Cairo has strong affinities with that of Mamluk

Opposite:
Detail of Jerusalem from the Mount of Olives by H. M. Hunt (see pp. 20-21)

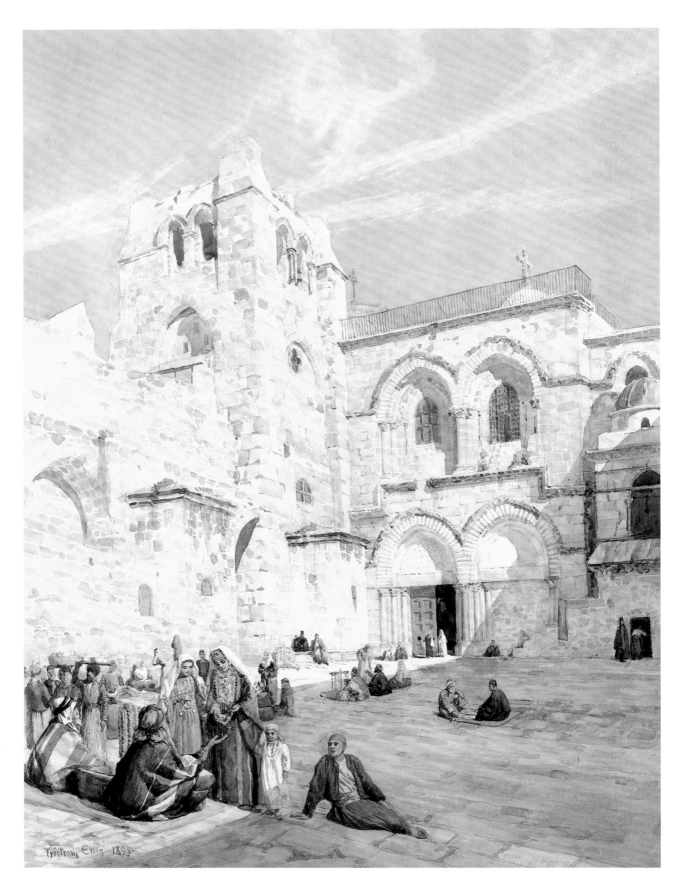

The entrance
to the Church
of the Holy
Sepulchre in
Jerusalem, by
Tristram Ellis
(see p. 92,
no. 10a)

(see p. 92,
no. 10a)

14 ~ INTRODUCTION

A watercolour view of Acre from across the bay, by Pierre Tetar van Elven. The mosque visible in the town is that of al-Jazzar (see p. 134, no. 50)

Jerusalem, and there are many similarities between the Islamic architecture of Egypt and Palestine. I still recall Acre, the town where I was born and spent my early childhood, and the eighteenth-century al-Jazzar mosque (based on a design by the sixteenth-century Turkish architect, Sinan), and compare its dome and pencil-slim minaret with those of some of the loveliest mosques of Egypt, and especially their Mamluk minarets.

As I collected, I discovered to my surprise that a creative circularity was at work: I collected Jerusalem and the Holy Land because of my love of the place; but then I found that my attachment was in turn greatly strengthened by my accumulating collection. And because of the collection I started to appreciate better the beauty of the countryside and historic sites of the Holy Land. Collecting may start because of appreciation and interest, but equally the interest is enhanced by the collection itself.

Knowing Jerusalem and Palestine so well greatly helped in building up the collection. But I have also ventured into neighbouring regions, in particular to Egypt, where I lived for six years as a uni-

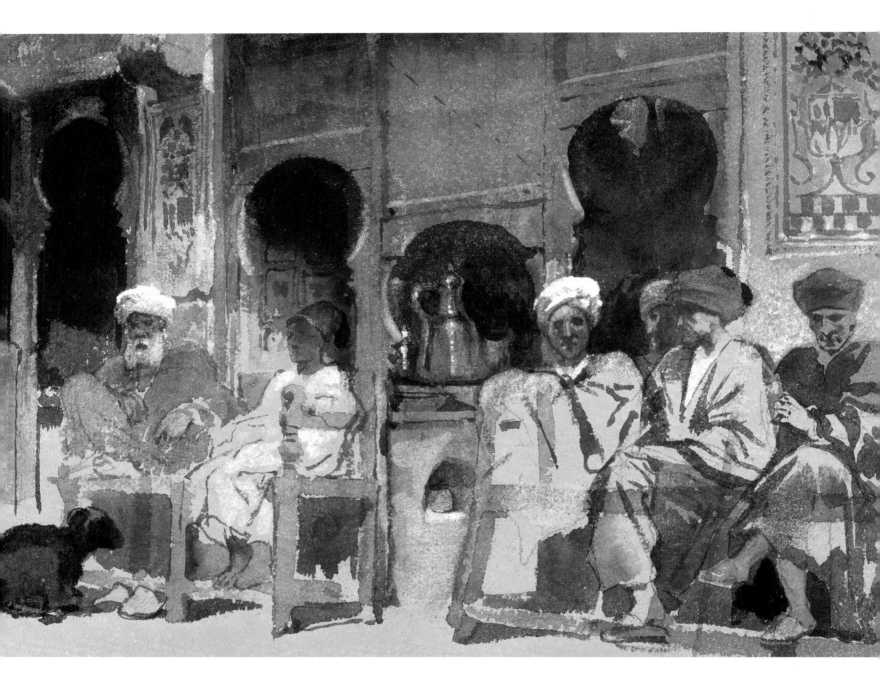

A Cairo Café, by Carl Haag (see pp. 101-02, no. 19g). Egyptian scenes by this
fine artist are less costly than his Holy Land paintings.

versity student in the 1950s, and got to know Cairo well. While all works relating to the Holy Land are scarce and expensive, those of Egypt are abundant and affordable; as a result I have collected many nineteenth-century paintings, prints and maps of Islamic and Ottoman Egypt. Attached as I am to them, their personal value to me comes second to images of the Holy Land. Also, though I lived in Britain for a few years, and maintained almost daily intellectual and professional contacts there, the British heritage never developed into an interest that might generate a collection.

I started my collection in the 1970s with paintings – mainly watercolours of the Victorian period. Because Holy Land paintings are somewhat scarce and expensive, I compensated by also acquiring nineteenth-century paintings and prints of Egypt. But gradually, for reasons explained later, I became interested in collecting books, particularly what are called 'valuable plate books', and also travel books. Then I ventured into photography, atlases (and some maps), travel guides and other printed works. As a result my collection consists mainly of objects on paper that are related to Jerusalem, the Holy Land and related regions, mostly Egypt.

The Dome of the Rock, photographed by Francis Frith, *c.* 1857
(see pp. 240-41, no. 2)

A collector is always driven by an urge (sometimes irresistible) to possess. But to build a viable collection three other things are needed – knowledge of your subject, specialization and money.

A good knowledge of the subject of the collection is probably the single most important item on the agenda for any collector. In my case the subjects were (in this order of importance) Jerusalem,

The cover of H. B. Tristram's *Scene s in the East*
(see pp. 198-99, no. 93)

the Holy Land, Egypt and the rest of the Levant. Knowing the subject motivates interest and allows you to interact with the collection. It also greatly contributes to the quality and economy of the collection, enabling the collector to identify items, evaluate their significance and put a financial value on them. Because I know the area of my collection well, I have usually been able to identify views of the Holy Land – which sometimes neither the seller nor other collectors recognized – and so understand their value.

To know the subject of such a collection you must not only know the sites and their history, but be able to use this knowledge over a wide range of media. References greatly assist the collector in identifying and evaluating objects, and studying the references relevant to the collection generates almost as much satisfaction as the collection itself. I have detailed the references that I have used in an annex to this book.

The second important requirement for a collector (especially one with limited means) is specialization. There are so many interesting objects around, but any collection which does not specialize will have limited significance. Specialization improves a collector's knowledge, optimizes limited purchasing power and significantly upgrades the quality of the collection. Without specialization the knowledge of the collector and the quality of the collection can remain mediocre.

I decided to specialize on Jerusalem and the Holy Land in the Ottoman period (1516-1917), a choice motivated by a number of considerations. First the heritage, customs, sites and objects of this

Opposite:
A woodcut map
of 1592 showing
the eastern
Mediterranean
coast and the
Holy Land;
from Sebastian
Münster's
*Cosmographia
Universalis*
(see p. 216, no. 4)

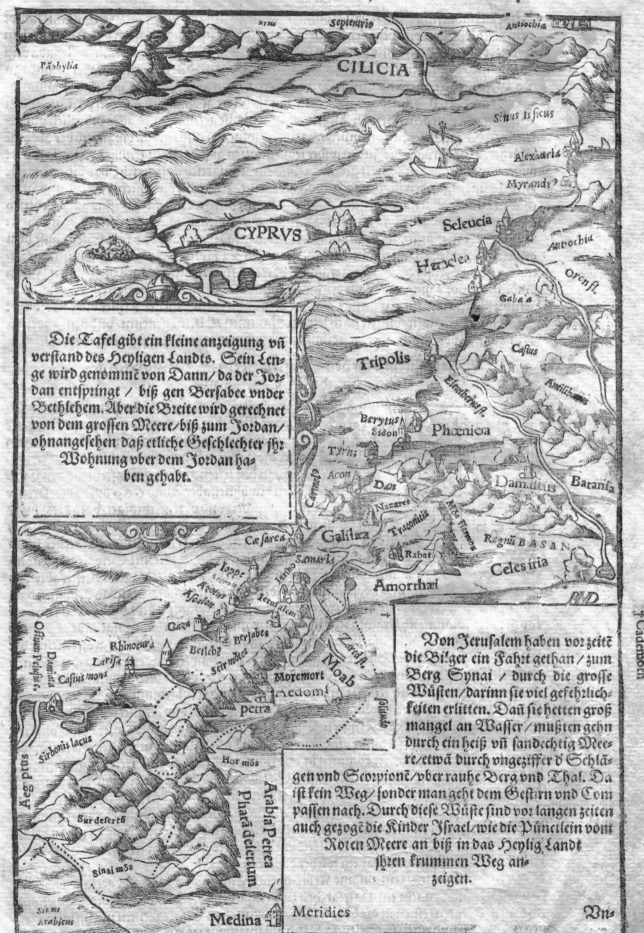

Septentrio

Antiochia

CILICIA

Pãphylia

Sinus Issicus

Alexaria

Myrandr

Seleucia

CYPRVS

Antrochia

Heraclea

Orens.

Gaba'a

Casius

Tripolis

Antiliba'

Die Tafel gibt ein kleine anzeigung vñ verstand des Heyligen Landts. Sein Lenge wird genommẽ von Dann/ da der Jordan entspringt / biß gen Berfabee vnder Bethlehem. Aber die Breite wird gerechnet von dem großen Meere/ biß zum Jordan/ ohnangesehen daß etliche Geschlechter jhr Wohnung vber dem Jordan haben gehabt.

Berytus

Eleutherus fl.

Sidon

Phœnicia

Tyrus

Acon

Carmelus

Dan

Nazaret

Damascus

Barania

Mõs Hermon

Galilæa

Traconitis

Regnũ BASAN

Cæsarea

Rabat

Celes iria

Samaria

Joppe

Ieriho

Amorrhæi

Azotus

Ascalon

Ierusalem

Gaza

Zared fl.

Betlehẽ

Berjabee

Moab

Rhinocura

Seir mõs

solitudo

Larisa

Moremort

Ostium Pelusiu.

Damiata

Casius mons

Aedom!

petra

Von Jerusalem haben vor zeitẽ die Bilger ein Fahrt gethan / zum Berg Synai / durch die große Wüsten/ darinn sie viel gefehrlichkeiten erlitten. Dañ sie hetten groß mangel an Wasser/ mußten gehn durch ein heiß vñ sandechtig Meere/ etwã durch vngeziffer d' Schlägen vnd Scorpionẽ/ vber rauhe Berg vnd Thal. Da ist kein Weg/ sonder man geht dem Gestirn vnd Compassen nach. Durch diese Wüste sind vor langen zeiten auch gezogẽ die Kinder Israel/ wie die Pünctlein vom Roten Meere an biß in das Heylig Landt ihren krummen Weg ãzeigen.

Sirbonis lacus

Hor mõs

Aegyptus

Arabia Petrea Phara d'desertum

Sur desertũ

Sinai mõs

Sinus Arabicus

Medina

Meridies

Vn

era (especially the nineteenth century) still survive and are accessible. Paintings, engravings, photographs, travel books, guides, etc., became readily available in the closing decades of that period and in sufficient quantities to satisfy the curiosity and interest of any collector; and buildings, objects, and even some social habits from the Ottoman period still exist in Palestine. The Ottoman period had a profound, though not always positive, influence on modern Palestine, but without the documentation that was produced then, it would be impossible to understand and interpret later events.

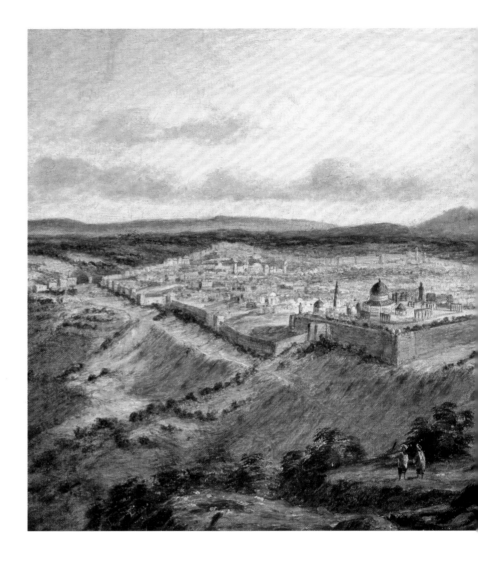

The final consideration is that a collector needs money. Interest in Holy Land objects has greatly increased in recent years so that one cannot, most of the time, buy something for nothing. Collectors are always in competition with other collectors and the ability to acquire can often depend on the size of the wallet; but study and specialization can to some extent compensate for limited financial means, together with professional knowledge of where to buy, and at what prices.

Two other factors are also significant. The first is patience. If collectors are over-zealous and venture to buy certain interesting objects at any price, they will end up spending their limited budget on a few objects, which may not be worth the effort and money spent. Patience is essential – rare objects can reappear at a later date and a collector needs to persevere and not waste limited resources on a few overpriced objects just because of the urge to collect.

The second requirement is flexibility. A collector often has to switch between objects for pragmatic reasons. This does not necessarily mean a change in specialization, but within the area

of interest there are varieties of media and the collector can move from one to another in accordance with their scarcity and cost. I started by buying paintings (mostly watercolours); when these became expensive, I switched to rare books and, as they became scarcer, to photographs. When these too became expensive I looked for maps and rare views of Jerusalem, etc. This ability to switch from one medium to another within the wider frame of an integrated collection allowed me to enhance the collection within my budget limits.

A panorama of Jerusalem from the Mount of Olives by the relatively unknown painter H. M. Hunt (see p. 108, no. 22)

Most of my purchases were from reputable British auction houses, and I kept a provenance record. Auction houses are not only places for acquiring highly priced items – indeed they often provide the best value for money. To my great surprise I discovered that a knowledgeable collector is sometimes better informed than experts from the auction houses – several items in my collection were unrecognized by the auctioneer and therefore undervalued. It is also advisable not to be present during bidding, relying instead on commission bids to avoid the temptation of going beyond the estimate or one's budget. To do so would result in an expensive collection or, for a limited budget, a limited one. Wise spending and patience, over several years, are the keys to successful collecting.

This, then, is the story of my collection – despite limited means I have been able to accumulate a significant collection (at least in historical and topographical value) through knowing the subject, specializing, flexibility, patience and careful spending.

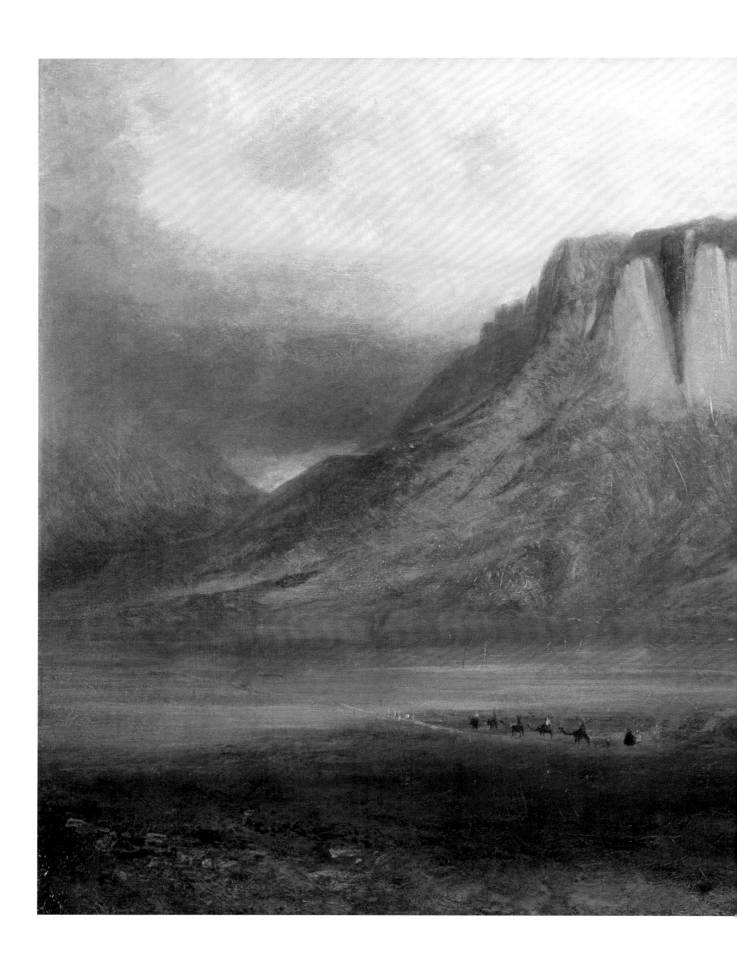

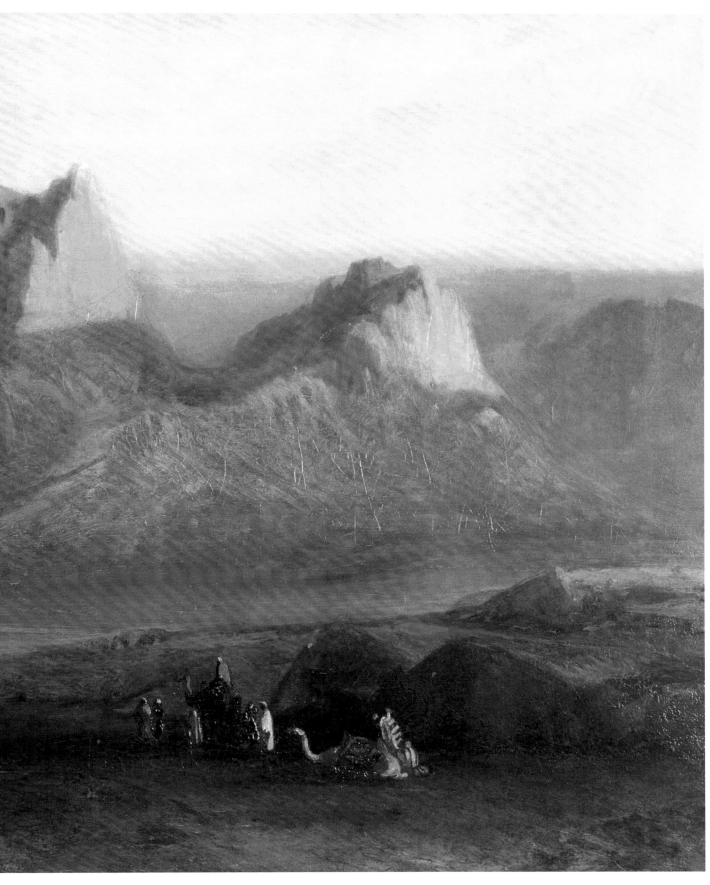

An oil painting of Mount Sinai by Edward Lear, unrecognized by the London auction house which sold it in 1983 (see pp. 110-13, no. 26a)

One of the manuscript Qur'ans in the Collection, with fine calligraphy;
Syrian/Persian? 1794 (1205 H)

It is a matter of regret to me that the collection contains few items produced or written by local Palestinians or Arabs, apart from the Qur'ans. During the Ottoman period, for reasons explained later, visual arts in the form of paintings or engravings hardly existed. The few Arab travel books and other related works, or photographs, were too rare for my budget. Misinterpretation of religious values as well as cultural attitudes delayed the appearance of locally-produced items until the beginning of the twentieth century. This is in contrast to the well developed Islamic architecture, and also pottery, metal objects and other artefacts. These are beyond the range of my collection which, as I have explained, is restricted to works on paper.

Among the primary urges of most collectors is the desire to correspond with other collectors with similar interests, and to exhibit their collections. It would be false modesty for me to deny that bringing my collection to public attention is part of the motivation in preparing this book. But its main purpose is to contribute towards an understanding of the history, art and heritage of Palestine and neighbouring regions during an enormously formative period in the modern history of the region.

Part I
The Ottoman Years

CHAPTER ONE

∼ Palestine During the Ottoman ∼ Period 1516-1917

European interest in Palestine diminished with the final defeat of the Crusaders in 1291 and still more so after the conquest of the area by the Ottomans in 1516. The rapid military expansion of the Ottoman Empire in the early sixteenth century soon absorbed Palestine, part of the Mamluk domain since 1250, as well as greater Syria, Iraq, Egypt and Arabia; this supremely power-ful empire also came to include much of south-eastern Europe. Ottoman rule of Palestine lasted 400 years, from 1516 to 1917, with a brief hiatus during the Egyptian occupation from 1831 to 1840.

Ottoman control of the Holy Land divides into four periods.[1] The first of these is the so-called Golden Age of the Ottoman Empire in the sixteenth century, in particular the reign of Suleyman the Magnificent (1520-1566). An efficient Ottoman administration in Palestine conducted surveys of population, taxation, food production and religious communities; the last of these surveys was con-ducted during 1596-97, after which information declined rapidly.[2] Aspects of the 'golden age' in Jerusalem are Suleyman's restoration of the Dome of the Rock and the construction of the city's walls in 1542 with their six magnificent gates.

The second period covers the onset of imperial decline in the seventeenth century. Currency devaluation led to financial difficulties, thence to deteriorating state institutions, while the economy was further damaged by external military threats particularly from Russia. Renaissance Europe then began its commercial penetration of the empire, including Palestine, where the loosening grip of the Ottoman administration facilitated the emergence of local families, particularly those of the al-Radwan, al-Tarbai and al-Farouki.

During this period Ottoman attention was directed to preserving the empire in Europe, to the neglect of Palestine. Revenues from this region were relatively insignificant within the empire as a whole and the province of Palestine had little strategic importance. Trade and agriculture were

Opposite:
Detail of a watercolour by Carl Haag (see pp. 36-37 and 101-02)

Next page:
The Haram al-Sharif and the 16th-century walls built by Suleyman the Magnificent stand out clearly in this rare lithographed drawing by Louis de Forbin from his *Voyage dans le Levant* (see pp. 152-53, no. 4)

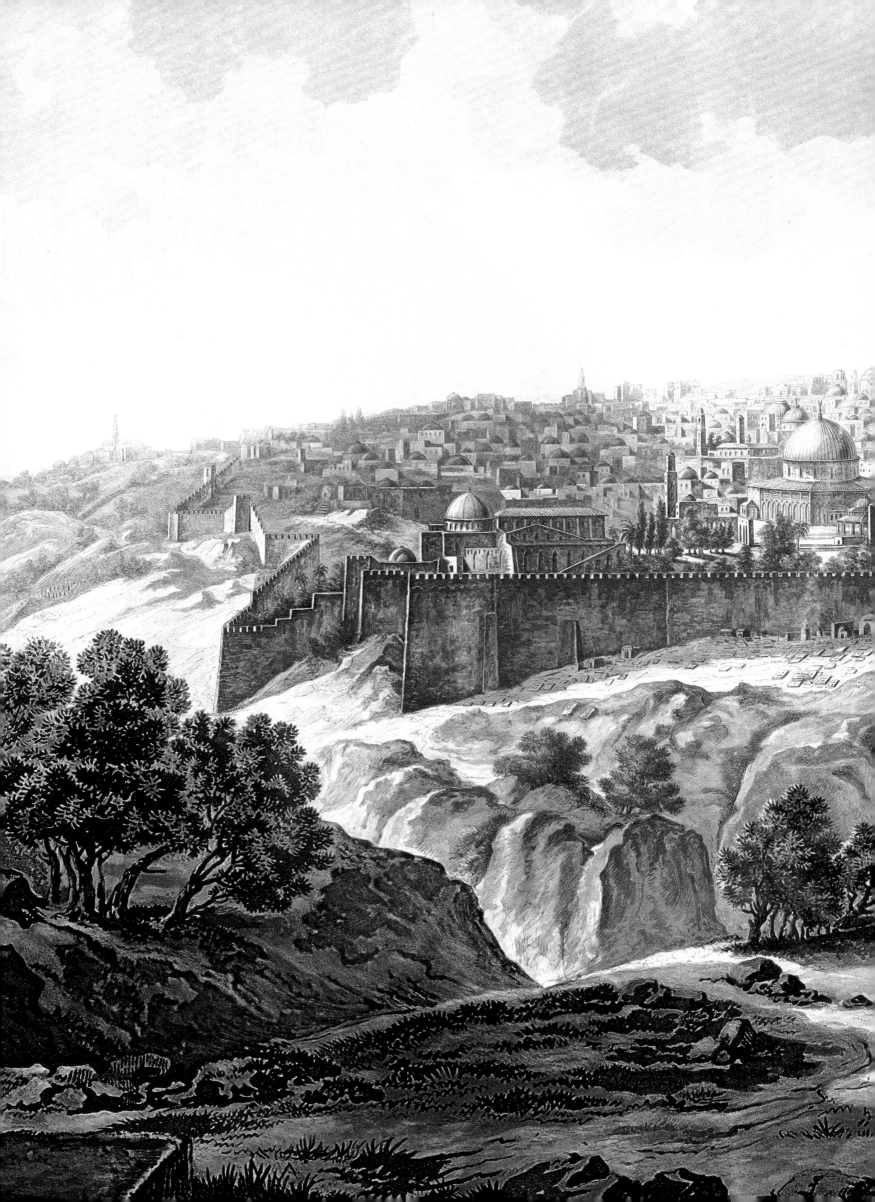

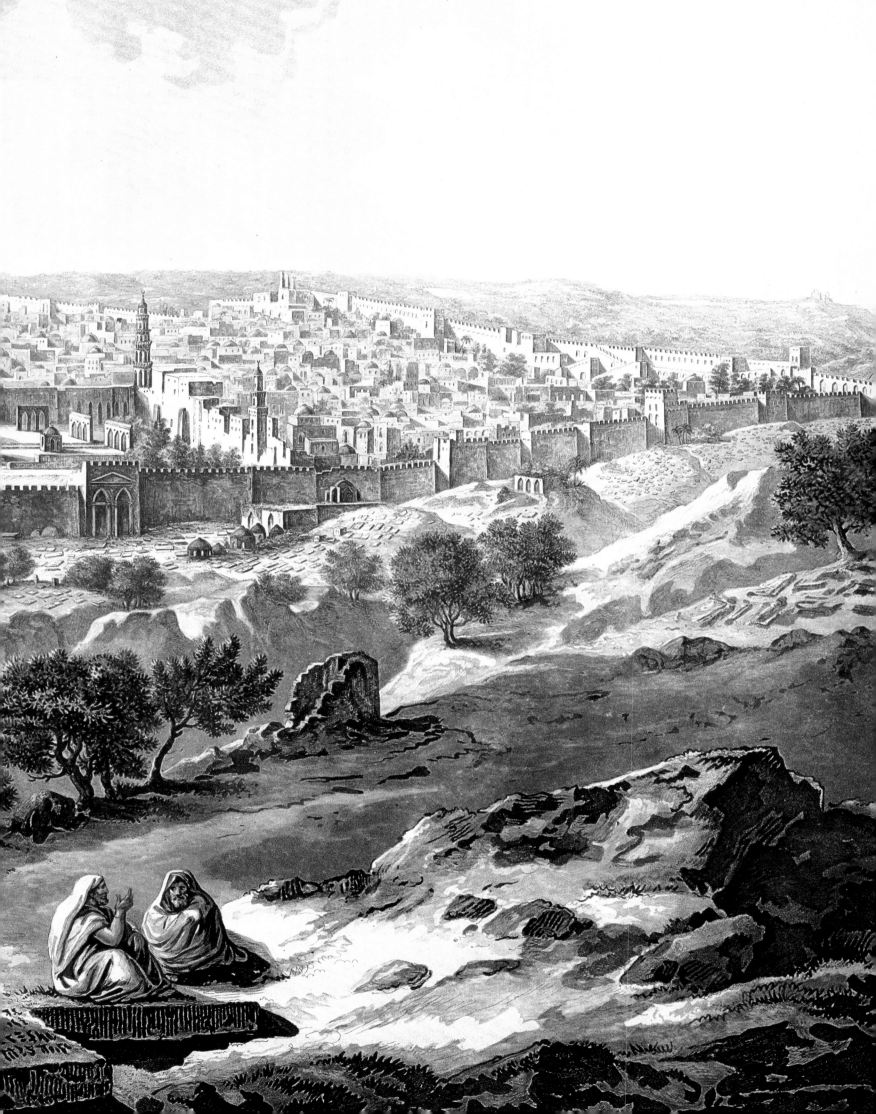

severely affected, the population became impoverished, and disorder and corruption spread. Bedouin tribes raided towns and villages, and these assaults continued to be the most serious cause of insecurity in Palestine until late in the nineteenth century.[3]

The third period – the eighteenth century – saw local leadership further strengthened with the increasing weakening of central Ottoman authority. Dahir al-Omar of the Zaydan family effectively controlled Galilee and other parts of Palestine; rural shaikhs controlled Mount Nablus, central Palestine and the Hebron area; others, such as the Turabay family, controlled Jenin, Lajjun and the Carmel area throughout much of the seventeenth and eighteenth centuries. Acre emerged at the end of the eighteenth century as a major military headquarters, from which Ottoman pashas governed

northern Palestine. These included the powerful Ahmad al-Jazzar (1775-1804), Suleyman Pasha (1804-18) and Abdullah Pasha (1819-1831), who between them brought a measure of order to this part of Palestine.

The fourth period begins with Napoleon's invasion of Palestine in 1799 and unsuccessful siege of Acre, following his invasion of Egypt the previous year. The French were only in Palestine for five months, and were defeated at Acre by al-Jazzar, assisted by a British fleet. But the invasion heralded a major political as well as economic shift in European-Ottoman relations, ending with the takeover of Palestine by the British in 1917. The period has been called 'the rediscovery of the Holy Land' by European powers, marked by the further decline of Ottoman power and the growing authority of the foreign consuls and missionaries in Jerusalem. There was also extensive Jewish immigration to the Holy Land, particularly from the end of the nineteenth century.

It is this period which had the profoundest impact on Palestine and its future; it is also the best documented and the rest of this chapter is devoted to it.

At the time of the Ottoman conquest in the sixteenth century the population was under 300,000; at the beginning of the nineteenth century it has been suggested there were only 150-200,000 while at the time of the Ottoman withdrawal the population is estimated to have doubled from the sixteenth-century figure to nearly 600,000.[4] Some 85 per cent of the population was Sunni Muslim, 11 per cent Christian and four per cent Jewish. Today, at the beginning of the twenty-first century over 8.5 million occupy the original land of Palestine. The population has increased 14 times, while only doubling during the 400 years of the Ottoman administration.

The siege of Acre in spring 1799, depicted by Francis Spilsbury (see p. 160, no. 15), surgeon on board HMS *Le Tigre* commanded by Sydney Smith. The siege marked the end of Napoleon's pretensions in Palestine

Until the beginning of the seventeenth century Palestine was part of the *ayalet* (later known as *vilayet*) of Damascus, divided into several districts (*sanjaks*). Later the Galilee districts were transferred to the newly established *vilayet* of Sidon, while the rest of the country, including central and southern Palestine and east of the River Jordan, continued to be ruled, at least nominally, from Damascus. At the end of the Egyptian occupation of Palestine in 1841 all Palestinian districts were placed in the *vilayet* of Sidon, later renamed the *vilayet* of Beirut.[5] Administrative reforms after the Crimean War (1853-56) led to the reorganization of the autonomous *vilayet* of southern Palestine to include Jerusalem, initially governed by a *wali*, later administered directly from Constantinople.

Initially Jerusalem was organized as a *mutasarrıflık* that included the *sanjaks* of Nablus and Gaza and governed by a *mutasarrıf* with the title of Pasha. From 1873 the *mutasarrıflık* of Jerusalem included all areas from Ramallah and Jaffa in the north to the Egyptian border in the south.[6]

Ibrahim Pasha, commander of the Egyptian force that invaded Palestine and Syria in 1831, drawn by Joseph Bonomi who accompanied the expedition (see p. 83, no. 2a)

Major changes occurred in the area in the course of the nineteenth century, largely stemming from Napoleon's ill-fated invasion in 1799. European attention was turned not only on Palestine but also on the Ottoman Empire as a whole, leading to the development of the so-called Eastern Question. The Ottoman Empire sat astride major communication routes between Europe and further east (notably to India, to the concern of the British), and these routes were threatened in 1831 by the invasion of Palestine and Syria by an Egyptian army. The Egyptians were commanded by Ibrahim, son of the Pasha of Egypt, Muhammad Ali, who had been promised Syria in return for his assistance to the Ottomans in trying to suppress the Greek uprising. Ibrahim died in 1848 but he had initiated a reorganization of the region including the enforcement of law and order, making it safer for pilgrims, Muslim and Christian, and European travellers. An alliance of European powers and the Sultan effected the withdrawal of the Egyptians in 1841. From the 1840s the Ottoman government was also introducing its own modernizing reforms, known as the *Tanzimat*.

Tanzimat reform worked well in central and northern areas where, despite political and military upheavals, travellers to and in Palestine reported a fertile land, a well-stocked Lake Tiberias, delicious figs and grapes from Hebron and olive oil and olive soap from the hills around Nablus.[7] Cotton was also grown in the north of the region. In more remote areas, however, punitive taxation was depopulating villages and depleting what had once been a flourishing agricultural economy. One of the outstanding characters in northern Palestine at this period was Akil al-Fasi, of bedouin origin and legendary fame, whose carefully negotiated truces with local bedouin tribes freed his territory from raids until his death in the 1860s.

European commercial involvement in the area had, since the sixteenth century, been governed by Capitulations, a system of commercial treaties regulating conditions of trade, dating from 1535 with

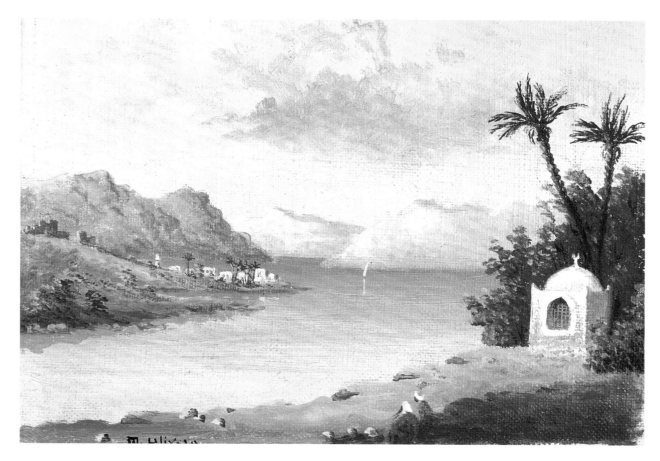

Lake Tiberias by
M. Olivero (see
p. 119, no. 36b)

The vineyards of Hebron, lithographed from a drawing by Elizabeth Finn, wife of
the British Consul in Jerusalem in 1845-63 (see pp. 179-80, no. 32)

the first grant to the French crown by Suleyman the Magnificent. From the mid-nineteenth century these were backed by the establishment of powerful consulates, representing not only the commercial and political interests of the various European powers but also religious communities – disputes between the various Christian communities in Jerusalem were in fact a major trigger of the Crimean War. The first was the British vice-consulate, established in Jerusalem in 1838 during the Egyptian occupation and with Egyptian permission.

After the restoration of Ottoman authority in Palestine in 1841, the British precedent was followed by others: Prussia in 1842, France in 1843, the USA in 1844, Austria in 1849 and Spain in 1854. Although established ostensibly for commercial reasons, the consulates soon constituted a major force for the expansion of European political influence in Palestine, particularly after the Crimean War which had demonstrated Turkey's dependence on European assistance for the defeat of Russia. Russia in fact opened its own consulate in 1858, ostensibly to protect the Russian Orthodox community, and the consulate bought up so much land for their church that by 1877 it was the largest non-Muslim property owner in the city. The Russian compound (*al-Muskoubeh*) remains one of the best known monuments in the city.

Consuls, enjoying special privileges and increasing power, were often high-handed in their protection of their citizens and pilgrims, arousing local resentment; thousands of Christians of various denominations as well as Jews came under the protection of the consuls who exploited their privileges to expand European involvement in the affairs of the Ottoman Empire, particularly in Palestine and Jerusalem. Missionary activities increased, mainly directed towards conversion of the Jews, and an Anglo-Prussian bishop was appointed in 1841 for this purpose. The second British consul, James Finn, and his wife Elizabeth were both zealous advocates of Jewish conversion, much to the irritation of the local Jewish community. Several of their many books about the Holy Land are in the Collection (pp. 179-80, nos. 32 and 33), including one of the most important, *Stirring Times*, published in 1878, a detailed record of Jerusalem and Palestine in the mid-nineteenth century. Christian schools were also established; after World War I their students, together with educated Muslims, were responsible for the awakening of a national consciousness and opposition to foreign domination.

The British consulate, with only the relatively small Anglican Protestant community under its wing, also protected Jews, thereby facilitating a powerful British-Jewish involvement in Palestine. Germany, after German unification in 1871, protected the Lutheran Protestant community, buying

land in the Muristan quarter of the Old City and building the Redeemer Church in 1898, the year of the state visit to Jerusalem of Kaiser Wilhelm II, organized by Thomas Cook. In 1910 the German community built the Augusta Victoria Hospital on Mount Scopus, one of the most impressive buildings in Palestine to this day.

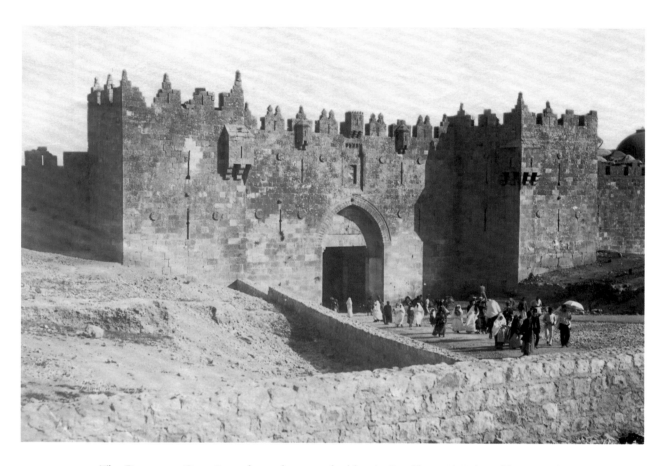

The Damascus Gate, Jerusalem, photographed by A. Bonfils, *c.* 1890 (see Chapter 10).
Jerusalem was the main focus of European activity in Palestine

Foreign investment, encouraged by extra-territorial privilege, also followed the establishment of the consulates. Thomas Cook pioneered the development of tourism after the inauguration of the Suez Canal in 1869, opening an office just outside the Jaffa Gate and organizing package tours to Egypt and the Holy Land; roads were paved, railways were built and hotels and other tourist facilities proliferated, particularly in Jerusalem. Muslim pilgrims gathered in Jerusalem for the *hajj*, their journey including pilgrimages to the Dome of the Rock and the shrine of Nebi Musa on the road to Jericho. Improved security facilitated archaeology, directed often towards greater elucidation of the Bible.

Next page:
A watercolour by
Carl Haag (see
pp. 101-02, no. 19f)
depicting Muslims
worshipping in the
cave beneath
the Dome of the
Rock, Jerusalem

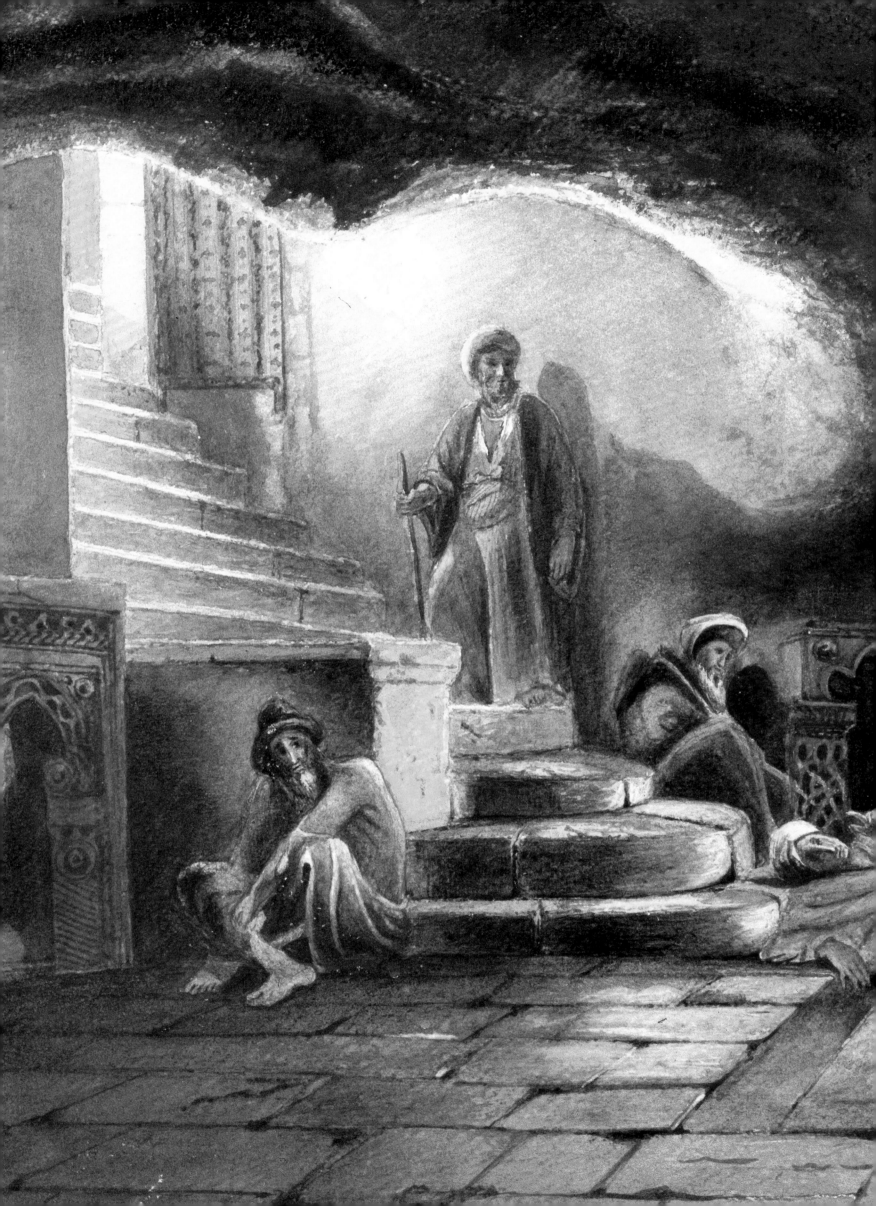

The Palestine Exploration Fund (PEF) was established in London in 1865 for the advancement of a more scientific approach to archaeology, and in the same year despatched Capt. Charles Wilson, fresh from completing the Ordnance Survey of Jerusalem, to do a feasibility study for a survey of the whole of Palestine. Following this, from 1867 to 1870, the PEF funded excavations in Jerusalem, led by Lieut. Charles Warren, in particular underground areas of the city beneath the Haram al-Sharif. In 1871, thanks to relative peace in the countryside, the PEF's great topographical survey of Palestine began, from 1872 led by Lieut. C. R. Conder, joined in 1874 by Lieut. H. H. Kitchener. The survey lasted until 1878 and in 1881 the nine-volume *Survey of Western Palestine*[8] was published, mostly written by Conder and Kitchener but with major specialist contributions (see also pp. 211-12).

All this interest transformed the face of the region. In a later book, *Tent Work in Palestine*, Conder commented: 'In 1882 I saw only too plainly the changes that had come over the land. The Palestine of the early years of the Survey hardly now exists.'[9] The same trend was noted by G. E. Franklin in his *Palestine Depicted and Described*, copiously illustrated with photographs and published in 1911.

The existence of the consulates and the system of Capitulations also encouraged foreign trade. The Palestinian market was opened to cheap foreign products, undermining local exports, in particular cotton, wool, wheat and citrus fruits. Larger cities such as Nablus were prosperous enough to survive the economic decline; Jerusalem with its pilgrim economy also survived. But in Palestine as a whole the decline in overseas trade, combined with oppressive Ottoman taxa-

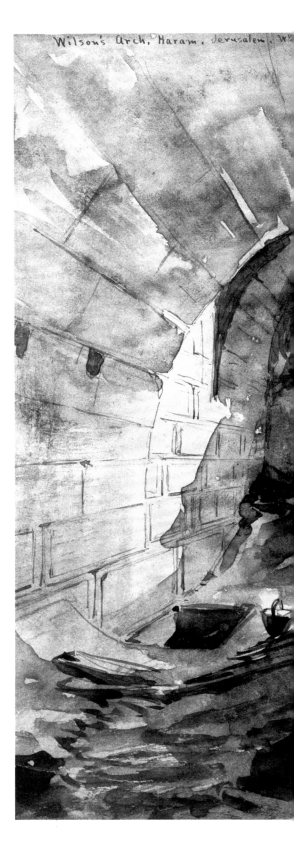

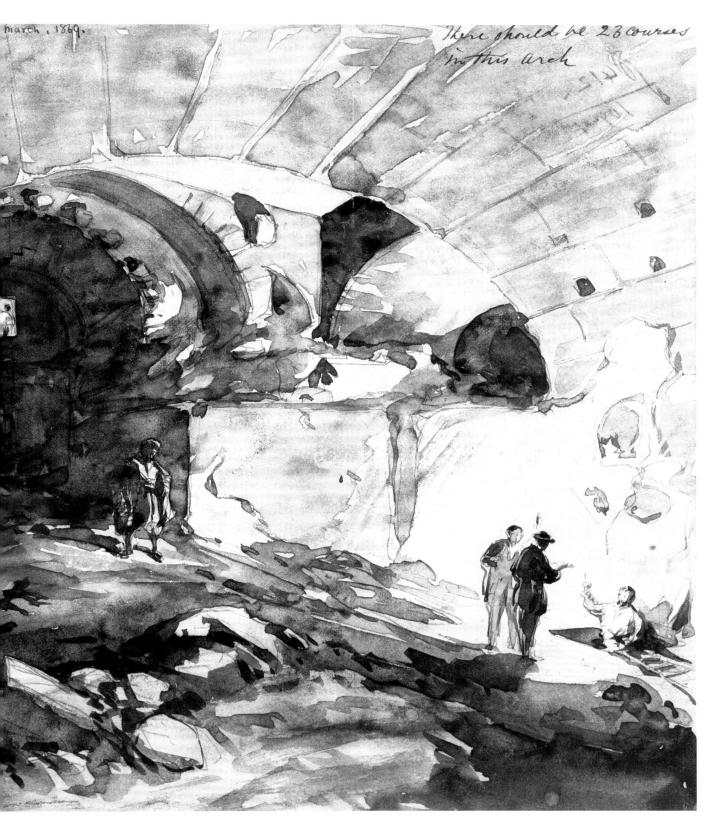

march . 1869 .

There should be 23 courses in this Arch

A sepia colour and wash by William Simpson showing Wilson's Arch beneath Haram al-Sharif
(see p. 129, no. 46b), drawn in 1869 during Charles Warren's excavations in Jerusalem for the PEF

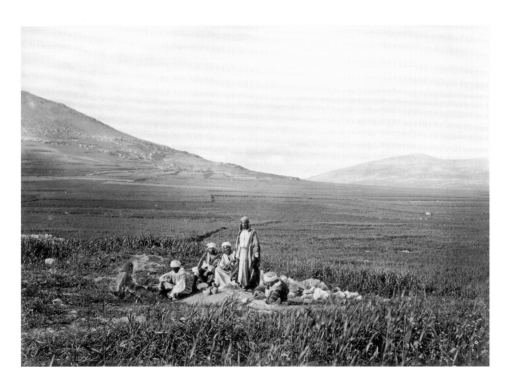

Arabs at Bir Yacoub (Jacob's Well), near Nablus, surrounded by rolling
farmland, photographed by Francis Frith *c.* 1860 (see pp. 240-41, no. 2).
By the late 19th century, increasing poverty forced many
people in the countryside to give up their land

tion, led to the collapse of local agriculture and the depopulation of the countryside. The opening of
those early consulates, and the consular privileges that went with them, were seen by Palestinians as
mortgaging their country to foreign governments, a major cause of economic difficulties and the
root cause of Arab resentment and suspicion of the West.

Moreover the countryside and the bulk of the population remained impoverished. The Ottoman
Land Law enacted in 1858 required the registration of property, mainly for purposes of taxation.
Ottoman military campaigns in the Balkans in the latter part of the nineteenth century, as well as the
Crimean War itself, had reduced available funds for administration, further depopulating villages.
This was especially true of the Hauran where peasants were reduced to a semi-nomadic existence,
working seasonally as landless labourers. Many small landowners failed to register, and their lands
were appropriated by the government and re-sold to the wealthy often for less than their real value.
A 70 square-km. holding in the northern Plain of Esdraelon was sold for a trifling sum to the Sursuq
brothers of Beirut, who then sold it on to Jewish land purchasers in 1910.

At the turn of the century Palestinian disaffection with the Ottoman regime was growing, has-tened by the emergence of the Young Turks in the early years of the twentieth century. The 'Arab awakening' was on the move. But so was another process – that of Jewish immigration.

In 1882 Russia passed the May Law which restricted Jews in Russia to small designated areas known as the 'pale of settlement'. A spate of pogroms throughout eastern and central Europe stim-ulated the mass migration of Jews at the end of the century, around one million moving to the USA. But a sizable religious minority chose Palestine, the first wave arriving in the last two decades of the nineteenth century. Many entered on pilgrim visas. In 1897 Theodor Herzl founded the World Zionist Organization, the principal aim of which was the creation of a home in Palestine for the Jewish people, thus encouraging more immigration.

A particularly bloody pogrom in Russia in 1903 stimulated a second wave of immigration, end-ing with the outbreak of war in 1914. Over 30,000 educated Zionist-inspired Jews migrated to Palestine in that pre-war period, despite Ottoman opposition. The number of Jews in Palestine rose sharply, from around 50,000 in 1897 to nearly double that number in 1914. Many settled in Jerusalem, upsetting the demographic structure of the city. Local opposition, led by educated Palestinians, became vocal in the local press (*Carmel* in Haifa, *Filastin* in Jaffa), stressing the coun-try's Arabic name, 'Filastin' as distinct from Syria.

Britain played a leading role in the encouragement of Jewish immigration, summarized by the American historian Thomas Idinopulos: 'Jewish immigration to Palestine began a few years after Britain gained sole control of the Suez Canal in 1875, and about the time British troops, in 1882, began occupying Egypt as a protectorate. With that occupation, British strategists began to see Palestine as a necessary buffer for both the Suez Canal and Egypt, both vital to communication with the Persian Gulf and India. With Britain now desiring Palestine for herself, the perceived need for a stable, loyal community of Jews in Palestine grew proportionately. Britain saw in her "protected Jews" a valuable ally and tool in Palestine for enhancing her own imperial powers in the Middle East'.[10]

The idea of a 'Jewish National Home' was thus part of British imperial strategy during World War I. Britain's aim was to control the Middle East region in order to protect its imperial interests; communication lines through the Canal, the Persian Gulf and Iraq played a major role in this strat-egy. This was the background to the Balfour Declaration which stated: 'His Majesty's government view with favour the establishment in Palestine of a national home for the Jewish people, and will

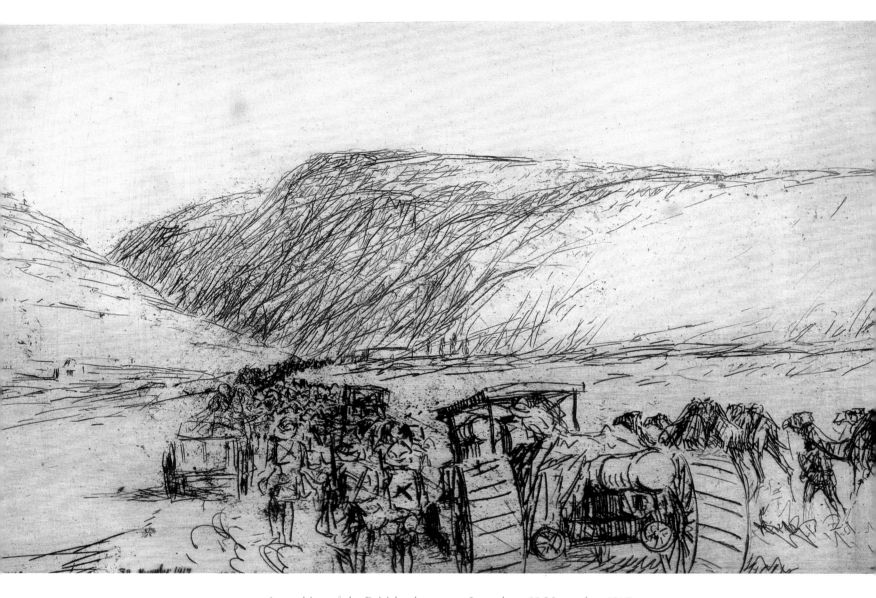

An etching of the British advance on Jerusalem, 20 November 1917,
by James McBey (see p. 255, no. 5c), official war artist with
the British Expeditionary Force

use their best endeavours to facilitate the achievement of this object, it being clearly understood that nothing shall be done which may prejudice the civil and religious rights of existing non-Jewish communities in Palestine, or the rights and political status of Jews in any other country'.[11] It was of course the rights of those existing non-Jewish communities which suffered the most.

Britain needed Arab assistance to defeat Turkey, the ally of Germany in World War I. The British government made many promises, never fulfilled, to Sharif Husayn (McMahon-Husayn correspondence – in the Collection) in the Hijaz but behind the scenes Britain was committed to the secret Sykes-Picot agreement of November 1915, whereby Britain agreed to split the Near Eastern parts of the Ottoman Empire with France. With Arab assistance the road was open for General Allenby to occupy Jerusalem on 11 December 1917.

World War I had taken a heavy toll of Palestine and its Arab population, leaving it damaged and impoverished. The population was reduced by a quarter through emigration; thousands had died from war and starvation. Allenby's entry to Jerusalem heralded a new and turbulent era for Filastin.

Notes

1 'Abd al-Ghani al-Nabulsi, *Al Hadra al-Unsiyya fi al-Rihla al-Qudsiyya*, (in Arabic) ed. Akram Hasan al-Ulabi, Beirut 1991

2 Mattar, Nabil, 'Two Journeys to Seventeenth-Century Palestine', *Journal of Palestine Studies*, vol. XXIX, no. 4, summer 2000, pp.37-50

3 Shepherd, Naomi, *The Zealous Intruders*, London 1987

4 Ma'oz, Moshe, *Studies on Palestine during the Ottoman Period*, Jerusalem 1975

5 Idinopulos, Thomas, *Weathered by Miracle*, Chicago 1998

6 Ben-Arieh, Yehoshua, *The Rediscovery of the Holy Land in the Nineteenth Century*, Jerusalem 1979

7 Doumani, Beshara, *Rediscovering Palestine: Merchants and Peasants in Jabal Nablus 1700-1900*, Berkeley 1995; Manna, Adel, *Tarikh filastin awakhir al-ahd al-uthmani* (in Arabic), Institute of Palestine Studies, Beirut 1999

8 *The Survey of Western Palestine*, published by the PEF, 1881, assisted by the British Ordnance Survey and the Royal Engineers

9 Conder, C. R., *Tent Work in Palestine*, London 1889

10 Idinopulos, *op. cit.*

11 See Hurewitz, J. C., *Diplomacy in the Near and Middle East 1535-1956*, vol. 2, 1914-1956, New York 1956

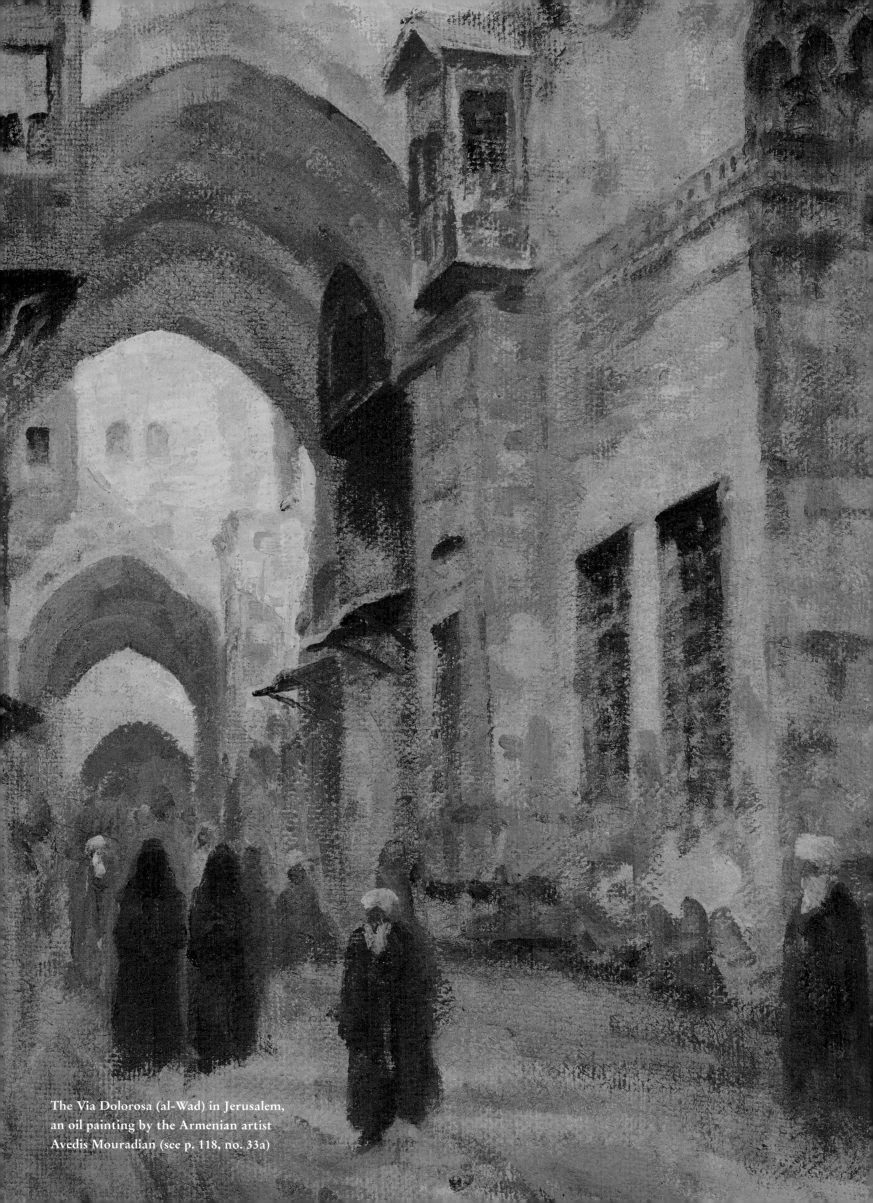

The Via Dolorosa (al-Wad) in Jerusalem,
an oil painting by the Armenian artist
Avedis Mouradian (see p. 118, no. 33a)

CHAPTER TWO

∼ Jerusalem's Development ∼

At the beginning of the nineteenth century Jerusalem was a neglected backwater of the decaying Ottoman Empire. Travellers reported appalling living conditions; sanitation and housing were deplorable. Water was a major problem, both in quality and quantity, supplied from cisterns, the Gihon and Ayn Rogel springs and the Silwan Pool. There was no hospital nor doctor, and until 1870 transport was exclusively by donkey, mule, horse or foot – carts only appeared in the 1870s. So neglected was the city that during the whole of his five months in Palestine Napoleon never even visited it. The population – estimated in 1838 as only three per cent literate – had stabilized at around 9-10,000, all of whom lived within the sixteenth-century walls, the greatest Ottoman contribution to the city. Virtually all property was in Muslim ownership, even the Via Dolorosa (now largely a street of churches). The gates closed every evening at sunset.

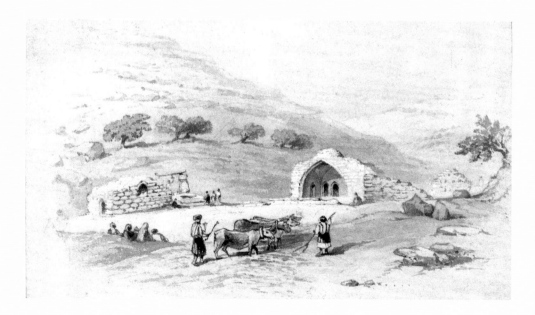

The spring at Ayn Rogel, one of the main water sources of early 19th-century Jerusalem; this drawing (sepia wash over pencil) is attributed to William Bartlett (see pp. 82-83, no. 1c)

The most distinctive site in Jerusalem, maintained over the last 1,400 years, is the Haram al-Sharif, the Noble Sanctuary, with the al-Aqsa Mosque and the Dome of the Rock. The site appears prominently in all plans and panoramas of Jerusalem and in most paintings of the city; it is appropriate, therefore, to give a brief account of its history.

The Haram al-Sharif encloses over 35 acres (14 hectares) filled with fountains, gardens, paths, buildings and tombs. The entire area, nearly one sixth of the walled city, is regarded as a sanctuary, a

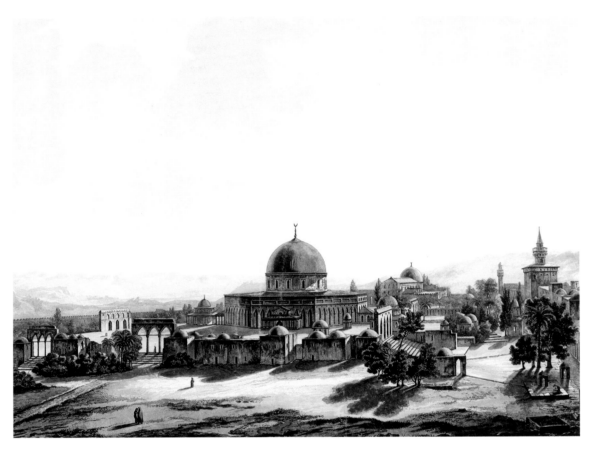

A study of the Haram al-Sharif by Louis de Forbin (see pp. 152-53, no. 4), with
the Dome of the Rock in the foreground and the al-Aqsa Mosque behind

testimony to the love and respect that all Muslims have for this site, one of the three most sacred places in Islam. At the southern end lies the al-Aqsa Mosque. The Dome of the Rock is in the centre.

In AD 638, six years after the death of the Prophet, Jerusalem fell to the Muslim armies under Caliph 'Umar ibn al-Khattab who received the keys of the city from the Patriarch Sophronius.

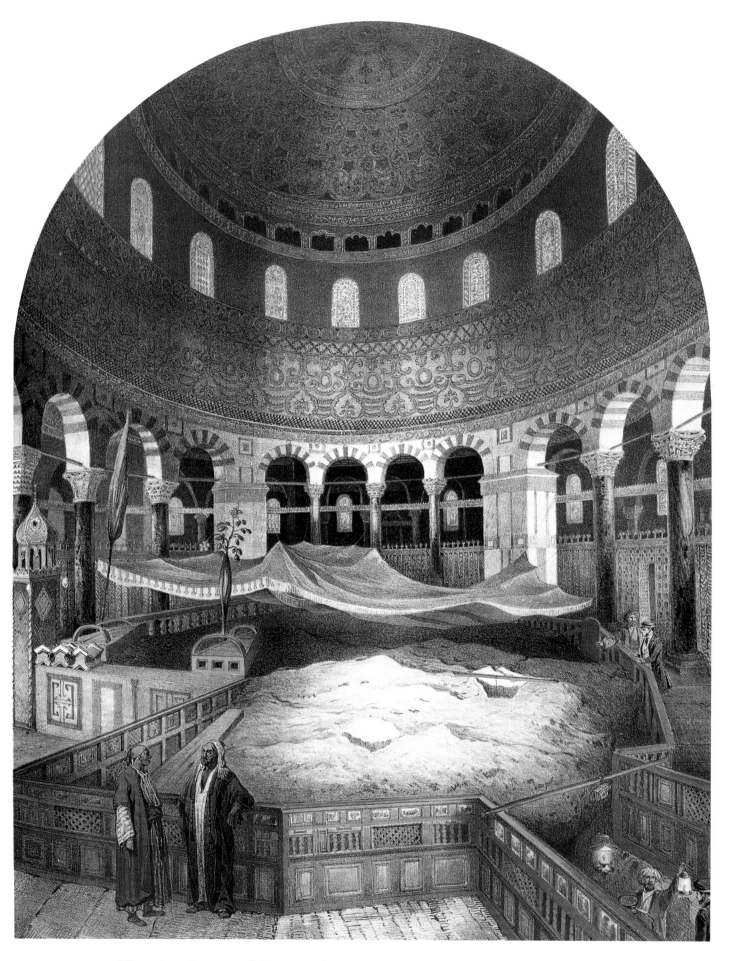

The rock at the centre of the Dome of the Rock, sacred because of its association with the
Prophet Mohammed's Night Journey *(Mi'raj)*; lithographed from a drawing
by the French Rear-Admiral François Pâris (see p. 156, no. 9)

The site on which the Dome of the Rock now stands had been used as a rubbish dump during the Byzantine period. But so important was the place from its association with the Prophet's Night Journey, or *Mi'raj*, from the rock in its centre, that the Caliph himself, renowned for his humility, joined in the work of cleaning it. In the years that followed a huge wooden mosque was built at the southern end of the precinct.

In AD 688 the Umayyad Caliph 'Abd al-Malik ibn Marwan initiated building work on the Dome of the Rock, which was completed in 691. Essentially unchanged for more than 13 centuries, the shrine remains one of the world's most beautiful and enduring architectural treasures. The 20-metre diameter of the golden dome rises 35 metres over the Noble Rock; on the outside the Qur'anic *surah* Yasin is inscribed round the base of the dome in brilliant tilework commissioned in the sixteenth century by Suleyman the Magnificent.

A watercolour of a bathhouse keeper by William Tipping (see pp. 134-135, no. 52). This is in Damascus but there were many bathhouses in Jerusalem, as in all Islamic cities of the Middle East

It was the next Caliph, 'Abd al-Malik's son al-Walid (705-715), who built a vast congregational mosque on the site of the original timber one to accommodate more than 5,000 worshippers. The building became known as Masjid al-Aqsa, al-Aqsa Mosque, though in reality the whole area of the Haram is considered the mosque and inviolable according to Islamic law. Every Friday, at prayer time, the sanctuary overflows with tens of thousands of worshippers, many of whom have to perform their prayers outside in the vast open expanse of the greater al-Aqsa Mosque.

While the Dome of the Rock, *Qubbat al-Sakhra*, was built as a shrine to commemorate the Night Journey, al-Aqsa became the centre of worship and learning, attracting famous teachers from all over the Muslim world. It has been modified several times to protect it from the earthquakes that sometimes occur in the region, and to adapt to the changing needs of the local population. The present structure is essentially that of the eleventh-century Fatimid Caliph al-Dhahir who narrowed it on each side.

For most of its history Jerusalem can be described as a Muslim city with certain characteristics in common with other Middle Eastern cities. Central to this theme is the Great Mosque, also known as the Friday Mosque, where the whole congregation can gather on Fridays and special holy days. In Jerusalem this is the al-Aqsa Mosque. There is also a governor's residence and a citadel, often the same building – in Jerusalem this is the Citadel of the Tower of David, which acted as both military base and residence of the Ottoman governor. The religious school or *madrasah* is also a prominent institution in any Islamic city (several are to be found in the Old City), as is the *khan* or caravanserai (in Jerusalem, for example, the al-Sultan Khan). In all these cities the *hammam* is a major feature both as bath house and as social gathering place – such as, in Jerusalem's Old City, Hammam al-Sifa, Hammam al-Ein (near the cotton market), Hammam al-Sultan (at the junction of Via Dolorosa and Haggai Street), Hammam al-Batrak (in the Street of the Christians) and Hammam Mariam (near the Lions' Gate).

The public fountain or *sabil* is another distinctive feature; there are several in Jerusalem, and a well-known one outside the city is close to the Sultan's Pool. A *sabil* in the Street of the Chain, at the entrance to the Haram al-Sharif,

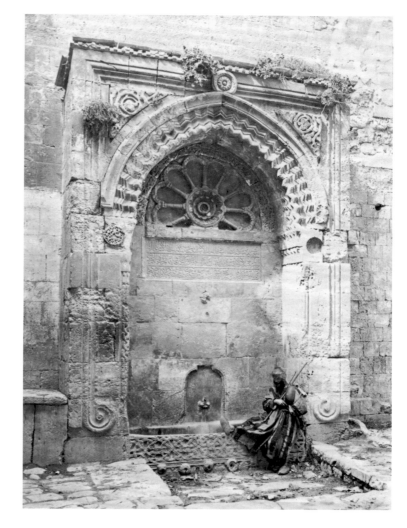

Sabil al-Silsila in the Street of the Chain, Jerusalem, built by Sultan Suleyman in 1532; probably photographed by F. M. Good, late 1860s (see p. 242, no. 3)

collected and supplied water to Jewish residents of the old city; and some in Haggai Street in the old city were still in use at the beginning of the twentieth century. Markets (*suqs*) are common features, found also in Cairo, Istanbul and other Muslim cities – as are city walls and gates.

The city is divided into residential quarters – the Jewish quarter, the Armenian quarter, the Christian quarter, the Moghrabi quarter, etc. – as in other Middle Eastern cities. Muslim society and way of life is also sustained in domestic architecture. In Jerusalem, as in most Middle Eastern cities, openings in houses face inwards onto an internal courtyard; the single door leads via a corridor to the courtyard and entrances to various parts of the house.

The end of the Egyptian occupation and the introduction of the Tanzimat reforms had an immediate effect on the city. Increased population (it multiplied sevenfold between 1800 and 1914) put pressure on living space within the walls, resulting from the 1850s onwards in construction outside including, in 1860, the new Russian compound. In the second half of the century increasing numbers of Jerusalem residents, Muslim and Christian, developed neighbourhoods beyond the walls, unrestricted by size limitations. The American Colony was built in 1881 by Rabbah al-Husseini whose relatives Salim and Ismail Husseini also built there, creating a Husseini quarter. The Nashashibis built in the Shaikh Jarrah area, as did the Jarallahs, while the al-Alami family and others developed the quarter outside Herod's Gate (*Bab al-Zahrah*). The Rashidiyyah school was built in the same neighbourhood at the beginning of the twentieth century. Palestinians also developed the Bak'a area, where the German Colony, the Greek Colony and the Katamon were built. Many of these beautiful buildings, with their distinctive Arab architecture, are still used to this day.

Printing was introduced to the city in the 1830s, with the opening of an Armenian press. Ten years later a Jewish press arrived, followed in 1846 by the Franciscans who in the following year produced the first Arabic book to be printed in Jerusalem; the press still functions today. A telegraph service arrived in 1865 and an effective postal service. Four years later the first paved road linked Jerusalem and Jaffa. Pilgrims were pouring into the city, nearly 14,000 reported in one year from eastern Europe. New cultures, new ideas were thus introduced to a now prospering city, whose prosperity, however, was to be rudely interrupted by World War I.

The Tanzimat reforms encouraged European investment and also the establishment of consulates and religious missions, each country supporting a particular religious community: Prussia (incorporated into the new German state from 1871) and Britain supported the Protestants, Russia the Greek

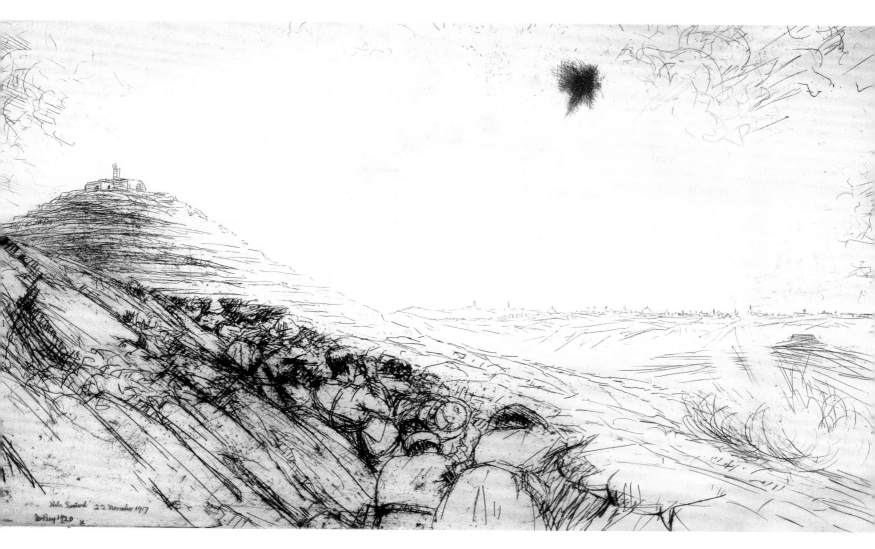

The British Expeditionary Force's first sight of Jerusalem from Nebi Samuel; one of the most renowned of James McBey's series of etchings on Palestine (see p. 255, no 5a)

and Russian Orthodox, France the Roman Catholics. Jews were also supported by funds from Jewish communities abroad (the British philanthropist Sir Moses Montefiore made seven visits to Jerusalem to help Jewish residents).

These foreign activities aggravated the internal divisions within the city and also discriminated against the majority Muslim community which received no assistance, not even from the Ottoman administration. In the fields of health and education Christian Arabs fared slightly better, benefiting from the foreign educational facilities, as well as commercial and cultural opportunities. By the end of the century an educated, cultured Arab élite was emerging, Muslim as well as Christian, leading to a nationalist movement in Palestine which challenged the growing Zionist threat. This Arab

nationalist movement spread rapidly in Palestine, encouraged by the tyranny of the Young Turk administration in the early twentieth century, and paving the way for the occupation of Palestine by Britain in 1917.

A personal account of the surrender of the city in November-December 1917 is related by Major Vivian Gilbert in his *With Allenby to Jerusalem*. As British troops were approaching Jerusalem from Nebi Samuel in the north early in the morning of 9 December, the Major sent his batman, Private Murch, to bring some eggs from the nearby village of Lifta. Private Murch lost his way:

'He came to the crest of a hill and there before him lay the village he had been looking for… The end of the road, previously deserted, was now covered by a large crowd advancing from the shelter of the houses. It was still some distance way, but a carriage drawn by a pair of horses could be seen leading the procession. As it got nearer two men on horseback could be distinguished carrying white banners on long poles and riding a little in the rear of the dilapidated vehicle.

'The noise now died down, and a little man in a black frock coat with a tarbush on his head and looking very much like a Turk, could be heard speaking from the carriage. "You are British solider, are you not?" he asked in a high falsetto voice… "Where is General Allah Nebi?" now enquired the man in the red fez. "I want to surrender the city, please. 'Ere are ze keys: it is yours!" went on the stranger, producing a large bunch of keys and waving them before the bewildered Britisher. Private Murch went back and related the story to his officer. When the man came to the end of his story, the major turned to colleagues and said quietly: "Gentlemen, Jerusalem has fallen!" Hearing this, General Watson, in charge, rode to Jerusalem. He met the mayor in his carriage outside the Jaffa Gate.

'Together the mayor of Jerusalem and the English general rode through the streets of Jerusalem until they came to the El Kala citadel. On the steps at the base of the Tower of David the mayor surrendered the Holy City and handed over the keys. General Watson accepted in the name of the Allies, and was loudly cheered by the inhabitants as he rode back to brigade headquarters.

'On December 11th General Allenby, followed by representatives of the Allies, made his formal entry into Jerusalem. The historic Jaffa Gate was opened after years of disuse, enabling him to pass into the Holy City without making use of the gap in the wall through which the Kaiser entered in 1898'.

After exactly 400 years of Turkish rule of Jerusalem, a new, dynamic but turbulent era in Jerusalem's history had commenced. The turbulence has not ended yet.

References

1. El-Aref, Aref, *Al-Mufasal ve Tarekh el-Quds*, 2nd edition, Jerusalem 1986 (in Arabic)

2. El-Aref, Aref, *A History of the Dome of the Rock and Al-Aqsa Mosque*, Jerusalem 1955 (in Arabic)

3. Ben-Arieh, Yehoshua, *Jerusalem in the Nineteenth Century*, Jerusalem 1989

4. Asali, Kamel (ed.), *Jerusalem in History*, London 1989

5. Rosovsky, Nitza (ed.), *City of the Great King*, Cambridge, Mass. 1996

6. Gilbert, Major Vivian, *With Allenby to Jerusalem*, London 1923

7. Baedeker, K., *Jerusalem and its Surroundings: A Handbook for Travellers*, Leipzig 1876 (reprint, Jerusalem 1973)

8. Natsheh, Yusuf, *Ottoman Jerusalem: The Living City 1517-1917* (Sylvia Auld and Robert Hillenbrand, eds.), London 2000

Important Dates in Jerusalem in the Nineteenth Century	
British Consulate opened in Jerusalem	1838
Christ Church built (begun/completed)	1841/1849
Commencement of building outside the walls	1850
Dome of the Rock (repair completed)	1860
Hurrah Synagogue (building/inauguration)	1860/1864
Building of Russian Compound (begun/completed)	1860/1866
Telegraphic line	1865
Foundation of the PEF	1865
First road for wheeled carriages (Jaffa-Jerusalem)	1869
Foundation of Husseini neighbourhood (American Colony)	1881
Notre Dame Convent (begun)	1884
Church of Mary Magdalene (Gethsemane)	1888
First railroad (Jaffa to Jerusalem)	1892
Church of the Redeemer	1898
First bicycle introduced into Jerusalem	1898
Augusta Victoria Hospital	1910
General Allenby enters Jerusalem	1917 (11 December)

Population growth in the main towns of Palestine from 1800 to 1922					
City	1800	1840	1860	1880	1922
Jerusalem	9,000	13,000	19,000	30,000	62,500
Acre	8,000	10,000	10,000	8,500	6,400
Haifa	1,000	2,000	3,000	6,000	4,600
Jaffa	2,750	4,750	6,520	10,000	47,700
Ramleh	2,000	2,500	3,000	3,500	7,400
Gaza	8,000	12,000	15,000	19,000	17,500
Hebron	5,000	6,500	7,500	10,000	16,600
Bethlehem	1,500	2,500	3,570	4,750	6,600
Nablus	7,500	8,000	9,500	12,500	16,000
Nazareth	1,250	2,250	4,000	6,000	7,500
Tiberias	2,000	2,000	2,500	3,000	7,000
Safed	5,500	4,500	6,500	7,500	8,800
TOTAL	54,000	70,000	90,000	120,750	228,600

Source: Moshe Moaz (ed.) *Studies on Palestine During the Ottoman Period*, Jerusalem 1975

CHAPTER THREE

≈ Travellers and Explorers ≈ of the Holy Land

L et us first define the Holy Land. Centred historically on Palestine it also includes Sinai, areas east of the Jordan River (including Petra) and the southern parts of Syria and Lebanon. Travellers often visited one or more of these areas on the same trip. Professor Reinhold Rohricht's *Bibliotheca Geographica Palaestinae von 333 bis 1878* (Berlin 1890), recording all travel writing on Palestine in that period, lists 3,500 writers, 2,000 of them post-1800, with literature totalling some 5,000 volumes. Prior to 1800 it was unsafe for travellers to stay long enough thoroughly to investigate the towns let alone the countryside; they often depended on earlier writings, hearsay and inaccurate maps, thereby compounding the misinformation.

The avalanche of writing after 1800 developed initially from the interest in the region which Napoleon's Egyptian and Palestine campaigns of 1798-99 aroused in Europe. Napoleon was accompanied by a team of 170 scientists, antiquarians and artists who studied, painted and wrote about the region, ultimately producing the voluminous *Description de l'Égypte* (1809-28) which stimulated European interest in the region. One of its most remarkable achievements was the first scientific map of Palestine, supervised by Colonel Pierre Jacotin. The Jacotin Map (in the Collection, pp. 211 and 212-13) contains 46 maps, the last six of which survey the Palestine coastline from al-Arish in the south to Sidon in the north, the interior round the towns of Nazareth and Tiberias and the hill country around Nablus. The Jerusalem area was also mapped as was the territory east of Jerusalem down to Jericho and the Dead Sea. Despite some inaccuracies, Jacotin's Map signalled the beginning of European 'discovery' of the region.

Those who produced the early nineteenth century accounts of the region fall into several categories. Some were scholars, others were missionaries, others diplomats, others naval officers from

Opposite:
Detail of a lithograph by Charles van de Velde (see pp. 160-61, no. 16) showing Jerusalem from the east

Cornelis de Bruyn's engraving of Jaffa's harbour and citadel, seen from the sea,
from *Voyage au Levant* (see p. 250, no. 1b)

ships visiting Acre and Jaffa. Most knew their Bibles but, with very few exceptions, they were igno-
rant of Islam, Islamic law or Islamic society. Their observations and interpretations were sometimes
absurd, as they interpreted their experiences according to their knowledge of the Bible. Some gave
new interpretations to old theories; others turned to theology to justify their ideas. Geographical
records and descriptions of antiquities were more accurate, some of these sufficiently precise to qual-
ify as reliable contemporary accounts.

In the second half of the century, the greater security following the end of the Egyptian occupa-
tion in 1840 and the Ottoman Tanzimat administrative reforms which took effect from the 1840s,
this tiny part of the world became one of the most surveyed, painted and excavated. Thomas
Idinopulos argues in his *Weathered by Miracle* that 'the Westerner's fascination with Palestine
sprang from major changes in the culture of the eighteenth and nineteenth centuries. Rapid indus-

trialization produced in British and American cities both material wealth and spiritual emptiness. The emptiness induced a nostalgic, spiritualized feeling about Palestine as the Holy Land, the place in which one's childhood innocence and faith might be recovered. Wealth spreading to a burgeoning middle class created a new tourist industry for Palestine, particularly after the mid-century. The Protestant religious revival that swept Britain and America emphasized a scripturally-based faith and inspired the "reborn" to visit the land of the Bible'.[1]

It is impossible in a brief space to refer to all the major travellers to the Holy Land but a few must be mentioned. Edward Daniel Clarke visited Palestine for 17 days in the first decade of the nineteenth century and thoroughly explored the holy sites, describing them and the people he encountered in his *Travels in Various Countries*, Part Two of which describes Greece, Egypt and the Holy Land (in the Collection; see p. 175-76, no. 23); this was the first scientific exploration of Palestine. He was followed in 1802 by the German Ulrich Seetzen who spoke fluent Arabic and claimed to have converted to Islam. His diary, published in four volumes in 1854 (*Reise durch*

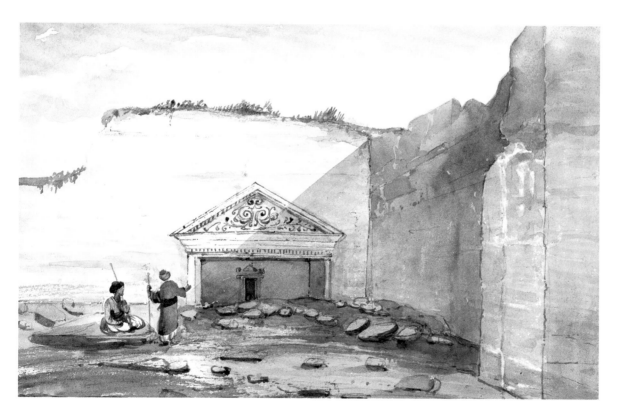

A watercolour by Selina Bracebridge (see p. 84, no. 4c) of the Tombs of the Judges, one of the much-described and painted antiquities of Jerusalem

Syrien, Palästina Phönicien, die Transjordan-Länder, Arabia Petraea und Unter-Aegypten) con-
tains a wealth of knowledge about conditions in the first decade of the century. He was the first
traveller to do a complete circuit of the Dead Sea and the first European to identify Gadara (Umm
Qais), Gerasa (Jerash) and Philadelphia (Amman). He also visited Mecca and went on to Yemen
where he was killed in 1811.

The next pioneer was Johann Ludwig Burckhardt (also known as Jean-Louis or John Lewis); he
too spoke Arabic fluently and may have converted to Islam. Burckhardt is best known as the first
European in modern times to visit Petra, the hidden Nabataean city with its magnificent carved
monuments, and also Abu Simbel. Burckhardt wrote five books, all of which were published
posthumously and all are in the Collection (pp. 172-74, nos. 14-18).

Another important scientific traveller was the American, Edward Robinson, who arrived in
Palestine in 1838. He surveyed the country in detail including Jerusalem where he made some sig-
nificant discoveries, as elsewhere in the Holy Land. He also drew maps that were a major contribu-
tion to the cartography of Palestine. Robinson is considered the most important of all contemporary
explorers of Palestine and his *Biblical Researches in Palestine*, first published in 1841, is a major sci-
entific record of the region (a later edition is in the Collection, p. 193, no. 79). However, his princi-
pal aim was to describe the country with reference to the Bible and most of what he wrote were
interpretations or illustrations of biblical passages. His book was one of the most popular in the
western world in the second half of the nineteenth century.

Travel to Palestine proliferated after 1840, with the enforcement of the Tanzimat reforms, as did
travel writing and painting, also encouraged by the religious revival within Europe's prosperous
middle class. The interest was still Bible-oriented with little interest in the local scene. But from
the 1860s more knowledgeable and better organized travellers came in increasing numbers. Some
lived in the country interacting with the local population and recording local culture. Most impor-
tant among these was Mary Eliza Rogers, who lived in Palestine between 1835 and 1859 and
whose book, *Domestic Life in Palestine*, first published in 1862, with two further editions, is a
major source on the life and folklore of Palestinians (the American edition of 1865 is in the
Collection, p. 194, no. 81).

Guide books started appearing early in the century. The first was *The Modern Traveller* in 1825,
followed by a more professional guide in 1858 with Murray's *Handbook* series, written by the

Houses at Bethlehem, one of the most frequently painted 'biblical' towns
in the Holy Land; a watercolour by Paul Ellis (see p. 90, no. 9a)

Rev. J. L. Porter, author of other illustrated books on Palestine (see p. 192, nos. 74-76). The first pilgrimage tours to Palestine were organised in the early 1850s by Roman Catholic groups from Italy. It was not until 1867 that pleasure tours began to arrive in Palestine – the first was an American group that included Mark Twain, whose *Innocents Abroad* was a huge success from the moment of its publication in 1869. Thomas Cook's Eastern Tours began shortly before the opening of the Suez Canal in 1869; from then until 1882 Cook brought 4,200 visitors to Palestine.

The single most important stimulus to exploration of the Holy Land at this time was the foundation in 1865 of the Palestine Exploration Fund (PEF) in London. Its main purpose, then as now, was to promote research into the archaeology and history, manners, customs and culture, topography and natural sciences of biblical Palestine and the Levant; but in its early days it was also used as a tool for extending British imperial influence and as a cover for obtaining strategic information to support British military interests. Nevertheless, its contribution to scientific knowledge about Palestine, Sinai and areas east of the Jordan River is unparalleled.

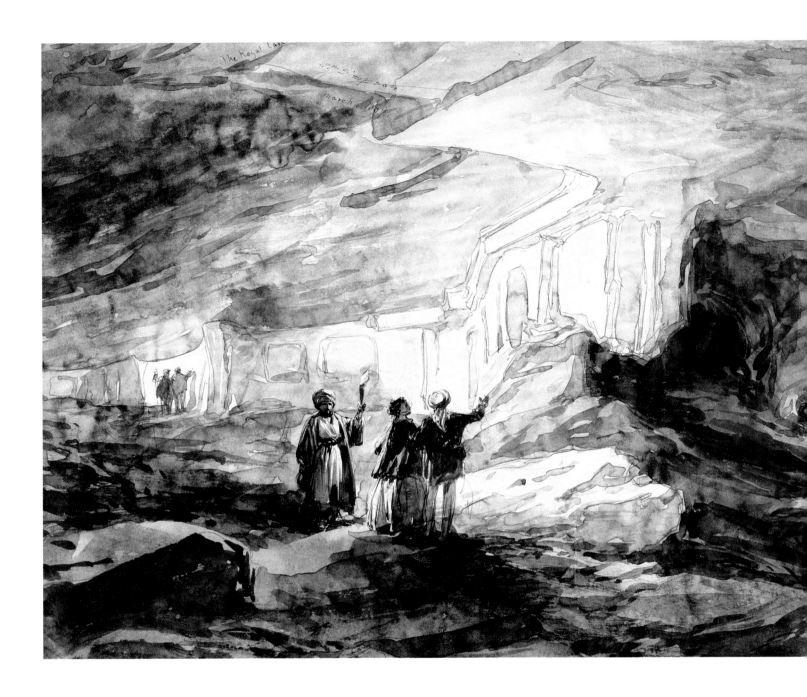

In the same year that it was founded, the PEF engaged Capt. Charles Wilson of the Royal Engineers (who had just finished the Ordnance Survey of Jerusalem) to carry out a feasibility study for a proposed Survey of Western Palestine and to identify sites for future exploration. He completed this work between January and April 1866. The PEF then appointed Lieut. Charles Warren, also of the Royal Engineers, to lead its first major expedition – the excavations in Jerusalem in 1867-70 which revealed the topography of the ancient city and the archaeology of the Haram al-Sharif. The information that Warren provided about Jerusalem captured the public imagination to such an extent that £60,000 was raised by public subscription to carry out the PEF's greatest project, the Survey of Western Palestine, from 1871 to 1878.

From 1872 the leader of the Survey was Lieut. Claude Reignier Conder who was joined two years later by Lieut. Horatio Herbert Kitchener, both of the Royal Engineers. Their aim was to survey and map Jerusalem and Palestine, an area of some 15,500 square km. extending from Tyre and Banias in the north to Beersheba in the south. Every town and village, every hill, stream, spring, saint's tomb, sacred tree and heap of stones was carefully recorded. Sites of particular interest were excavated, and drawn or photographed and casts of inscriptions were made.

The eventual nine-volume publication, which appeared between 1880 and 1884, was written largely by Conder and Kitchener, with contributions by specialists. There were three volumes of 'Memoirs' covering the topography, orography, hydrography and archaeology of Galilee, Samaria and Judaea (all by Conder and Kitchener), and one volume on each of the following subjects: Jerusalem (Warren and Conder), geology (E. Hull), fauna and flora (H. B. Tristram: see also pp. 198-99, nos. 92 and 93), Arabic and English place names (Conder, Kitchener and E. H. Palmer), special papers (Wilson, Conder, Kitchener and Palmer) and a general index (H. C. Stewardson). There was also a set of 26 highly detailed maps of western Palestine (in the Collection, see pp. 62-63 and 211-12), com-

The Royal Caverns, one of the series of sepia colour paintings by William Simpson (see p. 129, no. 46a) of the PEF's excavations in Jerusalem

piled by Conder and Kitchener, which name some 9,000 locations – villages (all of them Arab), ruins, mountains, wadis, cliffs, springs, wells, inns, mosques and churches.

The Survey was intended to include at a later date eastern, southern and northern Palestine. In fact only eastern Palestine was surveyed, under the direction of Conder in 1881. While he was working in the areas east of the Jordan river, problems arose between Britain and the Ottoman Empire and the Ottoman authorities refused to renew his permit. As a result, only one volume was published, appearing in 1889 (in the Collection, p. 176, no. 25).

The Ordnance Survey of Britain, which had commissioned Charles Wilson's original reconnaissance in Jerusalem, in 1868 undertook the Ordnance Survey of Sinai, financed by the PEF. They again

Next page: Sheet XIV, which includes Jerusalem and Bethlehem, from the PEF's set of maps in the *Survey of Western Palestine* (see pp. 211-12 no. 2)

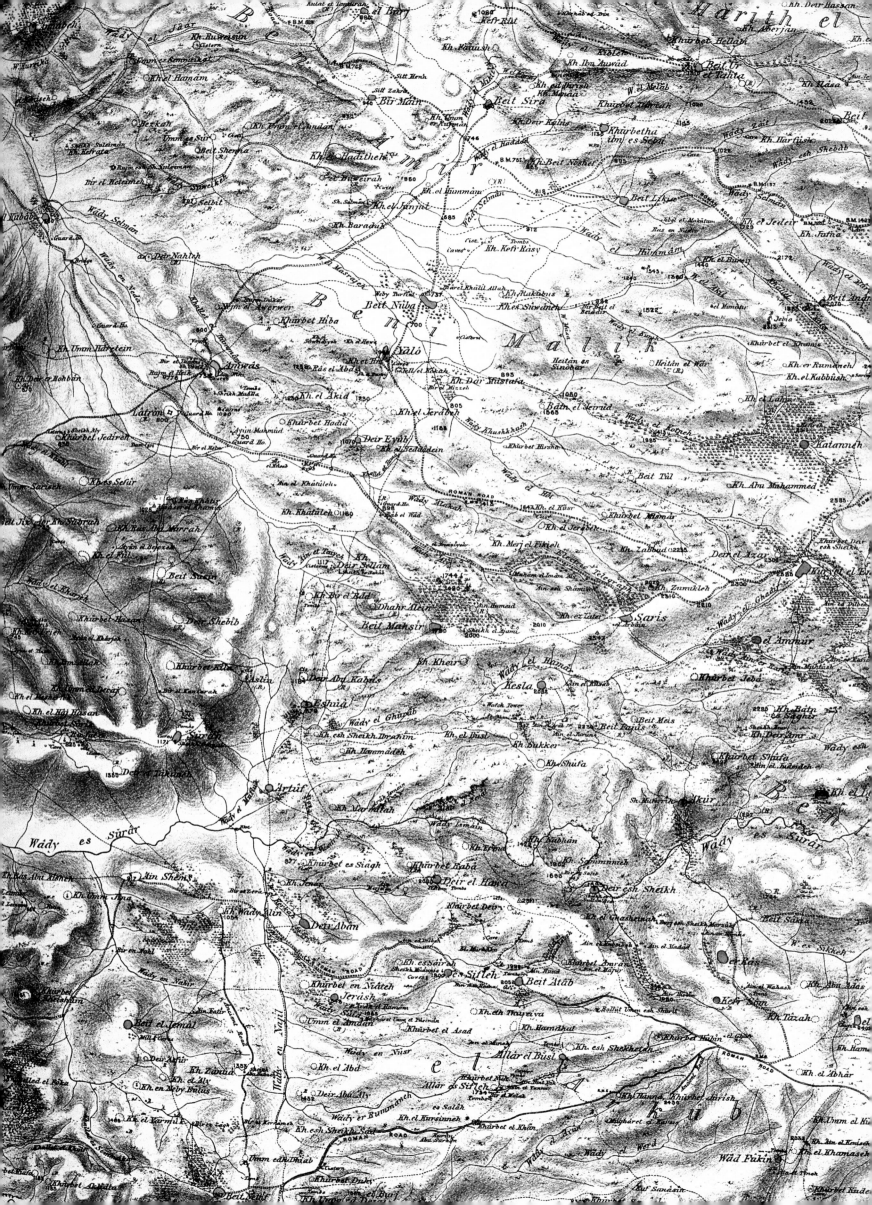

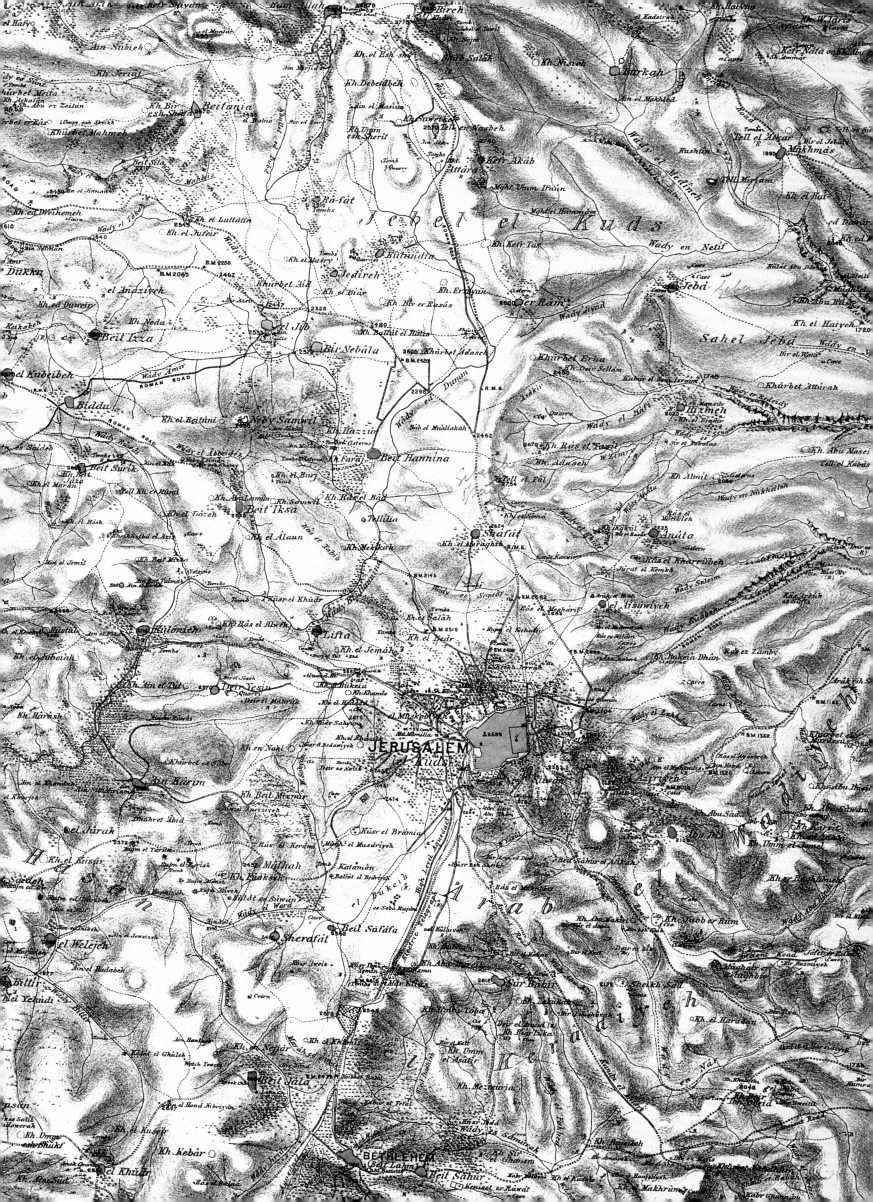

appointed Wilson, and also Capt. H. S. Palmer, and
their three-volume report was published in 1869 (in the
Collection, pp. 206-07, no. 103)

Most nineteenth-century travel literature included
illustrations in various media, as well as maps but until
the introduction of portable cameras in the late nine-
teenth century travellers used drawings to convey a
visual impression. Many travellers were skilled
draughtsmen themselves but if not, they relied on an
accompanying artist or used the work of others for this
visual record. Some of the results were published as
'plate books', with large and impressive plates illustrat-
ing places and scenery of interest and the text only
existing as an explanation of the plates (see Chapter 6).

In many cases illustrations were more accurate than
written descriptions, though this was not the case
when it came to depictions of Muslim holy sites. It
was difficult to enter such places and recording had to
be done from a distance. Even in non-Islamic sites,
conditions were not always conducive to making accu-
rate drawings and the artist had to rely on hasty
sketches. Another problem was that paintings were
often re-drawn by a professional artist back home – in
the case of etchings, engravings, lithographs and other
forms of printing they were then traced or re-drawn
by yet another artist; neither had ever visited the
scene. The result was often influenced by the style of
the artist, his emotions or a message he might wish to
convey. Contemporary Europe had a great appetite for
illustrated books; popular subjects included not only

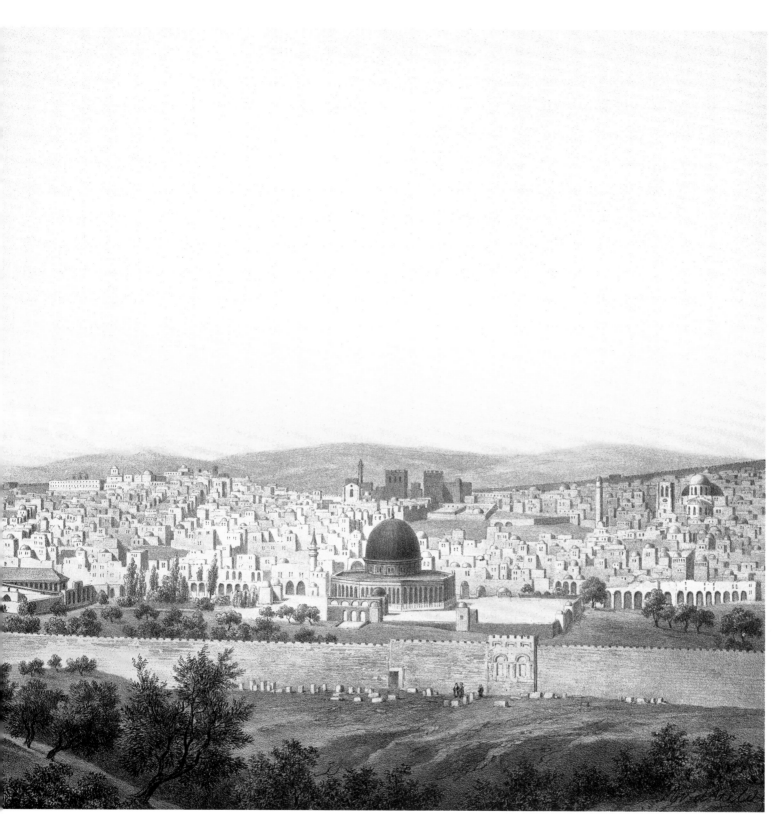

Jerusalem from the Mount of Olives, one of Charles
van de Velde's rare plates (see pp. 160-61, no. 16)

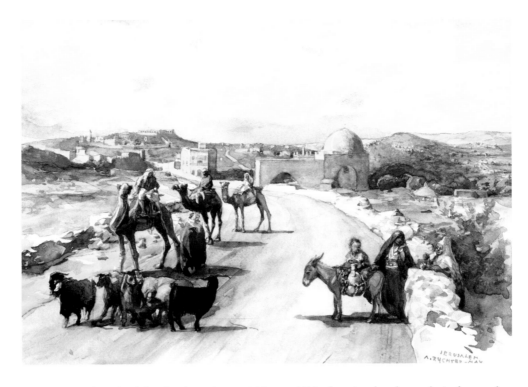

A watercolour by May Rychter (see p. 125, no. 42b), showing local people in front of
Rachel's Tomb (*Qubbat Rahel*), and the landscape between Jerusalem and
Bethlehem. The town in the left background is Bethlehem

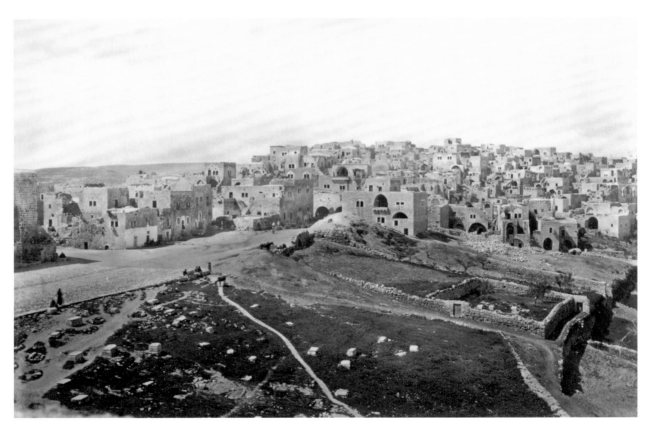

Bethlehem as it was in the late 1850s, photographed by Francis Frith (see pp. 240-41, no. 2).
Photographers, like artists, were drawn to 'biblical' subjects

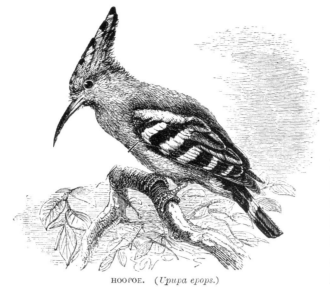

HOOPOE. (*Upupa epops*.)

The Rev. Henry Tristram (see pp. 198-99, no 93), a noted naturalist and artist, wrote and illustrated several books about the Holy Land, including the volume on flora and fauna of the PEF's *Survey of Western Palestine*. This drawing of a hoopoe (*hudhud* in Arabic) is from his *Natural History of the Bible*

Palestine and the Orient but also other parts of the world including Europe itself. Everything was recorded – landscapes and people, antiquities and holy places, geographical phenomena, fauna and flora. In the case of the Holy Land the illustrations did help to record the country and its people and have subsequently led to a greater understanding of the region and of the changes that have occurred since.

From the 1850s a new generation of travellers began to emerge. These were the photographers, whose splendid pioneering work was largely free from the 'improvements' in which painters and lithographers indulged. Photography is more realistic and gives a truer representation of local scenes and sites, though it can be guilty, it must be said, of careful selection of subjects for the benefit of potential clients. Several prints could be made from each negative , at first tediously and expensively pasted separately into each copy of the book. Slightly less tedious was reproduction in the form of engravings on wood, stone, copper or steel plates; by the end of the century printing blocks could be prepared directly from photographs (for more detail see Chapter 9).

With the exception of the PEF Survey, literature on the region during the last century of Ottoman rule was not of high quality. Paintings, prints and photography, generally of better quality, helped to remedy these erroneous impressions.

Next Page:
The star design on the floor of the Cave of the Nativity in the Nativity Church in Bethlehem, a frequent 'biblical' subject of 19th-century painters, here in a watercolour by Carl Werner (see p. 144, no. 58b)

Notes

1 Idinopulis, Thomas, *Weathered by Miracle*, Chicago 1998

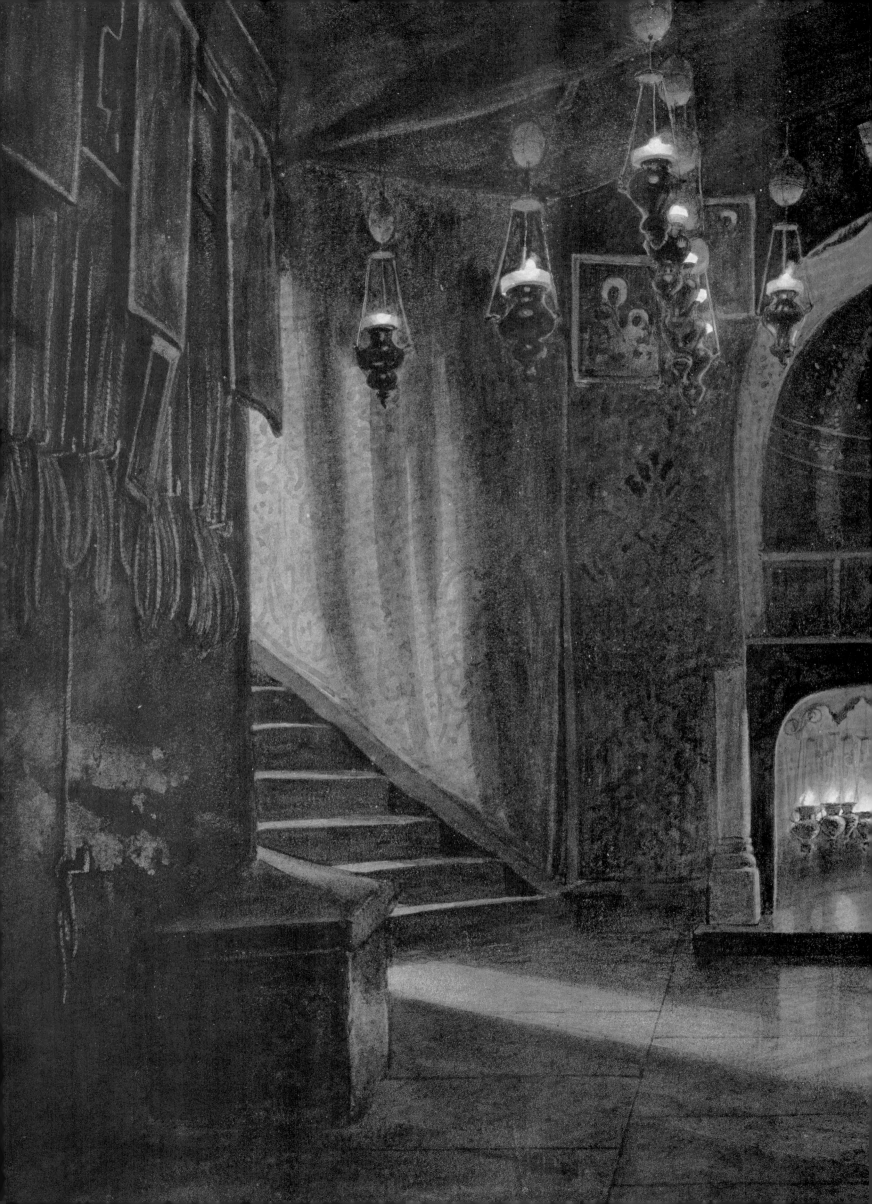

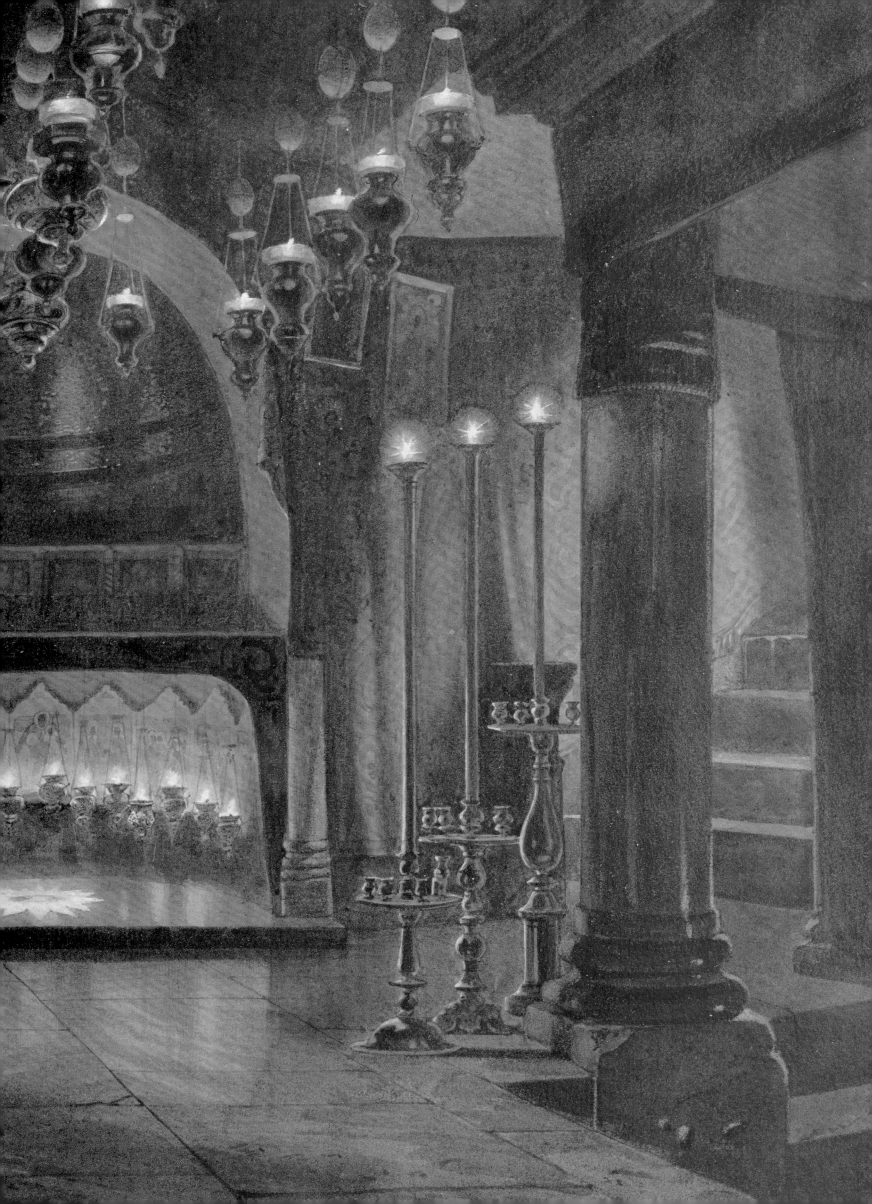

Detail of Georg von Rosen's
Church of the Holy Sepulchre
and the Mosque of Omar,
Jerusalem (see p. 74-75)

CHAPTER FOUR

⮂ Painting Jerusalem, ⮀
the Holy Land and Egypt

The Collection contains hundreds of paintings of Jerusalem and the Holy Land, and Egypt, most of them watercolours, while a few are oil paintings. The main theme is topography, with the emphasis on scenes and panoramas of Jerusalem. Nearly all the Collection is nineteenth-century, with only a few paintings from the last years of the Ottoman period in the early twentieth century. Very few paintings exist of Jerusalem and the Holy Land from the eighteenth century or earlier.

Egypt constitutes a substantial proportion of the paintings in the Collection. Many painters visited both Egypt and the Holy Land in the same trip, and some of them resided in Egypt, from where they made an occasional trip to the Holy Land. Egypt was not only a more exotic place for a painter, it was also more secure during the nineteenth century; antiquities were abundant, whereas the Holy Land offered far fewer; street scenes and local people were more colourful and the buildings were better preserved. Consequently Egyptian paintings are more abundant than those of the Holy Land, and relatively easier and cheaper for collectors to acquire.

A street in Cairo, the Darb al-Ahmar (today's Sharia' Bab al-Wazir), in an unsigned watercolour in the manner of John Singer Sargent (see p. 125, no. 43b)

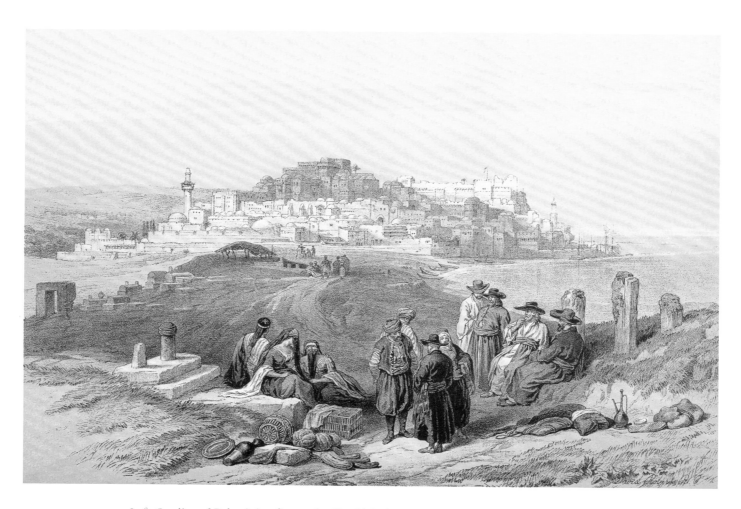

Left: Studies of Palestinian figures by David Roberts (see pp. 121-23, no. 39b). The group below the centre was used in the lithograph of Jaffa, *above*, which appeared in his book *The Holy Land, Syria...*(see pp. 157-59, nos. 11-12)

Again, practically all the paintings are by foreign artists. In the nineteenth century the indigenous local culture did not encourage the emergence of local painters. The local community was also not interested in the activities of foreign painters and on many occasions hindered their work. As a result, a painter had to content himself with a quick sketch, which was later developed either by himself or by another more accomplished artist into a full-colour painting or lithograph. Watercolours were more suited to such restrictions than elaborate oil paintings, which take a lot of time, material and effort to develop and finish.

In most cases watercolours begin with a pencil sketch, which can be very quickly realized and this was the preferred technique for the traveller and amateur artist with little time. The nineteenth century, particularly the Victorian period in Britain, was the golden age of watercolours. Since more travellers and artists from Britain visited the Holy Land than from any other country, most of the paintings in the Collection are watercolours by nineteenth-century British artists. Most were inter-

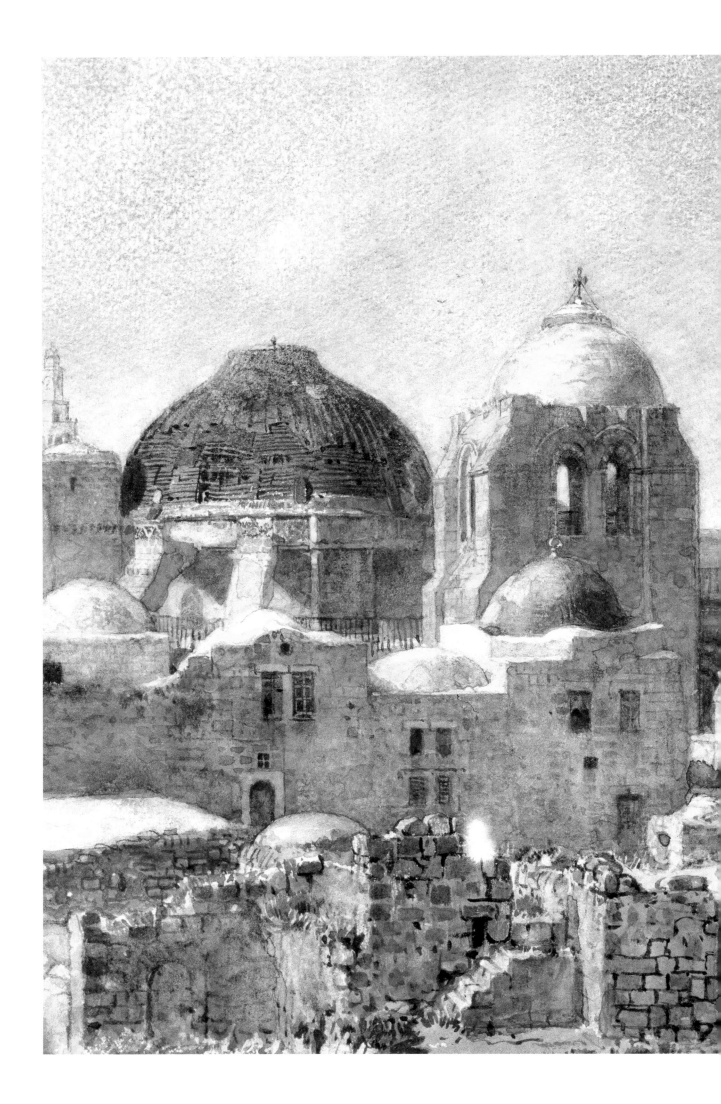

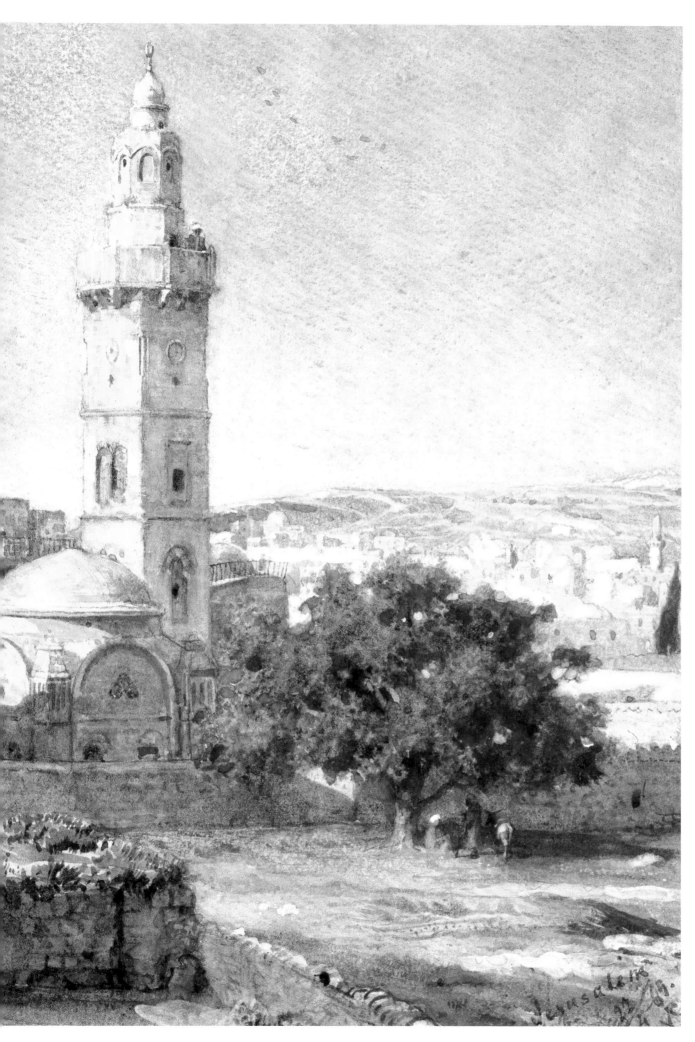

A watercolour dated 1865 of the Church of the Holy Sepulchre and the Mosque of Omar in Jerusalem by the Swedish artist Georg von Rosen (see p. 123, no. 40), showing the dilapidated state of the church's main dome with detailed realism (it was repaired three years later)

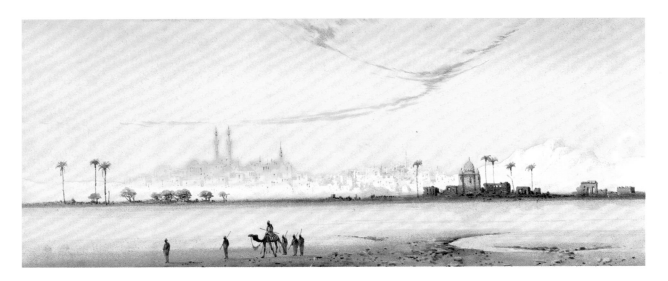

A romantic view of Egypt in this watercolour by Herbert Lynton (see p. 114, no. 28d)

ested in the biblical history of the Holy Land and many of their works were recordings of biblical background. Whereas exotic views and artistic flights of fantasy figured in paintings of Egypt and Turkey (the harem, palaces, hammams, etc.), a greater realism was applied to the Holy Land.

Prior to the nineteenth century it had been the romantic view of the East that had attracted travellers and painters to the region. Napoleon's expedition to Egypt and the Holy Land at the end of the eighteenth century was a turning point, and aroused European interest in visiting the East, thus opening the area to many artists and travellers. The interest – which was not restricted to Egypt but included the Holy Land as well – involved painters from all over Europe, and also a few Americans. But the main influx was from Britain and France, with the French mainly concentrating on Egypt and North Africa. The Grand Tour of wealthy Europeans, which until the late eighteenth century had been restricted to western and central Mediterranean areas, now started to include the Levant.

Some of the early painters of the Levant were officers of naval ships, who were travelling on assignments to chart or protect routes to the Far East and India which passed through the region. Sketching was part of the culture and education of the nineteenth-century élite in Europe, and as a result many drawings of the Holy Land of this period were executed by senior naval personnel – Francis Spilsbury, the Rev. Cooper Willyams (a ship's chaplain), Sir Robert Ker Porter, Henry Light, etc.

Another breed among the early painters were accomplished professional artists who accompanied wealthy travellers to the Levant, and were commissioned to paint and record the scenes of trav-

el. This practice even predated Napoleon. Such accomplished artists included Louis Cassas, Luigi Mayer, and John Dugmore. Some of the western diplomats dispatched to the Levant were also good amateur artists and they left a sizeable record of their stay in the Holy Land and Egypt in the form of accomplished books (like those of James Finn) or drawings (Henry Salt, William Turner, etc.).

Because few drawings were made of the Holy Land prior to the nineteenth century, even fewer are still available. Most of the work of eighteenth-century artists such as Mayer and Cassas appeared in prints, aquatints and lithographs. So, also, did most of the sketches that were made of Jerusalem prior to the nineteenth century (Chapter 10 is dedicated to these). Thus all the drawings shown are from the nineteenth or early twentieth centuries. Since space does not allow the reproduction of all the paintings in the Collection, I have chosen representative ones.

The accuracy of topographical paintings in the Holy Land was greatly enhanced by two technological developments. The first was the *camera lucida* – a prism arranged so that mirrors projected an image onto a sheet of paper, enabling the artist to trace its outlines. Designed in 1807 by Dr William Wollaston, this technique was used in Egypt and Nubia in 1825-28 by the English scholar Edward

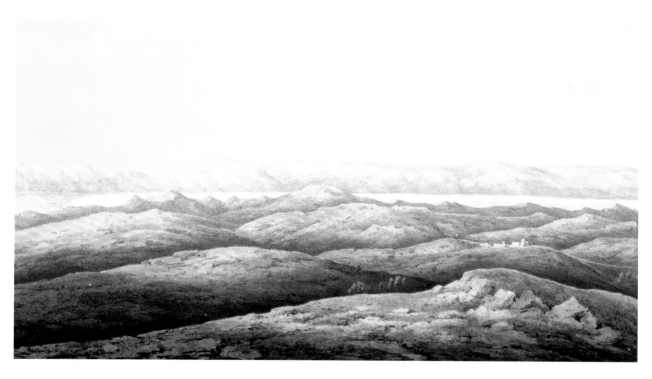

The artist John Dugmore (see p. 90, no. 8b) accompanied his patron to the Holy Land to record the places they saw. This watercolour, from the viewpoint of the Mount of Olives, shows the hills between Jerusalem and the Dead Sea, with the mountains of Moab in the distance

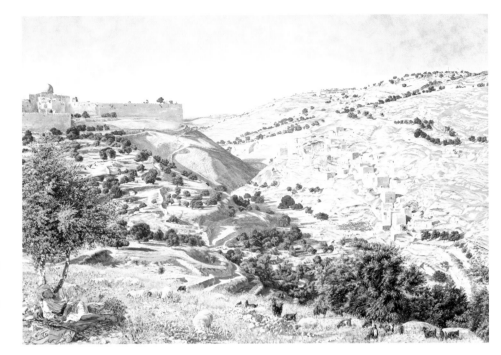

Thomas Seddon (see p. 260, no. 8), who accompanied William Holman Hunt to the Holy Land, may have used photographs to give the minute accuracy for which the pre-Raphaelites strove to this painting of Jerusalem and Silwan

William Lane for illustrating his book, *Description of Egypt*; and by the artist Frederick Catherwood when he travelled and painted in the Holy Land and Egypt in 1833.

The second development was the invention of photography and its increasing popularity in the second half of the nineteenth century. Painters could now produce detailed and accurate paintings by making use of photographs (viz. Thomas Seddon's The Valley of Jehoshaphat; see above).

Since the Bible was a major driving force and motive for many travellers and artists visiting the Holy Land, biblical scenes and interpretation of the landscape with biblical eyes dominated much of their work. There was little concern for the habits and customs of the local population, although this was not the case in paintings of Egypt. Some of the interpretation of the topography was also distorted – such as exaggerating the size of the dome of the Holy Sepulchre to outshine that of the Islamic Dome of the Rock (see de Bruyn, p. 250, no. 1; and Mayer, pp. 154-56, no. 8).

Because of this biblical interest, some British publishers financed artists' visits to the Holy Land in order to illustrate travel books. The most notable of these was Fisher & Son, who published the three volumes of *Syria, the Holy Land, Asia Minor, etc.* (1836-38), illustrated with prints made from drawings by William Bartlett and Thomas Allom (see p. 175, no. 20). With such publications, the Holy Land became a major attraction for travellers and painters in the later nineteenth century. It is not possible to record or ascertain exactly the extent of drawings of the Holy Land in the nineteenth century, but no doubt they run into thousands. The Collection contains a few hundred of them.

Part II
The Catalogue

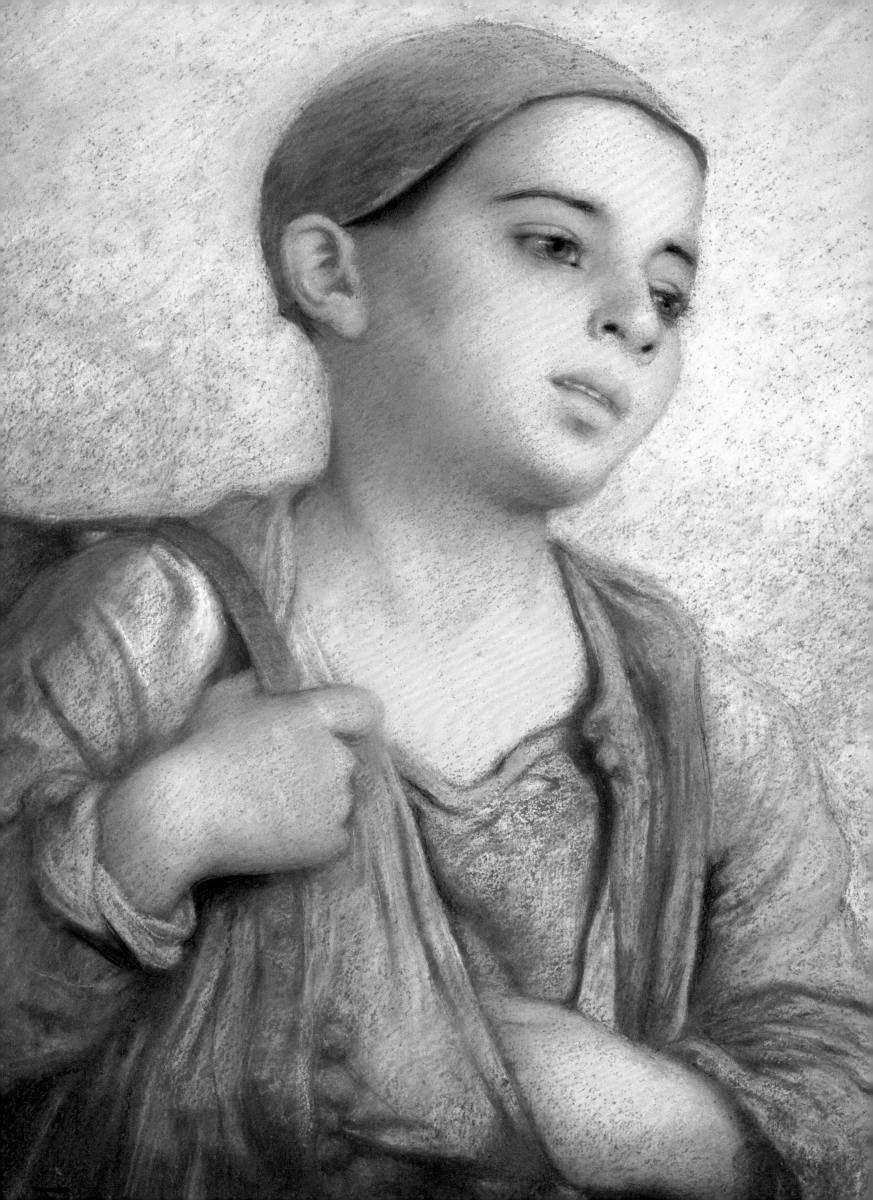

CHAPTER FIVE

～ The Paintings ～

Hundreds of artists and traveller/painters visited the Holy Land in this period: Egypt in particular in the nineteenth century attracted more artists than any other area of the world except Europe. Over 200 paintings by some of the most important of them (Bartlett, Haag, Hunt, Roberts, Sargent, Simpson, Werner, etc.) have been selected for inclusion here, most of them watercolours, the medium chosen by most travellers to the Holy Land. The majority are of Palestine, with emphasis on Jerusalem, but a significant proportion are of Egypt. Many of these paintings later appeared in books or other publications on the Holy Land and this information is also recorded. All the paintings are original, their authenticity and provenance well documented. Where doubts exist, these are noted.

The emphasis of the paintings listed here is on historical and topographical reality rather than merely on decorative value. Most of the scenes have now changed beyond recognition and many buildings have disappeared. The importance of these paintings lies in their faithful record of the Holy Land and Egypt during the last century of the Ottoman period. There are almost no exotic scenes (harem, baths, carpet merchants, etc.) which represented the fantasies of the artist rather than the realities of the place.

The introduction to each painter gives a brief biography and outlines the artist's association with the Holy Land and/or Egypt. For this I benefited from information in several reference works and exhibition catalogues (see Annex 3: References) and the catalogues of a few auction houses.

Entries are listed alphabetically with a number assigned to each artist. Where there is more than one painting by the artist, they are listed with alphabetic numbering. Each painting title is followed by media and drawing details; size in cm. (height x width); information about signature and inscription; and finally comments and description where relevant.

Opposite: Frederick Goodall's Study of an Egyptian Boy (see pp. 98-100, no. 16b)

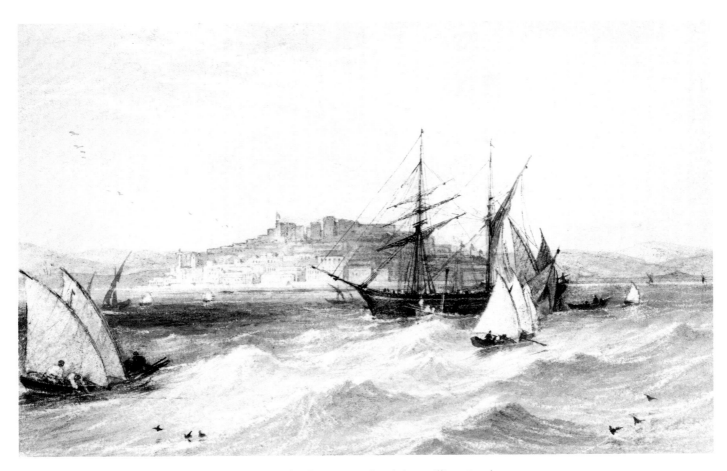

1a. Ships off Jaffa; a sepia sketch by William Bartlett

~ 1 ~

BARTLETT, William Henry (1809-1854)

Bartlett was a prolific topographical artist who travelled extensively in search of new and interesting subjects for his drawings. He visited North Africa and the Near East seven times, and made several other trips in Britain and Europe, as well as North America. Popular demand for travel books was high during the 1830s and 1840s, and Bartlett contributed illustrations to several of them, including about a dozen written by himself.

He is known to have visited the Near East on at least six occasions between 1834 and 1854, and was interested above all in those places which were closely associated with biblical events. On his fourth visit to the East in 1845 Bartlett travelled from Egypt to Petra via Suez, Mount Sinai and Aqaba.

His account of the journey in *Forty Days in the Desert* (1848; see p. 170, no. 9), with its careful description of sites mentioned in the Bible, was enlivened with details of his own travel experiences and illustrated with numerous engravings made from his drawings.

Literature: A. M. Ross, *William Henry Bartlett*, Toronto 1973

a) **A View of Jaffa from the Sea** *c.* 1840

Sepia wash over pencil with stopping out

11 x 19 cm.

Not signed

This is a typical Bartlett drawing which, despite being a rapid sepia sketch, gives a good view of Jaffa, seen from the sea, as it appeared in the mid-nineteenth century.

Attributed to W. H. Bartlett

b) **Panorama of Jerusalem**
Watercolour
50 x 83 cm.
Not signed
This panorama depicts Jerusalem as it appeared in the first half of the nineteenth century. The scene is a typical Bartlett drawing and, although less accomplished, is very similar to his engraved panorama of Jerusalem in Stebbing and Bartlett's *The Christian in Palestine* (see p. 195, no. 86).

Attributed to W. H. Bartlett

c) **Ayn Rogel, Jerusalem**
(Illustration p. 45)
Sepia wash over pencil with stopping out
11 x 18 cm.
Not signed
This drawing – another example of the artist's quick sketches – appeared in Bartlett's book *Jerusalem Revisited* (1862; see p. 170, no. 8). Ayn Rogel was one of the principal sources of water in Jerusalem in the mid-nineteenth century.

— 2 —

BONOMI, Joseph (1796-1878)
The second son of the architect Ignatius Bonomi (1739-1808), Joseph Bonomi was born in Italy but spent most of his life in England. He worked as a draughtsman in Egypt (principally for Robert Hay) from 1824 to 1832, and paid two subsequent visits there. He was fluent in Arabic and dressed like an Egyptian. He had a hand in many British projects concerning Egypt, including the illustration of J. G. Wilkinson's *Ancient Egyptians*, the cataloguing of the Egyptian antiquities at the British Museum and Hartwell House in Buckinghamshire, providing casts for the Egyptian Court at the Crystal Palace, and the design of Marshall's Mills, Leeds. In 1845 he married the daughter of the artist John Martin.

Bonomi apparently accompanied Ibrahim Pasha on the Egyptian expedition to Palestine and Syria. He was there in 1833-35, during which time he made many pencil sketches (of which the Collection contains three)

as well as his well-worked pencil drawing of Henry Salt. It is believed that Bonomi was probably the first non-Muslim to enter the sanctuary of the Islamic holy sites in Jerusalem, the Haram al-Sharif, and to draw there. He sketched the Dome of the Rock from various angles. A few days later he was followed by Frederick Catherwood who also adopted Egyptian clothes.

a) **Ibrahim Pasha** 1834
(Illustration p. 32)
Pencil drawing
8 x 8 cm.
Inscribed 'Ibrahim Pasha, Beyrout 1834'

2b. Bonomi: Portrait of Henry Salt

b) **Portrait of Henry Salt**
Pencil drawing
10.5 x 7.5 cm.
Inscribed 'Salt'
Henry Salt (1780-1827) trained as a portrait painter at the Royal Academy but is better known as a major collector of Egyptian antiquities. He visited Egypt for the first time while travelling in the East with the collector, Lord Valentia in 1802-06. His *Twenty-Four*

Views... (1809), which illustrated the tour, included a 'View of Grand Cairo' and another of the pyramids. After undertaking a government mission in Abyssinia in 1809-11 Salt was appointed British Consul-General in Egypt in 1815, based in Alexandria. Between 1816 and 1827 he financed several excavations in Egypt and Nubia, including those of Giovanni Belzoni, and formed three separate collections of antiquities, many of which were acquired by the British Museum.

c) **Cavalry of Ibrahim Pasha leaving Baalbek** July 1834
Pencil sketch
11 x 17 cm.
Inscribed

d) **Ibrahim Pasha's Syrian Horse**
Pencil sketch
13 x 12 cm.
Inscribed

⌐ 3 ⌐

BRABAZON, **Hercules Brabazon** (1821-1906)
Brabazon inherited the estates of his elder brother in 1847 and those of his father in 1858; his resulting financial independence enabled him to paint as he pleased, unconstrained by the demands of the art market. He devoted himself to watercolour studies of nature, travelling abroad for suitable subject-matter to France, Italy, Spain, Egypt, Palestine, North Africa and India. On these visits Brabazon made a large number of quick coloured sketches rather than detailed or well-worked topographical drawings. His impressionistic style greatly added to the popularity of his watercolours, and put him in the forefront of the modern movement.

Brabazon shunned publicity, and his watercolours were almost unknown till late in the nineteenth century, when a group of younger artist-admirers, including John Singer Sargent, finally persuaded him to show his work at the Goupil Gallery in 1892. Despite the success of this and subsequent exhibitions, Brabazon held on to his amateur status, donating all profits to charity.

Egypt
Pastel
16 x 23 cm.
Signed with initials and inscribed
An impressionistic drawing, very typical of Brabazon's style.

⌐ 4 ⌐

BRACEBRIDGE, **Selina, Mrs.** (*c.* 1800-1874)
This energetic traveller, who was Samuel Prout's favourite pupil, visited Italy in 1824, Italy and Germany in 1825, the Near East from 1833, Sweden in 1840, the Pyrenees in 1842, and in 1855 she nursed at Scutari with Florence Nightingale. Her work is at times reminiscent of that of Edward Lear, and at others of William Page. On her visits to the Holy Land and Syria she made extensive drawings of Jerusalem, as well as of Beirut and other places in the Levant. She is well known for her panoramas. A rare panorama of Jerusalem was published in 1836. The Collection contains an album of 13 of Mrs. Bracebridge's drawings of Jerusalem, all from 1833.

a) **Absalom's Pillar**
Watercolour 17.5 x 26 cm.

b) **King's Tomb**
Watercolour 23.2 x 30 cm.

c) **Tombs of the Judges**
(Illustration p. 57)
Watercolour 22 x 32 cm.

d) **Mosque at Mount Zion**
Watercolour 19.2 x 26.8 cm.

e) **Al-Aqsa and Siloam**
Sepia 16.5 x 26 cm.

f) **Mount of Olives**
Sepia 17.5 x 25.3 cm.

g) **Mount of Olives** (another view)
Sepia 11.2 x 22 cm.

3. Brabazon: Egypt

4a. Bracebridge: Absalom's Pillar (Tantour Far'oun), Jerusalem

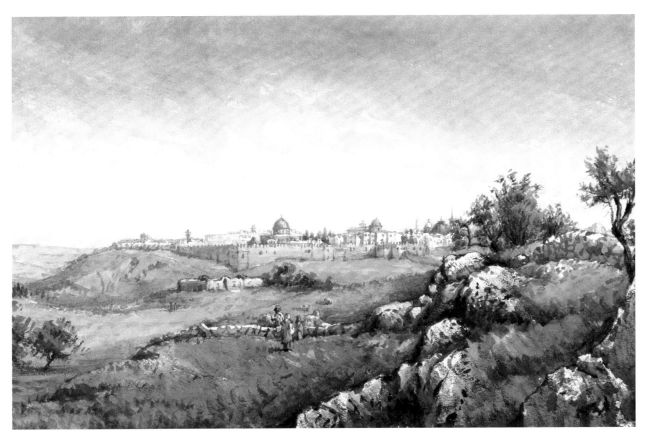

5. Carelli: Jerusalem

6a.Carline: Jordan Valley

h) **Pillar, Valley of Jehoshaphat**
Sepia 11.2 x 22 cm.

i) **Mosque on the Mount of Olives**
Sepia 18.8 x 28 cm.

j) **Tombs, Valley of Hinom**
Sepia 13.1 x 18 cm.

k) **Al-Aqsa**
Sepia 18 x 12.7 cm.

l) **Tombs at Aceldama**
Ink 9.2 x 11.3 cm.

m) **Rachel's Tomb**
Pencil 12.7 x 20.3 cm.

~ 5 ~

CARELLI, Conrad (1869-1956)
The son of Gabriel Carelli, a well-known artist of Italian origin who had settled in England, Carelli studied in Paris and travelled widely. He held a number of spring exhibitions at Menton. His style is rather looser than that of his father, whose eye for colour and detail was superior. He visited Jerusalem where he made a number of watercolours.

Jerusalem
Watercolour
23.5 x 35 cm.
Not signed
This is a view of Jerusalem from the south-east.

~ 6 ~

CARLINE, Sydney William (1888-1929)
This son of George Carline, who came from a family of known artists, painted landscapes and portraits and some of his works are exhibited in Leicestershire Art Gallery. He was in Palestine and Egypt during World War I, apparently as a military artist, where he made the following two watercolours:

a) **Jordan Valley** 1919
Watercolour
26 x 36 cm.
Signed, inscribed and dated 11/12/1919
This painting depicts the small sandhills common in the northern part of the Jordan Valley; paintings of this area are very rare.

b) **Egypt, The Harvest** 1919
Watercolour
26 x 36 cm.
Signed, inscribed and dated 1919

7a. Dillon: Sheikhs' tombs at Aswan

7d. Dillon:
Study of Sheep

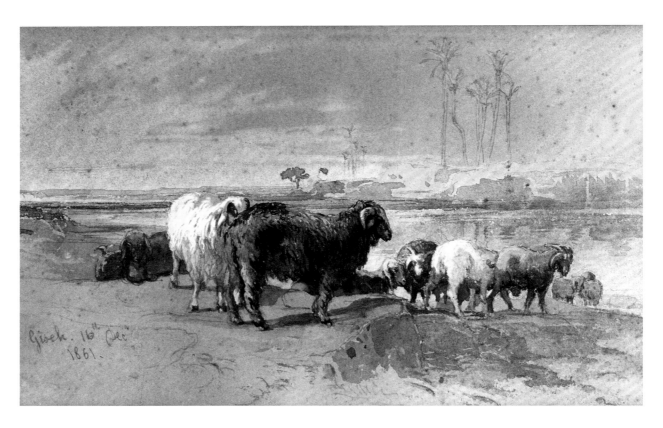

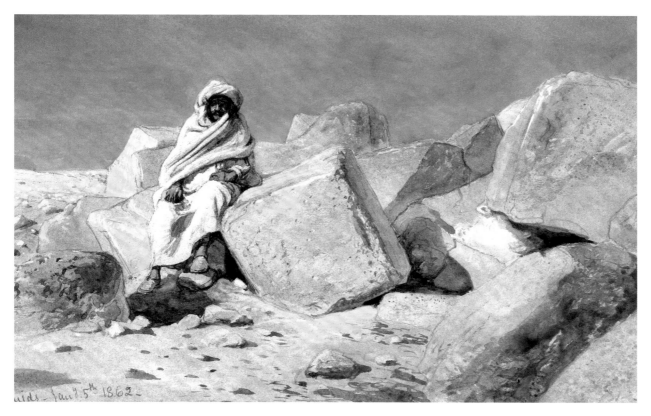

7e. Dillon: Stones by the Pyramids

— 7 —

DILLON, Frank, RI (1823-1909)

Frank Dillon's earliest known visit to Egypt was in 1854-55 and he returned there in 1861-62, 1869-70 and in 1873-74. During one of his later visits he and some friends tried to halt the destruction of Islamic buildings in Cairo, then in a ruinous state. He also opposed the building of the first Aswan dam, which resulted in the flooding of Philae.

Although Dillon exhibited numerous oil paintings and watercolours in London galleries, including the Royal Academy, over a period of more than 50 years, he is not so well known today as other nineteenth-century Orientalist painters. With the notable exception of J. F. Lewis, he was almost alone among fellow British artists in focusing on Cairo's domestic architecture. His major achievements in oil are his views of Egypt, particularly interiors of old Cairene houses. The Victoria & Albert Museum in London has a series of his watercolours of the interiors of affluent Egyptian houses.

a) **Sheikhs' Tombs at Aswan** 1855
Watercolour
20 x 38.5 cm.
Not signed but inscribed 'Sheikhs' tombs, Assouan' and dated 1855

The Collection also contains four of Dillon's Egyptian scenes and figures; all are watercolours, heightened with white. They are not signed.

b) **Study of a Fellah**
26 x 18 cm.

c) **Study of a water carrier**
28 x 18 cm.

d) **Study of sheep**
20 x 34 cm.

e) **Stones by the Pyramids**
20 x 35 cm.

DUGMORE, John (1793-1866)

This accomplished topographical artist, whose style harks back to the traditions of the eighteenth century, was a protégé of the Keeper family, one of whom he accompanied on a Grand Tour of Germany, Italy and apparently the Holy Land. The following are two excellent examples of his detailed and well-worked paintings.

a) **Tiberias on the Sea of Galilee**
Watercolour
24.5 x 31.5 cm.
Unsigned
Inscribed on reverse 'Tiberias on Lake Genesareth'
An excellent example of what Tiberias looked like early in the nineteenth century.

b) **Dead Sea From the Mountain of Olives, Jerusalem**
(Illustration p. 77)
Watercolour
25 x 39 cm.
Unsigned, but inscribed on reverse
A view from Jerusalem down to the Dead Sea, with the mountains of Moab in the distance.

ELLIS, Paul (active 1883-1891)

Paul Ellis was a flower and landscape painter based in Birmingham who exhibited at the Royal Academy and other London galleries between 1883 and 1891. Although nothing is known of his travels abroad, 'Houses at Bethlehem' has the freshness and spontaneity of a sketch done on the spot.

a) **Houses at Bethlehem**
(Illustration p. 59)
Pencil and watercolour
25 x 35 cm.
Inscribed lower left 'Bethlehem Houses'; signed and inscribed on the back
A quick watercolour sketch.

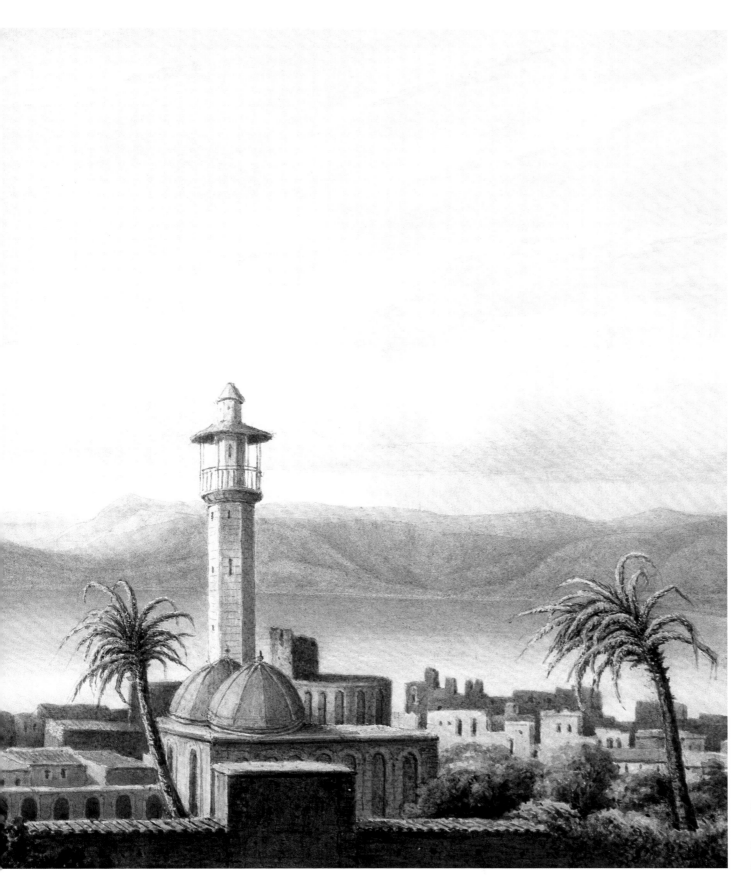

8a. Dugmore:
Tiberias on
the Sea
of Galilee

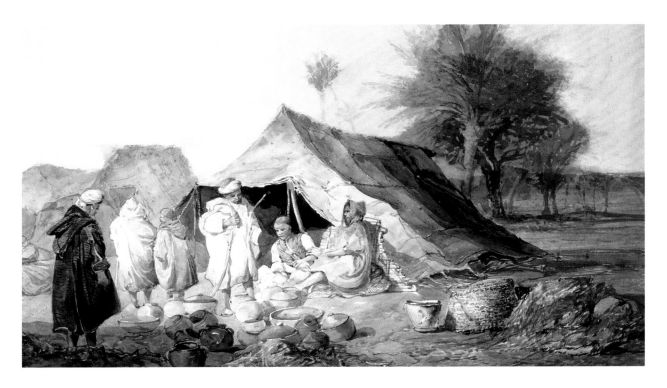

9b. Paul Ellis:
Arab Pot-sellers

b) **Arab Pot-sellers**
Pencil and watercolour
31 x 53 cm.
Not signed
A well-worked and very colourful painting.

~ 10 ~

ELLIS, Tristram James (1844-1922)
Ellis began his career as an engineer, working on the District and Metropolitan Railways in London and carrying out several minor engineering projects. In 1874, after deciding to become an artist, he entered Bonnat's studio in Paris to study painting. His visit to Cyprus four years later was the first of many journeys that took him to Palestine, Syria, Asia Minor, Egypt, Portugal, Greece and Turkey, which provided the subject-matter for most of his paintings and drawings. In 1879, after arriving in Beirut, Ellis made a short trip to Jerusalem and the Dead Sea and did some excellent paintings of Jerusalem, and also of Egypt. There is no record of any other visit to the Holy Land after this, but the late date of some of the watercolours indicates that he must have returned to the Holy Land and Egypt around the end of the century.

Ellis wrote several books, including *On a Raft and Through the Desert* (1881; in the Collection, p. 178, no. 29), an account of his journey in 1880 through northern Syria, Kurdistan and Lebanon.

Many of the sketches of this tour were reproduced in this book as etchings, 'the most artistic of illustrations because it is the work of the artist himself' (*On a Raft...*, Preface, p.ii).

a) **The Church of the Holy Sepulchre, Jerusalem**
1895
(Illustration p. 14)
Watercolour
73 x 59 cm.
Signed and dated 'Tristram Ellis 1895'
This is one of Ellis's best paintings. The church of the Holy Sepulchre is revered by Christians because it enshrined the traditional sites of the crucifixion, burial and resurrection of Christ. The church – originally built in the fourth century but now mostly dating from the twelfth century – had been almost destroyed by fire in 1808. It was rebuilt by the Russian Orthodox Church, which subsequently gained possession of its most sacred areas. The scene shows the entrance of the church, probably at Easter.

b) **Tiberias** 1902
Watercolour
25 x 53 cm.
Signed Tristram Ellis
Signed, inscribed and dated 'Tristram Ellis, Tiberias 1902'

c) **Jerusalem Viewed from the South** 1899
(Illustration pp. 94-95)
Watercolour
23 x 52 cm.
Signed 'Tristram Ellis' and inscribed 'Jerusalem 1899'

d) **Jerusalem Viewed from the West** 1900
Watercolour
17 x 33.5 cm.
Signed, inscribed and dated 1900
This is an impressionistic view of Jerusalem. Very few paintings of the city were done from the west; most were from the Mount of Olives on the east.

e) **On the Banks of the Nile, Cairo** 1902
Watercolour
25 x 53 cm.
Signed, inscribed and dated 1902

~ 11 ~
ENGLISH SCHOOL *c.* 1850
An album of eight large watercolour views of the Holy Land, mostly after Roberts or Bartlett, all by the same hand.
All 46 x 72 cm.
Unsigned but inscribed on the back

a) **Road from Jerusalem**

b) **Mount Carmel**

c) **Looking towards the Mountains of Moab**

d) **Pool of Siloam**

e) **Ford of the Jordan**

f) **Mount of Olives from the eastern City Wall**

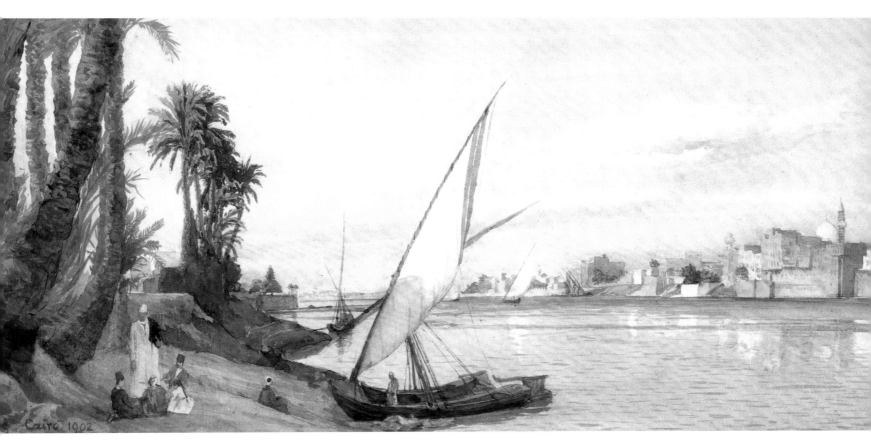

10e. Tristram Ellis: On the Banks of the Nile, Cairo

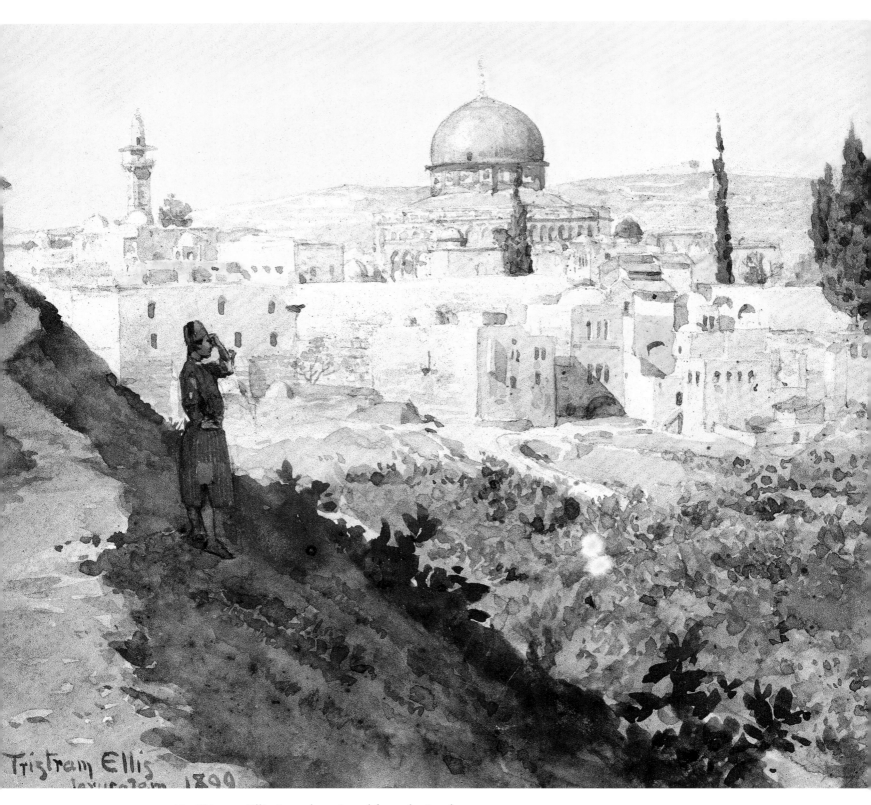

10c. Tristram Ellis: Jerusalem viewed from the South

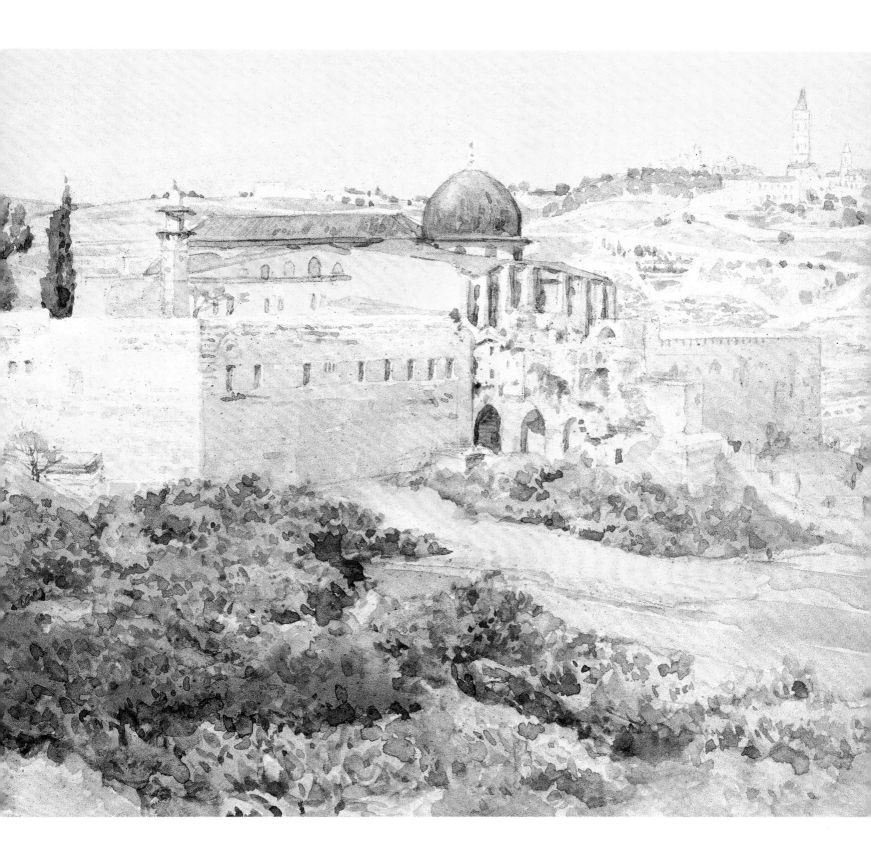

g) **Tombs cut into Rocks**

h) **Jerusalem**

ENGLISH SCHOOL

North African Market Scene
Oil on canvas
35 x 45 cm.
Unsigned

~ 12 ~

ESTOURMEL, Joseph Louis d' (active 1830-50)
The Collection contains an album of watercolours by d'Estourmel, who is well known for his book *Journal d'un Voyage en Orient* (1844; in the Collection, pp. 178-79, no. 30).
Joseph d'Estourmel travelled in the Levant from June 1832 until September 1833, visiting Greece, Asia Minor, Syria, the Holy Land and Egypt. During these travels he spent time with several fellow-artists: he met Joseph Michaud, spent two months in company with Marie-Joseph de Geramb and visited Robert Fauvel in Smyrna and Robert Hay in Egypt.

D'Estourmel painted over 200 watercolours during his Levant trip, many of which were published as lithographs in his book, including several of those listed below.
All are watercolours, 18.5 x 24 cm.
All inscribed on the back

a) **River Jordan out of the Sea of Galilee**

b) **Mosque in Tiberias**

c) **River Jordan Watershed into the Sea of Galilee**
Such scenes are now almost non-existent as most of the sources of the Jordan have dried out.

d) **Mount Tabor** (Plate 72 in the book)

e) **Cave and old Fig Tree in front of Tabor** (Plate 65)

f) **Peak of Tabor and old Church** (Plate 73)

g) **River Jordan out of Tiberias** (Plate 69)
(Illustration p. 178-79, no. 30)

h) **Site of the Miracle of the Multiplication of the Loaves** (Plate 67)

i) **Jabal al-Dabah**

j) **Remains of an Olive Oil House, Jabal al-Dabah**

k) **Rocks in Endor, Mount Tabor**

~ 13 ~

FANSHAWE, Admiral Sir Edward Gennys (1814-1906)
Fanshawe joined the Royal Navy in 1828, served in the Mediterranean and was promoted Commander in 1841. He painted in the East Indies in 1844, the Falklands, Pitcairn and Tahiti in 1849, Panama in 1850, China in 1851, and in San Francisco. His ships are well drawn, and his landscapes brightly coloured, if a little crude. He also visited Palestine, where he made a few drawings, of which one is mentioned below.

A view of Palestine (perhaps Galilee)
Watercolour
15 x 23 cm.
Signed
A rural view showing Mount Hermon (Jabal al-Sheikh) in the distance, covered in snow.

~ 14 ~

FORMBY, Henry (active mid-19th century)
Formby wrote many books on Jerusalem and the Holy Land (some of which are in the Collection), illustrated by some of his paintings.

Entrance to Jerusalem by the Pilgrim's Gate 1840
Watercolour
16 x 26 cm.
Signed and dated 1840
A view of the Jaffa Gate, also called the Pilgrim's Gate (Bab al-Khalil in Arabic).

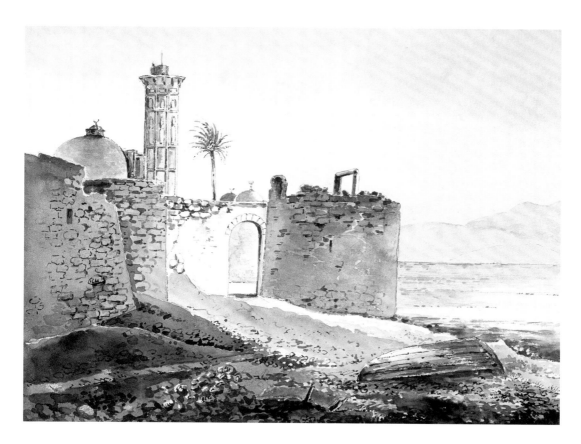

12b. d'Estourmel:
Mosque in Tiberias

12c. d'Estourmel:
Jordan Watershed
into the Sea
of Galilee

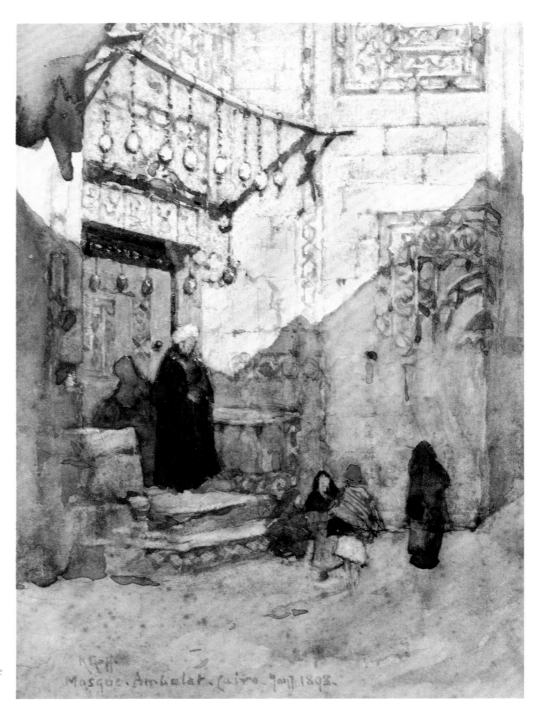

15. Goff: Mosque Ambalat, Cairo

~ 15 ~

GOFF, Colonel Robert Charles (1873-1922)
An Irishman who was commissioned in 1855 and served in the Crimea, Ceylon, Malta and China, Goff retired in 1878 and lived in Hove before settling in Florence and Switzerland. He travelled widely throughout his career, sketching in Egypt, England, Scotland and France and making etchings on his return home. A memorial exhibition of his works was held at the Fine Art Society in 1923.

Mosque Ambalat, Cairo 1893
Watercolour
Signed, inscribed and dated 1893

~ 16 ~

GOODALL, Frederick, RA (1822-1904)
Goodall was a prolific and popular Orientalist painter who first visited Egypt in 1858-59. He shared a house in Cairo with Carl Haag (q.v.), and they often sketched together in the streets, outside the city

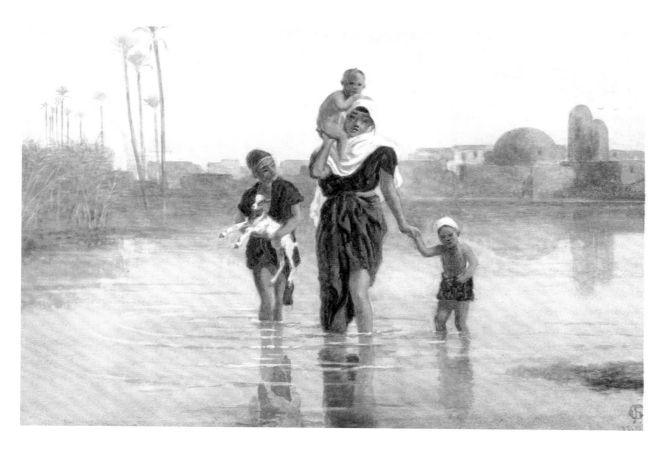

around the Pyramids, and also near Suez. During the 1860s Goodall used these sketches for several carefully constructed paintings of rural and urban Egyptian life and biblical scenes. When he visited Egypt again in 1870-71, he lived at Saqqarah, a few miles south of the pyramids, so that he could observe the daily life of the bedouin.

Living in England again for the next three decades, Goodall continued to paint variations on the same Egyptian themes. Indeed, his paintings of Egypt are the most popular and best known of his works, some executed in watercolour and others in oil; but because of their abundance they are not as expensive as those of J. F. Lewis.

a) **The Ford of the Nile**
Watercolour
29 x 39 cm.
Signed with a monogram
The theme of this Egyptian woman fording the Nile is repeated in other Goodall oil paintings.

b) **Study of an Egyptian Boy**
(Illustration p. 80)
Pastel
54 x 36 cm.
Signed with a monogram
Goodall's pastel drawings are rare and this study demonstrates the superb qualities of his work in this medium.

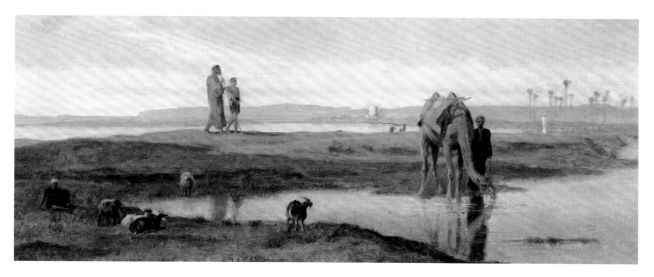

16c. Goodall: On the Nile

c) **On the Nile**
(Illustration p. 99)
Oil on canvas
34 x 93 cm.
Signed with a monogram
A typical Goodall scene of the Nile and Egypt.

~ 17 ~

GOODWIN, Albert (1845-1932)
An excellent experimental watercolourist, influenced by J. M. W. Turner, Goodwin paid great attention to effects of light and atmosphere. He travelled widely in Europe, India, Egypt and the South Sea Islands, painting landscapes, biblical and allegorical subjects, and illustrations of Sinbad the Sailor stories. Several of his works are in British and Australian museums. His watercolours of Cairo are some of the most picturesque and impressionistic recordings of the city.

The Nile
Watercolour and china ink
17 x 30 cm.
Signed and inscribed

~ 18 ~

GREEN, Nathaniel Everett (1832-1899)
Green was an astronomer and landscape painter who studied at the Royal Academy schools and exhibited from 1854. He was an unsuccessful candidate for the National Watercolour Society in 1852 and again in 1858 when living in North London. He painted in Ireland and a great deal in Scotland, and contributed illustrations to Queen Victoria's book, *More Leaves from the Journal of Life in the Highlands* (1884). His work is pleasant, if lacking in detail, and he is fond of greens. Green visited the Holy Land in 1884 and made a few large watercolours of Jerusalem and Bethlehem, including the one below.

Rachel's Tomb (Qubbat Rahel) 1884
Watercolour heightened with body colour
36 x 53.5 cm.
Signed and dated 1884
Rachel's Tomb at the entrance to Bethlehem is one of the most recorded sites in nineteenth-century paintings and photographs of the Holy Land.

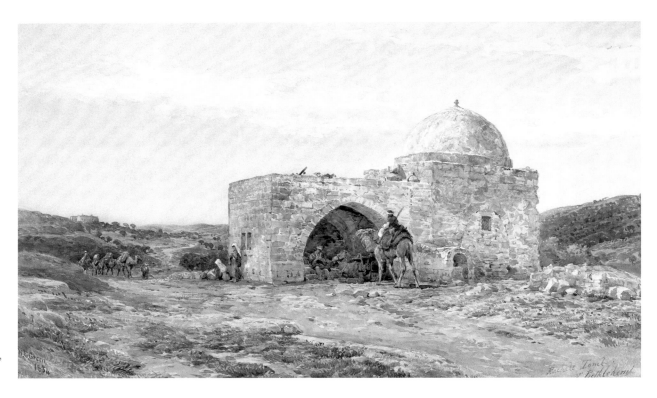

18. Green:
Rachel's Tomb
(*Qubbat Rahel*),
near Bethlehem

HAAG, Carl (1820-1915)

Born in Bavaria, Haag studied art at Nuremberg and Munich. After a winter in Rome in 1847-48 he based himself in London where he examined and elaborated on English techniques of watercolour painting. During the 1850s he became a member of the RWS and also enjoyed the patronage of Queen Victoria and Prince Albert. In 1858-60 he spent two years in the Near East. During the first winter in Cairo he shared a studio with a fellow-artist, Frederick Goodall (q.v.), and the following April he travelled to Jerusalem, then north to Syria and Lebanon, returning to Cairo for the winter. Back in London he worked up his studies into finished watercolours, which met with great critical and popular success. He revisited Cairo in 1873-74 to gather fresh material for further Oriental paintings. In 1903 he retired and he died 12 years later at the age of 95.

Haag was one of the most prolific and important painters of the Holy Land, Egypt and Syria in the second half of the nineteenth century. He concentrated on painting the local population and archaeological sites. At his death he left more than 400 paintings, mostly meticulous watercolours (some rather large in size) of subjects in this part of the world. The Collection contains ten of his watercolours and studies.

Literature: Sotheby's, London, *Watercolours...of Near Eastern Interest,* 29 April 1982, lots 1-76

a) **Studies of Arabs at Prayer**
Two pencil studies in the same frame
16.5 x 11.0 cm. and 16.5 x 9.5 cm.
Signed and inscribed; although the drawings are authentic, the signature was probably added later and by another hand
These are pencil studies of two Muslims praying. Similar figures are incorporated in Haag's final watercolours (see below).

b) **Study of an Egyptian Fellah** 1873
Pencil and wash over brown paper
40 x 29 cm.

Signed, inscribed and dated 1873
This work, dating to Haag's second visit to Egypt, was doubtless a study in preparation for a more accomplished work, which we could not trace.

c) **The Ablution Fountain in the Mosque of Sultan Hassan** 1860
Watercolour over pencil with coloured wash
47 x 34 cm.
Signed, inscribed and dated 1860
The mosque of Sultan Hassan, Cairo's most impressive Islamic monument, has often attracted painters (there are similar works by Roberts, Talbot Kelly, etc.). This painting shows the mosque's ablution fountain, in itself an impressive example of fourteenth-century architecture.

19c. Haag: Ablution Fountain in the Mosque of Sultan Hassan, Cairo

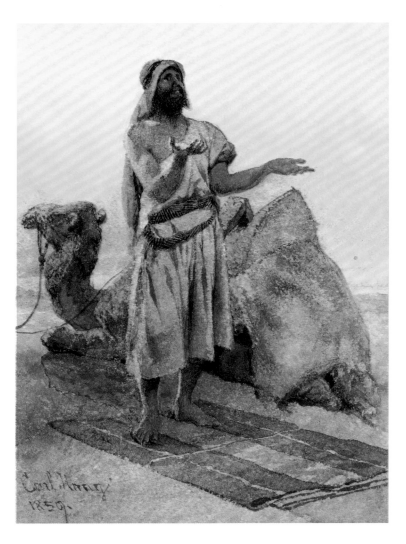

f) **In the Cave beneath the Holy Dome of the Rock in Jerusalem**
(Illustration pp. 26 and 36-37)
Watercolour
35.0 x 50.0 cm.
No signature, inscription or date
This is one of the best known of Haag's watercolours. A similar painting, dated 1859, was listed in the Mathaf Gallery catalogue of a 1982 exhibition; the same image apparently appeared later as a print. The men praying are not directed towards the Mihrab (i.e. pointing towards Mecca, as they should in Islam). This demonstrates an unusual flaw in the accuracy of Haag's work. He apparently made a quick sketch of the cave and then added the two praying figures later. (There is a question about the authenticity of this work because it is not signed or inscribed – unusual with Haag – and the white is richly applied, while Haag usually obtained white by scratching out. Otherwise the work is of Haag's quality and is recorded accordingly).

g) **A Cairo Café** 1874
(Illustration p. 16)
Watercolour
25.0 x 36.0 cm.
Signed, inscribed 'Cairo' and dated 1874
A fine scene depicting daily life in Cairo at that period.

h) **Shipwreck in the Desert**
(Illustration pp. 104-05)
Watercolour
76 x 130 cm.
Signed and inscribed
This is one of Haag's largest watercolours. Another version of it, the same size, appeared in *Les Orientalistes de l'Ecole Britannique*, Paris, ACR Éditions, 1991.

i) **A Nubian**
Watercolour
40 x 30 cm.
Not signed or inscribed
A vivid Haag watercolour of life in the desert.

19e. Haag:
A Muslim at
Prayer

d) **A Bedouin Camp** 1874
Watercolour and wash
18.5 x 49.5 cm.
Signed and inscribed 'Cairo' and dated 1874
This is typical of Haag's depictions of desert and bedouin life to which he devoted a great deal of effort.

e) **A Muslim at Prayer** 1859
Watercolour
26.5 x 18.0 cm.
Signed and dated 1859
This is an accomplished though small watercolour, showing a similarity between the man praying and the (bedouin) man in other Haag paintings. The date and features indicate that this painting was probably executed in Palestine.

19i. Haag:
A Nubian

Next page:
19h. Haag:
Shipwreck in
the Desert

20a. Harper: The Bay of Acre from the Carmel

HARPER, Henry Andrew (1835-1900)

An author and painter of the Holy Land, Harper began exhibiting from 1858. He accompanied the Earl of Dudley to the Near East, and later held many exhibitions at the Fine Art Society in London, based on his paintings of the Holy Land. He wrote several books about his travels in this part of the world, including *An Artist Walks in Bible Lands*, all illustrated with his paintings. He also wrote *Walks in Palestine* (1888), which contained 24 fine original photogravures by Cecil V. Shadbolt (in the Collection). Harper painted the Holy Land and Sinai extensively, mainly in watercolour, of which four are in the Collection.

a) **The Bay of Acre from the Carmel** *c.* 1888
Watercolour
52 x 74 cm.
The painting bears an incorrect signature (of Clarkson Stanfield RA) and, inscribed in Harper's hand, 'The Bay of Acre from the Carmel'
This is a superb large view which shows Haifa and Acre, and the empty bay as it was in the late nineteenth century; it is now filled with industrial and commercial activity.

b) **First Sight of Jerusalem** *c.* 1875
Watercolour
24 x 48 cm.
Signed and inscribed
The meeting-point of the valleys of Hinnom and Kidron.

c) **Jerusalem** 1897
Watercolour
24 x 17 cm.
Signed and dated 1897; inscribed on the back 'Jerusalem'
I could not accurately ascertain the location of this painting – if it is indeed Jerusalem it could be the Damascus Gate; but it could even be Egypt.

21. Horeau: Nubian Water-carrier

d) **Sinai, the Peak of Aburutha** 1892
Watercolour
11 x 20 cm.
Signed, inscribed and dated 1892

— 21 —
HOREAU, Hector (1801-1872)

Studies of Egyptian and Nubian Figures c. 1840
Nine drawings of different subjects and sizes, in
three frames, all of which appeared in Horeau's
*Panorama d'Égypte et de Nubie, avec un portrait de
Méhémet-Ali*, Paris 1841. Eight are watercolours
and one a pencil drawing with Horeau's name
inscribed on it.

— 22 —
HUNT, H. M. (active mid-late 19th century)
Jerusalem from the Mount of Olives 1871
(Illustration pp. 20-21)
Oil on canvas
29 x 60 cm.
Signed and dated 1871; inscribed on the back
'Jerusalem from Siloam'
A fine painting depicting Jerusalem in the second half
of the nineteenth century. This painting is probably
after W. H. Bartlett's 'Panorama of Modern
Jerusalem'. H. M. Hunt is not a very well known
painter and his biography appears in the biographical
books of lesser known British painters.

— 23 —
HUNT, William Holman (1827-1910)
Hunt was one of the seven founder members of the
Pre-Raphaelite Brotherhood, established in 1848 as a
reaction against the low standards of contemporary
British art. Although the group looked to painters
working before the time of Raphael for art which was
sincere and true to nature, Hunt denied that this
entailed a return to their aims and methods: 'It is sim-
ply fuller Nature we want. Revivalism, whether it is of
classicism or medievalism, is a seeking after dry bones'
(Hunt, Vol. I, p. 87). These early efforts were criti-
cized by the British press, but Hunt's reputation start-
ed to improve after the famous art critic John Ruskin
came to the defence of the movement in 1851.

Hunt decided to risk his hard-won success on a
journey to the Near East, intending to apply the pre-
Raphaelite principle of truth to nature to scriptural
subjects. After spending several months in Egypt,
Hunt travelled to the Holy Land in the summer of
1854, spending over a year in Jerusalem and making
two trips to the Dead Sea, the setting for his painting
'The Scapegoat'. This received mixed reviews when
shown at the Royal Academy in 1856; but 'The
Finding of the Saviour in the Temple' (1854-60), the
most important outcome of Hunt's first journey to
the East, established his reputation as a painter who
grounded religious art on geographical and historical
facts. Hunt followed up this success with other large

paintings of scenes from the Bible. 'The Shadow of Death', 'The Triumph of the Innocents' and 'The Miracle of the Sacred Flame' were all begun during three further visits to the East, in 1869-72, 1875-78 and 1892-93. Hunt's painstaking methods prevented him from finishing these paintings in the Holy Land, and each one took him several years to complete.

Unlike John Millais (1829-1896) and Dante Gabriel Rossetti (1828-1882), Hunt upheld the original aims of the pre-Raphaelite group throughout his career, and believed himself to be the movement's intellectual leader: 'I have established my claim as a pioneer for English art in the study of historic truth, which artists of other nations in their own ways have followed'. Literature: William Holman Hunt, *Pre-Raphaelitism and the Pre-Raphaelite Brotherhood,* 2 vols., 1905 (in the Collection, p. 181, no. 41).

The Pillar of Absalom, Jerusalem *c.* 1869
Watercolour heightened with white
11.5 x 16.5 cm.
Not signed
This watercolour probably dates from Holman Hunt's second journey to the Holy Land in 1869-1872. Absalom's Pillar stands in the Kidron Valley (Wadi Silwan in Arabic), just east of Jerusalem (the south-east corner of the Jerusalem wall can be seen on the right). The tomb dates from the first century AD but its name stems from a tradition which claims that King David's son, Absalom, who had no son, erected the monument to perpetuate his own memory. It is known in Arabic as *Tantour Far'oun* (headdress of the Pharaohs). David Roberts remarked in his *Eastern Journal,* that Absalom's Pillar was reminiscent of the tombs at Petra.

23. Holman Hunt: Pillar of Absalom (*Tantour Far'oun*), Jerusalem

～ 24 ～

KELLY, Robert Talbot, RI (1861-1934)

The son of Robert George Kelly (a portrait, figure and landscape painter), Robert Talbot Kelly was a painter of eastern scenes, especially in Egypt, which he visited on several occasions, and Burma. He also painted in Iceland. He lived in Liverpool and London, was a member of the RBA and was elected RI in 1907. An exhibition of his Egyptian views was held at the Fine Art Society in 1902. He published books on Egypt (1902) and Burma (1905), and illustrated Sir R. C. Slatin's *Fire and Sword in the Sudan* (1896), and also painted genre subjects.

View of Cairo and the Citadel from the Nile 1901
Watercolour
26 x 44 cm.
Signed and dated 1901
A beautiful view across the Nile towards the Citadel.

～ 25 ～

LAMPLOUGH, Augustus Osborne (1877-1930)

Augustus Lamplough studied at the Chester School of Art and taught in Leeds in 1898 and 1899. His early work depicted cathedral interiors and Venetian architecture, but he turned to Orientalist subjects after visiting Algeria, Morocco and Egypt. From about 1905 he almost exclusively painted views of the desert and the Nile, and market scenes in Cairo. In common with Robert Talbot Kelly (q.v.), from whom he learned much, he was expert in applying washes of watercolour to evoke swirling sandstorms, or sky and water tinged by dusk or dawn light. His ground colours were usually ochre or buff and cream. He used a curious backhand signature, which occasionally occurs in a tighter form. His watercolours were used to illustrate his own books, *Cairo and its Environs*, *Winter in Egypt*, and *Egypt and How to See It*, and he also illustrated two by Pierre Loti, *La Mort de Philae* and *Egypte*.

Lamplough was a prolific artist, and frequent exhibitions of his paintings were held during his lifetime in London and the English provinces. In the United States his paintings were shown in New York, Philadelphia and Buffalo. His work can sometimes be very beautiful, but it is abundant, repetitive and consequently not expensive. The following four paintings are all watercolours:

a) **Camel Train**
18 x 18 cm.
Signed
A small but beautiful impressionistic scene.

b) **Nile Scene**
18 x 43 cm.
Signed

c) **Nile Scene, Upper Egypt**
13 x 25.5 cm.
Signed

d) **On the Upper Nile**
15 x 30 cm.
Signed

～ 26 ～

LEAR, Edward (1812-1888)

Despite insecurity, epilepsy and ill-health, Lear was one of most intrepid of nineteenth-century artist-travellers. He spent most of his adult life abroad, living for many years in Rome and Corfu, and travelling from there to other parts of Italy, Greece, Albania and the rest of Europe, as well as to the Near East on several occasions. At the age of 60 he toured India and Ceylon.

Of the many dangers and hardships he endured on his travels, Lear's experiences at Petra were especially taxing. The day after he arrived there, on 13 April 1858, the local tribesmen gathered around his party to demand money. When they threatened violence he was forced to make a quick getaway, though not before he was robbed of 'everything from all my pockets, from dollars and penknives to handkerchiefs and hardboiled eggs. Astonishingly, he had already made several sketches, responding in typically individual manner to Petra's extraordinary combination of impressive ruins and dramatic landscape. He wrote to his sister Ann, 'All the cliffs are of a wonderful colour – like ham in stripes; & parts are salmon colour'.

24. Kelly:
View of Cairo
and the Citadel
from the Nile

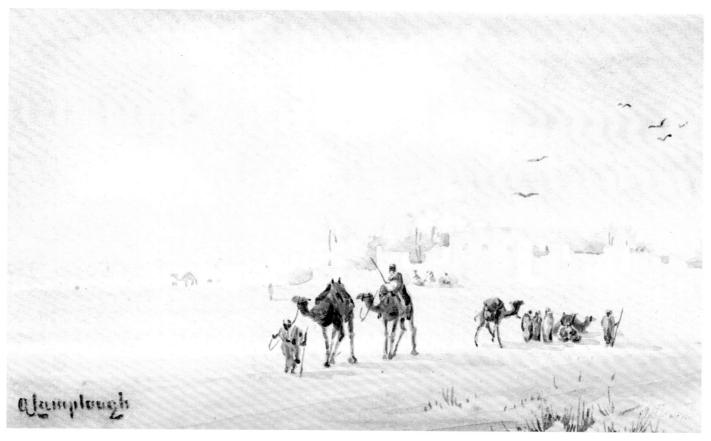

25a. Lamplough: Camel train

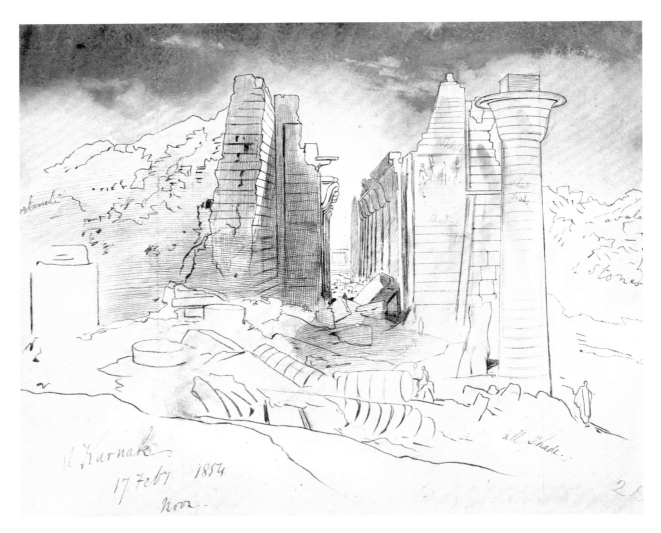

26b. Lear:
Karnak

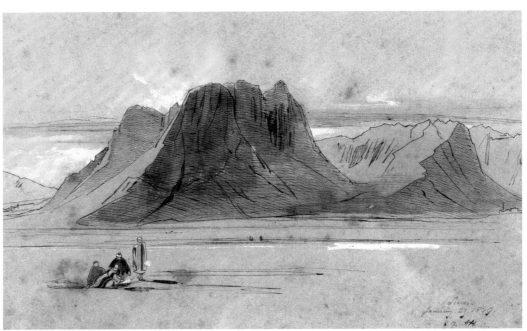

26c. Lear: Mount Sinai

Literature: Hisham Khatib, 'Lear's Visits to Jerusalem, Sinai and Petra', in *Travellers in the Levant: Voyagers and Visionaries*, Sarah Searight and Malcolm Wagstaff (eds.), ASTENE 2001.

a) **Mount Sinai**
(Illustration pp. 22-23)
Oil on canvas
42.5 x 70.5 cm.
Inscribed on label attached to backboard 'Drawing Room of W. T. Denison'
Apparently this oil painting was commissioned by Lieut. General Sir William Thomas Denison, Governor of New South Wales and Governor of Madras (I am indebted to Vivien Noakes, Lear's biographer, for this information).

b) **Karnak** 1854
Pen and brown ink and watercolour over pencil with colour notes
28 x 17.5 cm.
Inscribed and dated 'El Karnak, 17 Feb 1854, noon'
A beautiful scene of Karnak in typical Lear style.

c) and d) **Mount Sinai**
Two views of Mount Sinai
Pen and brown ink and watercolour over pencil, with colour notes
19 x 24 cm.
Inscribed and dated.
Mount Sinai is one of the most frequently depicted views in Lear's paintings both in oil and in watercolour.

~ 27 ~

LEWIS, John Frederick (1805-1876)
Lewis arrived in Cairo in late 1841 and spent the following decade there. When he returned to England he took with him a large collection of sketches, on which he based his highly acclaimed watercolours and oil paintings. Though less known, the watercolour sketches which he made while living in Turkey and Spain are also exceptional.

Lewis's purpose in travelling to the East seems to have been very different from that of either David Roberts or David Wilkie. For him the attraction of the Orient lay not so much in its antiquities or its biblical associations, but in the exotic 'otherness' of contemporary Islamic life and society. Soon after his arrival in Cairo he established himself in a large Mamluk-style house in an Ottoman quarter of the city, and there he remained, living in oriental splendour. Although he made a large number of sketches – both outside in the streets and bazaars of Cairo and inside in his own 'many-windowed, many-galleried' wooden house – he sent nothing home for exhibition until 1850 when his watercolour of the sale of a slave girl to a Mamluk bey, 'The Hareem', caused a sensation within the London art establishment.

Lewis occasionally ventured outside Cairo – to Suez and Sinai – but it was apparently not until 1850 that he at last made the journey up the Nile to Aswan. Even then his sketches of the tombs and temples were not plentiful – as in Cairo, it was contemporary life that held his attention: Arabs seated beside their camels in the desert was a favourite subject; or (still a common sight today) working the water-wheel, demonstrating the irrigation on which life in the Nile valley depended. Such sketches were for Lewis's private use, in contrast to David Roberts's watercolours of the antiquities, which were always intended for translation into lithographs, and therefore ultimately for public consumption. Lewis publicly exhibited paintings of contemporary life in Cairo which were immensely popular in England, and inspired many artists to follow him.

Lewis is probably the most important British painter to have painted Egypt; he is very much in demand and therefore expensive. The following painting is a reproduction of one of his Cairo masterpieces.

After John Frederick Lewis
A Turkish School in the Vicinity of Cairo
Oil on canvas
70 x 97 cm.
This is a recently painted reproduction of the original Lewis painting, sold at Sotheby's New York, May 1985. (The Collection also contains an original pencil drawing by Lewis, heightened with white, 10 x 13.2 cm., of an Italian monastery, signed with initials).

～ 28 ～
LYNTON, Herbert S. (1855-1922)
Herbert Lynton is not well documented in painters' biographical references, but some of his views are excellent representations of Egyptian scenery.

a) **Evening, Giza**
Watercolour
21 x 47 cm.
Signed and inscribed on mount

b) **Feluccas on the Nile**
Watercolour
39 x 27 cm.
Signed

c) and d) **Egyptian Scenes** (two rural scenes)
(Illustration p. 76)
Watercolour; each 27 x 69 cm.
Signed

～ 29 ～
MACCALLUM, Andrew (1821-1902)
MacCallum, a landscape painter in oil and watercolour, was originally apprenticed in his father's hosiery business. At 21 he studied at the Nottingham School of Art and later at the Government School of Design at Somerset House. He taught at the Manchester School of Art from 1850 to 1852, and was head of the Stourbridge School of Art until 1854, when he went to Italy. On his return in 1857 he helped in the decoration of Kensington Palace. In 1871 he visited Egypt and made many watercolours of Egyptian rural scenes.

Kfar al Aiot on the Nile 1871
Watercolour
22.5 x 45 cm.
Signed, inscribed and dated 1871

～ 30 ～
MACCO, Georg (1863-?)
Born in March 1863 at Aix-la-Chapelle, Georg Macco studied under Janssen and E. Ducker at the Düsseldorf Academy. He settled in Munich in 1887 to complete his training and it was there that he exhibited for the first time in 1888. A landscape artist, he painted views of Italy and scenes of popular life in the Orient. He was also known as an illustrator. Some of his works are in museums in Aachen, Düsseldorf, Prague and Munich.

After? Macco
Arab Market Scene
Oil on board
29 x 39 cm.
Not signed
A similar but larger painting, 48 x 72.5 cm., is in the Daniel B. Grossman collection in New York.

～ 31 ～
MASON, Frank Henry, RI (1876-1965)
After beginning his career at sea, Mason worked in engineering and shipbuilding, and during World War I served in the North Sea and Egypt. He made extensive sketching tours, illustrated many books and designed posters for railway companies. He exhibited from 1900 at the Royal Academy, was a Member of the RBA, and was elected RI in 1929. In 1973 an exhibition of his work was held at Greenwich, England.

The Banks of the Nile
Watercolour
11 x 15 cm.
Signed

～ 32 ～
MORESBY, Captain Robert (active 1829-1852)
Moresby came of a distinguished naval family and, as commander of the East India Company's ship *Palinurus*, spent 1829-32 in a survey of the coasts of the Red Sea and the Gulfs of Suez and Aqaba, in connection with the plans for an overland route to India. Like many naval officers of his time he was a competent amateur artist; altogether a series of 30 watercolours survive as a record of his survey work. Such views of the Red Sea and of the Gulf of Aqaba are very rare. A book, *The Route of the Overland Mail to India* (1842), contains a portfolio of engravings after original drawings by Robert Moresby and Thomas Grieve.

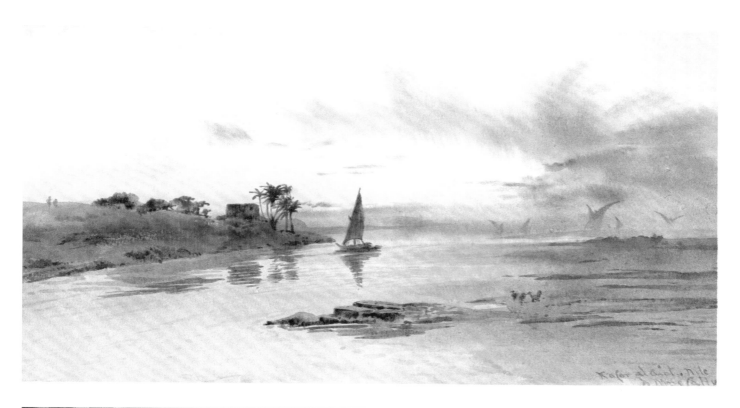

29. MacCallum:
Kfar al-Aiot on
the Nile

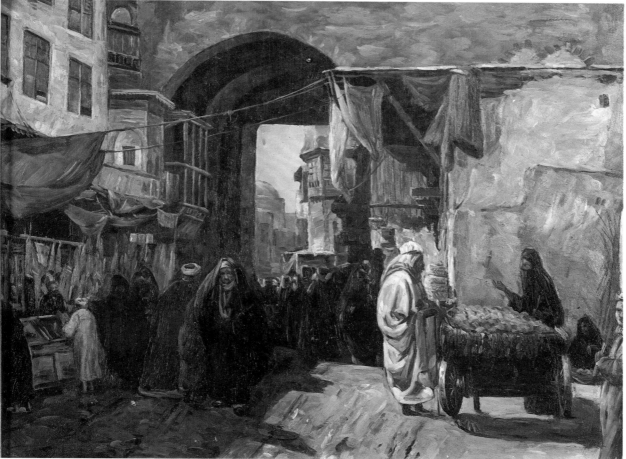

30. Macco:
Arab Market Scene

Next page:
32. Moresby:
Gulf of Aqaba
(and Taba)

Akabah the Ancient Eloth or E

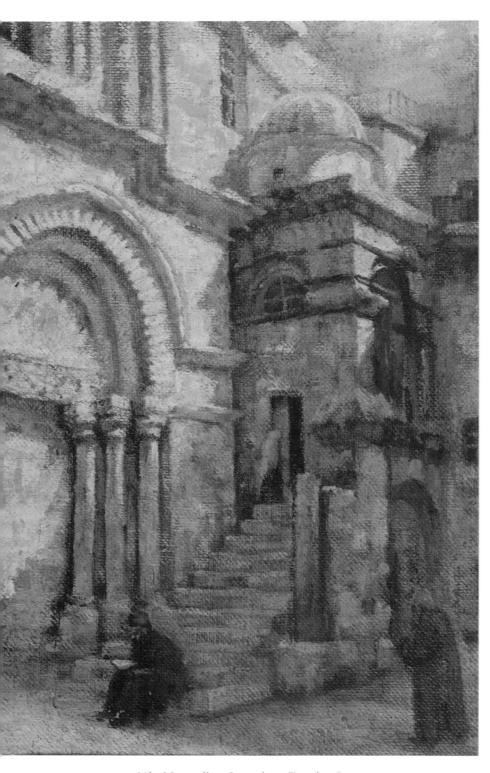

33b. Mouradian: Jerusalem, Façade of
the Church of the Holy Sepulchre

Gulf of Aqaba 1833
(Illustration pp. 116-17)
Watercolour
27 x 40.6 cm.
Inscribed and dated 1833
A rare view of the Gulf of Aqaba in the early nine-
teenth century, showing the location of Taba and the
empty shores of the Gulf, now occupied by two cities
Aqaba and Eilat.

~ 33 ~

MOURADIAN, Avedis (1895-?)
Mouradian was an Armenian who lived in Jerusalem
as well as in Nice, France. He was in Jerusalem around
1930 and made a few oil paintings of the city. Two
excellent examples are in the Collection. He is men-
tioned in the bibliography of Armenian artists, *Les
Peintres Armeniens* (p. 288).

Although these two paintings are after the
Ottoman period, I decided to include them in this cat-
alogue because I regard Mouradian as a local
Jerusalem artist.

a) **Jerusalem, Via Dolorosa** 1930
(Illustration p. 44)
Oil on canvas
61 x 41 cm.
Signed and inscribed; dated on reverse '1930'

b) **Jerusalem, Façade of the Church of the Holy
Sepulchre** 1930
Oil on canvas
56 x 41 cm.
Inscribed on board on reverse and dated 1930

~ 34 ~

MÜLLER, William James (1812-1845)
Müller was a successful painter of landscapes and
genre subjects, but this early promise was cut short
by his death when only 33. Though famed as a rapid
and fluent watercolour sketcher, he was disappoint-
ed by his failure to find recognition as an oil
painter. He travelled to the Near East twice in
search of new and exotic subjects, first to Egypt in

1838-39 (when this painting was made), and again in 1843-44 to Lycia in south-west Turkey, when Charles Fellows was removing the 'Xanthus marbles' for the British Museum. Working independently, Müller produced watercolours of the people, the scenery and ancient remains of Lycia that are accounted his finest work.

Egyptian Suq
Watercolour
25 x 20 cm.
Signed and inscribed 'Egypt'
The inscription appears to have been added by a later hand. The *suq* scene seems more like Malta than Egypt, but it may be the Suq of Assiout, which Müller painted often.

~ 35 ~

ODELMARK, Frans Wilhelm (1849-1937)
Odelmark is a relatively well known Swedish painter. He visited Egypt and made many colourful paintings of Cairo, in pastel as well as in oil. His paintings depict Egyptian scenes with great accuracy.

Cairo Street Scene
Pastel
60 x 43 cm.
Signed and inscribed

~ 36 ~

OLIVERO, M. (active *c.* 1900)
This Italian painter visited the Holy Land early in the 1900s. The Collection contains two of his paintings from Palestine.

a) **Le Mont Carmel et Caipha** (Haifa)
(Illustration p. 120)

b) **Le Lac de Tiberias**
(Illustration p. 33)
Both are oil on canvas
Each 14 x 19 cm.
Signed and inscribed

34. Müller:
An Egyptian Suq

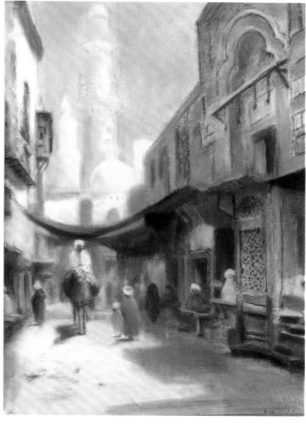

35. Odelmark:
Cairo Street Scene

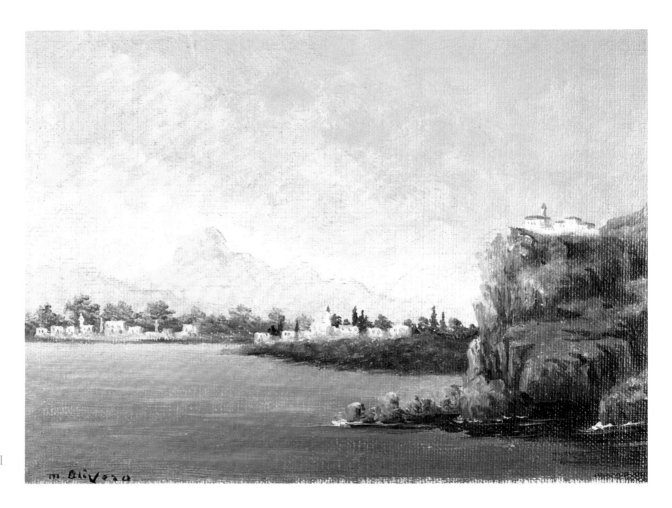

36a. Olivero:
Le Mont Carmel
et Caipha

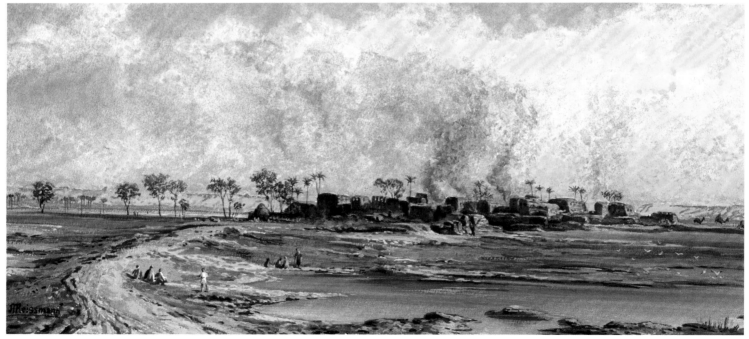

38. Reissmann: Arabs before an Egyptian town

～ 37 ～

PAYNE, A. (active early 20th century)
Little is known about Payne, but apparently he was a talented watercolourist who painted the Levant extensively.

Album of Watercolours

An album containing 39 watercolours of various sizes, mostly fine scenes of Jerusalem, Palestine and Egypt, but also some of Syria, Lebanon, Turkey and Greece.

～ 38 ～

REISSMANN, Karely Miksa (1856-1917)
This Hungarian painter visited the Levant and made many paintings of Palestine and Egypt. The following is one example:

Arabs Before an Egyptian Town

Body colour
19 x 47 cm.
Signed

～ 39 ～

ROBERTS, David, RA (1796-1864)
Roberts was brought up in a village outside Edinburgh, the son of a poor shoemaker, and began his working life as an apprentice house-painter. Soon after completing his apprenticeship he began to design and paint stage scenery, practising this trade for several years before moving to London in 1822 to work at Drury Lane and Covent Garden. He began to exhibit and sell oil paintings, and was soon able to give up his theatre work in order to concentrate on painting as a career. From 1824 he travelled on the Continent in search of picturesque subject-matter, to France, Belgium and the Rhineland. Drawings made in Spain between 1832 and 1833 established his reputation as a topographical draughtsman, but his most successful venture by far was the Near Eastern journey of 1838-1839.

In August 1838 David Roberts left England for Alexandria to begin his extensive travels through Egypt, Sinai and Palestine. His journey was the fulfil-ment of a long-held desire to draw Egyptian antiquities and scenes of biblical history, and he was determined to bring back a portfolio that would surpass anything that had yet been seen in Britain. As a topographical artist he was constantly faced with the necessity of finding novel subjects for his paintings, and he was well aware that the relative unfamiliarity of Egyptian temples, Islamic mosques and Holy Land scenery would make images of them highly desirable. As he wrote in the journal he kept during his journey, his sketches would make 'one of the richest folios that ever left the East'.

The first leg of his journey was a voyage by boat up the Nile as far as Abu Simbel, and he returned to Cairo with over 100 sketches of the Egyptian monuments. 'I am the first artist, at least from England, that has yet been here', he claimed, 'and there is much in this'.

He knew well the *Description de l'Égypte*, the ambitious French survey of Egypt and its antiquities made by Napoleon's team of savants after the French invasion in 1798. But he now dismissed it as conveying 'no idea of the splendid remains'. Although several English draughtsmen had in fact preceded him up the Nile during the 1820s and early 1830s, their records of the tombs and temples were not widely known because few were published, and in any case few possessed the same degree of artistic skill as Roberts. Unlike these earlier topographical draughtsmen – many of them architects by training – who visited Egypt under the auspices of a rich aristocratic patron, Roberts was a well known professional artist, an exhibitor at the Royal Academy who was travelling independently primarily to further his career. In Cairo he could draw with confidence the city's crowded streets and intricate medieval architecture, and he even obtained permission to sketch inside the mosques, provided he wore Turkish dress, shaved his side whiskers and did not use pig's bristle brushes. Travelling through Sinai to Petra, on to Jerusalem and other biblical sites in the Holy Land, and finally to the magnificent Roman ruins at Baalbek, he encountered further curious and mighty monuments as well as a bleak and rugged landscape

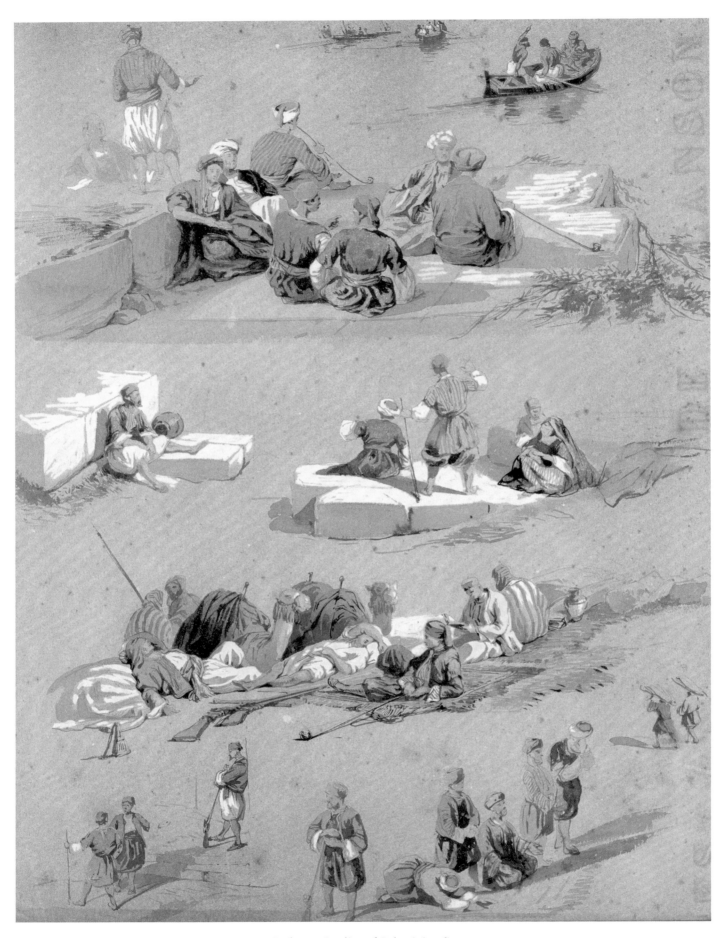

39a. Roberts: Studies of Palestinian figures

that held significant historic associations for his audience at home.

Roberts returned to England in July 1839 with 272 sketches, most of which he redrew during the following decade for his great series of lithographs, *The Holy Land, Syria, Idumea, Arabia, Egypt and Nubia*, published in four parts between 1842 and 1849. Their success assured Roberts's fame as an artist (which continues to the present day) and encouraged many others to follow in his footsteps.

Literature: J. Ballantine, *The Life of David Roberts RA*, Edinburgh 1866; Briony Llewellyn and H. Guiterman, *David Roberts RA 1796-1864*, London 1984 (both in the Collection).

The Collection contains Roberts's lithographed book, *The Holy Land, Syria...* (p. 157, no. 11), and also seven original watercolours by Roberts. Only two of these are of relevance to the Holy Land. The rest are European scenes.

a) and b) **Studies of Palestinian Figures** (pair)
(Illustration of the second of the pair p. 72)
Watercolour
Both 29 x 25 cm.
Watermarked De Canson

In the eighteenth and nineteenth centuries it was common practice for topographical artists who travelled abroad to include in their drawings 'typical' groups of a country's inhabitants. Such figures performed a number of important functions – they fixed the locality of the scene depicted; they brought vitality to drawings of ancient monuments and gave an indication of scale; and they could be used to indicate certain themes, such as the religious associations of a view of Jerusalem from the Mount of Olives.

The groups of figures in these well-executed studies can also be seen in several of the *Holy Land* plates (for an example, matched with the other page of studies, see pp. 72-73). These studies probably represent an intermediary stage between drawing and lithograph, but their exact function is unclear. It is possible that Roberts used them as compositional studies for the finished watercolours he made for his lithographer, Louis Haghe.

Reproduced: *Holy Land*, Vol. I, pl. 4, 6, 7, 8, 9, 11, 18, 19, 21; Vol. II, pl. 45, 56, 60, 74; Vol. III, pl. 121.

Attributed to David Roberts
c) **View Down to the Jordan Valley**
Watercolour
34 x 50 cm.
Unsigned

~ 40 ~

ROSEN, Georg von (1843-1924)
Rosen, a leader of the Swedish school of painting, executed the following magnificent watercolour during a visit to Jerusalem in 1865:

Church of the Holy Sepulchre and Mosque of Omar 1865
(Illustration pp. 70 and 74-75)
Watercolour
27 x 37 cm.
Signed and inscribed 'Jerusalem 22/4/65'
The painting shows the damaged state of the dome of the church which was repaired three years later, in 1868.

~ 41 ~

RUDYERD, Captain Reginald Burroughs (1848-?)
This Irishman, born on 28 December 1848, started his army career with the 39th Foot, though most of his service was with the Royal Irish Fusiliers. He was in the Holy Land and Egypt in 1875 and there painted the watercolours of the following two albums. He also painted many other parts of the world during his military career.

a) **An Album of Watercolours of Palestine** 1875
(Illustration p. 124)
11 watercolours, plus 2 pencil drawings
Various sizes
Most are scenes of Jerusalem.

b) **An Album of Watercolours of Egypt** 1875
15 watercolours
One signed with initials; all inscribed, one dated 1875

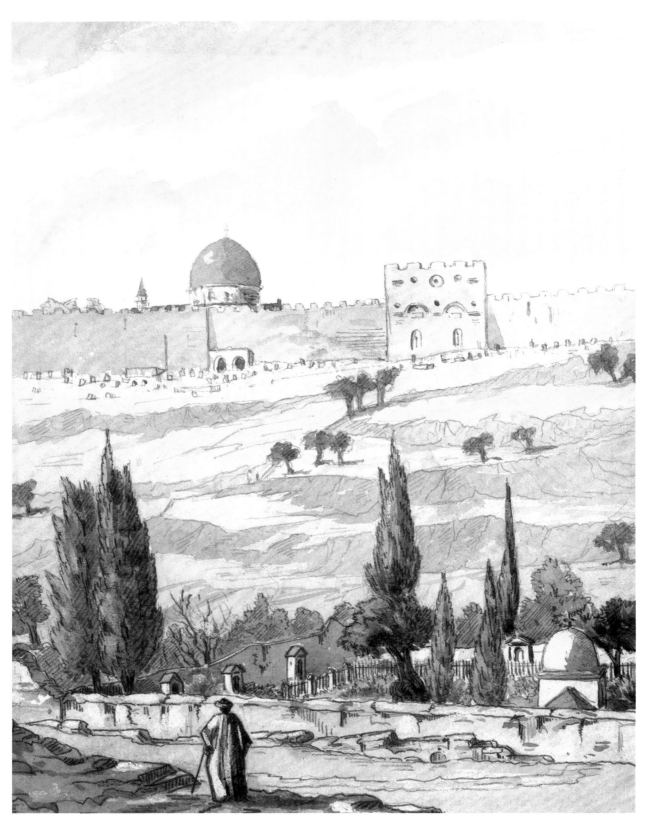

41a. Rudyerd: Jerusalem, showing the Golden Gate and the Dome
of the Rock; in the foreground is Gethsemane

~ 42 ~

RYCHTER, May A.

Not much is documented about May Rychter. Apparently she visited the Holy Land early in the 1900s and painted many watercolours of Jerusalem. The Collection contains three of them, all watercolours heightened with body colour.

a) **Jerusalem**
25.5 x 33 cm.

b) **Rachel's Tomb**
(Illustration p. 66)
21.5 x 29.5 cm.

c) **Jerusalem, Old City**
30 x 20.5 cm.
All are signed and inscribed

~ 43 ~

SARGENT, John Singer, RA (1856-1925)

The son of an American doctor, Sargent travelled widely in Europe and studied in Rome, Florence and Paris before settling in London in 1886. He became the most fashionable portrait painter of the age in both Britain and the United States, which he visited regularly. However he was also an enthusiastic landscape and architectural painter, and for these he turned increasingly to watercolour. His watercolours are dashing creations, rapidly executed on damp paper with a mixture of clear colours and Chinese white. They are concerned with facts rather than impressions – 'mere snapshots' he called them – but they convey atmosphere brilliantly. Sargent was elected ARA in 1894, RA in 1897 and RWS in 1904. He visited the Holy Land in 1905.

Attributed to Sargent
a) **Jaffa from the Sands** 1905
(Illustration pp. 126-27)
Watercolour
22 x 29 cm.
Not signed, inscribed or dated; but Sargent is known to have visited Palestine in 1905

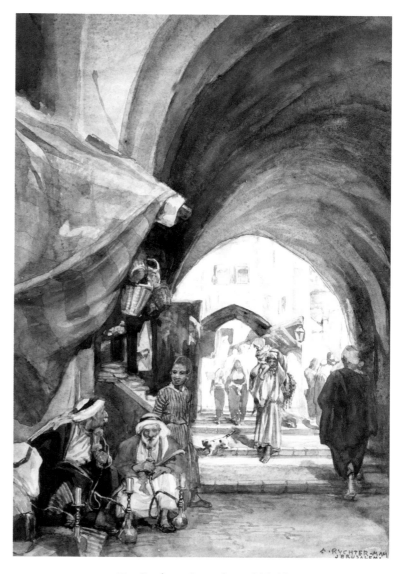

42c. Rychter: Jerusalem, Old City

Manner of Sargent
b) **The Darb al-Ahmar, Cairo**
(Illustration p. 71)
Watercolour
33 x 23.5 cm.
This masterly work represents the view looking north along part of the Darb al-Ahmar (now Sharia Bab al-Wazir). On the right is a corner of the Palace of Alin Aq (now almost destroyed); next, the mosque and tomb of Amir Khayrbak; behind this, the Mosque of Aqsunqur, also known as the Blue Mosque or the mosque of Ibrahim Agha.

Next page:
43a. Sargent:
Jaffa from the Sands

THE PAINTINGS ~ 125

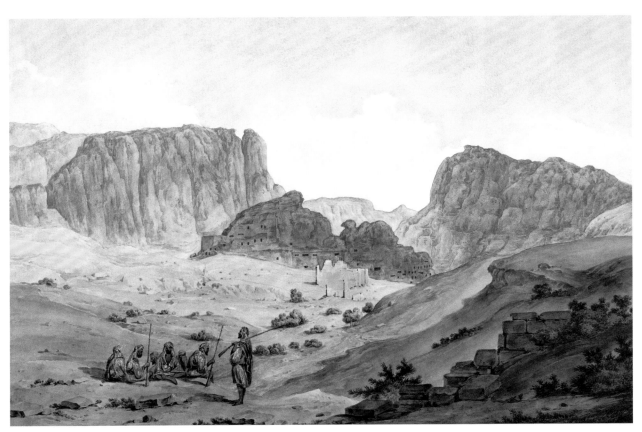

44b. Schranz:
Petra, general view
from the east

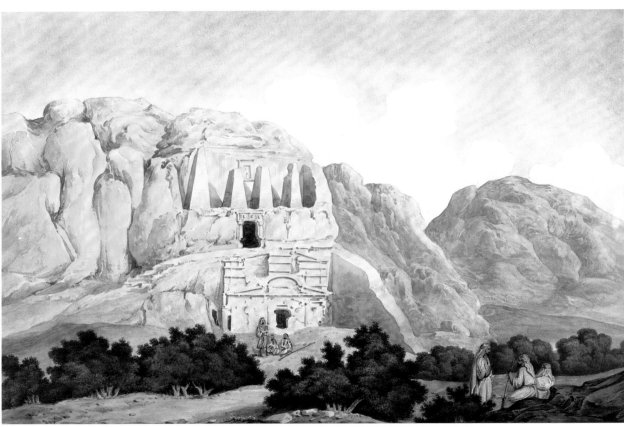

44c. Schranz:
Petra, Obelisk Tomb

46d. Simpson:
Interior of
Esbekieh Palace,
Cairo

～ 44 ～

SCHRANZ, Telesford (or, more likely, **Anton the Younger**) (1801-after 1865)
Schranz was one of a family of topographical artists based in Malta. Between 1823 and 1847 he made at least ten journeys to the Near East, often accompanying British travellers as their draughtsman. These watercolours resulted from one such journey, probably with Lord Castlereagh.

a), b) and c) **Petra**
All are watercolours over pencil
Each 37 x 53.5 cm.
Neither signed nor inscribed

～ 45 ～

SIMMONDS, William George (1876-?)
This English painter was born in Constantinople. He exhibited at the Royal Academy and some of his paintings are in the Tate Gallery.

Arab Coffee House 1913
(Illustration p. 130)
Watercolour
70 x 45 cm.
Signed and dated 1913
An Orientalist scene, one of very few in the Collection

～ 46 ～

SIMPSON, William (1823-1899)
William Simpson is the best known of the *Illustrated London News* 'special artists', renowned both for the interest of the events (of which they are often unique visual records), and for his own talents as a watercolourist and an extremely accurate and rapid draughtsman. As a testimony to his concentration and energy, many sketchbooks were found after his death, some of them relating to the Near East. Of special interest are Simpson's quick drawings in sepia colour of underground Jerusalem in 1869. Three of these drawings are in the Collection, as well as a drawing of the interior of Esbekieh Palace in Cairo, done in the same year.
The following are all quick sepia colours and wash, and each is inscribed and dated:

a) **The Royal Caverns at Jerusalem** 1869
(Illustration pp. 60-61)
26 x 43 cm.

b) **Wilson's Arch, Haram Wall, Jerusalem** 1869
(Illustration p. 38-39)
27x 21cm.

c) **Gallery at the Golden Gate, Jerusalem** 1869
16 x 12.5 cm.

45. Simmonds: Arab Coffee House

d) **Interior of Esbekieh Palace, Cairo** 1869
(Illustration p. 129)
27 x 43 cm.

The Collection contains, in the same series, the following eight sepia colours by Simpson of non-Middle Eastern subjects:

e) **Mont Cenis Tunnel** 1869
28 x 21 cm.

f) **Abyssinia (Women grinding Grains)** 1868
20 x 24 cm.

g) **Abyssinian Church** 1868
27 x 22 cm.

h) **Chimney, Moraix, Brittany** 1870
20 x 27 cm.

i) **Fountain of Egeria, Rome** 1870
22 x 28 cm.

j) **Church of Maria, Rome** 1870
26 x 23.5 cm.

k) **Vesuvius with Lava** 1872
23.5 x 36 cm.

l) **The Gates of Agra, India** 1872
26.5 x 31.5 cm.

The Collection also contains some issues of the *Illustrated London News* in which these drawings appeared.

~ **47** ~

SMITH, Carlton Alfred, RI (1853-1946)
A genre painter in oil and watercolour, Smith was the son of a steel engraver and was educated in France. He studied at the Slade and began his career as a lithographer before taking up painting full time. He exhibited from 1879, when he was elected to the SBA He was elected RI in 1889 and retired as an

47. Smith: Byway in Jerusalem

Honorary Member in 1939. His wife painted coastal scenes and exhibited from 1883. There is no record that he visited Jerusalem, and he may have borrowed this scene from the sketches of others.

Byway in Jerusalem
Watercolour
44.5 x 30.5 cm.
Signed, inscribed on label attached to backboard 'Exhibited in the Royal Society of Painters in Watercolours'

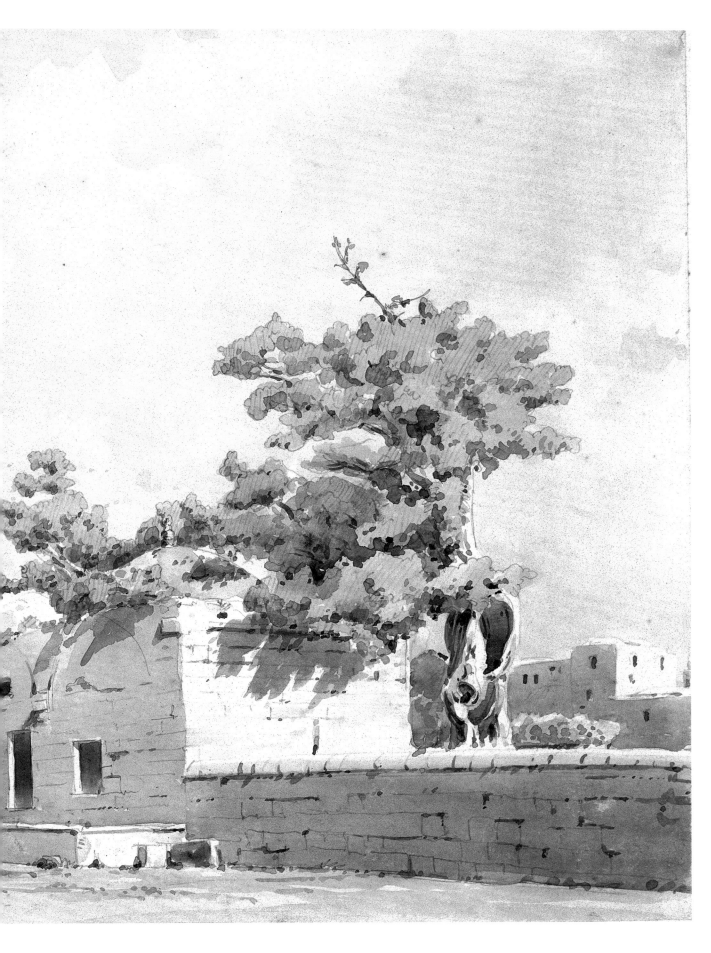

48a. Spiers:
Entrance
Gateway to al-
Haram al-Sharif,
Jerusaelm

48

SPIERS, Richard Phene (1838-1916)

Spiers was an architect, known better for his teaching and writing than as a practitioner. In 1865-66 he toured the Near East on a travelling studentship from the Royal Academy, studying ancient and Islamic architecture. On his return he exhibited several pictures with eastern subjects at the Royal Academy. A fine group of his watercolours of the Levant and Egypt is in the Victoria & Albert Museum, London.

a) **Entrance Gateway to Haram al-Sharif, Jerusalem**
(Illustration pp. 132-33)
Brush and sepia wash over pencil
31 x 49 cm.
Lettered on original mount with title 'Haram Ech-Sherif, Jerusalem', and name of artist
The drawing shows the north-western entrance to the compound of the Dome of the Rock in Jerusalem. A similar picture showing the north-eastern gateway to the same site has been donated to the PEF and is in their archives.

b) **Baalbeck, the Great Stones**
Brush and sepia wash over pencil
31 x 49 cm.
Lettered with title and name of artist on original mount
This impressive drawing depicts the large stones of the walls of the Baalbek temple.

c) **The Temple of Edfu** 1866
Watercolour
35 x 25 cm.
Signed and dated 1866
This painting demonstrates Spiers' skill in depicting impressive architectural sites.

49

STREIT, Karl (1852-?)

Streit is a relatively well known German artist. He was born in Frankfurt in 1852 and visited the Holy Land in the late 1870s.

Figures in Abu Nabout Courtyard, Jaffa 1879
Watercolour
9.2 x 15.9 cm.
Signed, inscribed and dated 'K. Streit 1879, Jaffa'
A fine *sabil* (drinking fountain) in Jaffa, a characteristic feature of an Islamic town.

50

TETAR VAN ELVEN, Pierre Henri Théodore (1828-1908)

A Belgian, born near Brussels, van Elven was taught by his father Jean-Baptiste, and then studied art at the drawing academies of Amsterdam and the Hague. He travelled to Paris and Italy and for some years was based in Turin. He also visited the Near East, Palestine, North Africa and India. He exhibited his pictures most frequently in Amsterdam and the Hague, but also elsewhere, including one at the Royal Academy.

A View of Acre
(Illustration p. 15)
Watercolour
31 x 51.5 cm.
Signed and inscribed 'San Giovanni d'Acre'

51

THACKERAY, Lance (?-1916)

Thackeray, who painted genre and sporting subjects, is known for his Egyptian paintings. He should be distinguished from the well-known British writer and traveller William Makepeace Thackeray who wrote *Notes on a Journey from Cornhill to Cairo* (1845).

An Aswan Egyptian
Watercolour
30 x 22 cm.
Signed and inscribed 'Assouan'
Exhibited at the Fine Art Society in 1910.

52

TIPPING, William J. (1816-1897)

Tipping was a respected amateur archaeologist, who from 1839 spent seven years in the Near East exploring ancient ruins. In addition to well known sites such

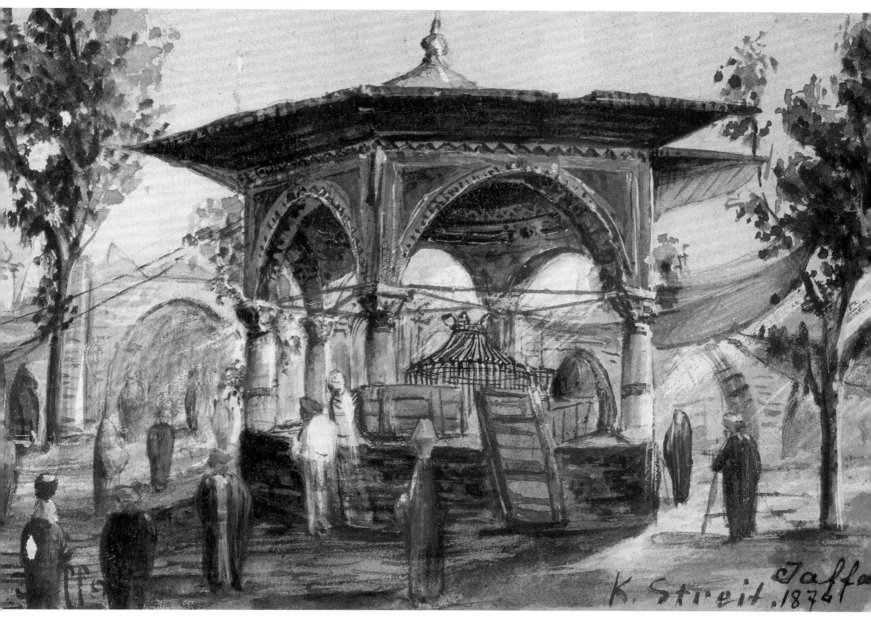

49. Streit: Figures around a *sabil* in Abu Nabout Courtyard in Jaffa

as the Parthenon, he visited others off the beaten track, like Jerash and Masada. In 1864 he was elected a member of the Society of Antiquaries.

The Bath Keeper
(Illustration p. 48)
Watercolour
17 x 24 cm.

Signed, inscribed and dated 'Damascus, May 31st, 1842'. The bath house had an important function in Syria and Palestine in the nineteenth century, not only as a place for cleaning but for socializing as well. Although since then public baths have disappeared from Palestine, they still exist in Damascus and many other areas of the Near and Middle East where they are popular to this day.

53. Treeby:
Mount Tourah,
and the Desert
outside Cairo

54b. Tyndale:
Egyptian
Rural Scene

～ 53 ～

TREEBY, J. W. F. (active 1869-1875)
Treeby exhibited at the Royal Academy, including a
painting entitled 'An Arab Soldier'.

Mount Tourah and the Desert outside Cairo
Oil on board
29 x 38 cm.
Signed; inscribed on the back
A rare oil painting of the Egyptian desert.

～ 54 ～

TYNDALE, Walter, RI (1855-1943)
Tyndale is best known for his watercolours of
Egyptian temples and North African streets, flooded
with the bright light of those countries. He was born
in Bruges but went with his family to England in 1871.
Having studied in Antwerp and Paris, he began
exhibiting oil paintings, but in 1889 turned to water-
colour, seeking technical advice from Claude Hates
and Helen Allingham. From 1894 he travelled widely,
visiting Morocco, Egypt, Lebanon, Syria, Palestine,

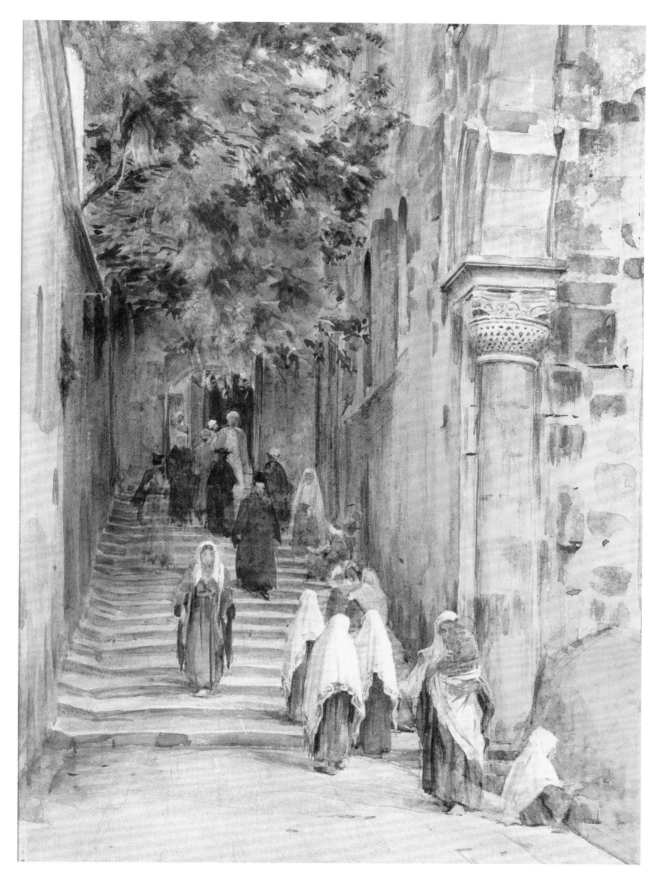

54a. Tyndale:
Stairs leading to
the Church of the
Holy Sepulchre,
Jerusalem

55. Vacher: Panorama of Wadi Sheram, Sinai

Japan, Tunisia and Italy, and held several exhibitions. Some of his best watercolours were executed in Palestine and Egypt. He wrote and illustrated several travel books, including two on Egypt: *An Artist in Egypt* and *Below the Cataract* (both in the Collection; see p. 199, no. 94).

a) Stairs leading to the Church of the Holy Sepulchre, Jerusalem
(Illustration p. 137)
Watercolour
26 x 17.5 cm.
Signed

b) An Egyptian Rural Scene
(Illustration p. 136)
Watercolour
29.5 x 23.5 cm.
Not signed

c) Inside a Cairo Mosque
(Illustration p. 198)
Oil on board
29 x 19 cm.
Signed
Tyndale painted this scene in both oil and watercolour versions.

~ 55 ~

VACHER, Charles (1818-1883)

This landscape painter, who studied at the Royal Academy schools, and in Rome from 1839, visited Sicily, France, Germany, Algeria and Egypt. He exhibited in London from 1838 and was elected ANWS in 1846 when he was once again in Rome. He became a full Member in 1850.

Vacher was a rapid and detailed worker, and he left more than 2,000 sketches at his death. Many of these are watercolours of Egyptian scenes and monuments, as well as a large number of Sinai. His finished work is well composed.

Panorama of Wadi Sheram, Sinai (1863)

Watercolour

15 x 70 cm.

Signed and inscribed and dated 1863

An excellent panorama of granite mountains in the southern Sinai peninsula. It is difficult to identify Wadi Sheram today as many names have changed – it could be in the area of Mount Sinai (Jabal Mousa), where the celebrated convent of St Catherine stands, one of the most visited places in Sinai and frequently depicted in paintings. Or it could be a view from Sharm (present-day Sharm al-Sheikh) at the southernmost tip of the peninsula.

56b. Varley: Dhows on the Nile

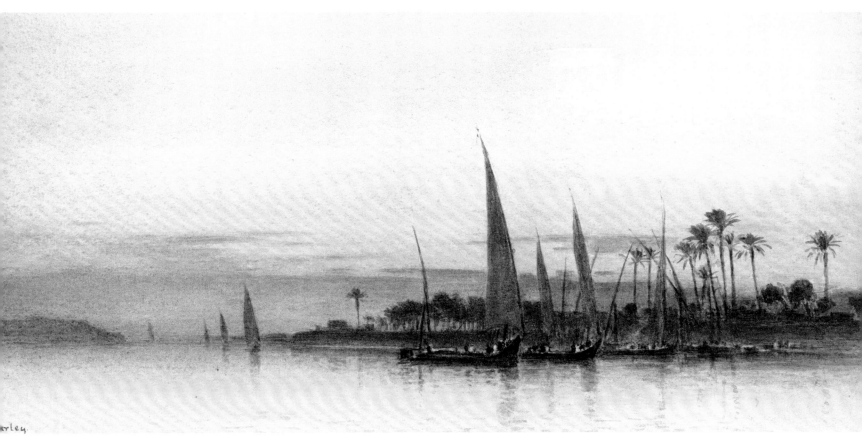

56c. Varley: Nile Scene

<div style="display:flex">
<div>

~ 56 ~

VARLEY, John Jnr (?-1899)

The son of A. F. Varley, John Varley specialized in Egyptian and Japanese scenes, which he exhibited from 1870 onwards. While his work is competent, it shows no great originality. The Collection contains a number of his watercolours; three are listed below.

a) **Entrance to the Temple of Abu-Simbel, Nubia**
(Illustration p. 142)
Watercolour
33 x 50 cm.

</div>
<div>

Signed; bears original receipt on reverse 'Exhibited Walker Galleries, Liverpool, 1886'.

b) **Dhows on the Nile** 1899
Watercolour
71 x 52 cm.
Signed and dated '99'

c) **Nile Scene**
Watercolour
17 x 37.5 cm.
Signed

</div>
</div>

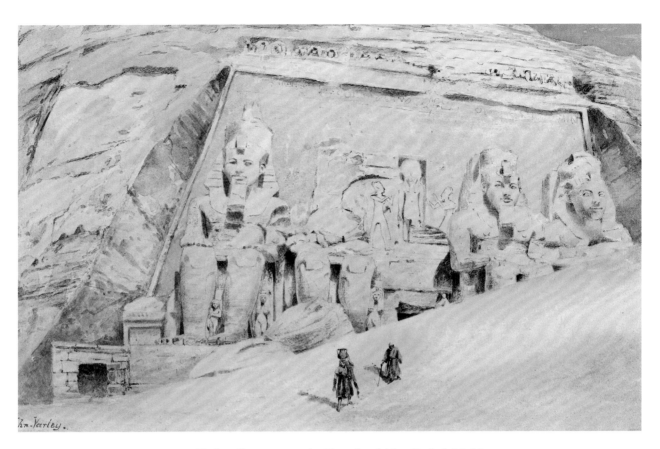

56a. Varley: Entrance to the Temple of Abu Simbel, Nubia

— 57 —

WALTON, Elijah (1832-1880)

Walton was often in Egypt during the 1860s, and made many drawings and watercolours of its people and landscape. He developed a special interest in the ubiquitous camel, and in 1863-64 spent some time in a bedouin encampment near Cairo studying the animal's habits and anatomy. The following year he published his drawings in *The Camel, its Anatomy, Proportions and Paces* (in the Collection, p. 161, no. 17), comparable in its detail and accuracy to Stubbs's *Anatomy of the Horse* of almost exactly a century earlier. Walton also visited Sinai and the Dead Sea where he made several watercolours, three of which are in the Collection. He was also known as a painter of romantic Alpine landscapes. He exhibited these, and Oriental subjects, at several London institutions, and published some of them in *Vignettes: Alpine and Eastern* (1873).

a) **Waddy Mukatteb, Sinai**
Watercolour
48 x 33 cm.
Signed and inscribed 'Waddy Mukkateb'
This scene resembles the Siq in Petra. The two sites have a somewhat similar topography.

b) **The Dead Sea**
Watercolour
15 x 22 cm.
Signed and inscribed

c) **Self-portrait**
Sepia colour
20 x 13.5 cm.
Signed and inscribed.
Self-portrait of Walton wearing local headdress, painted when he was at the Dead Sea.

57a. Walton:
Wadi Mukatteb,
Sinai

58c. Werner: Transport of Tourists at Giza, near Cairo

～ 58 ～

WERNER, Carl Friedrich Heinrich (1808-1894)
Although Werner was German by birth, he lived for nearly 20 years in England. While visiting Palestine and Egypt in 1862-64, he painted many polished watercolours, reproduced later in his two well-illustrated books. One of them, *Nile Sketches*, is in the Collection (p. 161 no. 18); the other, *Jerusalem, Bethlehem and the Holy Places* (1865), is very rare. The first two watercolours listed below appeared as lithographs in the second book. He is renowned for his detailed and well-worked watercolours, mostly of superb quality.

a) **Jerusalem, Outside Saint Stephen's Gate** 1864
Watercolour
34 x 50 cm.
Signed and dated 1864
Saint Stephen's Gate is also called the Gate of the Lions from the two lions carved on it, which are supposed to protect the city. It is called 'Bab al-Assbat' in Arabic.

b) **Bethlehem, Interior of the Church of Nativity**
1863
(Illustration pp. 68-69)
Watercolour with scratching out
34 x 50 cm.
Signed and dated 1863
The painting depicts the star design on the floor of the Cave of the Nativity in the Nativity Church in Bethlehem. A lithograph after Werner of this watercolour is also in the Collection.

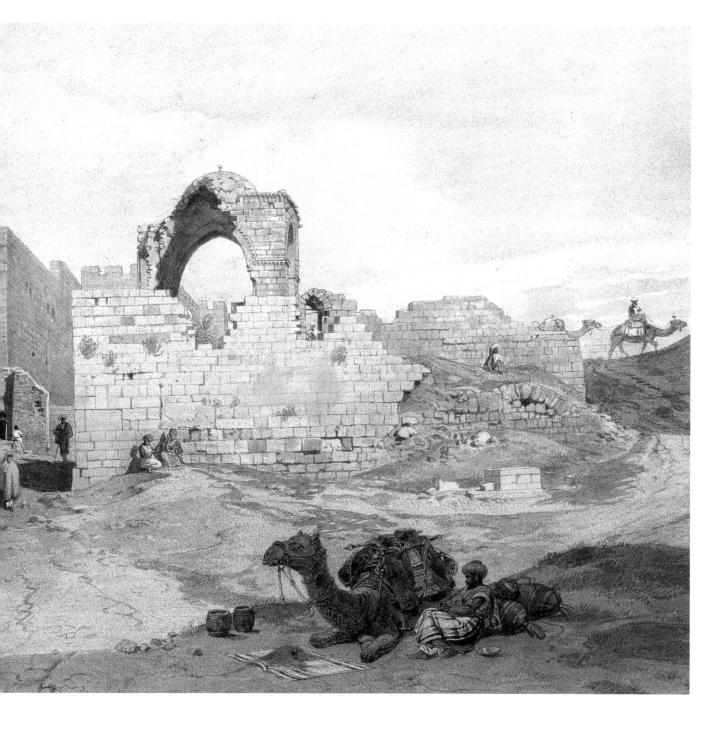

c) **Transporting Tourists at Giza** 1864
Watercolour, almost in a caricature style
17.5 x 12.2 cm.
Signed, inscribed and dated 4/12/1864

~ 59 ~

WEST, Joseph Walter (1860-1933)
West studied at the Royal Academy schools under E. Moore, and in Paris and Italy. He worked in many media, producing delicate landscapes and genre pic-tures of Quaker subjects. He was elected ARWS in 1901 and RWS in 1904. He also visited Egypt where he painted this large and striking watercolour of Philae.

Sunset at Philae
(Illustration pp. 146-47)
Watercolour
67 x 91 cm.
Signed with monogram and inscribed 'L88'; title inscribed on label

Next page:
59. West:
Sunset at Philae

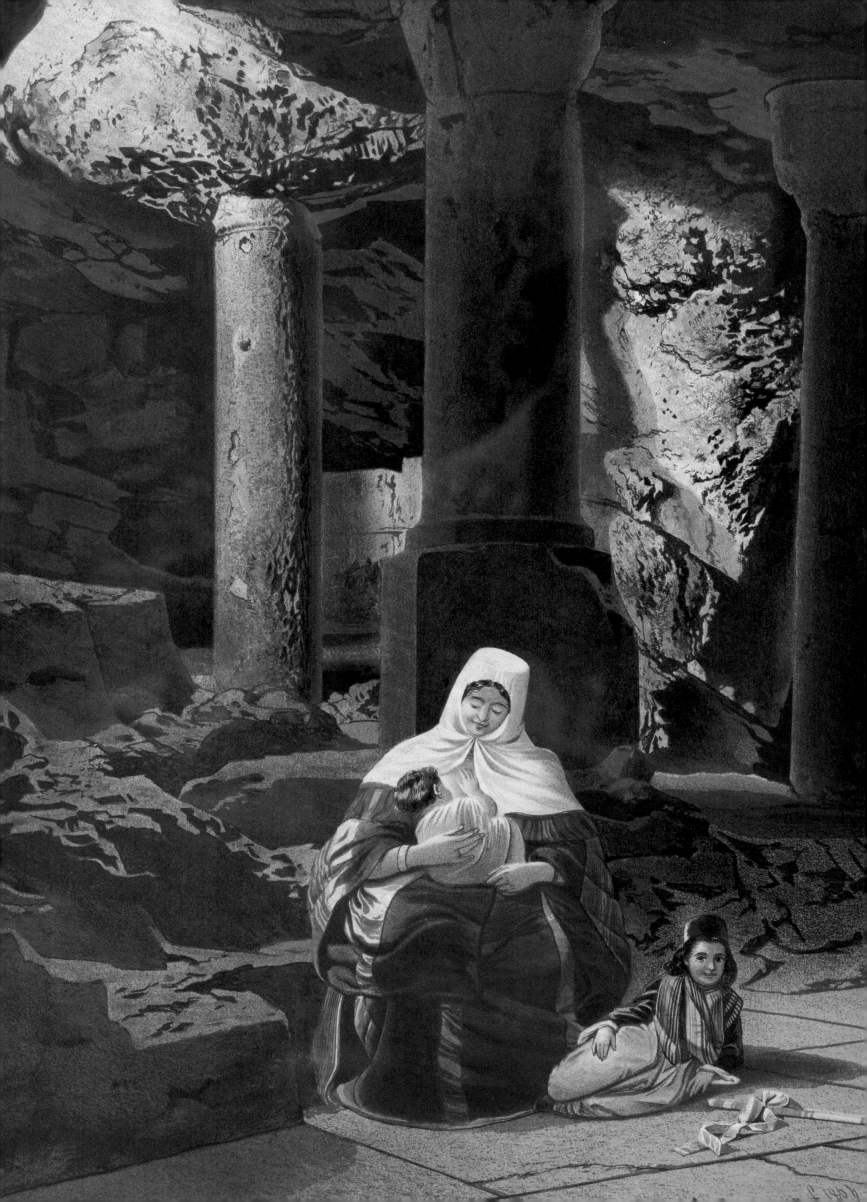

CHAPTER SIX

~ Valuable Plate Books ~

The nineteenth century, particularly the first half of it, was well known for its 'Valuable Plate Books', in which lithographs and plate prints were lavishly displayed. Most of these were in folio size (sometimes elephant folio), but occasionally they were oblong, in which case usually quarto or octavo. Some of the lithographs and prints were in sepia or black and white; others were tinted with more than one colour. Often they were coloured by hand some time after printing, either by the artist himself or, in most cases, by others.

As already explained, some travellers were themselves experienced artists, others were accompanied by professional artists; all were anxious to convey to their compatriots the sites they had visited. Since photography had not yet developed to the stage of mass printing, lithographs, woodcuts and steel engravings provided established techniques for obtaining the accurate prints that were required, and artists exploited these to the full. Egyptian monuments and the topography of the Holy Land were particularly suited to depiction in lithographs and prints. Usually a skilled lithographer or engraver was entrusted to develop the stones or steel plates from sketches or detailed drawings done by the artist/traveller. Sometimes the traveller made only quick pencil sketches, which were later developed into a painting for reproduction later as a print. After the 1850s some artists used photographs to develop and refine their paintings and prints.

It is not always easy to distinguish between a travel book enriched by plates and a Valuable Plate Book. We define the latter as a work in which lithography and plates dominate and descriptions are secondary, serving only to explain the plate, and not vice versa. Based on this definition, I have selected from the large number of plate books in the Collection the following 20 valuable plate books.

Opposite:
Mother and child in Bethlehem, from Werner's *Jerusalem, Bethlehem and the Holy Places* (see p. 161, no. 18)

3. Jerusalem from the south-east; from Mrs Ewald's *Jerusalem and the Holy Land*

⌒ 1 ⌒

BARTLETT, William Henry London *c*. 1850

Views Illustrating the Topography of Jerusalem Ancient and Modern. London, C. Virtue

Large folio. *Illus*: Many steel plates with 3 pages of description, followed by another two pages explaining different sites in Jerusalem; a plan of Ancient and Modern Jerusalem; title page with lithographic vignette of Robinson's Arch, Jerusalem; 3 full-page lithographs and 7 other smaller lithographs on three pages. All finely hand coloured by a later hand. The drawings are by Bartlett and drawn on stone by Challis, Bentley, Brandard and J. C. Bourne for the 3 last full-page plates. The plates were recently hand-coloured.

No date, but believed to be around 1850. A very rare book in this complete state.

Not in Blackmer

⌒ 2 ⌒

BAYNES, T.M. London 1784

Views of the Holy Land Drawn on Stone. By T. M. Baynes from original drawings in the possession of G. Ramsay Esq. London. Published by J. Dickinson. Printed at C. Hullmandel's Lithographic Establishment. London 1784

Large folio. *Illus*: 5 prints in original wrappers depicting scenes in and around Jerusalem. It is not known how many were originally called for. Very rare.

Not in Blackmer

⌒ 3 ⌒

EWALD, Mrs. London 1854

Jerusalem And The Holy Land. Being A Collection Of Lithographic Views And Native Costumes, From Drawings Taken On The Spot By Mrs. Ewald. London 1854

Oblong folio. *Illus*: 12 lithographed plates of which 9 are tinted and 3 (costume plates) printed in colour.

First and only edition, apparently published in two formats, one with 12 plates, the other with 7 plates. Both versions are in the Collection.

Nothing is known of Mrs. Ewald, but she may have been the wife of Ferdinand Christian Ewald, who published *Journal of Missionary Labours in the City of Jerusalem* (2nd edn. 1846). This identification may be in doubt, since Ewald's wife died in Jerusalem in 1844. Mrs. Ewald's drawings were lithographed by William Simpson, well known for his work on the Crimean War, *Seat of the War in the East*. The plates include views of Jerusalem, Bethlehem, Hebron, the

VIEWS

ILLUSTRATING THE TOPOGRAPHY OF

JERUSALEM

ANCIENT AND MODERN

REMAINS OF THE ANCIENT BRIDGE

LONDON, C. VIRTUE.

1. Titlepage of Bartlett's *Views Illustrating the Topography of Jerusalem*

4. The ruins of Karnak, from Forbin's *Voyage dans le Levant*

Valley of Jehoshaphat, Gethsemane, Samaria, the Holy Sepulchre and Christ Church on Mount Zion. The costume plates are of a Jew and Jewess, wandering Arabs, and a Samaritan priest and his family.

Blackmer 561

— 4 —

FORBIN, Louis Nicolas Philippe Auguste, Comte de Paris 1819

Voyage Dans Le Levant, Par M. le C.^te de Forbin... Paris, De L'Imprimerie Royale. 1819

Elephant folio, *Illus*: 78 plates (70 lithographs, 8 aquatints), most of scenes in Egypt and Palestine, after drawings by Forbin, Isabey, Prevost, Fragonard and Carle Vernet. The aquatinted plates are all after drawings by Forbin himself.

First edition. It is believed that only 325 copies were printed. Two editions, one marked 'Seconde', were issued in 1819 with the text in 8vo and the folio plates to be purchased separately. A dual-language French/German edition in this same format was published at Prague in 1823.

In 1816 Forbin became Director of Museums in Paris, and in August 1817 he made a semi-official year-long voyage to the Levant to purchase antiquities for the Louvre. He travelled to Athens, Constantinople, Asia Minor, Syria and Palestine. From Jaffa he went overland to Alexandria and visited Egypt. This book was the result; it was one of the first important French books to use lithography on a grand scale, and the standard of production is equal to that of Napoleon's *Description de l'Égypte* or Dominique Vivant Denon's *Voyage dans la Basse et la Haute Égypte* (2

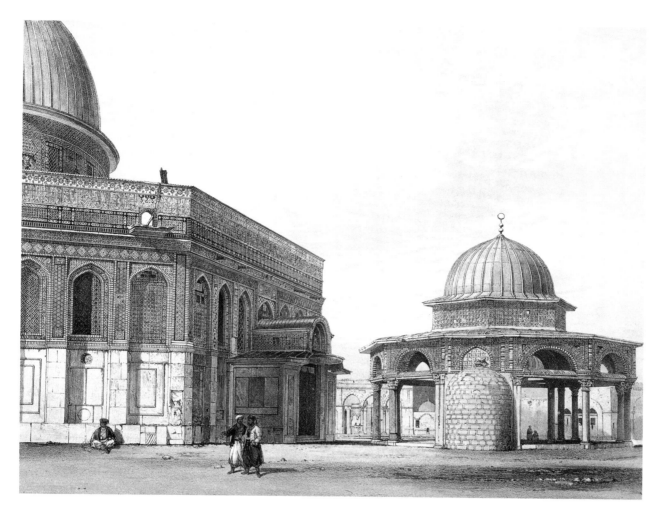

7. The Great
Mosque of
the Sakhra, (the
Dome of the Rock)
and the Dome
of the Chain from
Isaacs' *Four Views*

vols., Paris 1802). In 1843 Marcellus brought out a selection of Forbin's plates, in small folio with a text edited by himself under the title *Portefeuille de Comte de Forbin*.

(For other Forbin illustrations, see pp. 28-29 and 46).

Blackmer 614

~ 5 ~

HARTMANN, R. Julius Stuttgart 1899

Palestina: 24 Aquarelle von R. Julius Hartmann, mit Erläuterndem Text von Immanuel Benzinger. Titelbild: Omarmoschee, Jerusalem. Theodor Benzinger Verlagsbuchhandlung, Stuttgart 1899

Large 4to. *Illus*: 24 coloured aquatinted plates, of which 19 are of Jerusalem and the Holy Land, 3 of Egypt, 1 of Damascus and 1 of Baalbek.

First and only edition.

The album has 12 pages of description, half a page for each of the sites in the plates.

Not in Blackmer

~ 6 ~

HAY, Robert London 1840

Illustrations of Cairo. By Robert Hay, Esq. ... Drawn on Stone By J. C. Bourne, Under The Superintendence of Owen B. Carter, Architect. London: Published by Tilt And Bogue, 86 Fleet Street. 1840

Large folio. *Illus*: lithographed title, engraved dedication and 30 lithographed views. About half are from drawings by Owen Carter; the rest by C. Laver and by Hay himself.

First edition.

Hay is one of the best known explorers and artists of

8. The Holy Sepulchre misleadingly outscaling the Dome of the Rock, from Luigi Mayer's *Views in Palestine*

Egypt, which he visited from 1824 to 1838, systematically exploring the Nile Valley accompanied (among others) by Arundale (q.v.), Bonomi (q.v.) and Edward Lane. The *Illustrations*, one of the most important and colourful valuable plate books, depicts early nineteenth-century Cairo in lithography that is comparable in quality to David Roberts's *The Holy Land, Syria...* (see below no. 11)

Blackmer 794

Rev. A. A. Isaacs, each with a description of the site (General View of the Great Mosque of the Sakhra; The Great Mosque of the Sakhra and Judgment-Seat of David; Façade of the Mosque of al-Aqsa; and Marble Pulpit and Colonnades).

No views of these structures had ever been obtained or published before. Isaacs also published *The Dead Sea* in 1857, illustrated with his photographs.

Not in Blackmer

— 7 —

ISAACS, Rev. A. A. London 1857

Four Views – the Mosques and Other Objects of Interest. Drawn and lithographed from photographs taken by Rev. A. A. Isaacs, M.A., of Corpus Christi College, Cambridge, By Special Permission of the Pasha of Jerusalem. London: Printed and Published by Day & Son, 1 December 1857

Folio. *Illus*: Four tinted lithographs from photography by the

— 8 —

MAYER, Luigi London 1804

Views In Palestine, From The Original Drawings Of Luigi Mayer. With An Historical And Descriptive Account Of The Country, And Its Remarkable Places. Vues En Palestine, d'après Les Dessins Originaux De Luigi Mayer; Avec Une Relation Historique Et Descriptive Du Pays, Et Des Lieux Principaux Qu'On Y Remarque. London: Printed By

10. A page of calligraphy from Prisse d'Avennes' *La Décoration Arabe*

T. Bensley, Bolt Court, For R. Bowyer, Historic Gallery, Pall Mall, 1804

Large folio: *Illus*: 24 aquatinted plates, hand-coloured (2 are missing). Letterpress in French and English.

First edition, published in six parts. A second edition appeared *c.* 1807 as *A Series of 24 Views Illustrative of the Holy Scriptures*. A German edition appeared at Leipzig in 3 parts, 1810-14 as *Ansichten von Palästina* with text by E. F. L. Rosenmüller. Eight of the plates were published in 1812 as *Selection of Views in Palestine*. The *Palestine* (1804) is also found together with *Egypt* (1801 or 1804) and *Caramania* (1803) with a general title dated 1804: *Views in Egypt, Palestine and other Parts of the Ottoman Empire*. Ten of the views used for *Palestine* were also used for the plates engraved by William Watts in *Views in Turkey in Europe and Asia,* in the section 'Views… Comprising Palestine and Syria'. This work appeared in parts from 1801 to 1806, while the plates for Bowyer's *Palestine* were engraved in 1803 and 1804.

Trained in Rome, Mayer was employed from 1776 to 1794 as draughtsman to the diplomat and numismatist Sir Robert Ainslie (1730-1812), British Ambassador to the Ottoman Porte at Constantinople, whom Mayer accompanied to England at the end of Ainslie's term of office. His views of the monuments of Palestine and their environs were published as a set of aquatints, first in 1801 and again in subsequent years. This was the first of several volumes of views in the Ottoman Empire (parts of Europe, Asia and north Africa) engraved from Mayer's watercolours, whose publication between 1801 and 1810 was sponsored by Ainslie. More than 40 years before the appearance of David Roberts's great work, *The Holy Land*, Mayer provided detailed illustrations of many of the antiquities of Jerusalem and the Holy Land.

Blackmer 1099

~ 9 ~

PÂRIS, François Edmond Paris 1862

Souvenirs De Jérusalem Album Dessiné Par M. Le Contre-Amiral Pâris, Lithographié Par M. M. Hubert Clerget, Bachelier, Jules Gaildrau et Fichot. Ouvrage Publié Par L'Escadre De La Méditerranée. Paris Librairie Maritime et Scientifique Arthus Bertran,

Éditeur Librairie De La Société De Géographie, 1862

Large folio. Illus: 14 lithographed plates of which 12 are coloured and 2 tinted. Coloured lithographed plan of the Holy Sepulchre mounted on the title.

First and only edition of this pictorial account of the visit of the French Mediterranean squadron to Jerusalem in 1861. Most of the plates illustrate various parts of the church of the Holy Sepulchre.

Pâris was named commander of the third division of the Mediterranean squadron in December 1858. He was already well known as a naval artist (e.g. *Album Pittoresque d'un Voyage Autour du Monde, L'Art Naval* and *Souvenirs de Marine),* and he produced works on the technology of steam engines and other technical matters.

(Illustration p. 47).

Blackmer 1255

~ 10 ~

PRISSE d'AVENNES, Achille Constant Théodore Émile Paris 1885

La Décoration Arabe. Décors Muraux – Plafonds – Mosaiques – Dallages – Boiseries – Vitraux – Étoffes – Tapis – Reliures – Faiences – Ornements Divers. Extraits du Grand Ouvrage L'Art Arabe. Par Prisse d'Avesnes. Paris, J. Savoy & Cie., Éditeurs, 1885

Folio. Contains 3 sections – I: Décorations Murales, Étoffes, Tapis, Reliures, Faience, etc (50 plates); II: Mosaiques & Dallages (14 plates); III: Ornements Divers, Boiseries, Vitraux (19 plates).

Prisse d'Avennes was a remarkable and versatile man who, after his first arrival in Egypt in 1826, visited continuously for the rest of his life. His interests were wide-ranging. He published in 1843 Les Monuments Egyptiens to complement the work of the great French Egyptologist Champollion. His enthusiastic study of Islamic architecture resulted in the publication c. 1867 of the massive three volume *L'Art Arabe d'après les Monuments du Caire.* He was also a competent artist and published his *Oriental Album* in 1848-51 profusely illustrated with chromolithographs and engraved vignettes from his own drawings.

(Illustration p. 155).

Not in Blackmer

11. A group of bedouins in Petra, with the Urn tomb in the background,
from David Roberts's *The Holy Land...*

~ 11 ~

ROBERTS, David London 1842-49

The Holy Land, Syria, Idumea, Arabia, Egypt and Nubia. From Drawings Made On The Spot By David Roberts, R.A. With Historical Descriptions By The Revd. George Croly. Lithographed By Louis Haghe. London F. G. Moon, Publisher In Ordinary To Her Majesty. Vol. I. London, F. G. Moon, 1842

Only Vol. I is available in the Collection.

Folio. *Illus*: Lithographed title, portrait frontispiece in Vol. I of *The Holy Land*, 1 map and 20 full-page tinted lithographed plates, and 20 half-page lithographed plates in letterpress. All plates finely hand-coloured by later hand.

First edition, ordinary format. *The Holy Land* was issued in 20 parts in 3 formats: tinted lithographs in paper wrappers; proof plates in a portfolio; and coloured lithographs, mounted, in a portfolio. The vignettes (half-page) printed with letterpress in the ordinary format were printed as separate plates in the coloured and proof formats. *Egypt* appeared in the same manner and with the same formats. Roberts's original intention was to publish *Egypt and Nubia* together with *The Holy Land* in six volumes but this was not carried out, and the two works were brought out separately. They are frequently found bound together, and are often treated as one work. In 1849 both works were available in parts; the material published by 1846 was available bound in two volumes. A second edition of both works reduced by photography, i.e. in 4to format, appeared in 1855-56 in 6 vols. (see 12 below). A French translation appeared in Brussels in 1843 with 60 plates. Roberts had begun to establish himself as a painter of architectural subjects and he travelled to the east in search of picturesque source material. His journey to the Levant took place in 1838-39.

Blackmer 1432; Hilmy II, 176

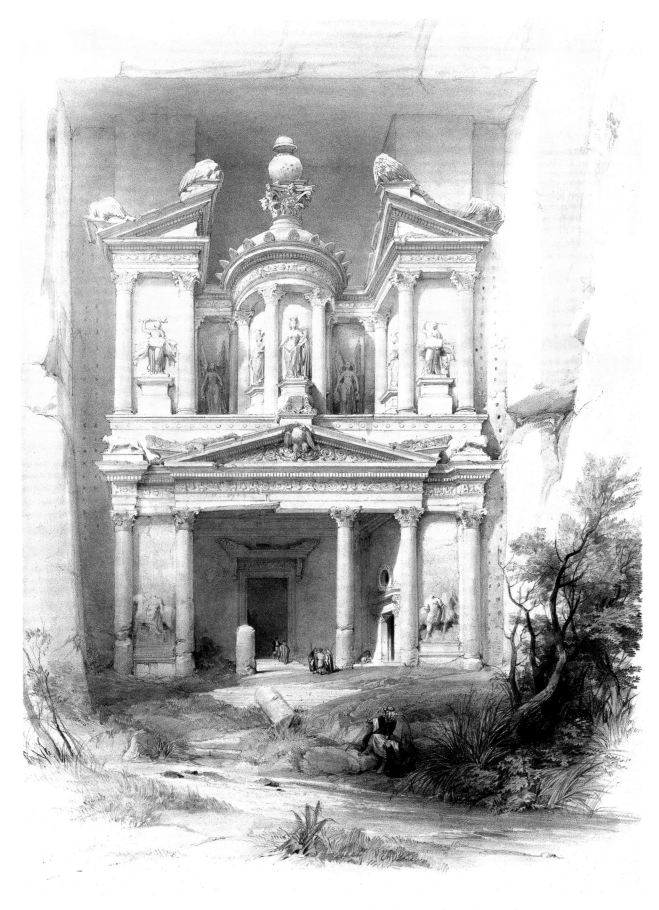

11. The Treasury (*al-Khazneh*) from David Roberts's *The Holy Land…*

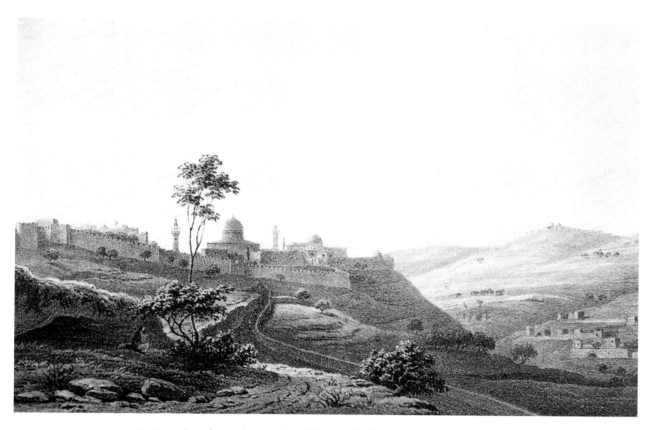

14. Jerusalem from the south, a lithograph after Bernatz, from Schubert
and Bernatz's *Album of the Lands of the Bible*

~ 12 ~

ROBERTS, David London 1855

The Holy Land, Syria, Idumea, Arabia, Egypt and
Nubia, six volumes in three books. Six pictorial lith-
ographed titles, two maps and 242 tinted litho-
graphed plates by Louis Haghe after David Roberts,
Day and Sons, 1855-1856

This is the complete Roberts in 6 volumes (referred to in 11
above) in 4to format, with the 250 plates reduced from
the originals by photography (therefore not original
lithographs), sepia coloured with plates in 2 tints; the 3
Egypt volumes have plates with 3 tints.

Not in Blackmer

~ 13 ~

**SCHUBERT, Gotthilf Heinrich von and
BERNATZ, Johann Martin** Stuttgart 1839

Bilder aus dem heiligen Lände

Oblong 8vo. *Illus*: Title page with lithographed vignette, 38
lithographed plates.

First edition, with text in German only. A second edition
appeared *c*. 1842 with text in both German and French.

Schubert and Bernatz travelled in the Levant, mainly in
Palestine, in 1836-37. Schubert's account of this journey
first appeared in 1838 with the title *Reise in das
Morgenland*. Bernatz was a well known landscape and
architectural painter.

Each plate, which is after Bernatz, depicts a site in
the Holy Land and is explained on the facing page.
The plates are very factual about the condition of the
Holy Land in the 1830s.

Blackmer 1510

~ 14 ~

**SCHUBERT, Gotthilf Heinrich von and
BERNATZ, Johann Martin** Stuttgart 1858

Album of the Lands of the Bible

Oblong 4to. *Illus*: 50 tinted lithographed plates after Bernatz,
folding map, wood-engraved frontispiece; original cloth,
re-backed retaining original spine.

In 1856 a new version of the above title appeared with paral-
lel English, German and French text and extra plates;
this is a later edition of this version.

Blackmer 1510

~ 15 ~

SPILSBURY, Francis B. London 1803

Picturesque Scenery In The Holy Land And Syria, Delineated During The Campaigns Of 1799 And 1800. By F. B. Spilsbury, Of His Majesty's Ship Le Tigre; Surgeon In That Expedition During Both Campaigns. London: Published By Edward Orme. Printed By W. Bulmer and Co., 1803

Folio. *Illus*: Uncoloured mezzotint portrait of Sydney Smith
 and 19 coloured aquatinted plates.

First edition. The work was published in 5 parts. A second
 edition appeared in 1819 (without the portrait) and a
 third in 1823.

Spilsbury was the surgeon on board HMS *Le Tigre*, commanded by Sydney Smith, the hero of Acre, to whom the work is dedicated. HMS *Le Tigre* took part in the English campaigns against the French in Egypt and Syria. Spilsbury's plates include views in Syria and Palestine and genre scenes, several of which depict officers of the expedition (Spilsbury's lithograph of the siege of Acre is illustrated on pp. 130-31).

Blackmer 1585

~ 16 ~

VELDE, Charles William Meredith van de Paris 1857

Le Pays D'Israel, Collection De Cent Vues Prises D'Après Nature Dans La Syrie Et La Palestine Par C. W. M. Van De Velde Ancien Officier De La Marine Royale Des Pays Bas, Chevalier De La Légion D'Honneur, Etc. Pendant Son Voyage D'Exploration Géographique En 1851 Et 1852. Dédié A Sa Majesté Guillaume III Roi Des Pays Bas. Paris V^e, Jules Renouard, Imprimeurs De L'Institut, 1857

Large folio. *Illus*: 100 lithographed plates (no. 74 forms litho-
 graphed title). Approximately half the plates are chro-
 molithographs, the remainder tinted lithographs in 1, 2,
 or 3 tints. Several of the chromolithographs were
 touched up by hand.

First edition, published in 20 parts. This is a rare proof copy
 in special large format. According to van de Velde's
 autograph letter, only 300 copies were printed, and of
 these a certain number (not specified but few) were
 proof copies published at £25 each. Then the lithograph-

er's stones were destroyed. The proof copies (according to the description taken from a copy at one time in the possession of B. Quaritch Ltd.) are much taller than the ordinary format, with the plates, measuring around 24 x 32 cm., printed on card of 44.2 x 62.2 cm. There is also a plan of Jerusalem which is not numbered and which is not included in the ordinary format.

Van de Velde's lithographs are major contributions towards recording Palestine, Lebanon and to a lesser extent Syria as they were in the mid-nineteenth century. Although they equal in quality the lithographs

— 17 —

WALTON, Elijah London 1865

The Camel: Its Anatomy, Proportions and Paces, By Elijah Walton. London: Published by Day & Son, 1865

Large folio. *Illus*: 94 lithographed plates giving the anatomy and full description of the camel. Plus a full-page lithographed drawing on the frontispiece, 'Dromedaries Near Sinai. Elijah Walton delt. and lith.' Some of the lithographs are hand coloured.

Elijah Walton trained at Birmingham Academy and the Royal Academy Schools, and later specialized in painting highly romanticized views of the Alps and Dolomites. His visits to Egypt and Sinai in 1860 and in the 1870s inspired him to produce watercolours and studies of camels. There are a few pages of Introduction and Contents.

Not in Blackmer

The Collection also has some of Walton's watercolours of Sinai and the Dead Sea (pp. 142-43, no. 57).

— 18 —

WERNER, Carl London *c*. 1875

Nile-Sketches, Painted from Nature During his Travels through Egypt. Gustav W. Seitz Watercolour Facsimiles, with Accompanied Text by Dr A. E. Brehm and Dr Johannes Dumichen. Pantographic Edition, Seitz Palent. Gushu Seitz, Publisher, Wordsbeck near Hamburg, London, Hildersheimer & Faulkner

Small folio. *Illus*: 24 plates and a map. The plates are facsimile pantographic prints from Werner watercolours; they are of superb quality, depicting the high value of Werner's watercolours. Each plate is accompanied by a written description by Brehm or Dumichen.

First and only edition, not dated but believed to be *c*. 1875.

Werner was in the region in 1863-64, following which he published *Jerusalem, Bethlehem and the Holy Places* (1865), with 32 pantographic prints of his watercolours of these places (see p. 148).

Not in Blackmer

The Collection has a few of Werner's watercolours, later lithographed (pp. 68-69 and 144-45, no. 58).

15. A street scene in Acre, from Spilsbury's *Picturesque Scenery in the Holy Land and Egypt*

of David Roberts they were not as popular, mainly because they are very rare, having been produced once only, and did not attract the attention of publishers and print reproducers. In 1854 van de Velde had published *Narrative of a Journey through Syria and Palestine* (in the Collection, p. 200, no. 97), an account of the visit during which he gathered material for this book.

(Lithographs from this work are illustrated on pp. 54, 64-65, 162-63 and 201)

Blackmer 1723

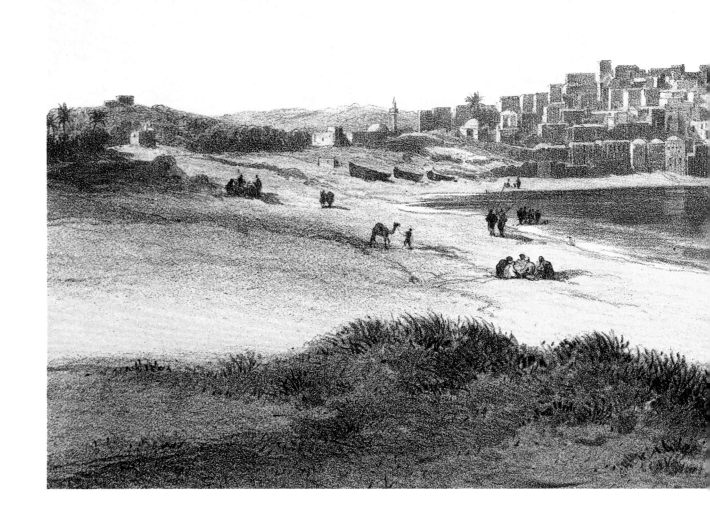

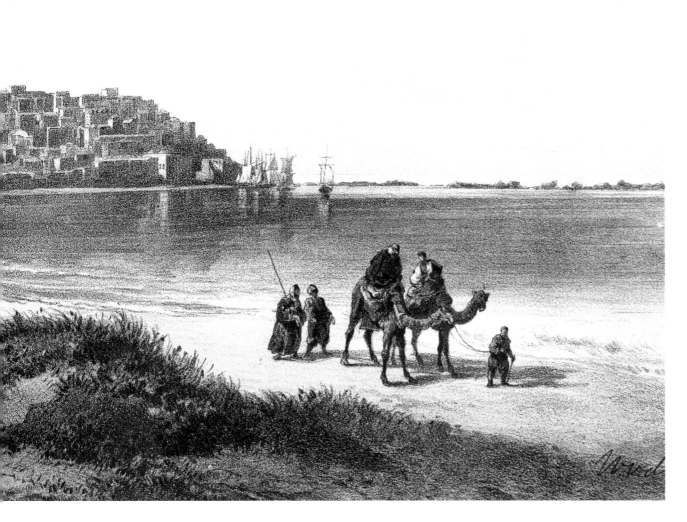

16. Jaffa, seen from the north, a lithograph from a drawing by Charles van de Velde

19. Title page from
Wharncliffe's
*Sketches in Egypt
and the Holy Land*

~ 19 ~

WHARNECLIFFE, John Stuart, Baron

London 1855

Sketches in Egypt and the Holy Land, By the Right
Honourable Lord Wharncliffe, taken during the
year 1855. Printed for private circulation by Paul &
Dominic Colnaghi Co., 1855

Large folio. *Illus*: Lithographic title with a vignette 'Entrance
to the Tomb of Ramses III (Bruce's) at Thebes'. With 18
coloured lithographs on 17 sheets.

Apparently the only edition of this rare work, which was
privately printed. It may have been produced as a mem-
orial to Lord Wharncliffe, who died in 1855. Most of
the plates illustrate sites in Egypt and only 3 of them
relate to Palestine. The plates are lithographed in 2 or 3
tints, with additional hand colouring for details.

John Stuart Wortley, the second Baron Wharncliffe,
is known to have studied drawing and was a keen
member of the Royal Geographical Society. On a visit
to the Holy Land and Egypt in 1855 he made the
drawings that form the basis of this book. He died of
consumption later the same year, on 22 October.

Blackmer 1843

~ 20 ~

WILKIE, David, RA London 1843

Sir David Wilkie's Sketches In Turkey, Syria &
Egypt, 1840 & 1841. Drawn on Stone by Joseph
Nash. Published by Messrs. Graves And Warmsley,
Feb 1st 1843. Printed By C. Hullmandel

Large folio. *Illus*: Lithographed title, engraved dedication leaf
and 25 tinted lithographed plates. All plates were recent-
ly mounted on cards, finely hand-coloured and rebound.

First edition. This work was published in two formats: the
ordinary, as ours, and a special version in which the
plates were coloured and mounted, in a portfolio.

Wilkie set out in 1840 to gather material for a series
of biblical pictures, visiting Constantinople, Beirut,
Jerusalem, Cairo and Alexandria (where he painted a
portrait of Muhammad Ali, now in the Tate Gallery
in London). He died on the return journey in June
1841. In 1846 a companion volume was published,
Sketches Spanish and Oriental, Wilkie's account of
his travels in Spain and the Levant. A few of these
plates are in the Collection, including two from the
Levant (one is on p. 11).

Blackmer 1796; Hilmy II, 329

SIR
DAVID WILKIE'S
SKETCHES
IN
TURKEY, SYRIA & EGYPT.
1840 & 1841.
Drawn on Stone by
JOSEPH NASH.

20. Title page from *Sir David Wilkie's Sketches in Turkey, Syria and Egypt*, with a portrait of Mohammad Ali

CHAPTER SEVEN

≈ Travel Books ≈

The Holy Land and Egypt were among the most frequently recorded areas in the world in the nineteenth century. Rohricht's bibliography of travellers to Palestine up to 1878 recorded 3,500 who wrote about their travels (most of them after 1800) and who produced a literature of about 5,000 volumes. Hilmy's bibliography of 1886, listing the works of travellers to Egypt, is even more extensive. The existence of such bibliographies, unusual for other parts of the world, indicates the significance of travel to Palestine and Egypt in this period and the importance of these travel books.

As most books, particularly those before the mid-1880s, were influenced by the author's misconceptions and religious convictions, they need to be read with great caution. However the value and richness of many of them lie in the maps, woodcuts and steel-plate engravings that they contain, which are of greater value and more accurate than the written descriptions.

There are around 300 travel books in this Collection, most from the nineteenth century but with a few from the fifteenth to eighteenth centuries. From these I have chosen 106 which I thought of particular importance and relevance mainly because of their illustrations and maps. A considerable number of these describe travels to both Palestine and Egypt as many travellers chose to visit both places in the same trip.

Each book is described with its contents, maps and illustrations, with the edition number and date, and the relationship of the author with the region, where known. The overall dimensions represented are as follows (width x height):

12mo (duodecimo): under 15 cm.

8vo (octavo): around 15 x 25 cm.

4to (quarto): around 25 x 35 cm.

Folio: 35 x 45 cm. and over

Opposite:
Frontispiece from Madden's *Travels in Turkey, Egypt, Nubia and Palestine*; this drawing by Henry Salt shows the author (a medical doctor) in local dress, taking a lady's pulse through a gap in the doorway (see p. 185, no. 57)

LADY OF DAMASCUS.

2. A Damascene lady, from Addison's *Damascus and Palmyra*

~ 1 ~

ADAM SMITH, George London 1907

Jerusalem, The Topography, Economics and History from the Earliest Times to A.D.70 by George Adam Smith. In two volumes, Hodder and Stoughton, London, 1907

4to. 2 vols. *Illus*: 13 maps and 15 plates.

First edition.

George Adam Smith is the author of the very popular book, *Historical Geography of the Holy Land*, first published in 1896 and reprinted many times later (the Collection contains a number of different editions of this book).

Not in Blackmer

~ 2 ~

ADDISON, Charles Greenstreet London 1838

Damascus And Palmyra: A Journey To The East. With A Sketch Of The State And Prospects Of Syria, Under Ibrahim Pasha. In two volumes. London: Richard Bentley, 1838

8vo. 2 vols. *Illus*: 10 coloured lithographed plates.

First edition.

Addison travelled in the Levant from April to October 1835, visiting Greece and Turkey as well as the Holy Land. According to the British Library catalogue, the illustrations are after drawings by William Thackeray; they were lithographed by G. E. Madeley and illustrate local costume.

Blackmer 5

~ 3 ~

AMICO, Bernardino Florence 1620

Trattato delle Piante & Immagini de Sacri Edefizi di Terra Santa

Small folio. *Illus*: 46 etched and engraved plans, elevations and views on 34 double-page plates by Jacques Callot after Amico, woodcut decorations, woodcut printer's device on colophon. Florence, (Pietro Cecconcelli), 1620 [colophon dated 1619]

Second edition. This edition of this valuable and scarce work was commissioned by Cosimo II de' Medici, and is the first edition with Callot's engravings.

Amico was the prior of the Franciscan order at Jerusalem in 1596, where he spent five years.

Blackmer 31

~ 4 ~

ARUNDALE, Francis London 1837

Illustrations Of Jerusalem And Mount Sinai; Including The Most Interesting Sites Between Grand Cairo And Beirout. From Drawings by F. Arundale, Architect. With a Descriptive Account of His Tour And Residence In Those Remarkable Countries. London: Henry Colburn, 1837

4to. *Illus*: Lithographed frontispiece on india paper, mounted, and 19 tinted lithographed plates (4 are missing), 1 map and 1 plan of Jerusalem.

First and apparently only edition.

Text inside the panorama engraving:

CITA DI OIE · LA VERA E REALE · RVSALEM COME SI TROVA OG

1. Arco di Pilato. 2. Betlem. ... 3. Butticella. 4. doue su angariato il Cirineo. 5. Casa del ricco Epulone. 6. Casa con sua Madre, 13. doue su carcerato S.Pietro.14. doue su decolato S.Giacomo minore.15 doue mori M. V.16. doue l'Ebrei ... si nasceuero li Apostoli 21 villa del mal consiglio.22. doue aparse la Stella a Magi 23 doue nacque Elia profeta 24. doue xpo.disse alle done mlteflere sugine.31. doue si uedene glii Compani sens Marche.92. doue abitaua S. Simona profeta.31 ... Mori 41 Notaterie Sile 42. Porta Area 43 Portadi S. Stefano 44. Piaza grande del Tempio 43 Palaza Bonicuale 46 Porta spetio si 47 Palaza ... 47 Spelunche Rege 50. Tempio dele Malonas5 torre Antonia 60 bazara di Carcere di Turchi 60. Emaus 63 Ceremonii64 Sepelchre li Abial

Veronica 7. Casa di Marco. 8.Casa de lettre M⁵ 9. couenti de frati Greci. 10 campo S⁺⁰ 11 doue su cocena M.V. 12 doue si centro xpo arrobare il corpo di M.V. 17 doue piense S. Pietro. 18. doue Salom⁴ teneua le done 19. doue l'Ebrei nascosero il fuoco S. 20 doue ue Abacue profeta. 25 doue nacque il figlio di Dio 26. monte Sion. 27 il S. Sepelchro 28. motana Giudea. 29. doue abitauoli E brei. 30. doue ... sepolcicono h Christians 34. doue nacque S. Tomaso 35 fonte de la Madona 36. Spicle 37. Tempio moderno 42 luego di S. frai N⁰ 33 citolo di Picomi. 42 Moiche ... sepelchre de la Madona doue si nascere S. Jacome.

Arundale studied architecture with A. C. Pugin, and some time after his studies were completed he went to the Levant and spent nine years there. He travelled in Sinai and Palestine with the artists Frederick Catherwood and Joseph Bonomi (for original drawings by Bonomi see pp. 83-84, no. 2) and it is this journey which is described here. The plates illustrate views of Sinai and Palestine and also of Beirut, Sidon and Suez.

Blackmer 47; Hilmy I, 43

~ 5 ~

BALLANTINE, James Edinburgh 1866
The Life of David Roberts, Compiled from His Journals and other Sources. By James Ballantine, with Etchings and Facsimiles of Pen and Ink Sketches by the Artist. Printed by Adam and Charles Black, Edinburgh, 1866

4to. *Illus*: Several Roberts' drawings and etchings.

First and only edition.

The first biography of David Roberts. This copy is decorated in the margins and on empty pages with over 100 fine original pencil sketches by the artist Alfred-Charles Conrade (1863-1955), making it a unique copy of this valuable book.

Not in Blackmer

~ 6 ~

BANNISTER, J. T. Bath n.d.
A Survey of the Holy Land: Its Geography, History and Destiny, Designed to Elucidate the Imagery of Scriptures and Demonstrate the Fulfilment of Prophecy. By J. T. Bannister, with an Introduction By the Rev. W. March. Embellished with Maps and Engravings. Bath (Binns and Goodwin)

8vo. *Illus*: 2 maps, one plan of Jerusalem and 18 plates.

First edition, no date.

Not in Blackmer

3. A panoramic view of Jerusalem, from Amico's *Trattato delle Piante…*

7. The cover of Bartlett's *Walks about Jerusalem*

Minor (1837). In all, Bartlett made five journeys to the Levant, in addition to his travels in Europe and North America. On his last journey, 1853-54, he died on the return voyage and was buried at sea. Upwards of 1,000 drawings were prepared during these travels. The Collection contains a few of these (see p. 45 and 82-83, no.1).

Blackmer 88

— 8 —

BARTLETT, William Henry London 1855

Jerusalem Revisited. By W. H. Bartlett, Author of Walks About Jerusalem, with illustrations. A. Hall, Virtue & Co., London, 1855

Large 8vo. *Illus:* Plates and a folding panorama of Jerusalem.

First edition.

This book was written during Bartlett's second visit to Jerusalem in 1853. It contains 22 original illustrations on steel and several woodcuts in the text from drawings by Bartlett.

Not in Blackmer

— 9 —

BARTLETT, William Henry London 1848

Forty Days In The Desert, On the Track Of the Israelites; or, A Journey From Cairo, by Wady Feiran, to Mount Sinai and Petra. By W.H Bartlett. London, Arthur Hall, Virtue & Co., 1848

4to. Illus: Engraved title and 27 engraved plates (mostly from Petra) including map and frontispiece.

Probably first edition; three editions had appeared by 1849.

This is an account of Bartlett's fourth journey to the Levant when he visited Egypt, Mount Sinai and Syria from August to October 1845.

Blackmer 92

— 10 —

BARTLETT, William Henry London 1872

Footsteps Of Our Lord and His Apostles In Syria Greece, and Italy: A Succession of Visits To The Scenes Of New Testament Narrative. By W. H. Bartlett, Author Of Walks About Jerusalem, The Nile Boat, Etc. With Numerous Illustrations. London: Arthur Hall, Virtue & Co., 1872

— 7 —

BARTLETT, William Henry London *c.* 1845

Walks About The City And Environs Of Jerusalem. By W. H. Bartlett, London, Arthur Hall, Virtue & Co., 1844

Large 8vo. *Illus:* Engraved title page, frontispiece and 24 plates (2 folding) of steel-engravings. Original, elaborately decorative cloth gilt, gilt edges.

Second edition. The first edition appeared in 1844.

Bartlett visited Jerusalem in the summer of 1842 on his third trip to the Levant. This is the first account of his travels written and illustrated by himself. Previously he had illustrated works written by others. His first journey to the Levant, from January 1834 to January 1835, provided the illustrative material for John Carne's *Syria, the Holy Land and Asia*

Large 8vo. *Illus*: Engraved title, map, and 22 plates of steel engravings.

Seventh edition. First published in 1851.

Some of the material used to illustrate this work was collected as early as 1834-35, during Bartlett's first journey to the Levant. His visit to Jerusalem took place in 1842. One of Bartlett's most successful works; a fifth edition appeared in 1862.

Blackmer 91

— 11 —

BEAUFORT, Emily Anne London 1861

Egyptian Sepulchres And Syrian Shrines Including Some Stay In The Lebanon, At Palmyra, And In Western Turkey. By Emily A. Beaufort... In Two Volumes. Longman and Roberts, 1861

8vo. 2 vols. *Illus*: 6 chromolithographed plates (1 a folding panorama of Tadmor/Palmyra) and a folding map, coloured in outline, in which there is a detailed inset plan of Jerusalem, depicting the development of the city.

First edition. A second edition appeared in 1874.

This describes travels in the Levant in 1858 and 1859. (For the Palmyra panorama see pp. 172-73)

Blackmer 101; Hilmy I, 57

— 12 —

THE HOLY BIBLE London 1858

Containing the Old and New Testaments with the Marginal Readings and Original & Selected Parallel References and the Commentaries of Henry and Scott Condensed by the Rev. John McFarlane. With a Series of Maps and Tinted Landscapes Illustrative of the Lands of the Bible, from original sketches by David Roberts. London, James Sangster & Co. 1858

Large 4to. *Illus*: 32 lithographs, 7 maps.

This is included as an example of the frequent use of Roberts's lithography to illustrate Bibles as well as travel books.

— 13 —

BUCKINGHAM, James Silk London 1822

Travels in Palestine, Through the Countries of Bashan and Gilead, East of the River Jordan, Including a visit to the Cities of Geraza and Gamala, etc. in the

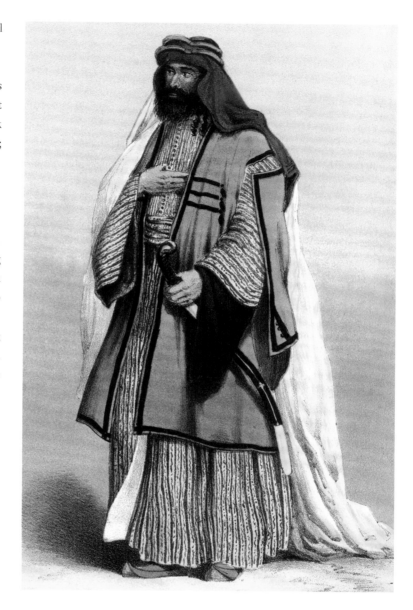

Decapolis. Printed for Longman, Hurst, 1822

Large 8vo. 2 vols. (only vol. 2 available in the Collection).
 Illus: Large engraved folding maps, including a 'Plan of the Modern Jerusalem'; wood engravings in the text including another plan of old Jerusalem.

Second edition.

In 1821 Buckingham published *Travels in Palestine* which described the first part of his voyage overland from Egypt to India in 1816-17 via Palestine, Syria and Mesopotamia. Buckingham again travelled extensively in the Middle East after his departure from India in 1822 and wrote several further accounts of his travels.

Not in Blackmer

11. A bedouin sheikh, from Emily Beaufort's *Egyptian Sepulchres and Syrian Shrines*

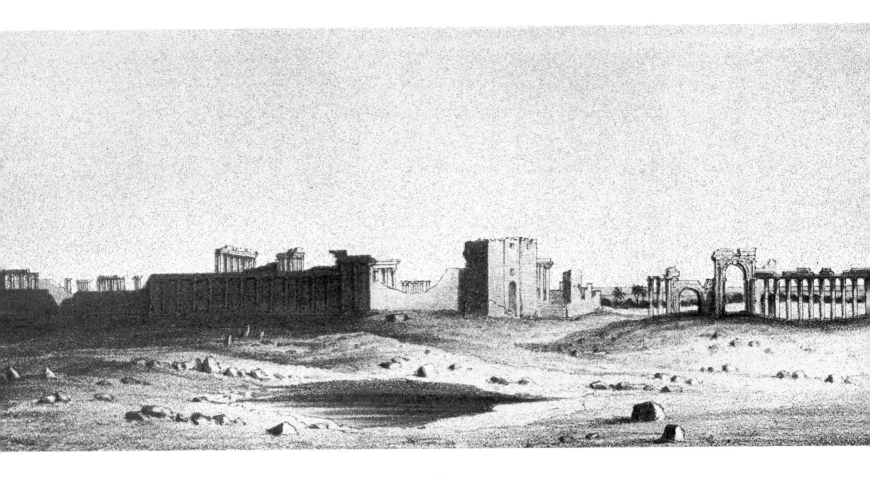

BURCKHARDT, John Lewis London 1819

Travels In Nubia. By the Late John Lewis Burckhardt. Published by The Association For Promoting The Discovery Of The Interior Parts Of Africa. First Edition. London: John Murray, 1819

4to. *Illus*: Etched portrait frontispiece of Burckhardt and 3 maps (2 folding).

First edition.

The travels described here took place in 1813 and 1814. Burckhardt left Aleppo in 1812 and made his way to Cairo; he then carried out two journeys, one along the upper Nile and the other through the Nubian desert. These travels were edited from Burckhardt's journals by William Leake, who was at that time secretary of the African Association; he also wrote the biographical memoir which is prefaced to the travels. This was the first of Burckhardt's works to be published and was followed by *Travels in Syria...* (1822). All these journeys were made on behalf of the African Association whose president, Sir Joseph Banks, had recruited Burckhardt for the long and difficult project of exploring Africa. The journeys described in these works were preparatory to the major effort of exploring the interior of Africa. In 1817 Burckhardt began planning the exploration of the Niger, but he was attacked by dysentery in Cairo, died in October of that year and was buried there. His tomb was discovered recently.

Blackmer 238; Hilmy I, 105

BURCKHARDT, John Lewis London 1822

Travels In Syria And The Holy Land. By the Late John Lewis Burckhardt. Published By The Association For Promoting The Discovery Of The

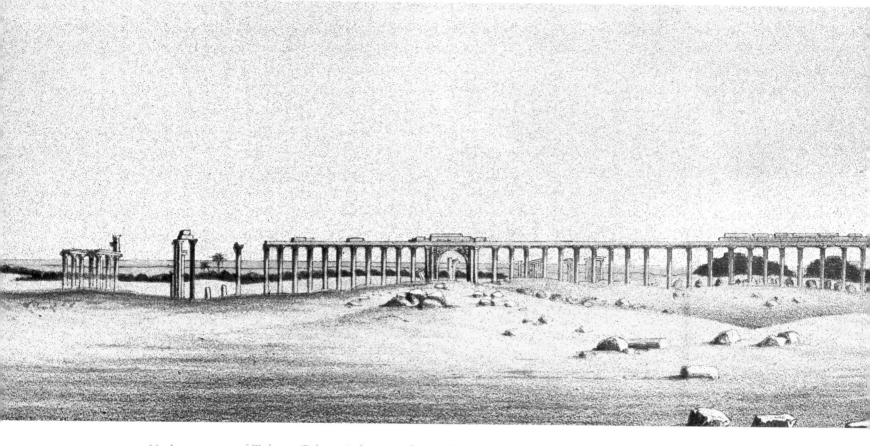

11. A panorama of Tadmor (Palmyra), from Emily Beaufort's *Egyptian Sepulchres and Syrian Shrines*

Interior Parts Of Africa. London: John Murray, 1822

4to. *Illus*: Lithographed portrait frontispiece of Burckhardt and 6 maps/plans.

First edition. German editions appeared in 1822 at Jena and 1823 at Weimar.

This work was edited from Burckhardt's journals after his death by William Leake, secretary of the African Association. The text consists of six sections describing journeys made in 1810-12 and in 1816, and presented in the journal form in which Burckhardt had written up his notes.

Syria was Burckhardt's first stopping-place in the Levant. He spent three years in Aleppo studying Arabic in preparation for his African travels, and while resident there he travelled through Syria and the Holy Land. In 1812 Burckhardt was the first European in modern times to visit Petra (as well as Abu Simbel in Egypt later); he gives a description of it here, but was unable to make sketches. Four of the maps are after drawings by Burckhardt. The portrait (p. 174) is after a sketch by Henry Salt (see also p. 260, no. 7; and for a portrait of Salt by Joseph Bonomi, p. 83, no. 2b).

Blackmer 237

~ 16 ~

BURCKHARDT, John Lewis　　　London 1829

Travels In Arabia, Comprehending An Account Of Those Territories In Hedjaz Which The Mohammedans Regard As Sacred. By the Late John Lewis Burckhardt. Published By Authority Of The Association For Promoting The Discovery Of The Interior Parts Of Africa. In Two Volumes. London: Henry Colburn, 1829

8vo. 2 vols. *Illus*: A folding map and 4 folding plans (of Mecca, Medina, Wadi Muna, and the Plain of Arafat).

Second edition. The first edition appeared in 4to the same year.

15. Portrait of Burckhardt by Henry Salt

Burckhardt undertook the journey to Mecca in 1814, disguised as an Arab. He had long since used the name Sheikh Ibrahim in his travels, which he began in 1809 under the sponsorship of Sir Joseph Banks and the African Association. According to Leake in his Preface, 'Burckhardt transmitted to the Association the most accurate and complete account of the Hedjaz, including the cities of Mekka and Medina, which has ever been received in Europe'.
Blackmer 239

⌒ 17 ⌒

BURCKHARDT, John Lewis London 1830
Arabic Proverbs, Or The Manners And Customs Of The Modern Egyptians, Illustrated From Their Proverbial Sayings Current At Cairo, Translated And Explained. By The Late John Lewis Burckhardt. Published By Authority Of The Association For Promoting The Discovery Of The

Interior Parts Of Africa. London: John Murray, 1830
4to. First edition
This very interesting and amusing view of Egyptian life was published posthumously, as were all Burckhardt's works. It was edited by the orientalist Sir William Ouseley, who also edited Burckhardt's *Travels in Arabia.*
Blackmer 240; Hilmy I, 106

⌒ 18 ⌒

BURCKHARDT, John Lewis London 1831
Notes On The Bedouins And Wahabys, Collected During His Travels In The East. By The Late John Lewis Burckhardt. Published By Authority Of The Association For Promoting The Discovery Of The Interior Parts Of Africa. Two Volumes In One Book. Published By Henry Colburn, London, 1831
8vo. 2 vols. *Illus*: One extended map of Arabia.
First Edition.
Vol. 1: Account of the Bedouin Tribes. Vol. 2: Material for a History of the Wahabys.
Not in Blackmer

It should be noted that Burckhardt wrote five books, all of which are in the Collection.

The Collection also includes Katharine Sims' *Desert Traveller, The Life of Louis Burckhardt* (London 1969), a large 8vo book with dust jacket, the only biography of Burckhardt. Katharine Sims also wrote a biography of David Roberts.

⌒ 19 ⌒

CAIGNART DE SAULCY, Louis Felicien Joseph
London 1854
Narrative Of A Journey Round The Dead Sea And In The Bible Lands In 1850 And 1851. By F. De Saulcy, Member of the French Institute. Edited, with Notes, by Count Edward De Warren. In Two Volumes. London: Richard Bentley, New Edition, 1854
Large 8vo. 2 vols. *Illus*: Engraved folding frontispiece and a folding map.
First English edition of the *Voyage Autour de la Mer Morte* (1853).

De Saulcy, a numismatist and archaeologist, was especially interested in oriental epigraphy. In the winter of 1850-51 he travelled to Palestine with the artist Léon Belly, his main object to explore the shores of the Dead Sea. He was one of the first to study methodically the historical geography of this area. De Saulcy's very important collection of coins and medals is now in the Bibliothèque Nationale in Paris.

Blackmer 266

~ 20 ~

CARNE, John London 1837

Syria, The Holy Land, Asia Minor, &c. Illustrated In A Series Of Views Drawn From Nature. By W. H. Bartlett, William Purser, […Thomas Allom] &c. With Descriptions Of The Plates By John Carne. Fisher, Son, & Co.

4to. 3 vols. *Illus*: 3 engraved title-pages, 117 engraved plates and 1 map.

First edition.

This work formed the first part of Fisher's projected series *The Turkish Empire Illustrated*, and it appeared in 30 parts of 4 plates each. The great majority of the views are by W. H. Bartlett, who travelled extensively in the Levant, and these must have been made on his first journey in 1834-35. This seems to be the first book in which any of Bartlett's eastern drawings appear. The third volume includes plates after drawings by Thomas Allom, who must have travelled in the Levant *c.* 1836-37. Although William Purser's name appears on the title page, he did not contribute to the book. The text is by John Carne, well known as the author of *Letters from the East*.

Blackmer 291

~ 21 ~

CHATEAUBRIAND, F. A. de Philadelphia 1816

Travels In Greece, Palestine, Egypt And Barbary, During The Years 1806 And 1807. By F. A. De Chateaubriand. Translated From The French By Frederic Shoberl, Philadelphia 1816

8vo. An American edition of this valuable work, first translated into English in 1811.

Several factors contributed to Chateaubriand's decision to travel in the Levant in 1806. One of these was the death of his favourite sister Lucile in July of that year; another was the desire to gather accurate data and local colour for his drama *Les Martyrs*. He journeyed to the East as a pilgrim, in a fanciful and extravagant manner. There are numerous editions of this work.

Blackmer 328 (3rd French edition)

~ 22 ~

CHATEAUBRIAND, F. A. de Paris 1827

Itinéraire de Paris à Jérusalem. Par Chateaubriand, Nouvelle Édition, Revue Avec Soin Sur Les Éditions Originales. Paris, 1827

Small 8vo. Another new edition in French of the above work.

Contains no map or plan.

Not in Blackmer

~ 23 ~

CLARKE, Edward Daniel London 1816-24

Travels In Various Countries Of Europe Asia And Africa. By E. D. Clarke. In three parts. Part The First Russia, Tahtary And Turkey. Part The Second Greece Egypt And The Holy Land. Part The Third Scandinavia. Fourth Edition. London Printed for T. Cadell and W. Davies, 1816-1824

Large 8vo. 3 parts, of which only Part the Second is in the Collection. *Illus*: Many engraved plates and folding maps/plans including one of Jerusalem; numerous wood-engraved vignettes in the letterpress. Many of the plates are based on drawings which Clarke bought from the French artist Michel-François Préaux whom he met in Turkey.

Fourth edition; the original edition appeared in 6 vols., in 4to, between 1810 and 1823, the last vol. being published posthumously.

Clarke, Professor of Mineralogy at the University of Cambridge, set off for Scandinavia with his student John Marten Cripps in May 1799. In 1800 they travelled overland, via Moscow, to Constantinople and continued to Syria and Palestine. Clarke continued to Egypt with Abercromby's forces and there, in 1801, he joined W. R. Hamilton, Lord Elgin's secretary, in a self-constituted deputation to prevent Egyptian

antiquities from being carried off by the French. In the course of this he succeeded in removing the Rosetta Stone from French hands. He then continued to Greece, where he managed to secure a colossal statue – the so-called Ceres – from Eleusis, and a number of other antiquities. Clarke died in 1822.

Blackmer 365

— 24 —

CONDER, Claude Reignier London 1878

Tent Work In Palestine. A Record of Discovery and Adventure. By Claude Reignier Conder, R.E., Officer In Command Of The Survey Expedition. Published for the Committee of the Palestine Exploration Fund. In Two Volumes. With illustrations By J. W. Whymper. London: Richard Bentley & Son, 1878

8vo. 2 vols. *Illus*: 10 engraved plates.

First edition.

The Palestine Exploration Fund placed Conder in charge of the Survey of Western Palestine in 1872, an extension of that of Jerusalem undertaken by Charles Warren. Conder remained in Palestine until 1875, when he and his party were attacked by a group of locals; he was invalided back to England in October of that year, having carried out a survey of 4,700 square miles. *Tent Work* is not the official report of the survey, but rather Conder's personal memoirs of his experiences in Palestine and accounts of the customs of the local inhabitants. In 1877 H. H. Kitchener, who had joined Conder in 1874, returned to Palestine to finish the survey and covered another 1,300 square miles.

Blackmer 389

— 25 —

CONDER, Claude Reignier London 1889

The Survey of Eastern Palestine. Memoirs of the Topography, Orography, Hydrography, Archaeology, etc. Volume I: The Adwan Country, By Major C. R. Conder. For The Committee of the Palestine Exploration Fund, London, 1889

Folio. *Illus*: Many photographs, drawings and sketches made on the spot.

First and only edition; this copy from the 'Special Edition – No. 235'. One volume only was published.

Although surveys east of the Jordan were outside the main activities of the PEF, Conder undertook this extensive work in the three summer months of 1881 and, with the help of a small team, covered about 510 square km. At this point, because of strained relations between Britain and the Ottoman Empire, permission to continue the work was refused. The volume is named after the Adwan tribe which controlled a large area south-east of the Jordan.

Not in Blackmer

— 26 —

DIXON, William Hepworth London 1869

The Holy Land. By William Hepworth Dixon. With Illustrations from Original Drawings and Photographs. Fourth Edition. London: Chapman and Hall, 193 Piccadilly. 1869

8vo. *Illus*: 4 engravings by Saddler after photographs by James Graham; 1 after Frederick Goodall RA; several woodcuts in the text and 4 maps.

Fourth edition of this detailed description of Palestine. In 1885 a new version was published with the same title, marked 'First Edition', and with 12 illustrations by David Roberts RA instead of the plates after Graham and Goodall. It is also in the Collection.

Not in Blackmer

— 27 —

EBERS, Georg & GUTHE, Hermann Stuttgart 1884

Palästina in Bild Und Wort. Nebst Der Sinaihalbinsel und Dem Lande Gosen, Nach Dem Englischen Herausgegeben, Von Georg Ebers und Hermann Guthe. Deutsche Verlags-Anstalt, Stuttgart und Leipzig, 1884

Small folio. 2 vols. *Illus:* Woodward and Fenn engravings from Wilson's book *Picturesque Palestine*.

First and only edition in German.

This book is a translation of Wilson's book, with an added commentary by Ebers and Guthe. Ebers was a prolific novelist but he also wrote books on Palestinian and Egyptian subjects. His *Ägypten in Bild und Wort Dargestellt*, first published in 1870, was translated into English in 1880-83.

Not in Blackmer

PALÄSTINA

IN

BILD UND WORT.

NEBST DER

SINAIHALBINSEL UND DEM LANDE GOSEN.

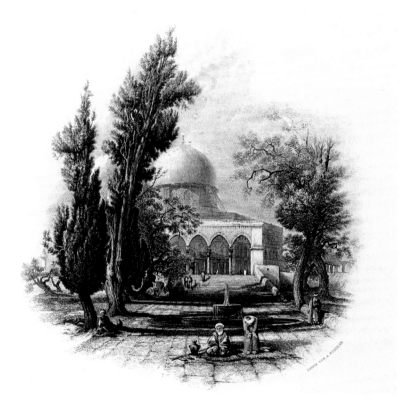

27. Title page of Ebers ans Guthe's Palästina in Bild und Wort

~ 28 ~

EGERTON, Harriet Catherine (later Countess of Ellesmere) London 1841

Journal Of A Tour In The Holy Land, In May And June, 1840. By Lady Francis Egerton. With Lithographic Views, From Original Drawings By Lord Francis Egerton. For Private Circulation Only; For The Benefit Of The Ladies' Hibernian Female School Society. London: Printed By Harrison And Co., 1841

8vo. *Illus*: 4 tinted lithographed plates.

First and only edition, privately published.

These extracts from Lady Francis Egerton's diary, originally intended only for friends, were published to benefit the society mentioned in the title. Harriet Egerton and her husband, Lord Francis Egerton, travelled extensively around the Mediterranean in the winter and spring of 1839-40 arriving in the Holy Land in May 1840. The four plates in this work were lithographed by Thomas Allom after drawings by Lord Francis, who later produced *Mediterranean Sketches* (1843) and an album of lithographed views of Syria and Palestine.

Blackmer 536

ELLIS, Tristram James London 1881

On A Raft, And Through The Desert: By Tristam J. Ellis The Narrative Of An Artist's Journey Through Northern Syria And Kurdistan, By The Tigris To Mosul And Baghdad, And of a Return Journey Across The Desert By The Euphrates And Palmyra To Damascus. Over The Anti-Lebanon To Baalbek And To Beyrout. In Two Volumes. Illustrated by Thirty-Eight Etchings on Copper by the Author. With A Map. Vol. I: On A Raft. Vol. II: Through The Desert. London, 1881

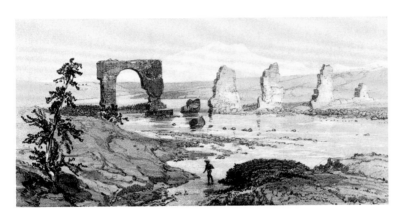

4to. 2 vols. *Illus*: A double-page map, 38 plates of etchings (the work of Ellis himself) and 8 illustrations in the letterpress.
First and only edition.

Ellis had previously produced the very rare *Twelve Etchings of the Principal Views... in Cyprus*, 1879.
Blackmer 545

There are many of Tristram Ellis's watercolours in the Collection (see p. 14; also pp. 92-95, no. 10).

~ 30 ~

ESTOURMEL, Joseph, Comte d' Paris 1844

Journal D'Un Voyage En Orient Par Le Comte Joseph d'Estourmel, A Paris De L'Imprimerie De Crapelet, 9 Rue De Vaugiraud, 1844

Large 8vo. 2 vols. *Illus*: 160 tinted lithographed plates (of which 2 are folding plans).
First edition; a second edition appeared in 1848 without plates.

D'Estourmel travelled in the Levant from June 1832 until September 1833, through Greece, Asia Minor, Syria and Egypt. The lithographs are after drawings by the author. This is a most interesting work, not

30. Watercolour of the River Jordan as it runs out of the Sea of Galilee by Joseph d'Estourmel, used as the basis for this lithograph (Plate 69) in his *Journal d'un Voyage en Orient*

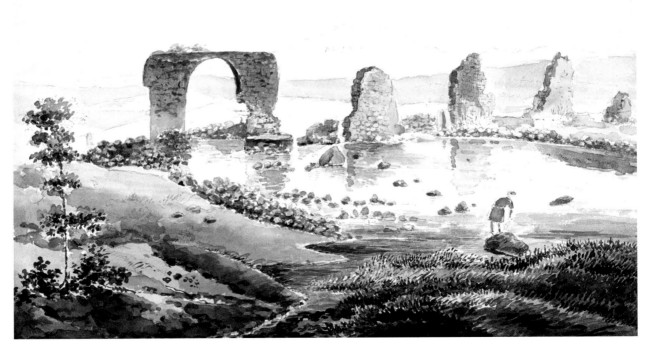

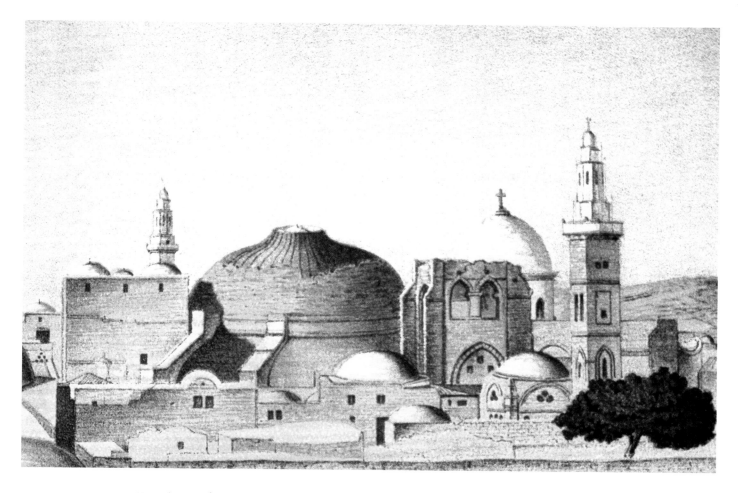

33. Frontispiece from James Finn's *Stirring Times*, depicting the Holy Sepulchre in Jerusalem (before the dome was repaired in 1868) and the Mosque of Omar

only because of the many plates which illustrate sites in Greece, Smyrna, the Holy Land and Egypt, and the detailed account d'Estourmel gives of his travels, but also because of the many contacts he had with travellers on the way.

Blackmer 557; Hilmy I, 183

The Collection includes an album of d'Estourmel's original watercolours, many of which appear as lithographs in this book (p. 96, no. 12).

~ 31 ~

FARRAR, F. W. London 1874
The Life of Christ. By the Rev. F. W. Farrar, Canon of Westminster. Published by Cassell, Peter and Galpin & Co., London

4to. *Illus*: 30 plates of David Roberts's lithographs and more than 300 woodcut illustrations in the text, including maps.

First and only edition.

The book deals mainly with the life of Christ and documents scenes of the Holy Land.

Not in Blackmer

~ 32 ~

FINN, Elizabeth Mrs. London n.d.
Sunrise Over Jerusalem, With Other Pen and Pencil Sketches. By Mrs. Finn, Author of "Home in the Holy Land" and "A Third Year in Jerusalem", Etc. John B. Day, London

4to. *Illus*: 15 lithographs with a lithographed cover.

First and only edition, no date.

The book contains no text but only the lithographs. These cover many sites and cities of Palestine and are after drawings by Mrs. Elizabeth Finn, wife of James Finn, British consul for Jerusalem and Palestine 1845-63.

(Illustration p. 33).

Not in Blackmer

⌐ 33 ⌐

FINN, James London 1878

Stirring Times, or Records From Jerusalem Consular Chronicles of 1853 to 1856. By the Late James Finn, Her Majesty's Consul for Jerusalem and Palestine from 1845 to 1863, Author of "Byeways in Palestine" and other books. Edited and compiled by his widow Elizabeth Finn. Published C. Kegan Paul & Co., 1878

8vo. 2 vols. (Vol. I only is in the Collection). *Illus*: A beautiful frontispiece lithograph after a painting of the Church of the Holy Sepulchre by J. Finn.

First and only edition.

This covers the history of the Eastern Question, the cause of the Crimean War (1853-56), from the Jerusalem standpoint. Finn was one of Jerusalem's most influential figures in the mid-nineteenth century.

(Illustration p. 179)

Not in Blackmer

⌐ 34 ⌐

FULLER, Thomas London 1662

A Pisgah-Sight of Palestine and the Confines Thereof; with the History of the Old and New Testament Acted Thereon. By Thomas Fuller, B.D. Printed by R. Davenport for John Williams at the Sign of the Crown in Saint Paul's Churchyard

4to. *Illus*: Engraved armorial plate, engraved allegorical additional title, 20 double-page engraved plates, full set of maps, including a plan of Jerusalem.

First and only edition.

One of the oldest and best known books on the Holy Land. Pisgah is now Mount Nebo in Jordan (*Siyagha* in Arabic), where Moses is said to have died.

Not in Blackmer

⌐ 35 ⌐

GAGE, Rev. William L. London n.d.

Palestine, Historical and Descriptive, or The Home of God's People. By the Rev. William Gage. Fully Illustrated with Nearly One Hundred and Fifty Engravings and Maps, London

8vo. *Illus*: Many engravings and maps.

First edition, no date.

Not in Blackmer

⌐ 36 ⌐

GEBHARDT, Victor Barcelona 1886

La Tierra Sancta, Su Historia, Sus Monumentos, sus Tradiciones, Sus Recuerdos, Su Estada Actuel, Barcelona 1886

Folio. 2 vols. *Illus*: A chromolithographed frontispiece, 44 full-page engraved plates and numerous illustrations in the text.

Spanish edition based on Wilson's *Picturesque Palestine*.

The illustrations are the same as those of Woodward and Fenn in Wilson's book.

Not in Blackmer

⌐ 37 ⌐

GEIKIE, Cunningham London 1891

The Holy Land and the Bible. A Book of Scripture Illustrations Gathered in Palestine. By Cunningham Geikie, D.D. With a Map of Palestine and Original Illustrations by H. A. Harper. Published by Cassell & Co., 1891

8vo. 1 vol. bound in 2. *Illus*: Over 450 plates from Harper's original illustrations; 1 map of Palestine.

First edition.

Contains detailed description and views of Palestine, including the countryside and the Lebanese coast.

Not in Blackmer

⌐ 38 ⌐

GUÉRIN, Victor Paris 1882

La Terre Sainte, Son Histoire, Ses Souvenirs, Ses Sites, Ses Monuments. Par Victor Guérin, Agrégé et Docteur des Lettres, Chargé de Missions en Orient. E. Plan et Cie., Paris, 1882

Small folio. *Illus:* Many steel-plate prints on separate sheets as well as many prints in the text.

French edition. Vol. 1 only (a second volume was printed later).

Both the text and plates (using the same illustrations as those by Woodward and Fenn in Wilson's *Picturesque Palestine*) cover Jerusalem, Palestine and Syria.

Not in Blackmer

The four books of Gebhardt (Spanish), Guérin (French), Ebers and Guthe (German) and Wilson (English) have similar plates. All are in the Collection.

～ 39 ～

HOLLAND, F. W. London *c.* 1870

Sinai and Jerusalem, or Scenes from Bible Lands. Illustrated by Twelve Coloured Photographic Views, Including a Panorama of Jerusalem with Descriptive Letterpress. By the Rev. F. W. Holland, Hon. Secretary to the Palestine Exploration Fund. Published by the Society for Promoting Christian Knowledge, London. Printed by Jas. Truscott and Son

4to. *Illus:* 12 plates based on photographs, 5 covering Egypt and Sinai, the rest Palestine.

First and only edition; no date, but *c.* 1870.

Not in Blackmer

～ 40 ～

HORNBY, Emily London *c.* 1901

Sinai and Petra, The Journals of Emily Hornby in 1899 and 1901, With Coloured Plates from the Original Watercolour Sketches by F. M. Hornby

8vo. *Illus:* 11 coloured plates after watercolour sketches by Sir F. Hornby.

First edition.

Emily Hornby visited Palestine and Jerusalem as well as other small towns of south Jordan (Kerak, Shobak, etc.). Her journal was printed privately earlier. This is part of the journal printed by her sister M.L.H.

Not in Blackmer

～ 41 ～

HUNT, William Holman London 1913

Pre-Raphaelitism and Pre-Raphaelite Brotherhood. By W. Holman Hunt, Chapman and Hall, 1913

8vo. 2 vols. *Illus:* Vol. 1: 155 plates; Vol. 2: 208 plates – all after Holman Hunt paintings.

Second edition, revised from the author's notes by M.E.H.H. Holman Hunt visited Jerusalem four times and much of this book refers to his experiences there and elsewhere in the Holy Land. The two volumns contain many of Hunt's Jerusalem and Holy Land drawings and paintings. A watercolour by Holman Hunt is in the Collection (p. 109, no. 23).

Not in Blackmer

～ 42 ～

IRBY, Charles Leonard and MANGLES, James
 London 1844

Travels In Egypt And Nubia, Syria, And The Holy Land; Including A Journey Round The Dead Sea, And Through The Country East Of The Jordan. By The Hon. Charles Leonard Irby, And James Mangles, Commanders In The Royal Navy. London: John Murray, 1844

Small 8vo..

Second edition, but first trade edition. The first edition was printed privately in 1823. This edition does not contain the plates which appeared in the first edition.

The text consists of six long letters, the first dated from Cairo in 1817, the last from Cyprus in 1818. These travels are of particular importance. Irby and Mangles left England in 1816 with the intention of touring the Continent, but their journey extended far beyond their original plans. They toured the Levant in 1817-18, and when they reached Egypt they helped Belzoni excavate the site of Abu Simbel, of which they gave an independent account in their letters. In addition they were among the earliest Europeans to visit Petra. Burckhardt had preceded them, but he was unable to make notes or sketches. The plan of Petra appended to Letter 5 may be the first ever published (this is only available in the first edition).

Blackmer 861; Hilmy I, 325

JOLIFFE, Thomas R. London 1819

Letters From Palestine, Descriptive Of A Tour
Through Galilee And Judaea, With Some Account Of
The Dead Sea, And Of The Present State of Jerusalem.
First edition, London: Printed for James Black, 1819

8vo. *Illus*: A map and 3 engraved plates (Jerusalem, Mount of
Olives and Holy Sepulchre).

First edition. Joliffe travelled in the Levant in 1817 and his
book was first published in 1819. A second edition
appeared in 1820 with the addition of *Letters from
Egypt*. A French translation also appeared in 1820, and a
third English edition in 1822.

Blackmer 878; Hilmy I, 332

KAYAT, Assaad Y. London 1847

A Voice From Lebanon, With The Life and Travels of
Assaad Y. Kayat. London: Madden & Co., 1847

8vo. *Illus*: Lithographed portrait frontispiece (missing).

First and apparently only edition.

Kayat was a Christian Arab from Beirut and seems to
have been a lay missionary. He worked with the
Syrian Society which promoted the education of Arab
youth. This amusing work, giving an account of the
author's travels in England, Europe and the Levant, is
one of those rare books to be written in English by a
local Arab in the mid-nineteenth century. It depicts
Arab views and impressions as well as giving a vivid
picture of life in the Levant at that time. Kayat later
became the British consul in Jaffa.

Blackmer 900

KELLY, Robert Talbot London 1912

Egypt Painted and Described. By R. Talbot Kelly,
Printed by Adam & Charles Black, 1912

8vo. *Illus*: 75 coloured plates covering various sites and scenes
of Egypt.

Fifth impression. First impression appeared in 1902.

Not in Blackmer

A watercolour by Robert Talbot Kelly is in the
Collection (p. 110-11, no. 24)

KELLY, Walter Keating (ed.) London 1844

Syria And The Holy Land, Their Scenery And Their
People. Incidents of Travel, &c. From The Best And
Most Recent Authorities. By Walter Keating Kelly.
With Illustrations. London: Chapman and Hall, 1844

8vo. *Illus*: Numerous wood engravings in the text.

First edition; there is also a later undated edition.

This is apparently the first volume in a 'Library of
Travel' edited by Kelly.

Blackmer 902

KINGLAKE, Alexander William London *c.* 1920s

Eöthen, Or Traces Of Travel Brought Home From
The East

4to. *Illus*: Drawings and designs by Frank Brangwyn.

A recent, undated edition of this classic of travel literature,
which has been reprinted innumerable times. The first edi-
tion for which the well-known artist Frank Brangwyn con-
tributed illustrations was in 1913.

Kinglake toured the Levant about 1835. *Eöthen* is not
an ordinary account of a tour, but 'a delightful record of
personal impressions rather than outward facts' (DNB).

Blackmer 911

KINNEAR, John Gardiner London 1841

Cairo, Petra, And Damascus, In 1839. With Remarks
On The Government Of Mehemet Ali, And On The
Present Prospects of Syria. By John G. Kinnear, Esq.
London: John Murray, Albemarle Street, 1841

Small 8vo.

First and only edition.

Kinnear, from a well-known family of Scottish bankers
and merchants, was a member of the Bannatyne Club
(for Scottish literature) from 1826, and in 1827 reprint-
ed Gavin Douglas's *Palice of Honour* (1579) at his own
expense. He met David Roberts in Egypt in 1839 and
travelled with him to Sinai and Petra. This account of
that journey, dedicated to Roberts, includes a
favourable discussion of Muhammad Ali's recently
established government in that country.

Blackmer 328; Hilmy I, 342

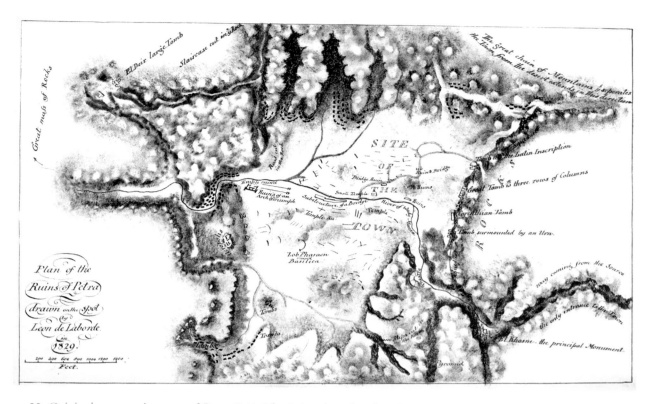

50. Original manuscript map of Petra (1836) by Léon de Laborde, which appeared as the engraved map in his *Journey through Arabia Petraea to Mount Sinai...* (see also p. 219, no. 10)

~ 49 ~

KITTO, John London 1841

Palestine: The Bible History Of The Holy Land. By John Kitto, Editor Of The 'Pictorial Bible'. Illustrated with Three Hundred And Sixteen Woodcuts, By The Most Eminent Artists. London: Charles Knight And Co., 1841

Large 8vo. *Illus*: Numerous wood engravings in the letterpress, of which several almost full-page. The wood engravings are based on illustrations from Alexander Russell's *The Natural History of Aleppo*, and from works by Forbin, Mayer, Lane, d'Ohsson etc. Contemporary blue calf, re-backed, original gilt back laid down.

First edition. A second edition appeared in 1850.

John Kitto, DD, FSA, was born in great poverty in 1804 and at the age of 13 became totally deaf. After five years in the workhouse he took a job in a library and there began his studies. From 1827 he travelled widely in the Middle East for the Church Missionary Society. He wrote many works on biblical subjects.

Blackmer 918

~ 50 ~

LABORDE, Léon Emmanuel Simon Joseph, Marquis de London 1838

Journey Through Arabia Petraea To Mount Sinai, And The Excavated City Of Petra, The Edom Of The Prophecies. By M. Léon de Laborde. Second Edition. London: John Murray, 1838

8vo. *Illus*: Engraved map and 26 plates, of which half are lithographs and half engravings; numerous wood engravings in the letterpress.

Second English edition. The first English edition in 1836 was based on the French folio edition of 1830. This is the 8vo edition of Laborde's celebrated folio book.

The translator/editor of this version is unknown. He has edited Laborde's text and has added to it information from other sources, particularly Irby and Mangles and Burckhardt.

Blackmer 930

The accompanying illustration is of Laborde's original manuscript map of Petra (see also p. 219, no. 10).

ᗧ 51 ᗤ

LAMARTINE DE PRAT, Marie-Louis-Alphonse de
Bruxelles 1836

Oeuvres de Lamartine – Souvenirs, Impressions, Pensées et Paysages, Pendant un Voyage en Orient (1832-1833), Par M. Alphonse de Lamartine, Membre de L'Académie Française. Édition complète en Un Volume. Bruxelles, J. P. Meline, Libraire-Éditeur, 1836

Large 4to. 4 vols. in 1. *Illus*: An engraved portrait, 2 folding maps and a folding table, 7 engraved plates.

? Second edition. The first edition is dated 1835 and many French editions followed. German, English and Dutch editions all appeared in 1835; a Spanish translation was published in 1846.

Lamartine, with his wife and daughter, left Marseilles in October 1832 in his private yacht which was fitted out with a library and an arsenal. He travelled in the style of an Ottoman prince, presented costly gifts to his hosts, and was known in the East as 'l'Emir Français'. Lamartine left his family at Beirut and went on to the Holy Land alone. His daughter Julie died of consumption at Beirut, and Lamartine returned to France overland via Constantinople and the Danube valley. He spent 16 months in the Levant.

Blackmer 942

ᗧ 52 ᗤ

LAWRENCE, T. E. and WOOLLEY, C. Leonard
London 1915

The Wilderness of Zin, Archaeological Report, Palestine Exploration Fund, 1914, with a Chapter on the Greek Inscriptions by M. N. Tod. P. E. F. Annual 1914-1915 (Double Volume), Published by Order of the Committee

Large 4to. *Illus*: 2 maps, 36 full-page plates of black and white photography and 59 illustrations in the text.

First and only edition.

This was the first published book by Lawrence. It covers the survey of southern Palestine, which he undertook with Woolley on behalf of the PEF. It was later used by British troops in their invasion of the region and Palestine.

Not in Blackmer

ᗧ 53 ᗤ

LAWRENCE, T. E. Cairo 1919

A Brief Record of the Advance of the Egyptian Expeditionary Force. Produced by the Government Press and Survey of Egypt, Cairo 1919

Large 4to. *Illus*: Maps.

First and only edition.

The book explains the events of the invasion of Palestine under the command of General Sir Edmund Allenby, July 1917 to October 1918, compiled from official sources and published by the *Palestine News*. Although only two chapters of this Record were contributed by Lawrence, the work has always been associated with his name.

Not in Blackmer

ᗧ 54 ᗤ

LIBBEY, William and HOSKINS, Franklin E.
New York 1905

The Jordan Valley and Petra. By William Libbey and Franklin E. Hoskins (Syria Mission, Beirut) with 159 illustrations. In two volumes. Printed by G. P. Putnam's Sons, New York and London in 1905

8vo. Vol. 2 only is in the Collection. *Illus*: 159 photographic reproductions.

First and only edition.

The book describes the regions of Petra, Kerak and Shobak in the early 1900s.

Not in Blackmer

ᗧ 55 ᗤ

LINDSAY, Alexander William Crawford, later Earl of Crawford and Balcarres London 1858

Letters On Egypt, Edom, And The Holy Land, By Lord Lindsay. Fifth Edition. London: Henry Colburn, 1858

8vo. *Illus*: 2 lithographed frontispieces.

Fifth edition. The first edition appeared in 1838.

Lindsay, a great book collector and traveller, dedicated this work to John Farren, formerly Consul-General in Syria. It consists of a series of letters to various members of his family. Lord Lindsay became Earl of Crawford and Balcarres in 1869.

Blackmer 1019

~ 56 ~

LYNCH, William Francis London 1850

Narrative Of The United States' Expedition To The River Jordan And The Dead Sea. By W .F. Lynch, U.S.N., Commander Of The Expedition... London: Richard Bentley, 1850

Large 8vo. *Illus:* 2 folding maps and 28 plates of wood engravings.

Third English edition. The first edition appeared in 1849 in Philadelphia, and in London in the same year. Nine editions had appeared by 1853. The official report was not published until 1852.

Lynch carried out his first successful navigation of the Dead Sea in 1848, travelling down the Jordan from the Sea of Galilee to the Dead Sea. Half the party travelled overland, the other half navigated the river. The boats had to be carried overland by camels from Acre to the Sea of Galilee. Lynch's explorations had no political motivation but arose from his keenness to visit the Holy Land. He also visited Ephesus, Smyrna and Constantinople. The plates are after drawings by members of the expedition.

Blackmer 1045

~ 57 ~

MADDEN, Richard Robert London 1833

Travels In Turkey, Egypt, Nubia, And Palestine, In 1824, 1825, 1826 And 1827. By R. R. Madden, Esq. M.R.C.S. In Two Volumes. Whittaker and Treacher Co.

8vo. 2 vols. *Illus:* Coloured aquatinted frontispiece of the author in Syrian costume. Original boards, uncut, paper labels.

Second edition. First published 1829.

This work is in the form of letters which were compiled from notes. Madden had trained as a surgeon and because of this (though he had never practised in England), during his travels in the Levant in 1824-27 he was able to enter areas closed to most Europeans, mainly the harem and some slave bazaars. His work also contains much information on Egypt and Egyptology. He attended Henry Salt in his last illness in 1827. The frontispiece portrait was drawn by Salt (illustration p. 166; see also the pencil portrait of Salt by Bonomi p. 83, no. 2b).

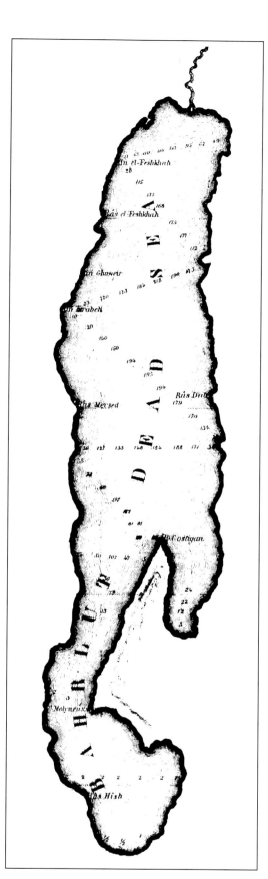

56. Lynch's map of the Dead Sea, from his *Narrative of the United States Expedition...*

Another of Madden's books was *Egypt and Mohammed Ali* (1841).

Blackmer 1056; Hilmy II, 3

⌐ 58 ~

MADOX, John London 1834

Excursions In The Holy Land, Egypt, Nubia, Syria, &c. Including A Visit To The Unfrequented District Of The Haouran. By John Madox, Esq. In Two Volumes. London: Richard Bentley. 1834

8vo.2 vols. *Illus*: 2 lithographed frontispieces and 24 litho-
 graphed plates and 1 engraving in the letterpress.

First and apparently only edition.

This work, Madox's only book, is an account of his travels between 1821 and 1826. It is not necessarily in chronological order but composed from journals of various excursions. Seven chapters contain incidents relating to the Greek War of Independence. He made three separate journeys to Egypt and Palestine between 1824 and 1826. The frontispieces are portraits of the author and Muhammad Ali. The plates include sites in Palestine, costumes and Egyptian wall paintings.

Blackmer 1059; Hilmy II, 3

⌐ 59 ~

MACGREGOR, J. London 1869

The Rob Roy of the Jordan, Nile, Red Sea and Gennesareth &c. A Canoe Cruise in Palestine and Egypt and the Waters of Damascus. By J. Macgregor, with Maps and Illustrations. Published by John Murray, 1869

8vo. *Illus*: 8 maps, 3 coloured plates and many woodcuts in the
 text covering Egypt and Palestine.

First edition.

The book mainly describes a canoe cruise along the river Jordan.

Not in Blackmer

⌐ 60 ~

MA(U)NDEVILLE, Sir John London 1883

The Voiage and Travaile of Sir John Maundevile, Kt. Which Treateth of the Way to Hierusalem; and of Marvayles of Inde, With Other Ilands and Countryes. Reprinted from the Edition of A.D. 1725. With an Introduction, Additional Notes, and Glossary, by J. O. Halliwell, Esq., F. S. A., F. R. A. S. London Reeves and Turner 196, The Strand 1883

8vo. *Illus*: Engraved frontispiece and numerous woodcuts in
 the text.

A reprint of the first edition (1839) to include Halliwell's additions, the main text of which was reprinted from an edition of 1725. The earliest English MS of this work dates to the late fourteenth century. Numerous subse-quent MS editions appeared in English, French and Latin; after the introduction of printing, they appeared in even greater quantity in these languages and also in Italian, Flemish and German.

The author of this work describes himself as an English knight from St. Albans, who set out on his travels in 1322 and wrote of his first-hand adventures and obser-vations in Palestine, Egypt, India and other remote parts of the world. In fact Sir John Mandeville never existed and this immensely popular book, first pub-lished in 1366, was discovered 500 years later to have been the work of a physician called Jean de Bourgoigne, who had spent some time in Egypt. Written originally in French, it is a compilation of authentic accounts by early travellers and historians, de Bourgoigne's own experiences in Egypt and some picturesque (and unre-liable) fables about the East; it captured western Europeans' imaginations for many centuries.

Not in Blackmer

⌐ 61 ~

MAUNDRELL, Henry London 1810

A Journey From Aleppo to Jerusalem At Easter, A.D. 1697... By Henry Maundrell, M.A., Late Fellow of Exeter College, Oxford And Chaplain to the Factory at Aleppo. The Eighth edition. Also, A Journal From Grand Cairo to Mount Sinai, And Back Again, in company with some Missionaries de propaganda fide at Grand Cairo. Translated from a Manuscript Written by the Prefetto of Egypt, By the Right Rev. Robert Clayton, Lord Bishop of Clogher

8vo. *Illus*: 15 engraved plates (9 folding or double-page).
 Contemporary gilt-ruled calf

A relatively recent edition of Maundrell's work, first printed
 posthumously in 1703. French translations appeared at
 Utrecht in 1705 and Paris in 1706.

Maundrell was the Levant Company's chaplain at Aleppo from 1696 to 1701 when he died of fever. His manuscript account of this journey was presented to the University of Oxford by his uncle, Sir Charles Hedges. Maundrell's work contains the first descrip-

tion of Baalbek by an Englishman. Both Baalbek and Palmyra seem to have been ignored by travellers and traders before the end of the seventeenth century. The plates include prospects of Aleppo and Baalbek. Maundrell's descriptions were extremely accurate. This late edition of Maundrell's book has the advantage of being combined with Clayton's *A Journal from Grand Cairo to Mount Sinai*, which is not available in earlier editions.

Blackmer: (Maundrell) 1095, (Clayton) 367

～ 62 ～

MERRILL, Selah London 1881

East of the Jordan: A Record of Travel and Observations in the Countries of Moab, Gilead and Bashan. By Selah Merrill, Archaeologist of the American Palestine Exploration Fund. Published by Richard Bentley & Son, London, 1881

4to. *Illus*: 70 illustrations and a map.

First and only edition.

One of the few books that survey east of the Jordan. This work was entrusted to the American Palestine Exploration Fund and covered mainly the north part of the present Hashemite Kingdom of Jordan.

Not in Blackmer

～ 63 ～

MERRILL, Selah London 1905

Galilee in the Time of Christ. By Rev. Selah Merrill, D.D., with a Map of Galilee. The Religious Tract Society, London. Fifth Edition, 1905

8vo.

Fifth edition. First published 1885.

By the same author as *East of Jordan*.

Not in Blackmer

～ 64 ～

MUNK, S. Paris 1845

Palestine, Description Géographique, Historique et Archéologique. Par M. Munk, Employé au Département des Manuscrits de la Bibliothèque Royale, Paris, Firmin Didot Frères, Éditeurs, 1845

8vo. *Illus*: 3 maps and 68 prints depicting almost all important sites in Palestine.

65. The title page of Michel Nau's *Voyage Nouveau de la Terre Sainte* of 1744

First and only edition; in French.

Not in Blackmer

～ 65 ～

NAU, Michel, SJ Paris 1744

Voyage Nouveau De La Terre-Sainte Enrichi De Plusieurs Remarques particulières qui servent à l'Intelligence de la Sainte Écriture, et de diverses Réflexions Chrétiennes qui instruisent les Âmes dévotes dans la Connoissance & l'Amour de J-C. Par le R.P. Nau de la Compagnie de Jésus. A Paris, Chez J. Barbou, 1744

12mo. 5 parts bound in 1.

The French bibliographer Joseph-Marie Quérard (1797-1865) wrote that this was not a new edition of this

French work but a reprint of the first (anonymous) edition of 1679. The work appeared under Nau's name in 1702 and was reprinted in 1726 and 1744.

Book 1: Defines the Holy Land and describes cities such as Caesaraea and Jaffa on the way to Jerusalem.

Book 2: A description of Jerusalem and its immediate vicinity.

Book 3: Des Lieux remarquables qui sont hors de Jérusalem: these 'remarkable places outside Jerusalem' include the pool of Siloam, the grotto of Jeremiah, and the tombs of the kings.

Book 4: Du Voyage de la Mer Morte, de Bethlehem & de Gaze: includes travel to the Dead Sea, Bethany, Jericho, Emmaus, Hebron, Gaza and other biblical sites

Book 5: Voyage de Galilée: includes travel to Tiberias, Cana, Nazareth, Acre, Tyre, and Sidon.

Nau left Paris in 1665 to enlist in the Jesuit order's Levant Missions. In the same year he travelled in Galilee with the French consul in Sidon, later publishing *Voyage de Galilée* (Paris 1670). In 1673-74 he accompanied the Marquis de Nointel, French Ambassador to the Ottoman Porte, on his travels to the Holy Land. His *Voyage Nouveau* is a very valuable account of the Holy Land as it was over 300 years ago and records edifices that have since changed or vanished. Father Nau made an effort to visit every biblical location, and the work gives a detailed account of everything he saw. A rare work.

Blackmer 1185

~ 66 ~

NEIL, C. Lany London n.d.

Pictorial Palestine, Ancient and Modern, Being a Popular Account of the Holy Land and its People. Compiled and edited by C. Lany Neil. With sections on "Jerusalem", "Village Life", and "The Lebanon", by Rev. G. Robinson Lees. Published by Miles and Miles, London

Large 4to. *Illus*: Original photographs by Rev. G. Robinson Lees.

First edition, no date.

Covers the description and condition of various towns in Palestine, Syria and Lebanon, as well as 'Village life in the Holy Land'.

Not in Blackmer

~ 67 ~

NEIL, James London 1913

Everyday Life in the Holy Land. By James Neil, with 32 pictures painted by James Clark, R.I., assisted by J. Macpherson-Haye and S. B. Carlill under the Direction of the Author

8vo. *Illus*: 32 plates from oil paintings by James Clark

Reprint of first edition in 1913.

Each painting illustrates an aspect of everyday life (e.g. 'Fishing in the Lake of Galilee') accompanied by text on the same subject.

Not in Blackmer

~ 68 ~

OLIN, Stephen New York 1843

Travels In Egypt, Arabia Petraea, And The Holy Land. By The Rev. Stephen Olin, D.D., President Of The Wesleyan University. With Twelve Illustrations On Steel. In Two Volumes. New-York: Harper & Brothers, 1843

8vo. 2 vols. *Illus*: 12 engraved plates and 3 maps/plans.

First edition.

Olin spent three years in Europe and the East, from 1837 to 1840, though he spent only the months from November 1839 to June 1840 in the Levant. Olin was a Methodist clergyman, and he comments at length on the work of the missionaries in the places he visited.

Blackmer 1218; Hilmy II, 79

~ 69 ~

OLIPHANT, Laurence London 1880

The Land of Gilead, with Excursions in the Lebanon. By Laurence Oliphant, Published by William Blackwood, London, 1880

4to. *Illus*: 2 maps, plates of photographs of Jerash.

First and only edition.

The book covers Palestine, east of the Jordan and Lebanon, with particular emphasis on Gilead in the north of today's Jordan. Oliphant, a British diplomat, lawyer, explorer and writer, lived for several years in a utopian community in the United States. In later life he settled for some time in Palestine.

Not in Blackmer

The Collection has a 1976 reprint of Oliphant's book *Haifa, or Life in Modern Palestine* (1887); and also *The Life of Laurence Oliphant* by Phillip Henderson (1956).

— 70 —

OLIPHANT, Mrs. London 1893

Jerusalem, The Holy City, Its History and Hope. By Mrs. Oliphant, with wood engraving from drawings by Hamilton Aide and photographs by F. M. Good. Published by Macmillan and Co., 1893

8vo. First and only edition. *Illus:* Numerous wood engravings and photographs.

Not in Blackmer

The Collection also contains Mrs. Oliphant's *The Land of Darkness* (1888).

— 71 —

PALMER, Edward Henry New York 1872

The Desert Of The Exodus: Journeys On Foot In The Wilderness Of The Forty Years' Wanderings, Undertaken In Connexion With The Ordnance Survey Of Sinai And The Palestine Exploration Fund. By E. H. Palmer, M.A., Lord Almoner's Professor of Arabic, and Fellow Of St. John's College, Cambridge. New York: Harper & Brothers, Publishers, Franklin Square. 1872

8vo. *Illus:* 5 folding maps, 2 engraved plates and 16 lithographed plates; 20 wood engravings in the letterpress.

First American edition. The first British edition was in 1871.

This important work contains accounts of two expeditions: the Sinai survey, which was headed by Charles Wilson, beginning in November 1868, and Palmer's journey with C. F. Tyrwhitt Drake from Sinai to the River Jordan on foot, a distance of 600 miles, from December 1869 to May 1870. The lithographed views are after drawings and photographs by Drake. Palmer was a self-taught orientalist who spoke Persian, Arabic and Hindustani. He also wrote *Jerusalem, the City of Herod and Saladin,* and edited part of the *Survey of Western Palestine* (1881-83), undertaken by C. R. Conder and H. H. Kitchener. He was murdered in Egypt during the rebellion of Arabi Pasha in 1882.

Blackmer 1238; Hilmy II, 88

— 72 —

PIEROTTI, Ermete London 1864

Jerusalem Explored, Being A Description of the Ancient and Modern City, With Numerous Illustrations Consisting Of Views, Ground Plans, And Sections, By Ermete Pierotti, Doctor Of Mathematics, And Architect-Engineer, Civil And Military, To His Excellency Surraya Pasha Of Jerusalem. Translated By Thomas George Bonney, Fellow Of St. John's College, Cambridge, Volume I: Text; Volume II: Plates. London: Bell & Daldy; Cambridge: Deighton, Bell And Co. 1864

Folio. 2 vols. *Illus:* Lithographed plates of which 40 are views and buildings (1 folding) and 23 are plans/diagrams (7 folding); most are after photographs taken by M. J. Diness (see also pp. 230 and 233-34).

First edition. The original Italian manuscript was first printed in English after it came to the attention of the Rev. George Williams of Cambridge who arranged for its translation and publication. In the same year another work by Pierotti appeared, *Customs and Traditions in Palestine,* translated and published in the same manner. A French version of both works appeared in 1865 as *La Palestine actuelle avec ses Rapports avec la Palestine ancienne.*

Pierotti had been in Palestine for some time before 1855, working as an architect and engineer for the Pasha of Jerusalem. He produced a plan of the city which was published c. 1860 as *Plan de Jerusalem rilevo et disegno nel 1855.*

(Illustration pp. 190-91)

Blackmer 1309

— 73 —

POOLE, Henry London 1856

Report of a Journey in Palestine. By Mr. Henry Poole, Communicated by the Earl of Clarendon. With a Map. Printed by William Clowes and Sons

Large 8vo. *Illus:* 1 map of Palestine.

First and only edition.

A small paper-covered booklet which describes a journey to Palestine undertaken by Poole in 1855. A very rare work.

Not in Blackmer

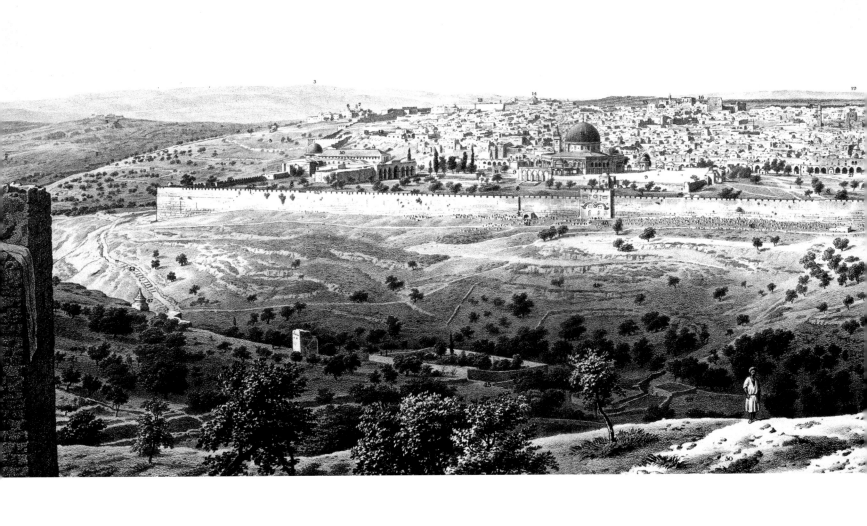

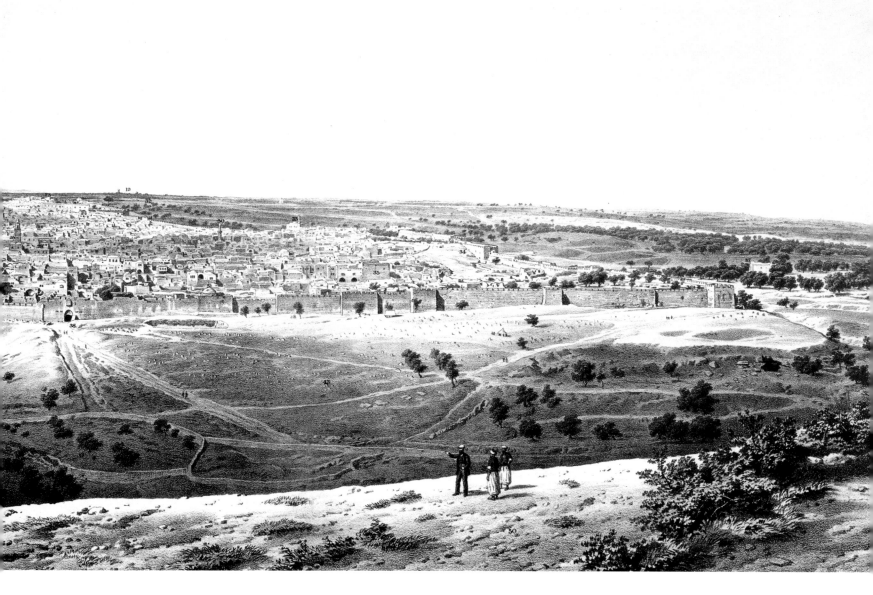

72. A lithograph based on one of M. J. Diness's photographs of Jerusalem seen from the Mount of Olives, which appeared (without crediting the photographer) in Pierotti's *Jerusalem Explored*

～ 74 ～

PORTER, Josias Leslie London 1855

Five Years In Damascus: Including An Account Of The History, Topography, And Antiquities Of That City; With Travels And Researches In Palmyra, Lebanon, And The Hauran. By Rev. J. L. Porter, A.M., F.R.S.L. In Two Volumes. With Maps and Illustrations. London: John Murray, 1855

8vo. 2 vols. (only Vol. 2 is in the Collection). *Illus*: Large folding map, coloured in outline, and 10 engraved plates, illustrations in the letterpress.

First edition. A second edition with a revised title was published in 1870.

Porter, a Presbyterian minister, was sent to Damascus in 1849 as a missionary and remained there for ten years, gaining an intimate knowledge of the Holy Land. This is a lively and very interesting account of Porter's first five years in Syria and his travels in the surrounding areas. The plates are after his own drawings and he also constructed the map. In 1858 another of Porter's books on the region was published, Murray's *Handbook for Travellers in Syria and Palestine*.

Blackmer 1333

～ 75 ～

PORTER, Josias Leslie London 1891

The Giant Cities of Bashan; And Syria's Holy Places. By the Rev. J. L. Porter, A.M., Author of "Five Years in Damascus"... London, T. Nelson And Sons, Paternoster Row; Edinburgh; and New York. 1891

8vo. *Illus*: Engraved title and 7 plates.

Reprint of first edition of 1865; earlier reprints were in 1866, 1867 and 1872.

Porter's ten years in Syria ended in 1859, during which time he had travelled extensively and wrote *Five Years in Damascus* and Murray's *Handbook for Travellers in Syria and Palestine*. In *The Giant Cities*, a very popular description of the massive buildings to be found in Bashan, Porter propounds his theory about their construction. He believed that the aboriginal inhabitants of the country had constructed these buildings, before its occupation by other tribes.

Blackmer 1334

～ 76 ～

PORTER, Josias Leslie Edinburgh 1887

Jerusalem, Bethany and Bethlehem. By J. L. Porter. Published by Thomas Nelson And Sons, Edinburgh, 1887

4to. *Illus*: Detailed illustrations in plates and in the text of all the cities in Palestine, including an impressive panorama of Jerusalem and a plan of Jerusalem and its environs by W. M. Thompson. The cover contains a vignette of the Dome of the Rock in gold.

First edition.

Another of Porter's books written after he left Syria, this describes his travels in Palestine.

Not in Blackmer

～ 77 ～

RELAND, Adrian Utrecht 1714

Hadriani Relandi Palaestina Ex Monumentis Veteribus Illustrata. Tomus I. [...Tomus II.] Trajecti Batavorum ex libraria Guilielmi Broedelet

4to. 2 vols. *Illus*: 11 engraved plates (5 of them folding) and 2 large folding maps; with an engraved title in the letterpress and titles in red and black.

First edition. A second edition appeared at Nuremberg in 1716 and a Dutch translation in 1719.

Reland, the celebrated Dutch orientalist, was Professor of Oriental Languages and Ecclesiastical Antiquities at the University of Utrecht. His description of Palestine is a remarkable work for its time, especially considering that it is not based on his own travels but collected from accounts of other authors. He wrote many other works on Palestine, and *De Religione Mohammedica* (1705). (For a map from this book see p. 218, no. 7)

Blackmer 1406

～ 78 ～

REYNOLDS, James London 1836

The History of the Temple of Jerusalem. Translated from the Arabic Ms. of the Imam Jalal-Addin al-Siuti, with Notes and Dissertation. By the Rev. James Reynolds, B.A. Published under the Auspices of the Oriental Translation Fund of Great Britain and Ireland. London: A. J. Valpy, 1836

Large 8vo.

First and only edition.

The book includes an account of the history and antiquities of al-Aqsa Mosque (including the Dome of the Rock) as well as historical and traditional notices of Jerusalem, Palestine and Syria. It is a translation of two Arabic manuscripts, which are deposited in the British Library and belong to Rich's Collection. This is one of the very few Arab manuscript books to be translated into English. It contains no plates or plans.

Not in Blackmer

— 79 —

ROBINSON, Edward and SMITH, Eli

London 1867

Biblical Researches In Palestine and the Adjacent Regions, A Journal of Travels In The Years 1838 and 1852, By E. Robinson D.D. LL.D. And E. Smith, Undertaken In Reference To Biblical Geography. Drawn Up From the Original Diaries, With Historical Illustrations, By Edward Robinson, D.D.... Third edition, With New Maps And Plans, London, John Murray, 1867

8vo. 3 vols. *Illus*: 3 folding maps.

Third edition. First edition was published simultaneously in England, America and Germany in 1841; second edition 1856.

Robinson spent four years in Germany where he became interested in Hebrew studies and biblical history. In March to July 1838 he travelled in Palestine with Eli Smith, an American missionary who spoke Arabic and knew the country and the people well. Robinson edited both their journals and added extensive notes and essays to produce this landmark in the development of historical geography. The mass of material gathered together in this work surpasses all contributions to the subject of biblical history up to the early nineteenth century. The appendix contains an annotated bibliography of works on Palestine. A very important and interesting work, which was widely circulated. Robinson is considered one of the pioneers of historical geography and cartography of the Holy Land.

Blackmer 1434

HADRIANI RELANDI

PALAESTINA

EX

MONUMENTIS

VETERIBUS

ILLUSTRATA.

TOMUS I.

TRAJECTI BATAVORUM,

ex libraria GUILIELMI BROEDELET.

M. D. CC. XIV.

77. The title page of Adrian Reland's *Palestina ex Monumentis Veteribus Illustrata* of 1714

— 80 —

ROBINSON, Edward

Boston 1865

Physical Geography of the Holy Land By E. Robinson D.D. LL.D. Professor of Biblical Literature in the Union Theological Seminary, New York. A Supplement to the Late Author's Biblical Researches in Palestine, Boston:...1865

8vo. First and only edition.

By the same author as no. 79 above; a good book with fair descriptions of the geography and resources of the Holy Land.

Not in Blackmer

— 81 —

ROGERS, Mary Eliza Cincinnati 1865

Domestic Life in Palestine, by Mary Eliza Rogers, Cincinnati... 1865

Small 8vo. First American edition. First published in Britain in 1862.

An important and intimate source of information on domestic life and folklore in Palestine in the mid-nineteenth century; an excellent reference.

Not in Blackmer

— 82 —

SCHWARZ, Rabbi Joseph Philadelphia 1850

A Descriptive Geography and Brief Historical Sketch of Palestine. By Rabbi Joseph Schwarz, for Sixteen Years a Resident in the Holy Land. Translated by Isaac Leeser. Illustrated with Maps and Numerous Engravings. Published by A. Hart, Philadelphia, 1850

8vo. 3 parts in 1 vol. *Illus*: A portrait of Rabbi Schwarz, 2 maps and 22 lithographed plates (2 to a page), all sepia coloured.

First and only edition in English.

The original of this work, in German, was published in 1845. Part I: Jerusalem, the Boundaries of Palestine, and Palestine Beyond Jordan. Part II: Of the Products of Palestine in the Animal, the Vegetable and Mineral Kingdoms. Part III: A Short History of Palestine. The illustrations are not accurate depictions of Palestine.

Not in Blackmer

— 83 —

SHAW, Thomas Edinburgh 1808

Travels, Or Observations, Relating To Several Parts of Barbary And The Levant. Illustrated With Copperplates. By Thomas Shaw, D.D., F.R.S., Vicar of Bramley, Regius Professor of Greek, And Principal Of Edmund Hall, In The University Of Oxford. The Third Edition, Corrected, With Some Account Of The Author. In Two Volumes. Edinburgh: Printed by J. Ritchie. Sold by A. Johnstone... [et al.] 1808

8vo. 2 vols. *Illus*: 11 maps and 39 engraved plates, some folding and double-page.

Third edition. The first edition was published in folio in 1738; this edition includes the material published in the Supplement of 1746 and the additions included in the second edition of 1757.

Shaw was chaplain to the English factory at Algiers from 1720 to 1733, during which time he visited Egypt, Sinai, Palestine, Cyprus and most of North Africa. Shaw's *Travels* has been praised by many. It is especially valued for its botanical and zoological plates in addition to the information Shaw gives on the antiquities, geology and geography of the areas he visited. The appendix includes catalogues of plants and animals of Barbary, Egypt and Arabia.

Blackmer 1535

— 84 —

SPENCER, Jesse Ames London 1850

The East. Sketches Of Travels In Egypt And The Holy Land. By The Rev. J. A. Spencer, M.A. With Illustrations. London: John Murray, 1850

Large 8vo. Illus: 8 tinted lithographed plates, several illustrations in the letterpress, including 2 maps. Original green cloth, faded.

First English edition.

The work consists of a series of 22 letters describing Egypt and the Holy Land, dated 18 December 1848 to 5 May 1849. They were addressed to the author's wife in New York, and he has published them much as they were written, with a few revisions. The plates are after drawings by J. B. Atkinson, one of the party of travellers.

Blackmer 1583

— 85 —

STANLEY, Arthur Penrhyn London 1856

Sinai And Palestine In Connection With Their History. By Arthur Penrhyn Stanley, M.A. Canon Of Canterbury. With Maps And Plans. London: John Murray, 1856

8vo. *Illus*: 7 chromolithograhed maps, 4 plans in the letterpress.

First edition. Second and third editions of this work also appeared in 1856, a fifth by 1858, in which year a French translation also appeared.

Stanley travelled in the Holy Land in the winter and spring of 1852-53. In this very popular work he emphasized the connection between history and geography; that is, he interpreted history through geography. The maps are very good.

Blackmer 1600

~ 86 ~

STEBBING, Henry and BARTLETT, W. H.

London 1847

The Christian In Palestine; Or, Scenes of Sacred History, Historical and Descriptive. By Henry Stebbing, Illustrated From Sketches Taken On The Spot By W. H. Bartlett. London: George Virtue

4to. *Illus*: Engraved title, map and 78 plates of steel engravings (1 double-page panorama of Jerusalem with later hand-colouring). The double-page view of Jerusalem is accompanied by an unsigned leaf which acts as a key to the plate.

First edition.

The material for these plates was collected during Bartlett's third journey to the Levant, in 1842, when he visited Cyprus, Rhodes, Palestine and Syria. Some of the plates have been reprinted from *Walks about Jerusalem* (1844). Many paintings based on Bartlett's panorama of Jerusalem are in the Collection.

(The panorama is illustrated on pp. 196-97)

Blackmer 1603

~ 87 ~

STEPHENS, John Lloyd　　　　London 1854

Incidents Of Travel In Egypt, Arabia Petraea, And The Holy Land. By J. L. Stephens. William and Robert Chambers, 1854

4to. First edition published outside the United States. The first American edition appeared in 1837 and achieved a phenomenal success – eight editions appeared within one year and a further two by 1839. This edition is in one volume with no illustrations.

Stephens left the US in 1834 and visited Greece and Asia Minor in 1835. In 1836 he travelled through the areas described in the present work. Some of his letters had appeared in the American Monthly

Magazine and proved so popular that in 1837 he published his travels in Egypt and the Holy Land and in 1838 his travels in Greece and Turkey. Both these works were extremely successful; overnight Stephens became known as 'the American traveller'.

Blackmer, 1607; Hilmy II, 34

~ 88 ~

TEMPLE, Sir Richard　　　　London 1888

Palestine Illustrated. By Sir Richard Temple. Published by W. H. Allen & Co., 1888

4to. *Illus*: 32 coloured illustrations, 2 lithographs and 4 maps.

First edition.

The book describes a journey undertaken by the author. The illustrations are based on the coloured sketches he executed during his trip, which covered almost all sites of note in Palestine.

Not in Blackmer

~ 89 ~

THOMPSON, Charles　　　　London 1767

Travels through Turkey in Asia, the Holy Land, Arabia, Egypt And other Parts of the World:... With A Curious Description of Jerusalem as it now appears, And other Places mentioned in the *Holy Scriptures*. By Charles Thompson, Esq;... The Third Edition. London: Printed for J. Newbery, at the Bible and Sun, in St Paul's Church-Yard. 1767

12mo. 2 vols. (only Vol. II is in the Collection). *Illus*: Engraved panorama of Jerusalem by Cornelis de Bruyn; 3 views on one sheet of the Holy Sepulchre; 1 map of Egypt; 1 view of the pyramids and sphinx in Egypt; a few views and plans of sites in Palestine and Sinai; all folding.

Third edition. The first edition appeared in one volume in 1744 at Reading, under the title *The Travels of the Late Charles Thompson, Esq.*, with a reprint in the same year and a second edition in 1752. In 1754 it appeared in 2 vols. with the present title. There was a further edition in 1798.

Nothing is known of Charles Thompson and this may be a fictional voyage, like that of Sir John Mandeville, but this did not detract from its popularity.

Blackmer, 1653

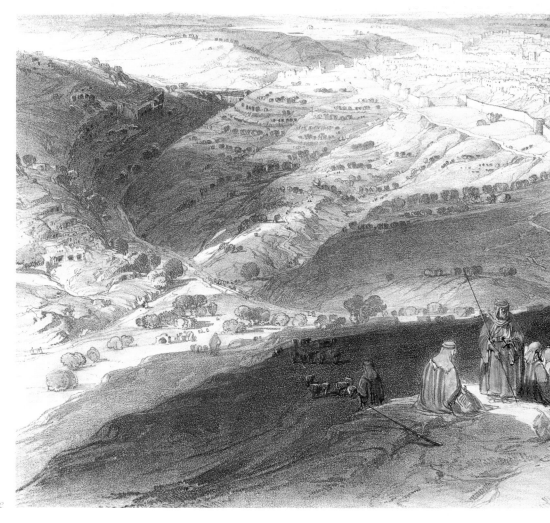

86. Bartlett's panorama
of Jerusalem, from
Stebbing and Bartlett's
The Christian in Palestine

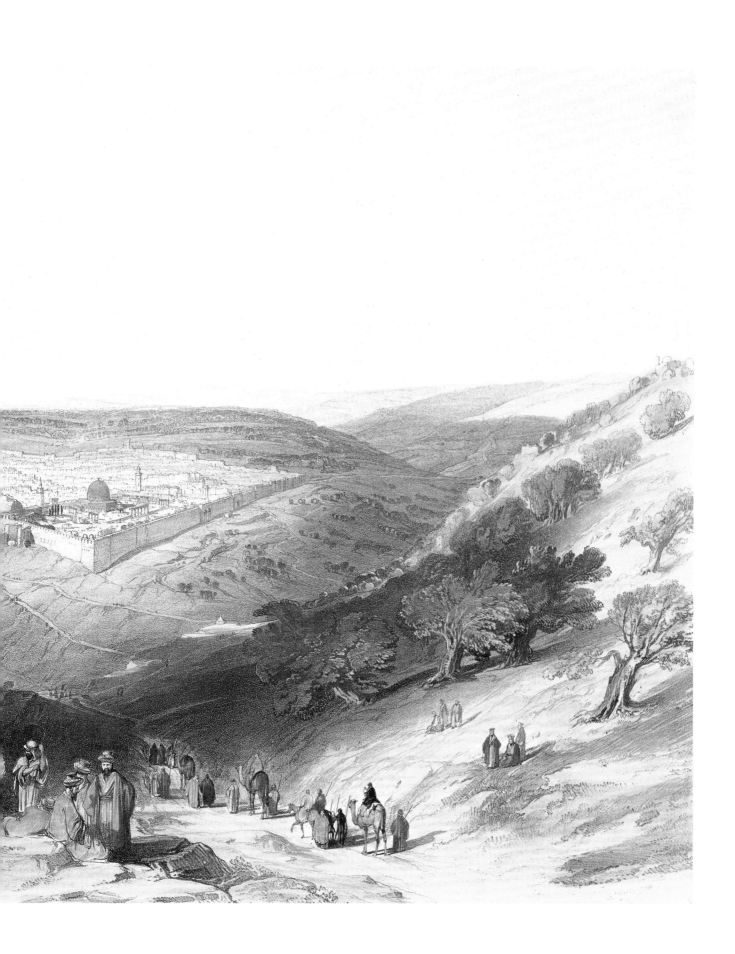

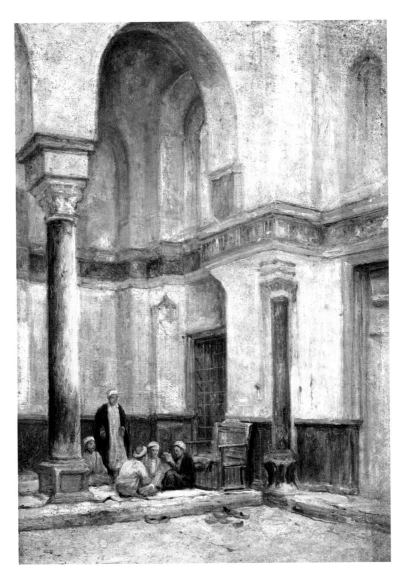

94. One of Tyndale's oil paintings of the inside of a mosque
in Cairo (see p. 138, no. 54c); a similar view was used
in his *An Artist in Egypt* and other books

⌐ 90 ⌐

THOMPSON, W. M. London 1875

The Land and the Book, or Biblical Illustrations,
Drawn from the Manners and Customs, The Sciences
and Scenery of the Holy Land. By W. M. Thompson,
D.D. Published by T. Nelson and Sons, London, 1875

8vo. *Illus*: Numerous woodcuts, plates and one folding map.

No edition number; the first edition was published in 1857.

This was one of the most popular and frequently
printed books on the Holy Land. It appeared in

many editions and forms over the last quarter of the
nineteenth century. The Collection contains several
different editions of this abundantly printed work.

Not in Blackmer

⌐ 91 ⌐

TILLOTSON, John London n.d.

Palestine: its Holy Sites and Sacred History. By John
Tillotson, Illustrated With More than Three Hundred
and Fifty Engravings From Designs by Eminent
Artists, London: Ward, Lock and Tyler

8vo. *Illus*: Numerous steel plates, 6 coloured maps

New edition; no date.

Not in Blackmer

⌐ 92 ⌐

TRISTRAM, Henry Baker London 1875

Bible Places, or the Topography Of The Holy Land:
A Succinct Account of All The Places, Rivers, And
Mountains Of The Land Of Israel, Mentioned In
The Bible, So Far As They Have been Identified:
Together With Their Modern Names And Historical
References. By H. B. Tristram. London: Society For
Promoting Christian Knowledge

Small 8vo. *Illus*: Numerous steel engravings in the letterpress,
some full page.

New edition, corrected. First edition appeared in 1872.

Tristram, divine and naturalist, travelled in Palestine
in 1858-59 and 1863-64. He had an extensive knowl-
edge of the history and topography of Palestine and
wrote much on the subject. He was a noted ornithol-
ogist after whom the ubiquitous Tristram's grackle
was named. Among his many publications are *The
Natural History of the Bible* (1867); *The Land of
Israel, a Journal of Travels* (1882); *The Land of Moab*
(1873), and *The Survey of Western Palestine: Flora
and Fauna* (1884).

Blackmer 1677

⌐ 93 ⌐

TRISTRAM, Henry Baker London 1870

Scenes in the East, Consisting of Twelve Coloured
Photographic Views, of Places mentioned in the
Bible, with Descriptive Letterpress, By the Rev. H. B.

Tristram. Published by the Society for Promoting Christian Knowledge, London, 1870

4to. *Illus*: 12 coloured plates; the cover contains a vignette of the Dome of the Rock, Jerusalem.

First edition.

The plates are based on photographs by Rev. A. A. Isaacs, J. Graham, and Rev. G. W. Bridges, covering Bethlehem, Nazareth, the River Jordan, Tiberias, Jacob's Well, Sidon, the Pool of Bethesda, the Pool of Siloam, Jericho, Bethany, Gaza and Joppa.

Not in Blackmer

Other Tristram books are also in the Collection: *The Land of Moab*, first edition (1873); *Eastern Customs in Bible Lands*, second edition (1894); *The Natural History of the Bible*, seventh edition (1883); *The Land of Israel*, fourth edition (1882).

~ 94 ~

TYNDALE, Walter London 1912

An Artist in Egypt. By Walter Tyndale, R.I. Hodder and Stoughton, 1912

4to. *Illus*: 27 tipped-in coloured plates after paintings by Walter Tyndale.

First and only edition.

This book is based on Tyndale's travels in Egypt in 1894. He also wrote another book on Egypt, *Below the Cataract*, which contains a further set of his Egyptian plates.

Not in Blackmer

There are two of Tyndale's original watercolours and one oil painting in the Collection (p. 136-38, no. 54).

~ 95 ~

VALENTINE, L. London 1893

Palestine Past and Present, Pictorial and Descriptive, Compiled and Edited by L. Valentine, Illustrated with Upwards of One Hundred and Fifty Wood Engravings and a Series of Eight Full-page Coloured Plates. Fredrick Warne, London, 1893

Large 8vo. *Illus*: Numerous woodcuts in the text and 8 coloured steel plates.

First and possibly only edition.

94. The fine cover of Tyndale's *An Artist in Egypt*

The book describes Palestine, sites east of the Jordan (mainly Petra), Sinai, Lebanon and Syria in relation to their ancient history.

Not in Blackmer

~ 96 ~

VAN DYKE, Henry London 1908

Out of Doors in the Holy Land, Impressions of Travel in Body and Spirit. By Henry Van Dyke, Illustrated, Published by Hodder and Stoughton, London, 1908

8vo. *Illus*: 12 coloured plates in the text.

First edition.

Not in Blackmer

~ 97 ~

VELDE, Charles William Meredith van de

London 1854

Narrative Of A Journey Through Syria And Palestine In 1851 And 1852 by C. W. M. van de Velde... Translated Under The Author's Superintendence. In Two Volumes. Vol. I...[...Vol. II] William Blackwood And Sons, Edinburgh and London, 1854

8vo. 2 vols. *Illus*: 2 folding maps, 2 chromolithographed frontispieces and a folding plate of inscriptions.

First English edition, published originally in Dutch, Utrecht 1854.

Van de Velde, an officer in the Royal Netherlands Navy for 17 years, travelled in the Holy Land between October 1851 and June 1852. During this time he gathered material for his collection of 100 lithographed plates, published in 1857 as *Le Pays d'Israel* (in the Collection, pp. 160-61, no. 16). The work listed here is an account of that journey. Van de Velde had earlier published *Gezigten uit Nêerlands Indë* (c. 1845), containing views of Java and Sumatra in the Dutch East Indies.

(Other van de Velde lithographs are illustrated on pp. 54, 64-65 and 162-63)

Blackmer 1722

~ 98 ~

VOLNEY, Constantin François de Perth 1801

Travels in Syria and Egypt During The Years 1783, 1784 & 1785. By M. C. F. de Volney, Member of the National Institute of Arts and Sciences. Reviewed and Corrected by the Author, and Enlarged With an Abstract of Two Arabic MSS. Containing Much New and Interesting Information Respecting the History, Population, Revenues, Taxes, and Arts of Egypt. And two Engravings Not in Any Former Edition, Representing the Pyramids and the Sphinx. Translated from the French. In two Volumes. Embellished with Maps and Plates. Perth: Printed by R. Morison, 1801

12mo. 2 vols. *Illus*: 3 folding maps, 6 engraved plates and a folding table.

Third edition. The first and second editions both appeared in 4to in 1787. The Supplements 1 and 2 and the plates of the Sphinx and the pyramids first appeared in the third edition.

De Volney set out for Egypt at the end of 1782 and spent three years travelling, mostly on foot, in Syria and Egypt, studying the history, political institutions, customs and manners of the people. He spent seven months in Cairo and later travelled with Louis Cassas in Syria in 1785. His work, which is not an account of his travels but the sum of his observations, enjoyed a tremendous success on its appearance. It is the best account of Ottoman Egypt at the end of the eighteenth century.

Blackmer 1748; Hilmy II, 186

~ 99 ~

WARBURTON, Bartholomew Eliot George

London 1855

The Crescent And The Cross; or, Romance And Realities Of Eastern Travel. By Eliot Warburton, Esq. London: Henry Colburn, Publisher, Great Marlborough Street, 1855

8vo. *Illus*: 15 wood engravings in the letterpress.

Eleventh edition. The first edition appeared in 1845, with two more in the same year; a total of 17 editions had appeared by 1880.

In 1843 Warburton made an extended tour of Syria, Palestine and Egypt and wrote accounts of his travels for the Dublin University Magazine, then under the editorship of Charles Lever, who persuaded him to make a book out of them. The work achieved an even greater success than *Eöthen*, which had been dedicated to Warburton by Kinglake, a life-long friend.

Blackmer 1771

~ 100 ~

WILLIAMS, George London 1845

The Holy City or Historical and Topographical Notices of Jerusalem; with Some Account of its Antiquities and of its Present Condition. By the Rev. George Williams, M.A., with Illustrations from Sketches by the Rev. W. F. Witts. Published by John Parker, London, 1845

Large 8vo. *Illus*: A plan of Jerusalem (see pp. 202-03) and 11 lithographed plates of the city.

First and possibly only edition.

97. Charles van de Velde's unusual view of Jerusalem from the north (see pp. 160-61, no. 16)

98. The Pyramids of Giza, from de Volney's *Travels in Syria and Egypt*

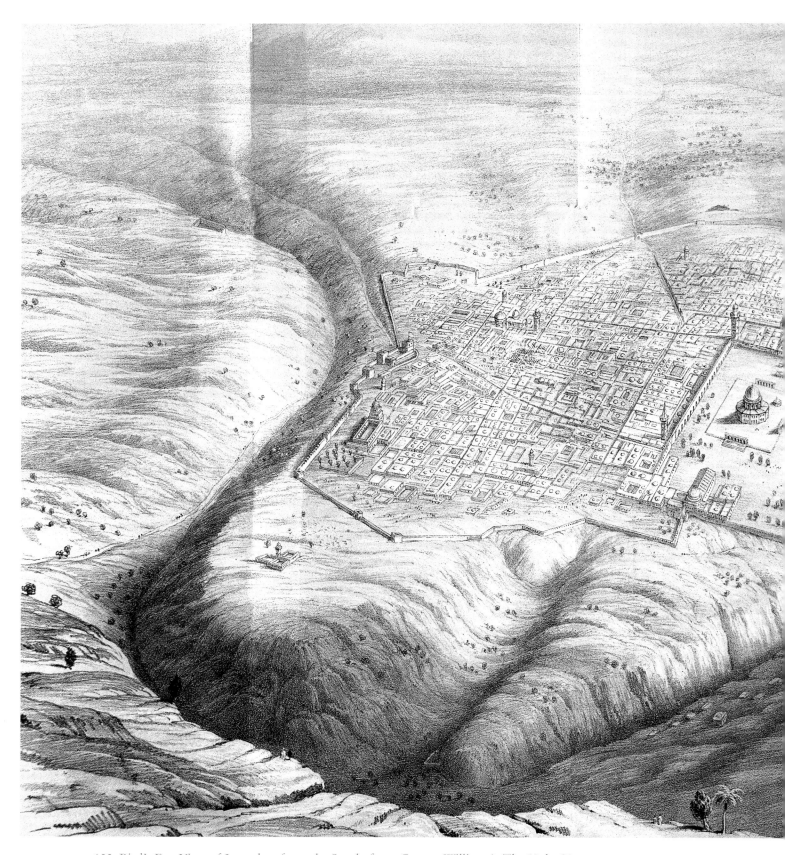

100. Bird's Eye View of Jerusalem from the South, from George Williams's *The Holy City*

The book is in two parts: Part I: History; Part II: Topography, Antiquities, etc. of Jerusalem. It contains a folding 'Bird's-Eye View of Jerusalem', of great beauty and accuracy.

Not in Blackmer

~ 101 ~

WILLYAMS, Cooper London 1802
A Voyage Up The Mediterranean In His Majesty's Ship The Swiftsure, One of The Squadron Under Nelson, With A Description Of The Battle Of The Nile On The First Of August 1798, And A Detail Of Events That Occurred Subsequent To The Mediterranean. By the Rev. Cooper Willyams, Chaplain Of His Majesty's Ship The Swiftsure. London: Printed by T. Bensley, 1802

4to. *Illus*: Engraved dedication, a folding map and 41 sepia coloured plates; wood engravings in the letterpress.

First edition. German translations appeared in Hamburg in 1803 and Vienna in 1804. 32 of the plates were reproduced in 1822 as *A Selection of Views...* 100 special copies, coloured, were produced on large paper; some ordinary copies also coloured.

In 1798 Willyams served as chaplain of the *Swiftsure*, a ship in the squadron which Nelson commanded at the Battle of the Nile and his is 'the first, the most particular, and the most authentic account of the battle' (DNB). The plates are after drawings by the author and include a plan of the battle, in addition to views of Palestine, Sicily, Egypt, Gibraltar etc.

(Illustration pp. 204-05)

Blackmer 1813; Hilmy II, 335

~ 102 ~

WILSON, Charles William London 1881-84
Picturesque Palestine Sinai And Egypt Edited By Sir Charles Wilson, R.E., K.C.B., F.R.S. Formerly Engineer To The Palestine Exploration Fund Assisted By The Most Eminent Palestine Explorers Etc. With Numerous Engravings On Steel And Wood. In Four Volumes. London: J. S. Virtue And Co.

4to. 4 vols. *Illus*: Engraved title and frontispiece to each vol., and plates of steel engravings; numerous illustrations in the letterpress; titles in red and black.

Next Page:
101. The Bay of Acre from the Top of Carmel, from Cooper Willyams's *Voyage up the Mediterranean*, showing some of the sailors from HMS Swiftsure, on which Willyams served as Chaplain

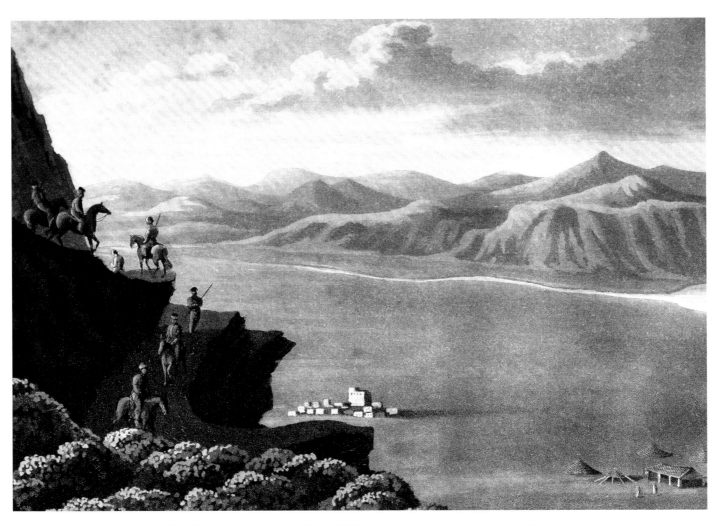

104. The Plain of Jericho from W. R. Wilson's *Travels in Egypt and the Holy Land*

First edition. The contributors include C. R. Conder, Stanley Lane-Poole, H. B. Tristram, E. H. Palmer, Selah Merrill. The supplement, Vol.5, entitled *Social Life in Egypt, A Description of the Country and its People*, by Stanley Lane-Poole, is not in the Collection. The prints in Wilson's book proved very popular and were printed in similar books about Palestine in French (Guérin), German (Ebers) and Spanish (Gebhardt). All are in the Collection.

Charles Wilson (1836-1905) was appointed in 1864 to carry out an Ordnance Survey of Jerusalem to enable improvements in the city's polluted water supply. In the following year the Palestine Exploration Fund sent him back to prepare a feasibility study for a proposed Survey of Western Palestine and to identify suitable sites for future excavation. In 1868 he returned to the region again to take part in the Ordnance Survey of Sinai together with Captain H. S. Palmer (see below).
Blackmer 1817

~ 103 ~

WILSON, C. W. and PALMER, H. S. London1869
Ordnance Survey of the Peninsula of Sinai, under the direction of Colonel Sir Henry James. Published by the Ordnance Survey Office, 1869
Part I: Account of the Survey with Illustrations; Part II: Maps, Plans and Sections; Part III: Maps: Photographic views.

Large folio. 3 vols. (only Part I is in the Collection). *Illus*:
Photographic frontispiece and 20 plates.

First and only edition.

This is the most comprehensive survey of Sinai, including reports on the prehistoric and Byzantine archaeology as well as chapters on the route of the Exodus.

Not in Blackmer

～ 104 ～

WILSON, William Rae London 1823

Travels In Egypt And The Holy Land. By William Rae Wilson, Esq... London: Printed For Longman, Hurst, Rees, Orme, and Brown, 1823

8vo. *Illus*: Engraved frontispiece and 7 aquatinted plates.

First edition. The second edition in 1824 was expanded to include a journey through Turkey and Greece, and 13 plates. The third edition appeared in 2 vols. with additional material, also with 13 plates but with some differences from the earlier edition.

Wilson's voyage began in 1817. This work was the first of his series of travel books, which included *Travels in Russia, Records of a Route through France and Italy* and *Travels in Norway, Sweden....*

Blackmer 1822; Hilmy II, 338

～ 105 ～

WYLIE, James Aitken London 1850

The Modern Judea, Compared with Ancient Prophecy with Notes Illustrative of Biblical Subjects. By Rev. James Aitken Wylie, New Edition

8vo. *Illus*: Seven fine steel plates by Bartlett.

A new edition of a work first published in 1841.

Not in Blackmer

～ 106 ～

ZELLER, Mrs. Hannah London 1876

Wild Flowers of the Holy Land, Fifty Four Plates Printed in Colours, Drawn and Painted after Nature by Mrs. Hannah Zeller (Nazareth), with a Preface by H. B. Tristram and an Introduction by Edward Atkinson, Printed by James Nisbet and Co.

4to. *Illus*: 54 plates in colour depicting wild flowers of Palestine.

Second edition. First edition appeared 1875.

Mrs Hannah Zeller, a resident of Nazareth, painted a wide range of the wild flowers and grasses of her native land. Each is printed with its botanical name in Latin, and common names in English, French and German.

Not in Blackmer

106. A Palestine bramble (Rubus sanctus; Arabic 'oleiq), from Hannah Zeller's Wild Flowers of the Holy Land

IERVSALEM MOD...

Chapter Eight

∽ Atlases, Maps and Views ∽

In the early Christian period the Church was in the forefront of map-making. A good example of this can be seen in the Church of St George at Madaba in Jordan, where a mosaic floor portraying a map of Palestine was laid in the second half of the sixth century. In its organization of places along a network of roads, the map seems to follow a Roman map of the whole Roman Empire, now known only from a medieval copy, the *Tabula Peutingeriana*; its place names appear to have been based on those in the fourth-century *Onomasticon* of Eusebius. The map contains a wealth of late-sixth-century historical and geographical information but it is of particular interest to a cartographer because Jerusalem, at the very centre of the map, has been exaggerated in size to a scale of about 1:1,600, which gives us a remarkably accurate plan of the city in those days.

Medieval Muslim Arab mapmakers made significant contributions to Palestine cartography prior to

Jerusalem, as depicted in the 6th century mosaic map in Madaba

Opposite:
A 1685 woodcut view of Jerusalem from Mallet's *Description de l'Univers* (see p. 228, no. 17)

the Ottoman period. Al-Farisi al-Istakhri's map of Syria-Palestine appeared in 952 in his atlas of 21 maps entitled *The Book of Roads and Countries*. The great medieval cartographer, Sharif al-Idrisi (1099-1164), produced another manuscript map of Syria-Palestine; although rough, in some respects it was the most accurate map available at the time. His atlas, *Book for the Amusement of Him who Desires to Travel Round the World*, improved on the work of Ptolemy and on that of other early Islamic cartographers; he has been described as one of the medieval world's foremost geographers and cartographers.

Thirty years after the invention of the printing press in Europe, printed maps began to appear, the first, in 1477, being Ptolemy's *Geography*, the principal work on the subject since its appearance in the second century AD. The first printed atlas to include maps of Palestine was the 1482 Florence edition of Ptolemy's work by Francesco Berlinghieri. In 1580 Ortelius published his *Theatrum Orbis Terrarum*, the first modern atlas, which contained maps of Palestine. In 1493 Hartmann Schedel's illustrated *Liber Cronicarum* appeared, containing two imaginary views of Jerusalem, probably the first time views of the city appeared in print (in the Collection).

Another transition into print was that of the itinerary, an account of a particular journey. The Christian world's principal preoccupation was with the Holy Land. Bernhard von Breydenbach visited Palestine in 1483 and described his experiences in the *Peregrinatio in Terram Sanctam*, published by Erhard Reuwich in 1486. In fact Reuwich had accompanied Breydenbach and personally contributed a map of the Holy Land (see no. 11 below). The *Peregrinatio* was the first illustrated travel account and the views in it are the earliest of any city known to have been taken from life. The Holy Land continued to fascinate a Christian audience and a large number of books were devoted either to travels in the Levant or to more detailed descriptions of the Bible lands (see Chapter 7).

As atlases, maps and views constitute an important part of the Collection, it would be wise to commence by differentiating between maps and views. A map is defined as 'a drawing or representation, usually on a flat surface, of part or all of the surface of the earth or of some heavenly body... indicating a specific group of features, ... in terms of their relative size and position' (*Random House Dictionary of the English Language*). These are geographical and topographical maps and are distinct from views. We define a view as an approximate and not-to-scale drawing of the setup and outlines of a city or vicinity, with some detailing of the composition and outline of important buildings and streets. It is the image drawn by the artist, and it is now largely replaced by photography. An atlas is a collection of many maps pertaining to one or more countries, or to specific locations.

I – Atlases and Surveys of the Holy Land

The Collection contains many atlases of the Holy Land. Only the maps that resulted from Napoleon's survey at the end of the eighteenth century and that of the Palestine Exploration Fund in the second half of the nineteenth century are referred to in detail, because of their importance. Both are in the Collection in their original form. However their value can only be appreciated by reference to the surveys which led to their publication. The following description relies on the catalogue of the Victoria & Albert Museum/PEF exhibition, *The World of the Bible*, London 1965.

⁓ 1 ⁓

THE JACOTIN MAP

Set of 48 Maps of Egypt and Palestine

(Illustration pp. 212-13)

The first serious mapping of Palestine was commissioned by Napoleon in 1799 as an extension of his survey of Egypt. From bases near Alexandria and Cairo Colonel Pierre Jacotin (1765-1827) and his surveyors mapped the Nile Delta, and 42 sheets of Egypt were eventually published on a scale of 1:100,000. Six more sheets extended into Palestine but here the control was less rigid and the topography also suffered in accuracy because the surveyors were only able to work in areas where the troops had recently fought and were thus hampered by active service conditions. The whole collection of maps is known as the Jacotin Map.

The Palestine sheets are beautifully engraved and show relief by hachuring. They contain much detail of communications and vegetation, and a careful attempt appears to have been made to depict the correct shape of towns and villages. Two interesting features are the liberal use of Arabic script for place names – the transliteration of which caused such controversy in Paris that a special commission was formed to carry out this task – and the marking of Napoleon's battles, which are dated according to both the Napoleonic and Gregorian calendars.

Survey work on the ground was completed in 1801 and the compilation was finished in 1803. The engraving took a little over four years but, although the maps were printed in 1808, Napoleon kept them under seal as state secrets and they were not published until about 1817.

⁓ 2 ⁓

THE PALESTINE EXPLORATION FUND SURVEYS

Set of 26 Maps from the *Survey of Western Palestine*

(Illustration pp. 62-63)

A number of explorations of the country had been carried out during the first half of the nineteenth century, including that by Lieut. Lynch of the US Navy who, in 1848, sketched the course of the Jordan as he descended the river in a boat and mapped the Dead Sea (see p. 185, no. 56). However, little survey work is recorded until 1864 when Capt. Charles Wilson of the Royal Engineers, who was attached to the Ordnance Survey of Britain at the time, volunteered to make the plans of Jerusalem. By May 1865 he had completed a 1:10,000 map of the environs, and a 1:2,500 plan of the city, which was so accurate that when a new one was required in 1937 only a revision was necessary. After the formation of the PEF in 1865 Wilson returned to Palestine under their auspices to make a thorough reconnaissance of the country. He was followed by Lieut. Charles Warren, also of the Royal Engineers, who spent three years excavating and exploring the ancient buildings in Jerusalem – the PEF's first project. Wilson's last expedition for the PEF took him to Sinai in 1868.

Wilson's reconnaissance in 1865-66 had shown that a complete topographical survey of the whole country was required, and the PEF launched its Survey of Western Palestine in 1871. The Ordnance Survey was asked for assistance to produce maps at a scale of one inch to one mile. Lieut. C. R. Conder, who was later joined by Lieut. H. H. Kitchener, completed the survey in 1877.

To control the survey, Conder's party used a chain to measure a four-mile base at Ramleh and another of four and a half miles on the plain of Esdraelon. They then observed a rigid framework with a seven-and-a-half-inch theodolite, forming triangles with sides five to eight miles long in the hills and ten to 15 miles long on the plains. The area covered by this survey, from the Mediterranean to the Jordan and from Tyre and Banias in the north to Beersheba in the south (over 15,500 square km.), resulted in the publication in 1879 of the *Survey of Western Palestine*, an exceptionally detailed nine-volume work, accompanied by a set of 26 maps. Printed in four colours,

with relief shown in brown 'chalk-work' hachuring, the maps contain a wealth of detail, even to the location of wine presses in the vineyards, and became the basic topographical map of Palestine until 1936 when the first of a new 1:10,000 series was produced under the Mandate.

East of the Jordan efforts were more fragmentary and not so successful. The American Palestine Exploration Society had undertaken to survey this part but apparently ran into financial difficulties after completing a large area between Banias and Amman. Their results were printed by the Ordnance Survey in 1879 as a series of 13 sheets at one inch to the mile. In 1881 Conder returned to Palestine to extend his work across the Jordan but after measuring a base near Madaba and connecting it with the West Palestine triangulation, he ran into difficulties because of Britain's worsening relations with the Ottoman Empire. As a result, one volume only of the *Survey of Eastern Palestine* was published (see p. 176, no. 25).

In 1915 the PEF published *The Wilderness of Zin*, the Annual of the PEF for 1914-15, by C. Leonard Woolley and T. E. Lawrence (see p. 184, no. 52). This was a survey of the Negev, Wadi Araba (between Aqaba and the southern end of the Dead Sea) and the areas immediately to the east of it including Wadi Mousa (Petra) and Ma'an. It was carried out mainly for intelligence purposes and the Ottomans were tricked into allowing it under the pretence that it was an archaeological report.

Only Sinai now remained without detailed maps. Triangulation and field work at a scale of 1:125,000 was completed by the end of May 1914, in the remarkably short time of six months, and the maps were printed by the War Office for official use only in 1915. The hurry shows in the field sheets, which, though similar to the western Palestine work and probably more accurate, appear rougher and were obviously compiled in a less leisurely manner. The surveyors were aware that war was imminent and they collected whatever intelligence they could about the country and its Turkish rulers, and entered this on their field sheets with the survey data. T. E. Lawrence was also involved in this survey and the intelligence he gathered helped General Allenby in his invasion of Palestine two years later.

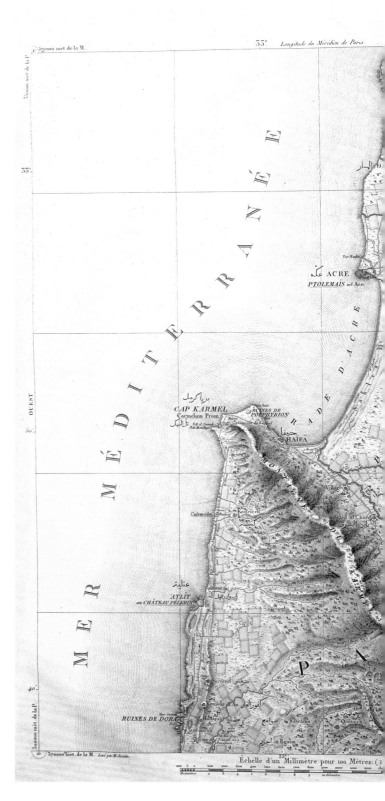

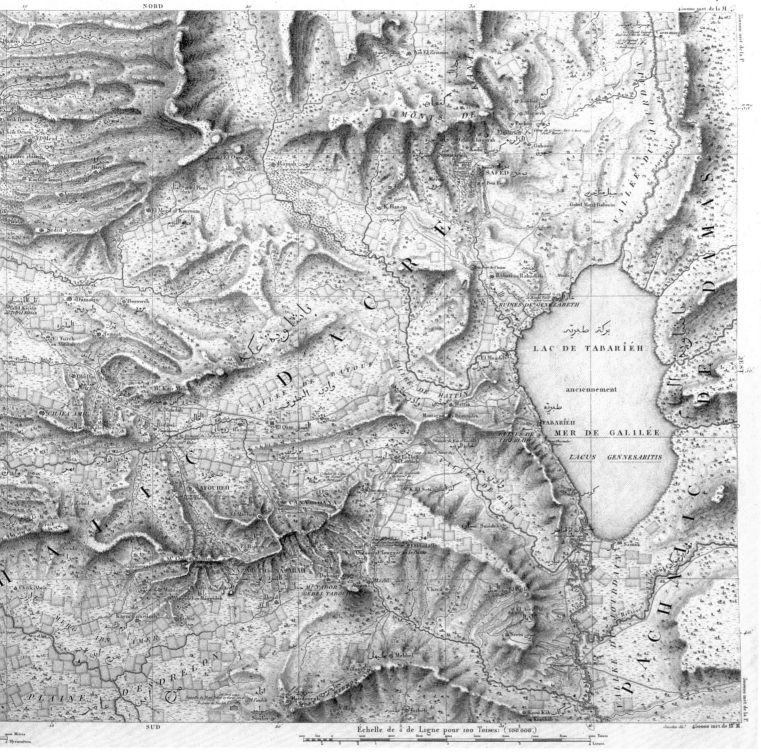

1. A map of 'Acre, Nazareth, le Jourdain', from the
Jacotin Map, commissioned by Napoleon Bonaparte in
1799, printed in 1808 but not made public until 1817

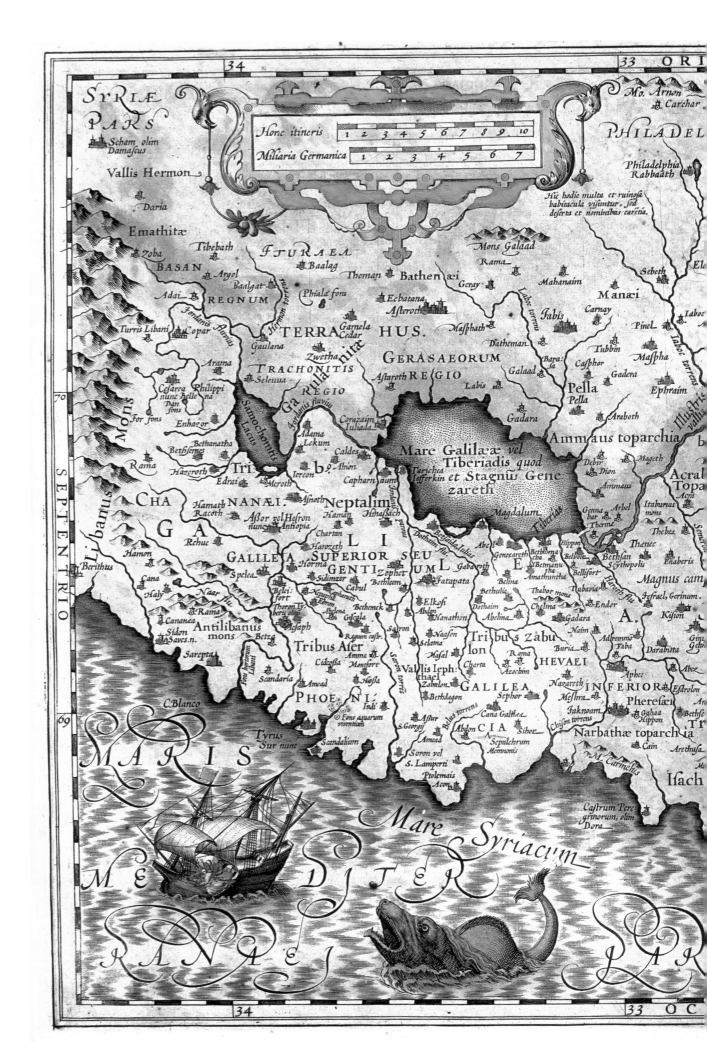

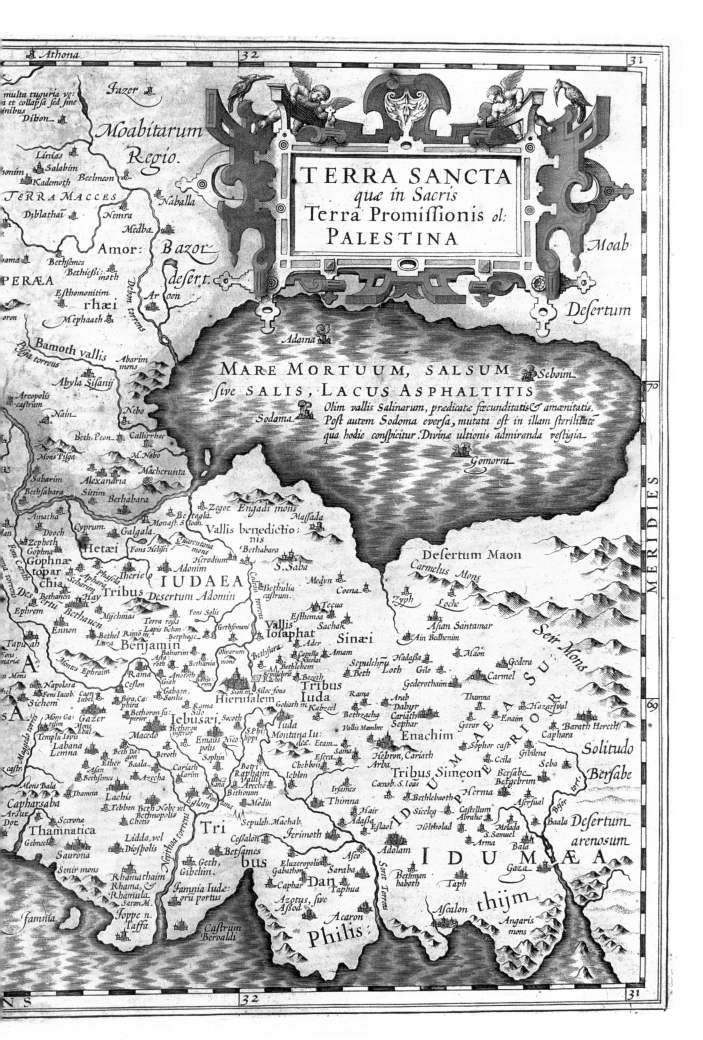

3. Abraham Ortelius's map of the Holy Land, engraved by Christian Schrot, which appeared in *Theatrum Orbis Terrarum* in 1584, the first modern atlas

II – Maps

The Holy Land, and particularly Jerusalem, in relation to its size is probably the most mapped spot on earth. From the end of the fifteenth century when the first map of Jerusalem was printed until the beginning of the nineteenth century, over 300 maps of Jerusalem (here we mean geographical maps as well as views) were drawn and printed. Most of these are views of the city. Most maps were inaccurate and based on biblical stories with imaginary cartouches.

From the beginning of the nineteenth century, and with the advent of geographical maps based on accurate surveys, hundreds of maps of Jerusalem and the Holy Land appeared, and also a few atlases. Many of the maps appeared in travel books and Bibles – see, for instance: Fuller (1662), Reland (1714), Shaw (1738), de Volney (1787), all of which are in the Collection. However, we are here concerned with recording only some of the geographical maps prior to the nineteenth century, of which the Collection has some fine examples. Only a few of these are recorded below. Reference is made where relevant to the numbering in Eran Laor's definitive work, *Maps of the Holy Land*.

～ 3 ～

ORTELIUS, Abraham (1527-1598)
Map of the Holy Land 1584
(Illustration pp. 214-15)
Terra Sancta, quae in Sacris Terra Promissionis, Ol(im) Palestina
Original copper engraving
36.5 x 50 cm.
A map of Palestine (the Holy Land) on both sides of the Jordan; from *Theatrum Orbis Terrarum* (Theatre of the Sphere of the Earth), with cartography by Christian Schrot, published in Antwerp by Abraham Ortelius. The engraver was Frans Hogenberg (1535-1590), scion of an old Flemish family of artists in Mechlin (Malines). For some of Hogenberg's later work see below, George Braun (no. 13).

The *Theatrum...* was the first 'complete' atlas, composed of maps of all known parts of the world according to the latest knowledge of contemporary geographers. The 70 maps of the first issue were, in the course of time, partly replaced by plates based on more recent research. Five supplements brought the contents of the atlas up to a final 178 maps. Between 1570 and 1697, more than 70 different editions of the *Theatrum* appeared, in Latin, Dutch, German, French, Spanish, English and Italian.
Laor 543

～ 4 ～

MÜNSTER, Sebastian (1488-1552)
Map of Palestine 1592
(Illustration p. 19)
26 x 16 cm.
Woodcut
A nice early woodcut map, with two blocks of German text, from Münster's *Cosmographia Universalis* which first appeared in 1544 and went through numerous editions in Latin, German (as ours), French, Italian and Czech. The map shows the eastern Mediterranean, with the coastline from southern Asia Minor to the Nile delta, and details the Holy Land, with emphasis on Jerusalem. It includes Cyprus (with a ship and a monster in the sea), all the important east Mediterranean ports, early cities and regions of Palestine as far south as Egypt and places further east including Damascus, Petra and Medina.

Münster, a German theologian, mathematician and cartographer, settled in Basel as professor of Hebrew and reader in mathematics and cosmography, but later he concentrated solely on cosmography. His first publication was a Latin edition of Ptolemy's *Geography*; but his most celebrated work was the *Cosmographia*, from which this map comes. The Collection also has a view of Jerusalem by Münster (see 14 below).
Laor 528C

～ 5 ～

LA RUE, Philippe de (active mid-17th century)
The Collection contains some maps by Philippe de la Rue, including the following:

a) **Map of Canaan in the Time of Abraham** 1651
Terra Chanaan ad Abrahami tempora... Auctore Ph.

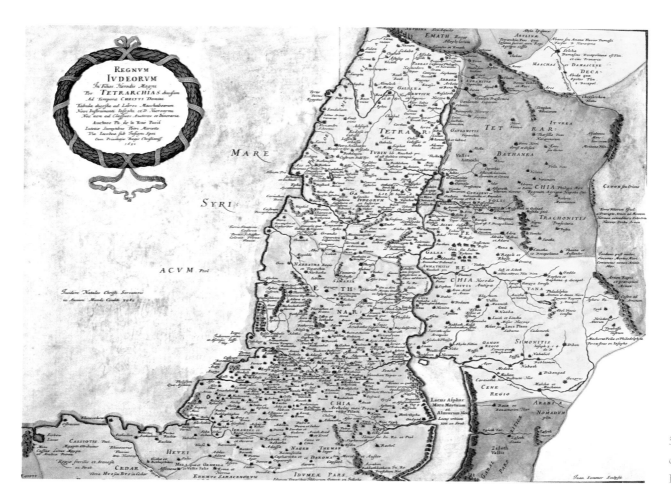

De la Rue. J. Somer sculp. Parisi., Sumptibus Petri
Mariette.

41.8 x 56 cm.

Coloured copperplate

The map shows the whole Phoenician-Palestinian
coast and the Nile Delta. In the right-hand bottom
corner is an inset map: 'Abrahe Peregrinatio'. One of
the series of biblical maps published by the French
cartographer Philippe de la Rue in his *La Terre
Sainte en six cartes géographiques*, Paris (Pierre
Mariette) 1651.

Laor 415

b) **Map of Central Palestine** 1651

Regnum Iudeorum... Auctore Ph. de la Rue Paris,
Sumptibus Petri Mariette.

39.6 x 54 cm.

Coloured copperplate

This map, from the same source as a) above, shows
the Phoenician-Palestinian coast and both sides of
the Jordan.

Laor 418

~ 6 ~

BLOME, Richard (*c.* 1660-1705)

Canaan, Commonly Called the Holy Land 1687

(Illustration p. 218)

Engraved by Richard Palmer for Richard Blome.

26 x 45 cm.

Copperplate

A map of Palestine oriented to the west, with the
coastline running from Biblium (Byblos) to
Rhinocolura (al-'Arish) and showing the division of
the land at the time of Jesus into Galilee, Samaria
and Judaea.

Laor 112

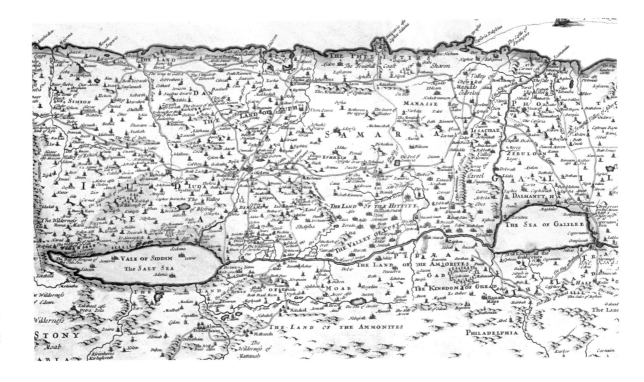

~ 7 ~

RELAND, Adrian (1676-1718)

Facies Palaestina 1714

'The Appearance of Palestine', from Reland's *Palaestina ex Monumentis Veteribus*, published in Utrecht by Willem Broedelet in 1714 (see p. 192, no. 77).

56 x 49.5 cm.

Copperplate

The map shows Palestine on both sides of the Jordan in Roman times. The coastline runs from Sidon to Rhinocolura (al-'Arish) and the land is divided into three main regions. At bottom left the port of Jaffa forms the background to the illustration of a woman in chains.

Laor 643

~ 8 ~

DUNN, Samuel (?-1794)

Countries and Places Mentioned in the New Testament 1774

Inset are a plan of Jerusalem and a map of the region around the city.

30 x 45 cm.

Etching, outlined in colour

Not in Laor

~ 9 ~

VAUGONDY, Gilles Robert de (1686-1766)

The Collection contains a few of de Vaugondy's original maps, including:

a) **Judée ou Terre Sainte** 1790

Engraved by E. Dussy and published in Paris by Charles François Delamarche.

24.4 x 21.7 cm.

Copperplate

Three maps of the Holy Land, geographically identical but varying in political divisions, with the coastline running from Sidon to Gaza, and reaching inland to show both sides of the River Jordan.

Laor 670

b) **La Judée ou Terre Sainte divisée en ses douze Tribus** 1793

Published in Paris by Charles François Delamarche.

48 x 59 cm.

Copperplate

A large map of Palestine showing both sides of the Jordan and the coastline from Sidon to Gaza. An inset map shows the Nile Delta, Sinai and Canaan.

Laor 667

c) **Carte de la Terre Sainte partagée... aux douze Tribus** *c.* 1797

Engraved by G. Delahaye; published in Paris 'Chez Delamarche'.

48.3 x 68 cm.

Copperplate

The map shows Palestine, with the coastline running from Sidon to Rafah, and extends to the eastern side of the Jordan river.

Laor 673

— 10 —

LABORDE, Léon Emmanuel Simon Joseph, Marquis de (1807-1869)

The Collection contains two original maps by the renowned French traveller and writer, Marquis Léon de Laborde:

a) **Original Manuscript Map of Petra** 1836
(Illustration p. 183)

23 x 38 cm.

Sepia and ink, showing relief by hachuring

Laborde travelled with the well-known Louis Linant de Bellefonds, who at that time was in service with Muhammad Ali as a hydraulic engineer. They set out in February 1828 from Cairo, where Laborde had established himself after his long journey in Asia Minor and Syria (1826-27), and made their way to Petra via Suez and Mount Sinai.

Both Burckhardt (q.v.) and Irby and Mangles (q.v.) had explored Petra before Laborde, but Laborde was the first to be able to make plans, views and maps of the area. This appeared as the engraved map in Laborde's *Journey Through Arabia Petraea To Mount Sinai And the Excavated City of Petra* (first edition, 1836; the second edition, published in 1838, is in the Collection, p. 183, no. 50).

b) **Original Manuscript Map of Egypt** 1830

42 x 26.5 cm.

Sepia and ink with water colouring, showing relief by hachuring

This manuscript map of Egypt and Sinai displays city names from Graeco-Roman times.

III – Views and Plans of Jerusalem

The Collection and the literature contain a huge number of views and plans of Jerusalem during the Ottoman period. As already mentioned, there are few places in the world that were as frequently depicted in views, plans and prints as the Holy Land, particularly Jerusalem. What we are mainly concerned with here is the development of views and plans of Jerusalem during the Ottoman period.

The oldest surviving plan of Jerusalem, the Madaba map, was discovered in 1881 in the Church of St George in Madaba, east of the Jordan (described above). Not a single original map survives from the early Islamic period (638-1099). Christian map-makers in Europe continued to give graphic expression to Jerusalem as the centre of the world; such maps are called *Orbis Terrarum*. These were, of course, manuscript maps, most were circular, and Jerusalem was presented as a magnificent city, thus giving the impression of the map-maker rather than reality. After Gutenberg invented the printing press in the fifteenth century, there was a surge of interest in plans of Jerusalem, because these could now be printed and reproduced in large numbers.

As already mentioned, there were only 300 maps or views of Jerusalem before the beginning of the nineteenth century. Following the opening of the country to travellers, pilgrims, tourists and artists there was an avalanche, running into thousands, of maps and views of the Holy Land, particularly of Jerusalem. Most of the nineteenth-century books mentioned elsewhere in this catalogue contain maps as well as lithographs and steel prints of the Holy Land, and invariably the majority of these were plans of Jerusalem. Many are covered in our record of Valuable Plate Books. In this section we are only concerned with Jerusalem views prior to 1800, in which the Collection is rich, but only a few of the more valuable views are recorded below.

We must start by distinguishing between two sets of views. On the one hand there were the realistic views, which tried to portray the city in as accurate a manner as possible. These were based on actual visits to Jerusalem and mapping it (original views), or a modification of existing views (derivatives). On the other

hand there are the imaginary views and maps of ancient Jerusalem (maps and views based on Reisner and Adrichom, Villapando, Laicstein, the Visscher family). The realistic views have at their centre the Dome of the Rock, while the imaginary views have a temple.

The Collection contains many realistic views and a few imaginary ones. We shall record below only the realistic views because they relate to Jerusalem as it existed in the Ottoman period. These views (over the period 1489-1799) were mainly created by pilgrims to the Holy Land, who were usually cared for by the monks of the Franciscan order in Jerusalem, Custodia Terrae Sanctae. Some of the best realistic views were made by Franciscan fathers who served in Jerusalem (de Angelis, 1578; Amico and Quaresmius, 1639), or by Franciscan pilgrims (Bianco and Zeinner). Many other views appeared in Europe by imitators who never visited the city, but who based their work on these views drawn by pilgrims or visitors.

The first printed realistic map of Jerusalem and the Holy Land was that of Bernhard von Breydenbach who visited the Holy Land in 1483. In 1486 he published a book which included a large folded map of the Holy Land with Jerusalem as its centre. The map was printed on large sheets and includes Mecca, Sinai, the Nile and Alexandria, while its left-hand border (i.e. north) reaches to Beirut and Damascus. Jerusalem fills the centre of the map and is depicted as it appears from the Mount of Olives. This map was the background for many copies, or new views of Jerusalem, which appeared in the sixteenth century (Duchetti, du Perac, van Schoel and Orlandis). In the middle of the seventeenth century a famous view of Jerusalem, based on Breydenbach but with modifications, was produced by Matthäus Merian (Frankfurt 1645; see no. 15 below) and was imitated by many others, including Jansson.

Other important views of Jerusalem which were copied by others are those of Hermanus Borculus ('Civitas Hierusalem', Utrecht 1538). These were copied by Ligorio (Rome 1559) and Camocio (Venice 1570); and the famous Sebastian Münster view (Basel 1544; see no. 14 below) was based on the Borculus map, as was Noè Bianco's miniature (no. 12).

In the last decade of the sixteenth century Amico served in Jerusalem and wrote a book on the city's holy places, *Trattato delle Piante e Immagini de Sacri Edifizi di Terra Santa* (Firenze 1620: in the Collection, p. 168, no. 3). This included a well-known view of Jerusalem which was later abundantly copied by others, including O. Dapper who never visited the Holy Land but still wrote a book about it (Amsterdam 1677), and F. Halma (Leeuwarden 1717: see below, no. 18).

With the passage of time an increasingly scientific trend led gradually to a more faithful and realistic portrayal of the city. This matured in the nineteenth century with Sieber's map of Jerusalem in 1818, followed by Frederick Catherwood's and many others until Charles Wilson's fully scientific map for the British Ordnance Survey in 1864-65 (described above). His maps were the first to use contour lines to show topography. In this century there were probably more plans of Jerusalem than of any city in the world.

All realistic plans of Jerusalem have the Islamic al-Aqsa Mosque and Dome of the Rock in the centre. This was, and still is, the most significant site in Jerusalem, and a symbol of the city.

～ 11 ～

BREYDENBACH, Bernhard von (1440-1497)
Jerusalem and the Holy Land 1486
29 x 66 cm.
Woodcut
Probably the first ever printed view of the whole of the Holy Land and drawn by someone who had actually been there Erhard Reuwich's view appeared in Bernhard von Breydenbach's *Peregrinatio in Terram Sanctam*, Mainz 1486
Breydenbach was a cleric who in 1483 set out on a pilgrimage to the Holy Land, accompanied by a large entourage. This included Erhard Reuwich, a Flemish artist who drew this view of Jerusalem and the Holy Land which became a reference for other illustrators to copy. It is relatively realistic in depicting Jerusalem and it is the earliest and most important view of the city. In its original form the view depicts a wide range of the Levant with Jerusalem, in detail, at its centre. This is a much reduced coloured copy of the original view.
Laor 129

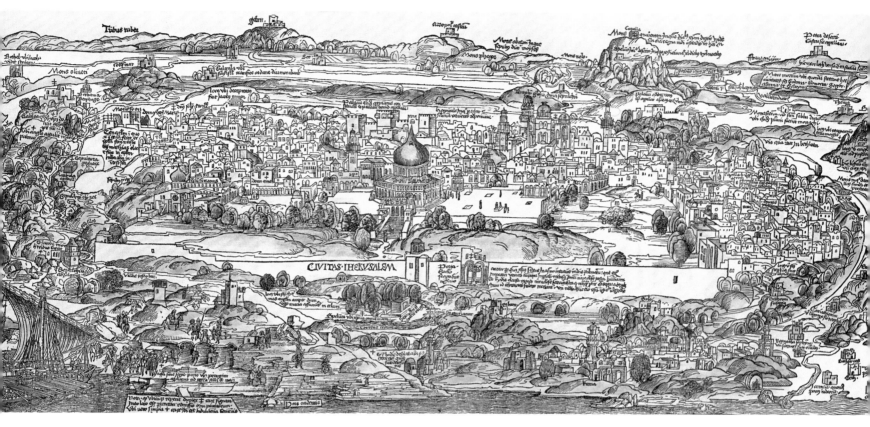

11. Erhard Reuwich's view of Jerusalem and the Holy Land which appeared in
Bernhard von Breydenbach's *Peregrinatio in Terram Sanctam* in 1486

~ 12 ~

BIANCO, Noè (active early 16th century)

Hierusalem 1521

11 x 8.5 cm.

Woodcut in the text

This small and partial view of Jerusalem is based on the Reuwich/Breydenbach view (see 11 above) and shows the Golden Gate, the Dome of the Rock and the Holy Sepulchre. It appeared in Bianco's *Santissimo viagio de Hierusalem...*, a handbook for pilgrims published by Nicolo Zopino in Venice in 1521. This work is not, in fact, by Bianco but was originally published in Bologna in 1500 under the name of Joanne Cola and is based on Breydenbach's *Peregrinatio*. Having been adopted by Bianco, it appeared in numerous editions over the next 200 years.

Laor 957

~ 13 ~

HOGENBERG, Frans (1535-1590)

There are two important views in the Collection, published by Georg Braun, or Joris Bruin (1541-1622), a German priest, historian and topographer, in collaboration with the engraver Frans Hogenberg:

a) **Hierosolyma, Clarissima totius Orientis civitas, Iudaee Metropolis... Hoc tempore Hierosolyma Turcis Cuzumbarech dicitur** 1572

33.7 x 48.3 cm.

Copperplate

'Jerusalem, the most Famous City in all the East, Metropolis of Judaea... In these days Jerusalem is called in Turkish [Arabic] Quds al-Mubarak...' Two plans of Jerusalem on the same sheet – left: an imaginary topographical representation of the city at the

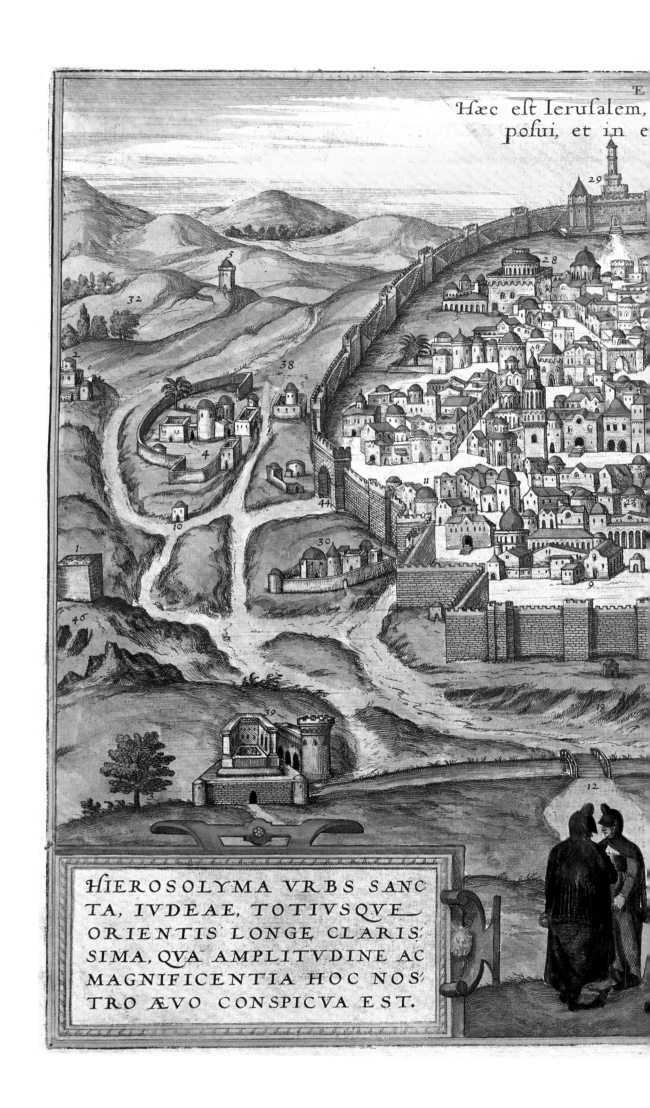

Hæc est Ierusalem,
posui, et in e

29

32

5

28

2

38

5

4

11

44

30

10

9

1

46

39

19

3

12

HIEROSOLYMA VRBS SANC
TA, IVDEAE, TOTIVSQVE
ORIENTIS LONGE CLARIS·
SIMA, QVA AMPLITVDINE AC
MAGNIFICENTIA HOC NOS·
TRO ÆVO CONSPICVA EST.

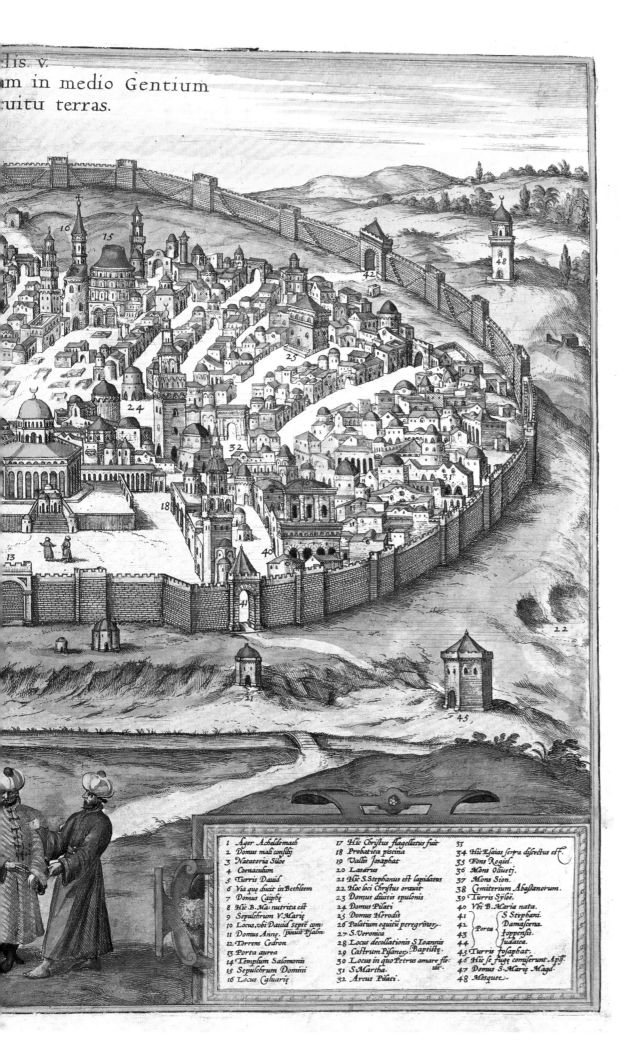

lis. v.
m in medio Gentium
uitu terras.

1. Ager Acheldemach	17. Hic Christus flagellatus fuit	33.
2. Domus mali consilij	18. Probatica piscina	34. Hic Esaias serra dissectus est
3. Natatoria Siloe	19. Vallis Josaphat	35. Fons Rogiel
4. Coenaculum	20. Lasarus	36. Mons Oliueti
5. Turris Dauid	21. Hic S. Stephanus est lapidatus	37. Mons Sion
6. Via que ducit in Bethleem	22. Hoc loci Christus orauit	38. Cemiterium Abastanorum
7. Domus Caiphe	23. Domus diuitis epulonis	39. Turris Syloe
8. Hic B. Ma: nutrita est	24. Domus Pilati	40. Vbi B. Maria nata
9. Sepulchrum V. Marie	25. Domus Herodis	41.
10. Locus, ubi Dauid septe com:	26. Palatium equitu peregrinor:	42. Porta { S Stephani, Damascena, Ioppensis, Iudaica }
11. Domus Anne. Iposuit Psalm:	27. S. Veronica	43.
12. Torrens Cedron	28. Locus decollationis S Ioannis	44.
13. Porta aurea	29. Castrum Pisanor: Baptiste	45. Turris Josaphat
14. Templum Salomonis	30. Locus in quo Petrus amare fl: uit	46. Hic se fuge comiserunt Apli
15. Sepulchrum Domini	31. S. Martha	47. Domus S. Marie Magd.
16. Locus Caluarie	32. Arcus Pilati.	48. Mosquee

13b. 'Jerusalem, the Holy City…', engraved by Frans Hogenberg for Georg Braun's *Civitates Orbis Terrarum* of 1572

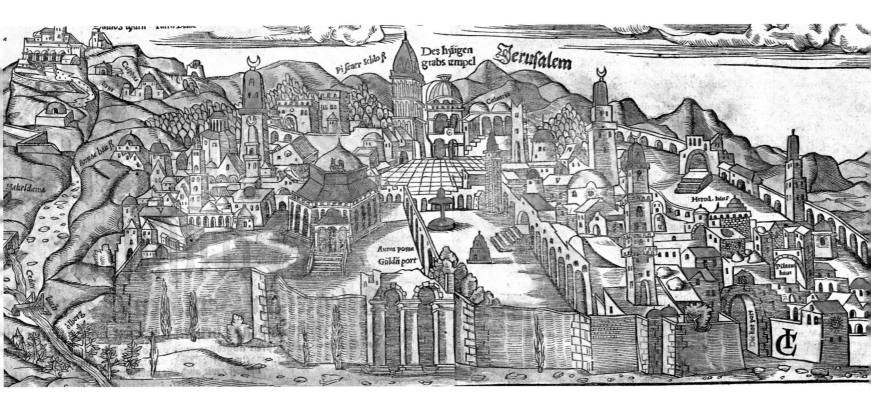

time of Jesus; right: a topographical representation of the modern city. It was plate 53 from Vol. I of *Civitates Orbis Terrarum* (Cities of the Earth's Sphere), a collection of 362 double-page plates with more than 600 views of towns throughout the world. It was published in six volumes at Cologne between 1572 and 1618 by Georg Braun with engravings by Frans Hogenberg. Hogenberg, from a Flemish family of artists in Mechlin (Malines), worked for Abraham Ortelius in Antwerp (see 1 above) before settling in Cologne where he engraved most of the copperplates for this monumental pictorial atlas. His son Abraham Hogenberg later took his place as co-editor of the *Civitates* and engraver of its illustrations.
Laor 1039

b) **Hierosolyma Urbs Sancta, Iudeae, Totiusque Orientis Longe Clarissima, Qua Amplitudine Ac Magnificentia Hoc Nostro Aevo Conspicua Est** 1572
(Illustration pp. 222-23)
32.7 x 41.3 cm.

Copperplate
'Jerusalem, the Holy City, for a Long Time the Most Famous City of Judaea and the East, in her Present Time, Size and Greatness.' This bird's eye view of the city, seen from the east, formed plate 54 of Vol. 2 of *Civitates Orbis Terrarum*.
Laor 1040

~ 14 ~

MÜNSTER, Sebastian (1488-1552)
Die Heylige Statt Jerusalem contrafehtet nach Form und Gestalt wie sie zu untern Zeiten erbawen ist 1600
18 x 39 cm.
Coloured woodcut
Published in Basel by Heinrich Petri (1588-1628)
'The Holy City of Jerusalem shown in the form and character as it is built in our times.' Another important view of Jerusalem, which followed a large wood-cut view by Hermanus Borculus of Utrecht in 1538 (not in the Collection). It also borrowed from Breydenbach's view. This view first appeared in

Münster's *Cosmographia Universalis*, Basel 1544, and later in many Latin and German editions (as ours).
Laor 1087

~ 15 ~

MERIAN, Matthäus (1593-1650)
Jerusalem *c*. 1645
21 x 34 cm.
Coloured copperplate
This view, printed in Frankfurt around 1645, follows that of Breydenbach (above, no. 11), but modified. Merian's version, one of the best known views of Jerusalem, was imitated by many other engravers later.
Laor 1982

~ 16 ~

JANSSON, Jan (1588-1664)
Jerusalem Turcis Cusembareich, Nazareth, Ramma 1657
(Illustration pp. 226-27)
37 x 50 cm.
Coloured copperplate
'Jerusalem, in Turkish [Arabic] Quds al-Mubarak…'
This print, made in Amsterdam in 1657, contains three views on the same plate: a bird's-eye view of Jerusalem as seen from the Mount of Olives (an imitation of Merian's plan), and below it plans of Nazareth and Ramma (Ramleh).
Laor 1050

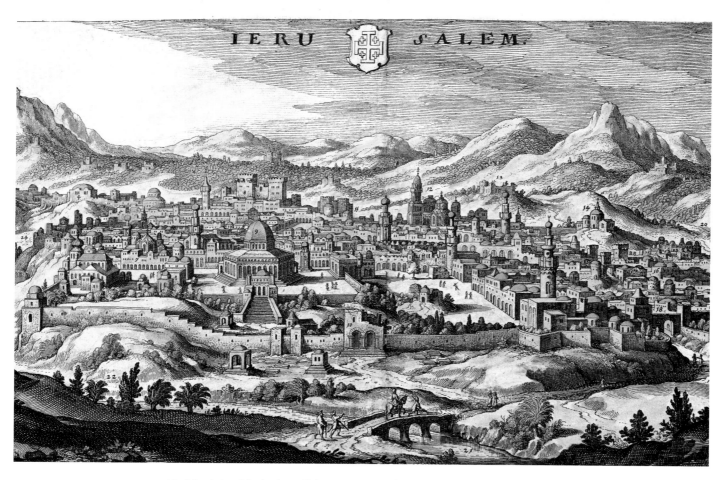

15. Matthäus Merian's well-known view of Jerusalem, published c. 1645, was imitated by many later engravers

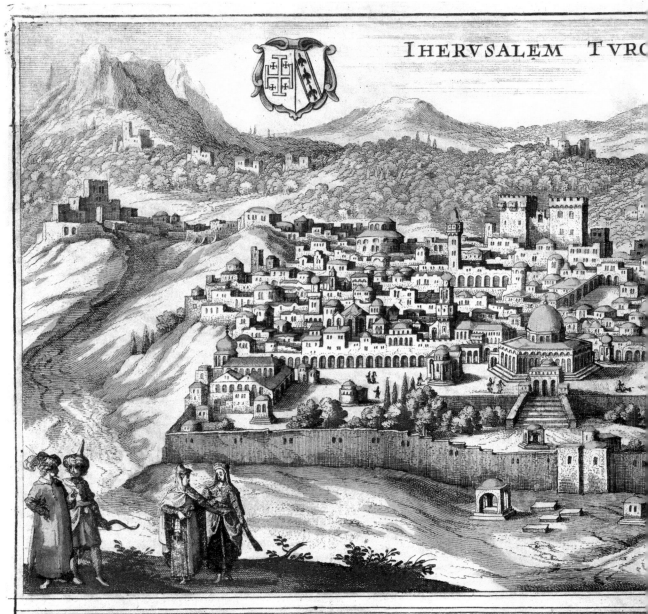

IHERVSALEM TVRC

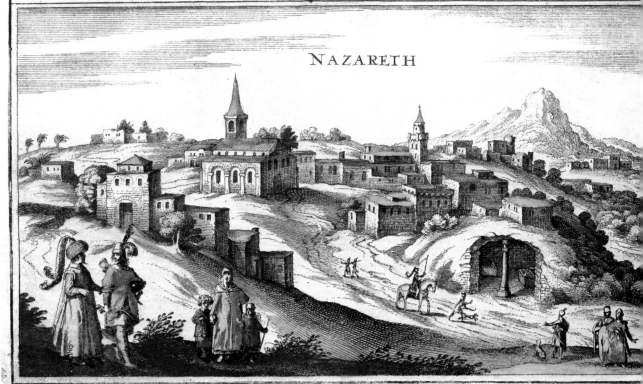

NAZARETH

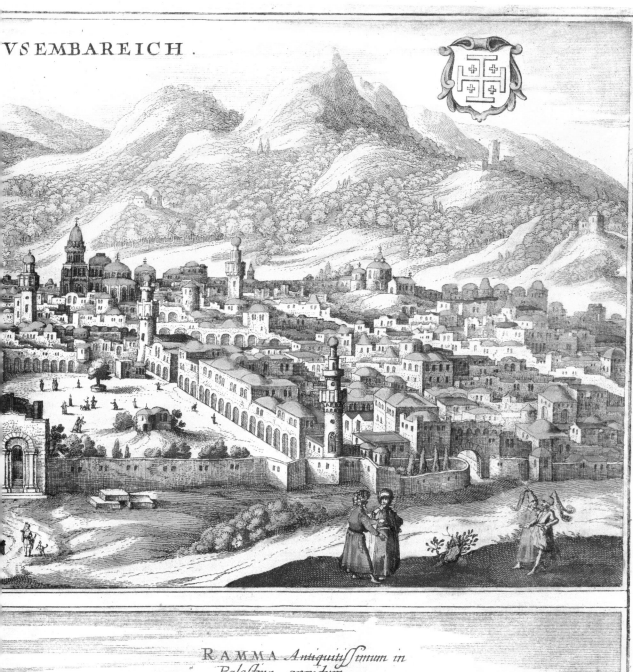

VSEMBAREICH.

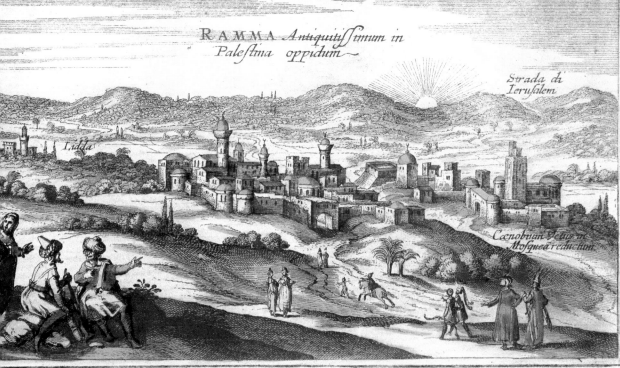

RAMMA *Antiquißimum in Paleſtina oppidum*

Lidda

Strada di Ieruſalem

Cœnobium Vetus in Moſquea reductum

16. Jan Jansson's 1657 view of Jerusalem from the Mount of Olives, with plans of Nazareth and Ramma (Ramleh) below

~ 17 ~

MALLET, Alain Manesson (1630-1706)
Jerusalem Moderne 1685
(Illustration p. 208)
14.5 x 9.5 cm.
Woodcut
A small woodcut view of modern Jerusalem as it appeared in Mallet's book *Description de l'Univers*, Frankfurt 1685.
Laor 1077

~ 18 ~

BOROWSKY, G. (active early 18th century)
Prospeckt der heutigen Stadt Jerusalem 1710
(Illustration: endpapers)
30 x 50 cm.
Coloured copperplate
'View of Today's City of Jerusalem'. This perspective view of the city in the early eighteenth century was engraved by F. Kraus, with a detailed key below. It was published in Vienna in 1710.
Laor 963

~ 19 ~

HALMA, Franciscus (1653-1722)
Die Stadt Jerusalem 1717
20 x 33 cm.
Coloured copperplate
This view of the modern city of Jerusalem appeared in Halma's book *Kannan en domleggende Ladden*, Leeuwarden 1717. It is after Amico's view in *Trattato delle Piante & Immagini de Sacri Edefizi di Terra Santa*, Florence 1620 (p. 168, no. 3).
Laor 1033

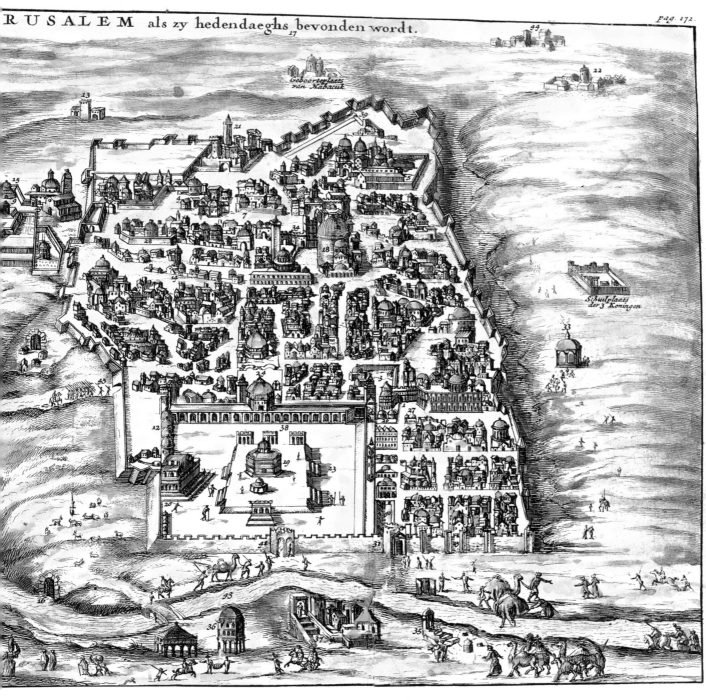

RUSALEM als zy hedendaeghs bevonden wordt.

Geboorteplaets
van Habacuk

Schuilplaets
der 3 Koningen

19. 'Die Stadt Jerusalem' from Halma's *Kannan en domleggende Ladden* of 1717

CHAPTER NINE

~ Photography in the Holy Land ~

The techniques of photography developed by Louis Daguerre were first made public on 19 August 1839, and even before the end of that year a pioneer photographer, the Frenchman Frederic Goupil Fesquet, was at work in Palestine. Thus the Holy Land was one of the first areas in the world to be photographed. Jerusalem in particular, with its religious sites, was highly suited to topographical photography and it is estimated that during the nineteenth century there were as many as 300 photographers active at one time or another in Palestine.

Fesquet was followed by many others, mainly French and British but there was also a scattering of Americans, Russians, Germans and Italians. In 1844 Joseph Philibert Girault de Prangey, a French expert on Islamic architecture, visited Jerusalem in the course of an extended expedition around the Mediterranean on which he took more than 1,000 photographs, including several of Jerusalem. Many of these were preserved and are still available. In the same year the Scotsman George Skene Keith arrived, his main interest being biblical authentication, and engravings made from his photographs illustrated many books. Fesquet, de Prangey and Keith all took 'daguerreotypes' which achieved a high quality of print but the main disadvantage of this process was that only one positive image could be made from each exposure.

Meanwhile progress was being made with another photographic process, which produced a 'calotype' negative, invented by Englishman William Henry Fox Talbot about the same time as the daguerreotype. Initially the quality of print produced by the calotype was not as good as that of the daguerreotype, but its great advantage was that several positive images could be made from one negative and it soon became popular. The first photographer to take calotypes in Jerusalem was probably the Rev. George W. Bridges, a friend of Fox Talbot, who visited in 1849-50. He was fol-

Opposite:
Detail of a rare Diness albumen photograph of Bethany (*al-Auzreeh*), taken in 1857

The entrance to the Holy Sepulchre. This photograph appeared under Francis Frith's name (see below, no. 2), but was probably by Good c. 1867. Though exposure times were much reduced by the late 1860s, not all the people in this photograph managed to stay still as long as was required

lowed by the Frenchman Maxime du Camp (also using the calotype process) who arrived in 1850 with the writer Gustave Flaubert, both of them on official visits on behalf of the French government. Another Frenchman, Auguste Salzmann, produced magnificent calotype studies of Jerusalem in 1852 which are still available.

Some foreign photographers lived for several years in Jerusalem, notably the Scotsman James Graham who arrived in 1853 and gained a considerable reputation. The Rev. Albert Augustus Isaacs visited Jerusalem in 1856 and, with Graham's help, photographed extensively (calotypes) and published many books with lithographs based on his photographs. One of these, a rare plate book, is in the Collection (pp. 153-54, no. 6). Both daguerreotypes and calotypes were soon replaced by prints

made from wet collodion glass negatives, introduced in 1851; though cumbersome, they considerably reduced the exposure time required. Twenty years later dry gelatin replaced collodion and made the whole process simpler and quicker. The long exposure times required in the early days meant that most photography had concentrated on stationary subjects, particularly topographical sites. For daguerreotypes, exposure could take up to 15 minutes, making it difficult to photograph people, but with gelatin this was reduced to one second, hugely extending the range of possible subjects.

With the advancements in printing, expert artists began making prints and engravings from photographs. Until the 1870s it was difficult to print photographs directly into books, while engravings could be produced easily from the original printer's block. But in the 1850s a new style of book began to appear, in which original photographs, now usually printed on light-sensitive albumen-coated paper, were glued to the pages and the text was mainly an explanation of the photographs.

The first local photographer was Mendel John Diness, a Russian Jew who came to Jerusalem in 1846 and was baptized by the British consul, James Finn, in 1849. It was the friendship between Finn and Diness that brought the latter to photography. When James Graham arrived in Jerusalem in 1854 he had the idea to teach photography to a local Christian and chose Diness, to whom Mrs. Finn gave her rarely-used camera. Soon the pupil was taking better photographs than the teacher. During his active years in the city, Diness met other British photographers – John Cramb, James Robertson, Titus Toiler and Mason Turner – who thought him comparable to the best European photographers.

Diness was the victim of an early case of photographic piracy in the Near East when the Italian architect Ermete Pierotti published an album on Jerusalem architecture in 1864 entitled *Jerusalem Explored* (in the Collection, p. 189, no. 72, and pp. 190-91). It was illustrated with lithographs made from photographs credited to the author, but eventually Pierotti had to acknowledge that the photographs had been taken by Diness. His excuse for the credit was that he owned the prints.

After the death of his wife Rebecca in 1858, and because of his inability to compete with another local photographer, Peter Bergheim, Diness left Jerusalem in the early 1860s and emigrated to the United States. Except for an album in the collection of the Israel Museum, all Diness's photographs and negatives disappeared and were only rediscovered in 1989 in a garage sale in the United States. There is no indication of the extent of his work, but the quality of the existing images, as well as of the lithographs in Pierotti's album, testifies to a sensitive eye and a careful operator. His knowledge of the countryside and of the light conditions was obviously a major help in his pro-

A self-portrait by Khalil Ra'ad; undated, but probably c. 1940

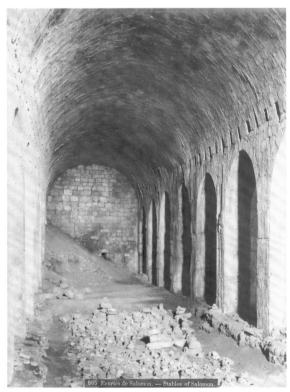

A. Bonfils, photgraph of the so-called 'Solomon's Stables' beneath the Haram al-Sharif, now a mosque (Masjid al-Marwani); 1890s

duction of successful images. A rare original albumen photographic print by Diness is in the Collection (see p. 230).

Another local photographer was the Armenian priest Yessayi Garabedian, who later became the Patriarch of the Armenian Church. As a photographer he was active in the late 1850s, founding his own portrait studio with Father Yezekil Kevork and Deacon Garabed Krikorian as his assistants, both of whom later established their own studios. In the 1870s Garabed Krikorian opened the first local studio in Jerusalem for commercial photography.

One of Krikorian's pupils was the first Arab photographer, Khalil Ra'ad, who had settled in Jerusalem in 1890. In 1897 he established his own studio near the Jaffa Gate, directly opposite Krikorian's and became his ex-teacher's competitor. He later married Krikorian's daughter and the two became partners, together with Krikorian's son Hovhannes who had studied photography in Germany and who married Ra'ad's niece. Ra'ad remained active in Jerusalem until 1948. Some 1,263 of his negatives were presented by his daughter to the Institute for Palestine Studies and were used extensively to illustrate the book *Before the Diaspora – A Photographic History of the Palestinians, 1876-1948*. Part of his archive was reportedly destroyed in the 1948 war. A few of Ra'ad's orig-

inal glass lantern slides are in the Collection. These include a self-portrait, Ra'ad's studio shop (his wife? seated) and the interior of the Dome of the Rock.

All these photographers were members of the local Christian community. Among Muslims and Jews photography took longer to be adopted as a profession because of religious beliefs which rejected the making of images, particularly of human beings.

The interest of Europeans in the Holy Land and its scenes, coupled with the improvements in the photographic process and also better travel facilities, led to a rapid

One of Zangaki's rare photographs from the Holy Land, showing the courtyard in front of the Holy Sepulchre over flowing with church dignitaries and worshippers on Easter Day; late 19th century

increase in photographic activity in Jerusalem. Subjective photographers, prompted by religious and biblical interests, or by scientific and archaeological motives, had been the first to work in Palestine in the mid-nineteenth century. They were now joined by a new class of 'commercial' photographers – those like Bonfils, Frith, and Good who were anxious to sell their photographs to tourists.

Tourists' photographic requirements in the 1860s and 1870s were met by the various studios which were established in the Middle East. The best known was that of the Bonfils family in Beirut, who opened branches in Jerusalem, Cairo, Alexandria and Baalbek and became enormously prolific and popular from 1867 until after World War I. Another active studio was started by the Cretan (or Cypriot) Zangaki brothers, based in

An American Colony advertising leaflet; *c.* 1930

Port Said, who were noted not only for their views but also for depicting the life of local people. Their photographs of the Holy Land are rare, but the PEF inherited some of their original negatives. Also prominent in the 1880s was the Italian Luigi Fiorillo in Aswan, who made at least one visit to the Holy Land and was photographer to the Russian Imperial Orthodox Palestine Society. Some of his later photographs are signed 'V. L. Fiorillo et Fils' or, confusingly, 'Marquis and Fiorillo'.

After 1890, with the widespread use of dry gelatin, photography became simpler, many more local photographers appeared and more studios opened to sell photographs to tourists. These were mostly owned by Arabs or local Armenians, and included Maroum and Boulus Meo, whose shops remained open till 1998. Also locally based, but foreign owned, was Vester's American Colony studio, whose photographers were among the most active in Jerusalem. By the turn of the century their work was both comprehensive and very prolific and, although mainly intended to be sold to tourists, many of their photographs were included in books. They are now regarded as a major reference to Jerusalem in the nineteenth and early twentieth centuries.

From the early 1860s photographers had started to experiment with adding colour, and chromolithography was introduced. Another technique was that of hand-colouring and tinting lantern slides. But the most successful and impressive photographic technique was that developed by Photoglob of Zurich in the 1880s. In the 1890s their first photographic colour postcards began to appear and soon became very popular with tourists. The Photoglob photographs are renowned for their brilliant colouring. The process called photochromy had been developed in Zurich by Orell, Füssli and Co. in 1887. The English Photochrome Company, which was not formed until 1896,

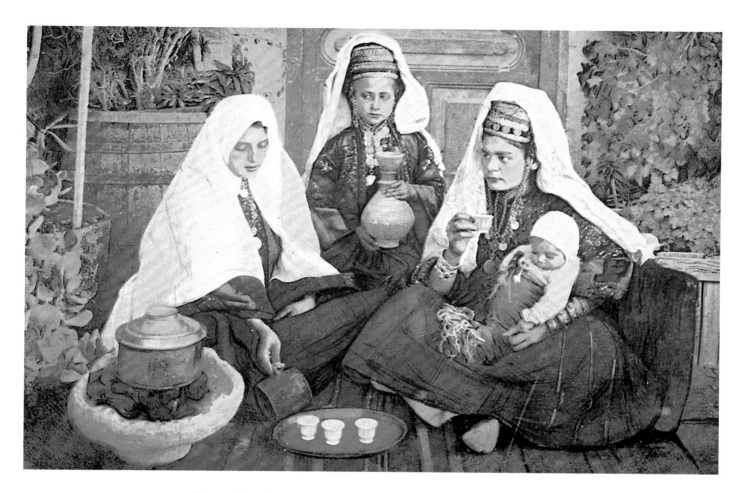

Photoglob coloured postcard of women in Bethlehem; early 1900s

produced vast quantities of postcards but no large photographs and did not achieve the same standards as the Zurich company. The process is not colour photography, but rather the use of collotype photolithography with a solution of asphaltum of ether and involves as many as 16 printings of different colours. The Photoglob prints of the Holy Land were made from photographic prints or negatives by several photographers, including Zangaki or, more usually, Bonfils. Various editions of the Baedeker guide to Palestine recommended to tourists the photography of Bonfils, the American Colony and the coloured photographs (postcards) of Photoglob of Zurich.

To what extent did photography in the nineteenth century depict the real Palestine? No doubt it was much more faithful in its representation of reality than romantic and decorative paintings but, even so, many photographers continued to try to present Jerusalem in a romantic light. Most western photographs were influenced by the photographer's personal impressions and attitudes towards the Holy Land, trying to portray the place and its people as fascinating, picturesque, mysterious and exotic.

Because of the early problems with long exposure times, photographs of the indigenous population of Palestine only began to appear from the 1860s onwards. But even then the subjects were mainly models who were employed by photographers to create the idea of an exotic orient, rather than to portray the lives of real local people. Thus the images were distorted.

Although photography had assumed an important role in the exploration of the Holy Land – particularly with those keen to find links between the geography of the land and the history of the Bible – the poor security of the area restricted photographers to a limited number of sites that could be reached by secure routes. Consequently many photographs are mere repetitions. The same restrictions applied to artists – reviewers of Mrs. Ewald's *Jerusalem and the Holy Land* (in the Collection, p. 150, no. 3) complained that the views did not present any new features, 'for the subject has been gone over again and again, until the Holy Land is better known in England than the English Lakes'.

The nineteenth-century publication of books illustrated with photographs of the Holy Land reached a peak in the late 1850s when books started to appear with original photographs (albumen prints from collodion negatives). A second peak occurred after the introduction of the photomechanical process in the 1880s which led to a vogue for half-tone illustrations – clear indications of the popularity that photography gave to books on the Holy Land.

Among the best photographic records of Jerusalem are those contained in the *Ordnance Survey of Jerusalem*, under Capt. Charles Wilson, with photographs by Sgt. James McDonald, published in 1866. In addition to this, the Palestine Exploration Fund published an impressive catalogue in 1894 which lists 485 photographs, of which many were taken by H. Phillips in 1866-67. An album of 22 of Phillips's photographs is in the Collection (see below, no. 5).

The best known American photography of the Holy Land is that of the firm Underwood & Underwood, who produced hundreds of stereoscopic views in the 1890s and the beginning of the twentieth century. These stereographs were assembled in sets, accompanied by guidebooks and linked to maps. The Underwood & Underwood series of stereographs (many are in the Collection, of which two are listed below) epitomize the great popularity of photographic images from the Holy Land, and the extent to which they were combined with other visual aids to enhance the feeling of reality.

The Collection contains almost 3,000 original photographs from the nineteenth century. Nearly 1,000 of these are of Jerusalem, the Holy Land and Egypt. Because of space limitations it is possible to refer to only a few of these in the following section.

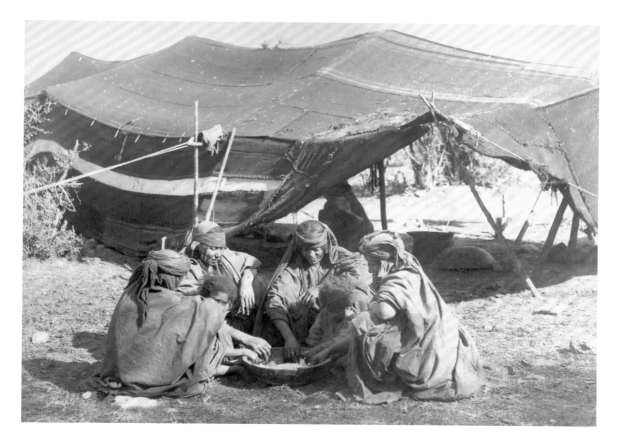

Bedouin women and
children taking a meal
outside their tent, by
A. Bonfils; 1880s

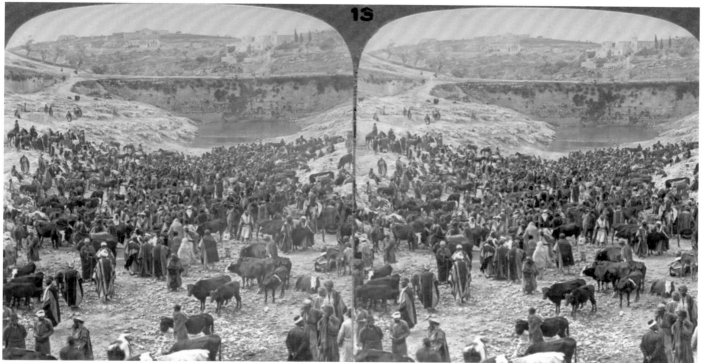

Stereoscopic view of the cattle market in the lower Gihon Pool in Jerusalem, produced by
Underwood & Underwood (see below, no. 10); 1897

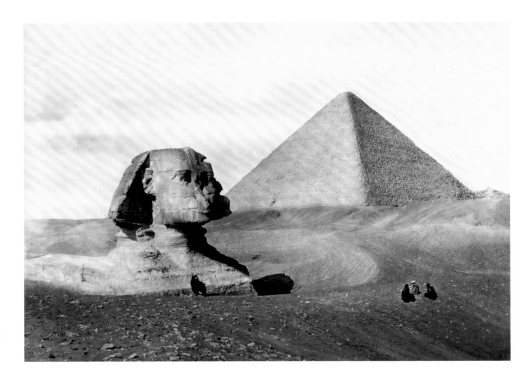

The Great Pyramid and Sphinx at Giza. Although published under Frith's name, it was probably photographed by F. M. Good; late 1860s

Books and Albums Illustrated with Original Photographs

The short biographies that follow (and those in the introduction above) have benefited from Colin Osman's *Jerusalem Caught in Time* (London 1998) and Nissan N. Perez's *Focus East* (Jerusalem 1988).

⌐ 1 ⌐

FRITH, Francis

Cairo, Sinai, Jerusalem, and the Pyramids of Egypt, Photographed by Francis Frith: Sixty Photographic Views With description by Mrs. Poole and Reginald Stuart Poole. Published by James Virtue, London 1860

Folio size book containing 60 photographs, each 23.0 x 15.7 cm. or vice versa. Photographs signed in the negative 'Frith Photo 1857'.

Each photograph is accompanied by one or two pages of detailed description. Only 10 of the photographs are of Palestine (including 7 of Jerusalem), while 13 are of Sinai and the rest of Egypt, mainly Cairo.

By far the most successful and prosperous of all the photographers of the Near East, the Englishman Francis Frith (1822-98) made his first trip to Egypt, Nubia and the Holy Land between September 1856 and July 1857. His equipment included not only a normal size camera but also an extra large one (producing 'mammoth' prints, up to 50cm.) and a stereoscopic camera. His companion was Francis Wenham, optical adviser to Negretti and Zambra, who eventually published Frith's stereoscopic photographs. On his second tour, from November 1857 to May 1858, he again visited the Holy Land, Syria and Lebanon.

Obscurity surrounds Frith's third and final trip to the Middle East and it is difficult to pinpoint the results as these photographs are not dated like the earlier ones. It is usually said that he went in the summer of 1859, but this is unlikely since any experienced traveller to Egypt and Nubia would have known that the heat would be intolerable.

⌐ 2 ⌐

FRITH, Francis

Photo-pictures from the Lands of the Bible, Illustrated by Scripture Words (late 1860s)

Small folio. Each image is 15.7 x 20.7 cm. or the reverse, numbered in small numerals outside the photograph.

The original number of photographs in this series is not exactly ascertained since the they are mounted

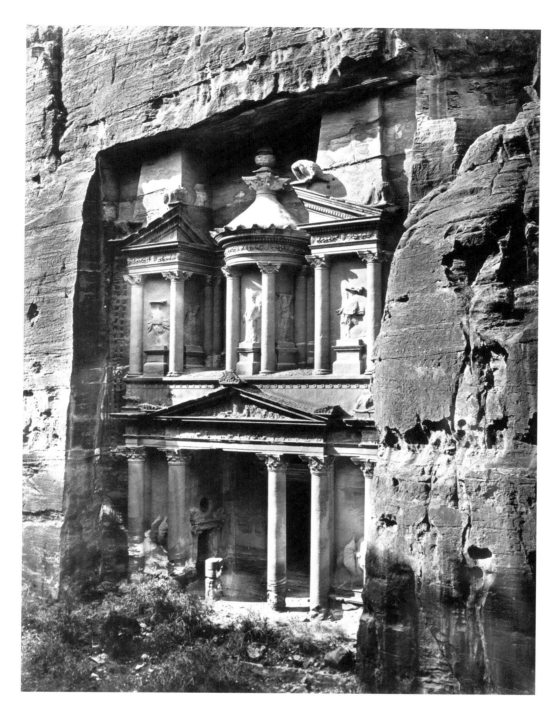

The Treasury (al-Khazneh) at Petra, photographed by Francis Frith; c. 1860

on card and are unbound. The series in the Collection has 43 photographs; most are of Jerusalem and the Holy Land (including Sinai, Petra and Baalbek), but there are also a few of Cairo and Athens. On the card mount of each photograph appear the name of the location and sentences from the Bible. It is possible that many of these photographs were taken by Frank Mason Good (see below) – Frith signed and dated most of his early prints, but some in this series have only the name 'Frith' printed on the mount; if they were taken after 1866 they were probably by Good.

PHOTOGRAPHY IN THE HOLY LAND ⁓ 241

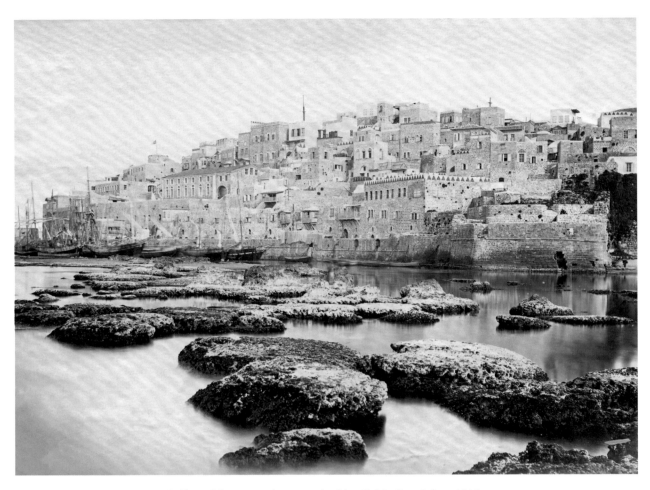

Jaffa and its port, photographed by F. M. Good; late 1860s

~ 3 ~

GOOD, Frank Mason

Photographs of Old Jerusalem, Sinai, Petra, etc. (late 1860s)

An album containing 100 original photographs, by F. M. Good.

Small folio. Most photographs are 15 x 20 cm. or the reverse. They contain scenes of Jerusalem, Palestine, Sinai, Petra and Lebanon in the 1860s. Most are numbered in the negative. They are mounted on card, two to the page and on both sides of the card.

It has been suggested that Good (1839-1928) was an assistant to Francis Frith, but he did travel independently and later sold his prints to Frith's publishing company. Good made four Middle East trips – in 1866-67 to Egypt and the Holy Land, published by Frith in 1876; in 1868-69 to Egypt and Nubia, published by Mansell; in 1871-72 to Egypt, Constantinople and Malta, published by Frith; and

1875 to the Holy Land, published by Mansell and by Good himself. Lantern slides were also published by the Woodbury Publishing Company and apparently by the George Washington Wilson Company.

~ 4 ~

MOTT, Mrs. Mentor

The Stones of Palestine. Illustrated with Photographs by Francis Bedford. Seeley, Jackson and Holliday, London 1865

8vo. Contains 12 albumen photographs by Francis Bedford, each 7.5 x 9.8 cm. All are of Palestine, except one of Mount Hermon.

The book is inscribed by the author.

Francis Bedford (1816-1894) was in turn an architect, a lithographer and a photographer specializing in church architecture and he was one of the first to start systematically photographing large views of the whole of England. In 1862 Queen Victoria commanded him to

accompany her son Edward, Prince of Wales, on his tour of the Middle East, together with Prince Alfred. The tour began in Cairo on 3 March 1862 and was carefully documented. During the next four months Bedford made 210 negatives. The complete portfolio comprised 48 views of Egypt, 76 of the Holy Land and Syria, 48 of Constantinople, the Mediterranean, Athens etc.

～ 5 ～
PALESTINE EXPLORATION FUND (PEF)
Album of photographs of Palestine (1867)

22 original albumen prints of PEF photographs of different sites in Palestine taken by H. Phillips between 1865 and 1867, each 16.2 x 20.8 cm. Some are numbered. Each has a detailed description of the site.

Phillips, one of the main photographers used by the PEF, first visited Palestine as a corporal in the Royal Engineers with Capt. Charles Wilson's four-month reconnaissance expedition of 1865-66. They started in Lebanon, visiting Baalbek, and continued via Damascus to Galilee, then as far south as Hebron, and ended in Jerusalem. During this time, and despite some minor local difficulties, Phillips made 185 negatives of the sites they visited as well as some of the local population. In 1867, now a sergeant, Phillips returned to the Middle East to photograph for the PEF's excavations in Jerusalem under Lieut. Charles Warren, when he took a similar number of negatives as on his first trip. Despite the documentary nature of the PEF's work, Phillips brought to it considerable technical proficiency and a good eye, resulting in views that are sharp and well-composed.

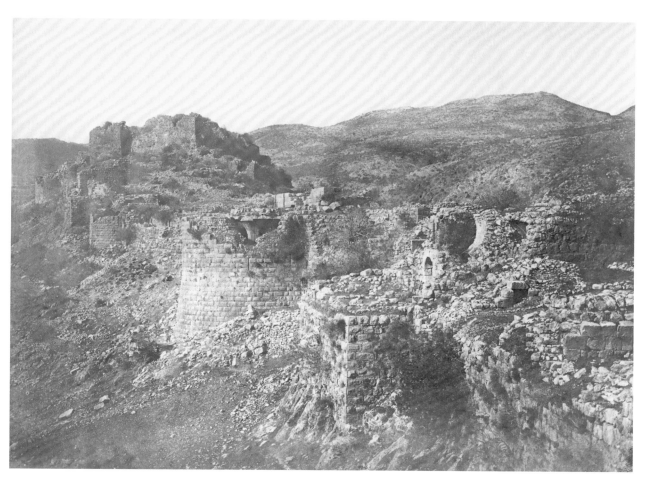

Qal'at Nimrud (originally known as Subeiba), an Ayyubid/Mamluk fortress near Banias in northern Palestine, photographed by H. Phillips on his first visit to the Middle East, 1865-66

A group of Jerusalemites in the Old City, by A. Bonfils; c. 1890

~ 6 ~

BONFILS, FÉLIX

Souvenirs d'Orient, Volume 3: Palestine (1878)

A collection of photographs taken by Félix Bonfils in Palestine prior to 1878.

Each photograph is 21.8 x 27.2 cm. or the reverse.

La Maison Bonfils was established in Beirut, Lebanon in 1867. The head of the family was Félix Bonfils (1831-1885), who founded the firm with his wife, Marie-Lydie, who took the studio portraits. When Félix died in 1885, their son Paul Félix Adrien Bonfils (1861-1929) joined his mother in the business until 1895 when he left to open a hotel at Broummana, near Beirut. After World War I he left Lebanon for France. Marie-Lydie continued the business until 1916 when she was evacuated by the United States Navy from Beirut to Cairo. Her assistant, Abraham Guiragossian, an Armenian possibly from Palestine, took over and ran the business until about 1932.

Adrien Bonfils published *Catalogue Général des Vues photographiques de l'Orient*. All the prints were signed simply 'Bonfils' so it is not possible to work out which member of the family took them. They are numbered but not dated, and the only guide to dates is in the 1876 catalogue compiled by Félix Bonfils alone. The catalogue has four different numbers for each view according to format, but the highest is 426, so presumably all the numbers below this were taken by Félix before 1876.

The Bonfils family, and assistants, were hugely prolific, producing 15,000 views and 9,000 stereo-cards of Palestine, Egypt, Syria, Greece and Lebanon in 40 years. They had branches or depots in Cairo, Alexandria, Baalbek and Jerusalem. Some Bonfils sepia prints were used by Photoglob in Zurich for their popular colour series. The Bonfils photographs of the Holy Land and Egypt were almost as popular in their field as David Roberts's lithographs were in another.

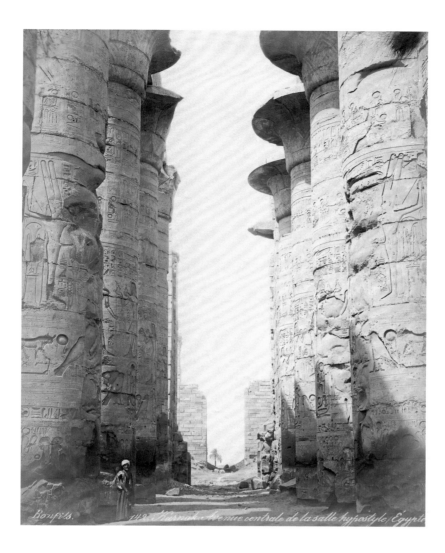

The columns of the temple at Karnak, photographed by A. Bonfils; 1890

7

MR. & MRS. WILLIAM LINDSAY

Album of Travel in 92 Cities (1879)

Six large folio-sized album that contains over 2,000 original
photographs, mostly large albumen prints. The majority
of the Palestine photographs are by Félix Bonfils, includ-
ing a panorama of Jerusalem; most of those of Cairo are by
Henri Bechard.

The following sections are of interest and relevance to
the Holy Land and Egypt:

Section 6: Suez, 7 photographs

Section 88: Jaffa, 2 photographs

Section 89: Ramleh, 7 photographs

Section 90: Jerusalem, 128 photographs

Section 91: Beirut, 2 photographs

Section 92: Cairo, 49 photographs

This album was compiled by an Australian couple, Mr.
& Mrs. William Lindsay, during their travels from
Australia to the United Kingdom and back through

Europe and Asia. A manuscript document in the
album reads: 'Port Said, S.S. Chebine 25 March 1879. I
have had two passengers, Mr. & Mrs. William Lindsay
of Australia, for one week in 'Quarantine' on board
this ship. Name: Commander'.

8

MARROUM, F. F.

Photographies de Terre Sainte (1897)

Album with covers of olive wood, inscribed 'Jerusalem'
and the reverse carved with the Jerusalem cross.

Oblong large 4to (24.5 x 32.5 cm.)

Contains 40 albumen photographs, all by Bonfils, each 21.8 x
27.2 cm. All photographs are numbered, inscribed in French
and English in the negative. Also signed in the negative as
'Bonfils' or 'A. Bonfils'. The Collection also contains a
three-part panoramic view of Jerusalem, 82 x 21.8 cm.

Although the album itself has no date, the inscription
is dated 6 May 1897.

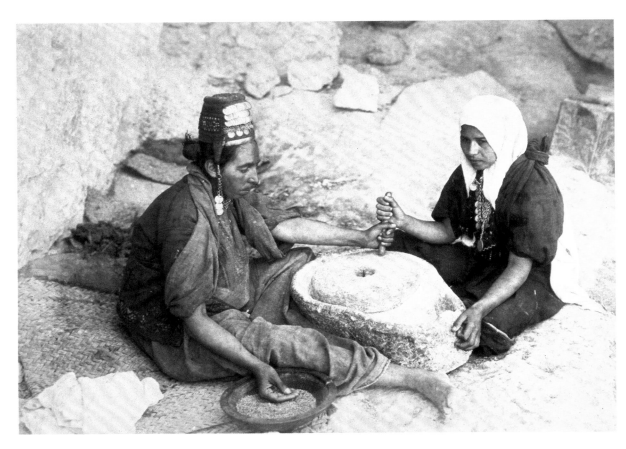

Women grinding corn, from the American Colony's Album of
Photographs of the Holy Land; c. 1910

~ 9 ~

ANON.

A Voyage to Jerusalem: By One Who Went. A
Handbook for Divines (1901)
A manuscript book of a voyage to Jerusalem by a lady
traveller (name not given).

Folio. 157 pages. Contains a printed map with the route of the
journey; 65 watercolours; 17 pencil sketches; 16 large
albumen photographs (9 are American Colony, 10.7 x
14.9 cm.); over 100 small photographs, apparently taken
by the author. All photographs are originals. One is a
large scene, perhaps of Port Said, by Édition Photoglob.

~ 10 ~

**UNDERWOOD AND UNDERWOOD, J. L.
Hulbert**

Jerusalem, Through the Stereoscope (1905)
Small 8vo. Contains 35 stereographs, believed to have been
taken 1897, accompanying a guidebook describing the
scenes and a location map.
In 1882, the 20-year-old Elmer Underwood and his

18-year-old brother Bert expanded their bookselling
agency to become agents for stereocards in all areas
west of the Mississippi River. Over the next few years
they photographed in Italy, Greece, the Holy Land
and Egypt. By 1901 they were producing 25,000 stere-
ocards a day and selling 300,000 viewers a year. Their
salesmen concentrated on school superintendents,
public librarians and the town bankers. Production
was discontinued in 1920 and in 1921 the stock and
rights were sold to the Keystone View Company.

The 35 Jerusalem stereocards were sold in a box
shaped like a book. The cards had the title and copy-
right under the picture on the front, and the title was
repeated in six languages on the back, sometimes
accompanied by some explanatory text. The box also
contained a 100-page booklet for the images. The
booklet included a map of Jerusalem, which showed
not only the important sites but also the camera posi-
tions and the angles of view of the various shots. A
similar arrangement with 100 stereocards was made
for Palestine (see 11 below).

— 11 —

UNDERWOOD AND UNDERWOOD, J. L.
Hulbert
Traveling in the Holy Land through the Stereoscope
(1905)

Small 8vo. Part of Underwood and Underwood's tour
'Traveling in the Holy Land' conducted by Jesse
Lyman Hulbert, containing 100 double stereoscopic
views, believed to have been taken 1897, with a guide-
book describing the scenes and a location map.

— 12 —

VESTER & Co., American Colony
Album of Photographs of the Holy Land (*c.* 1910)
Vester & Co., The American Colony Store, Jerusalem
Album with covers of olive wood, with the Jerusalem
cross carved on the front, and inscribed 'Jerusalem'
on the reverse.

Oblong large 4to (24.5 x 32.5 cm.), containing 36 albumen pho-
tographs, all by American Colony, each 21 x 27.2 cm. or
the reverse. All photographs are numbered and inscribed
in English, French and German in the negative. Also
signed in the negative 'American Colony, Jerusalem'. It is
estimated that the album appeared *c.* 1910.

Horatio Spafford arrived in Jerusalem from
Chicago in 1881 and founded the Utopian commu-
nity called the American Colony, soon to be joined
by Swedish and Swedish-American pilgrims. The
American Colony Hotel was established in 1902 in
the luxurious palace of the Husseini family and still
exists today.

In 1898 two members of the community from Nas
in Sweden, Lewis Larson and Erik Lind, with Elijah
Meyers and Frederick Vester, started the photographic
department. The Jerusalem-born Vester, according to
his daughter, sold photographs at his gift shop near the
Jaffa Gate, next door to Bonfils. At a later stage, some
prints were issued by Vester & Co. An important fig-
ure was G. Eric Matson (1888-1977), who took over
the business and changed its name to Matson Photo
Service in 1934. He continued taking photographs
until 1946 when he moved to America. In 1966 he
donated 20,000 negatives to the Library of Congress.

— 13 —

ANON.
Album of Photographs of Palestine and Egypt (*c.*
1930)
A private album containing photographs probably
taken between 1918 and 1930, containing a manu-
script map, 50 original photographs of Jerusalem and
the Holy Land and Syria and 120 photographs of
Egypt and the Oasis.
Each photograph is 7.9 x 13.5 cm.

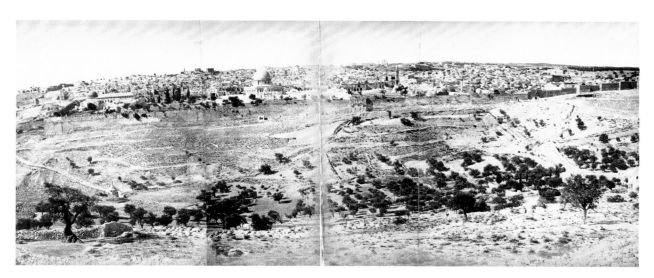

Panorama of Jerusalem in three parts by an unknown photographer; 1860s

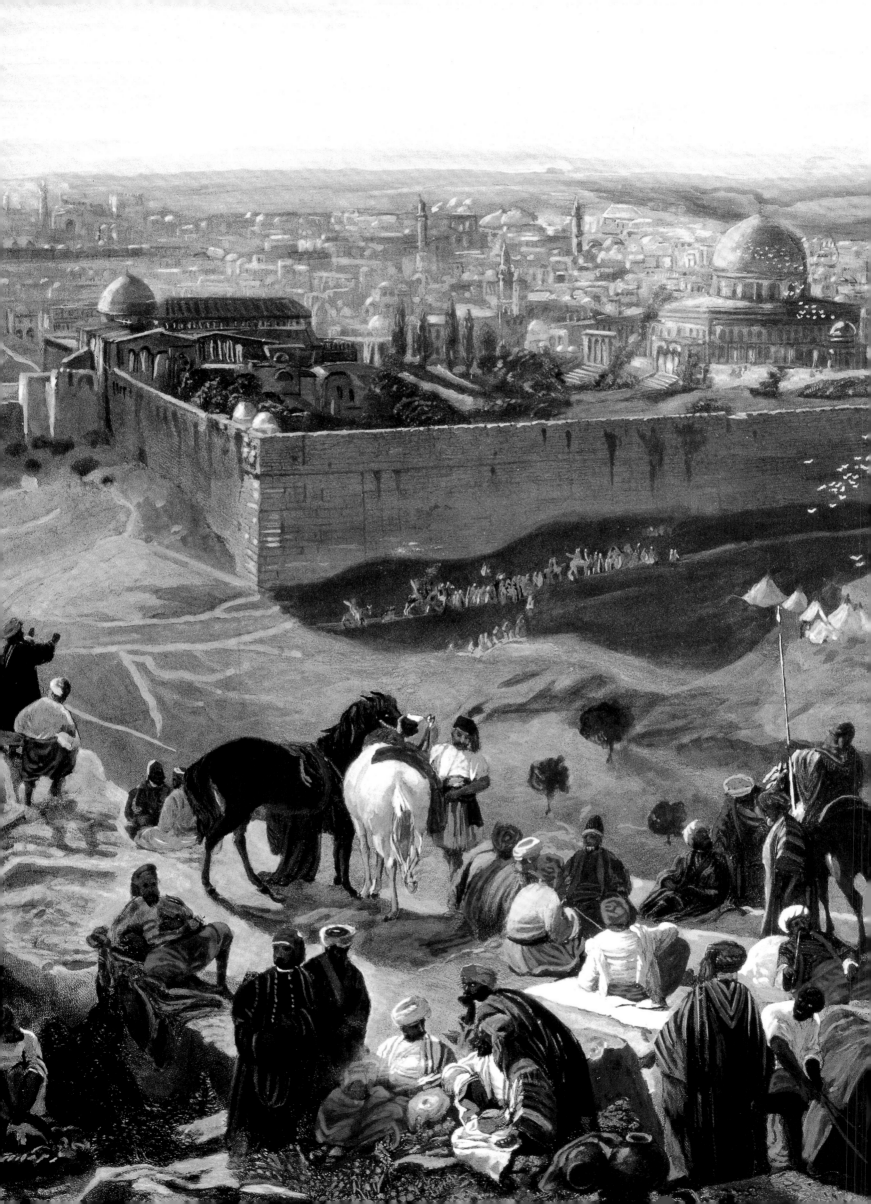

CHAPTER TEN

⁓ Engravings, Etchings ⁓ and Lithographs

The best known lithographs of the Holy Land and Egypt were those made by Louis Haghe from drawings by David Roberts. Some of these, particularly the limited subscribers' editions, were hand coloured and mounted on card from the beginning; but most were either sepia prints or were hand coloured later and then framed to enhance their appeal and value. Recently huge numbers of prints, calendars and postcards have been made from these lithographs and sold to tourists (especially in Egypt, Jerusalem and Petra) as well as to residents of the region. These prints now decorate so many homes and offices throughout the world that David Roberts, the most significant nineteenth-century artist of the Holy Land and Egypt, has also become the most popular.

Copper and steel engraving – techniques developed in the early sixteenth century in Germany, Italy and the Netherlands – also became popular for portraying scenes of the Holy Land. These, as with lithographs, could be made by a craftsman working from the original drawing or painting. Etchings – in the early days made on iron but now on copper, or sometimes zinc – are the original work of the artists themselves and are therefore considerably rarer and of greater value.

The Collection contains thousands of lithographs, etchings and other engravings, most of which are included in the Valuable Plate Books and Travel Books sections. There are, however, certain etchings and lithographs which were published separately and not as part of a travel book or plate book, such as the James McBey etchings and Henry Selous's lithographs and prints. There are many of these in the Collection but because of limited space I include only a few of the more valuable in this section.

Details of the various printing techniques – lithography, etching, engraving, etc. – can be found in Annex 2.

Opposite: Detail of one of Henry Selous's engravings of Jerusalem (see p. 260, no. 9b)

BRUYN, Cornelis de (active late 17th and early 18th centuries)

De Bruyn, a painter and traveller, left Holland for Italy in 1674. In 1678 he went on to Smyrna and travelled in the Levant until 1685, when he returned to Italy and settled in Venice for eight years. He returned to Holland in 1693. The very interesting plates in this work are almost all after designs by de Bruyn, who specialized in landscapes and interiors. Most of the plates are views, including large panoramic scenes of Constantinople, Smyrna, Alexandria and Jerusalem. The costume plates are of particular interest since de Bruyn has concentrated almost entirely on Greek and Turkish female head-dresses. In 1701 he undertook an extensive journey to Persia and India via Moscow, an account of which was published in Dutch in 1711.

These two engravings depict Jerusalem and Jaffa at the end of the seventeenth century. Note how the size of the Church of the Holy Sepulchre is exaggerated to outshine the much larger Dome of the Rock and Haram al-Sharif, thus reflecting the painter's prejudices rather than factual topography (this was repeated in Luigi Mayer's *Views in Palestine* 100 years later (see p. 154, no. 8).

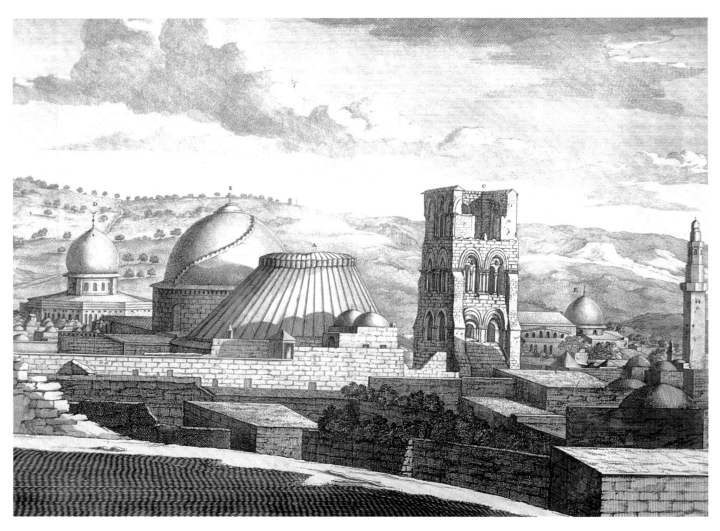

1a. Cornelis de Bruyn's engraving of the Holy Sepulchre in Jerusalem, with the Dome of the Rock made misleadingly small in the background, from his *Voyage au Levant* of 1714

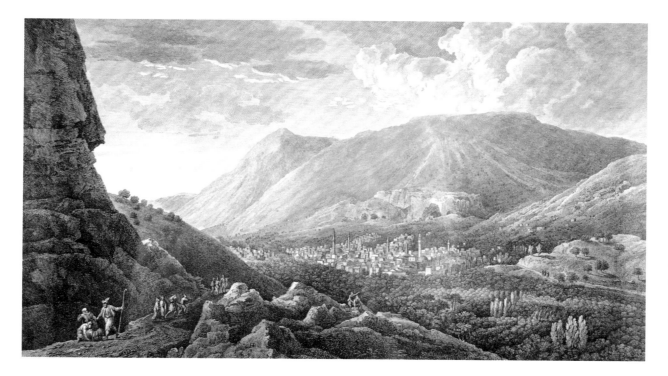

2. François Cassas's engraving of Nablus, surrounded by olive trees, from his *Voyage Pittoresque...* of 1799

a) **Jerusalem Seen from the West**

b) **Jaffa from the Sea**
(Illustration p. 56)
Each 32 x 39 cm.

Both engravings are from de Bruyn's *Voyage Au Levant, C'est à-dire, Dans les Principaux Endroits de l'Asie Mineure, dans les Isles de Chio, Rhodes, & Chypre &c. De même que dans les plus Considerables Villes d'É-gypte, de Syrie, et de la Terre Sainte; Enrichi de plus de Deux Cens Tailles-douces, où sont représentées les plus célèbres Villes, Païs, Bourgs, & autres choses dignes de remarque, le tout dessiné d'après nature*: Par Corneille Le Brun. Se Vend à Paris, Chez Guillaume Cavelier, Rue St. Jacques à la Fleur de Lys d'Or. 1714

~ 2 ~

CASSAS, Louis François (active late 18th centuries)
Vue Générale de Neapolis (Nablus)
23 x 39 cm.

This engraving (numbered 6) appeared in Cassas's *Voyage Pittoresque de la Syrie, de la Phoenicie, de la Palestine, et de la Basse Aegypte*, Paris 1799.

~ 3 ~

FRÈRE, Charles-Thédore (1814-1888)
Having lived for a while in Algiers, Frère moved on in 1851,visiting Malta, Greece, Constantinople and Smyrna en route to Syria, Palestine, Egypt and Nubia. This coloured tinted lithograph is after one of Frère's large oil paintings (142 x 204 cm.). He painted Jerusalem from the Mount of Olives, to the north-east of the city and separated from it by the Kidron valley, a viewpoint recommended to travellers by nineteenth-century books because of its commanding vista. Frère depicted Jerusalem's wonderful skyline of domes and minarets, the impressive crenellated city walls and bastions built by the Ottoman sultan Suleyman I in the early sixteenth century, the dome of the Holy Sepulchre, the Golden Gate and the Haram al-Sharif which contains the al-Aqsa mosque and the imposing Dome of the Rock.

Pilgrims Worshipping outside Jerusalem
(Illustration pp. 252-53)
Tinted lithograph, published in London by Gambart & Co, *c.* 1850
37 x 57.5 cm.

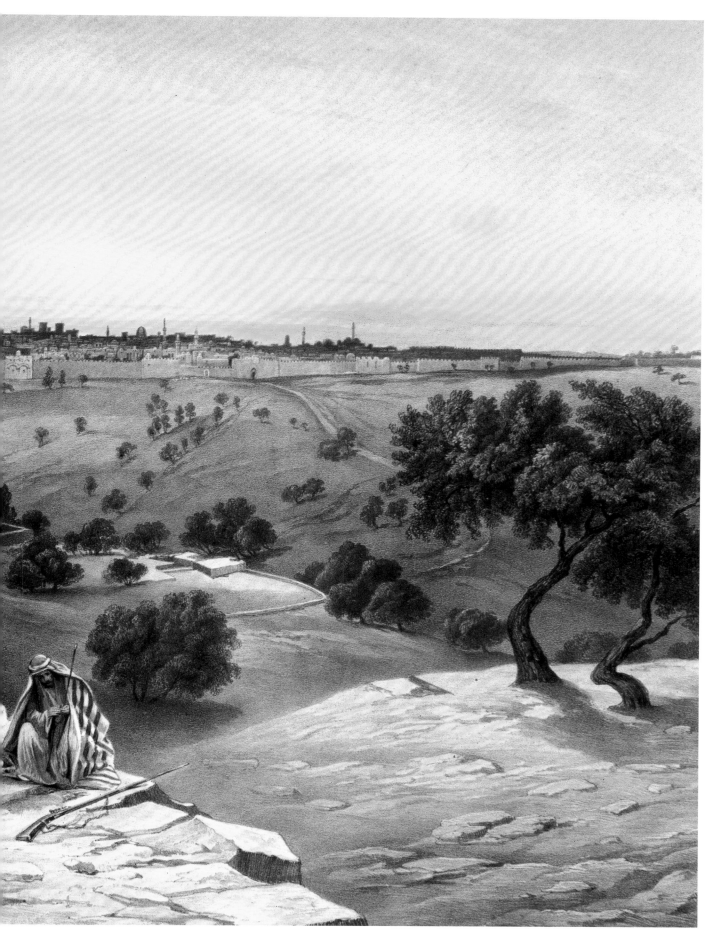

3. A coloured tinted lithograph of pilgrims worshipping outside Jerusalem, after a painting by Charles-Théodore Frère

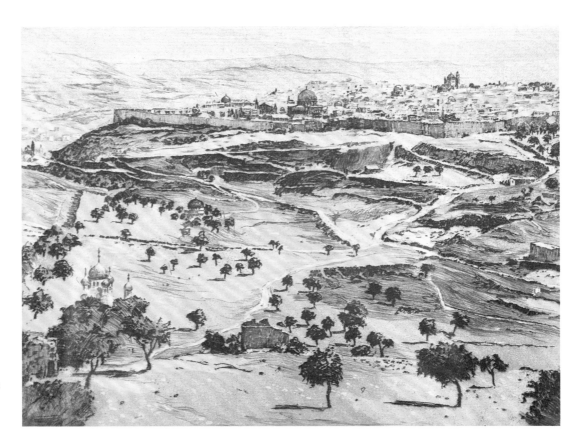

4a. A hand-coloured etching by René Halpern of Jerusalem seen from the Mount of Olives

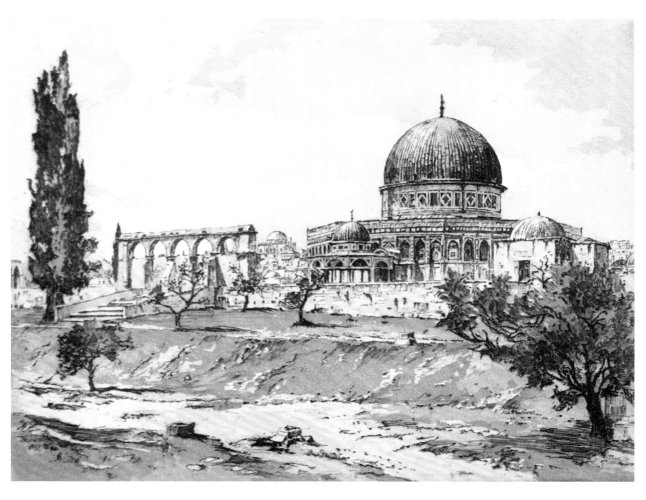

4b. A hand-coloured etching by René Halpern of the Dome of the Rock

— 4 —

HALPERN, René (1914- ?)
Halpern was a well known French etcher, whose etchings of western Europe are particularly valuable.

a) **Jerusalem, General View from the Mount of Olives**

b) **The Dome of the Rock, in al-Haram al-Sharif, Jerusalem**
2 hand-coloured etchings
Each 20 x 26 cm.
Signed in pencil and numbered 8/25. No date is given, but apparently they were executed in the early twentieth century.

— 5 —

McBEY, James (1883-1959)
James McBey, probably the most important British etcher of the twentieth century, was born in 1883 in a small town near Aberdeen in Scotland. Although he was a good portrait painter, he is better known for his wide-ranging etchings, covering the United States, Europe, North Africa and the Levant.

In 1917 he became an official war artist with the British Expeditionary Force in Egypt. 'The object of this appointment', he was informed, 'is to enable you to make drawings of appropriate war scenes in Egypt and Palestine for the purposes both of propaganda at the present time and of historical record in the future'. Altogether he completed over 300 watercolours in Egypt and Palestine, which are now in the Imperial War Museum and the British Museum. He also produced a number of now-famous portraits, particularly that of T. E. Lawrence. He recorded: 'The sitting took place during his last days with the Arabs and there was a constant procession of Sheiks kneeling before him and kissing his hands, many in tears'. He also painted two portraits of King Faisal just before he sailed home on 4 February 1919.

Between 1919 and 1921 McBey produced three limited edition sets of etchings of Palestine and Sinai, based on his war drawings. They were issued to great acclaim and became the most famous of all his works. The Collection contains many of McBey's Palestine and other etchings. It also contains the catalogue, *Etchings and Dry Points from 1902-1924*, by James McBey, issued by Martin Hardie, Colnaghi, 1925.

a) **First Sight of Jerusalem**
(Illustration p. 51)
Etching
37.5 x 45.5 cm.
Signed in the plate 'McBey 1920' and also signed by hand. Numbered E. Inscribed in the plate 'Nebi Samuel, 22 Nov. 1917'.
During World War I, British forces occupied Nebi Samuel, overlooking Jerusalem, on 22 November 1917, and from there they entered Jerusalem without resistance. McBey captured the occasion in this outstanding etching, one of his best.

b) **The Midday Halt in Sinai**
(Illustration p. 256)
17 x 23 cm.
Signed by James McBey, inscribed and dated 'Sinai July 1917' and numbered XLIII
The British Expeditionary Force's camel caravan resting in Sinai, en route from Egypt to Jerusalem.

c) **The Advance on Jerusalem – Amwas** (Palestine)
(Illustration p. 42)
20 x 35 cm.
Signed by James McBey, dated 30 November 1917 and numbered E
British troops advancing on Jerusalem.

d) **The Moonlight Attack, Jelil**
22.6 x 39.1 cm.
Signed by James McBey and numbered XXXIX

e) **On the Road to Damascus**
(Illustration p. 256)
22 x 37 cm.
Signed by James McBey and numbered L
British troops passing Kuneitra and the Hermon, 10 October 1918.

5b. The Midday Halt in Sinai; etching by James McBey, with the British Expeditionary Forces en route to Jerusalem from Egypt in 1917

5e. On the Road to Damascus; etching by James McBey, showing the British Expeditionary Forces on the final march to Damascus in 1918

6a. Lithograph of David Roberts's 'Destruction of Jerusalem by Titus'

— 6 —

After **ROBERTS, David** (1796-1864)

a) **Destruction of Jerusalem by Titus** 1850
Colour lithograph by Louis Haghe
69.9 x 106.7 cm.
Published with a key to the places shown.
The destruction of Jerusalem by the Roman commander, Titus, occurred in AD 70, during the reign of Nero, after a Jewish revolt against Roman rule. The view is taken from the north side of the Mount of Olives showing Jerusalem to great advantage. In the foreground are the Roman soldiers with their captives. This view is similar to other Roberts paintings of Jerusalem from the Mount of Olives, but employs a very high vantage point to show the whole city. This the largest of Roberts's lithographs.

b) **Lithographs from** *The Holy Land, Syria, Idumea, Arabia, Egypt and Nubia*
The Collection contains more than 100 original lithographs by Haghe from sketches by David Roberts. These are from the above book (1842-1849) and are folio sized, some from the rare subscribers' edition. All are hand coloured. These are separate from the lithographs in the volumes of the book. Fakes and cheap reproductions have proliferated in recent years.

c) **Lithographs from** *La Terre Sainte*
These are lithographed views by F. Stroobant and J. Lots after David Roberts and Louis Haghe, from the folio-sized Brussels edition of 1843. They are slightly smaller in size than the English edition of F. G. Moon and also of slightly lesser quality. All are hand coloured by a later hand.

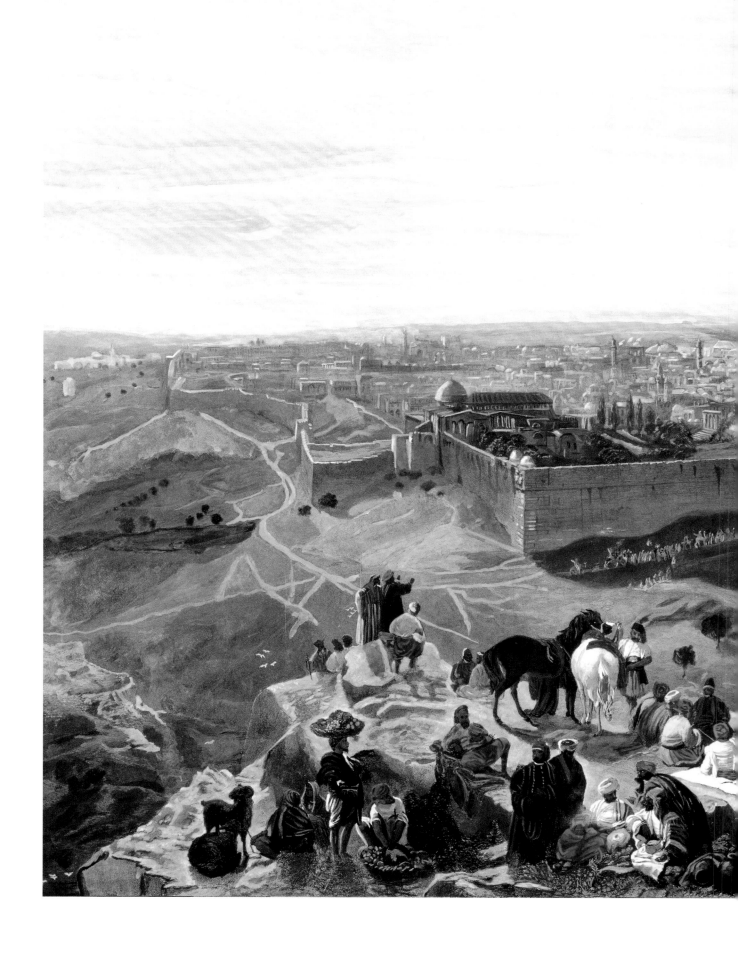

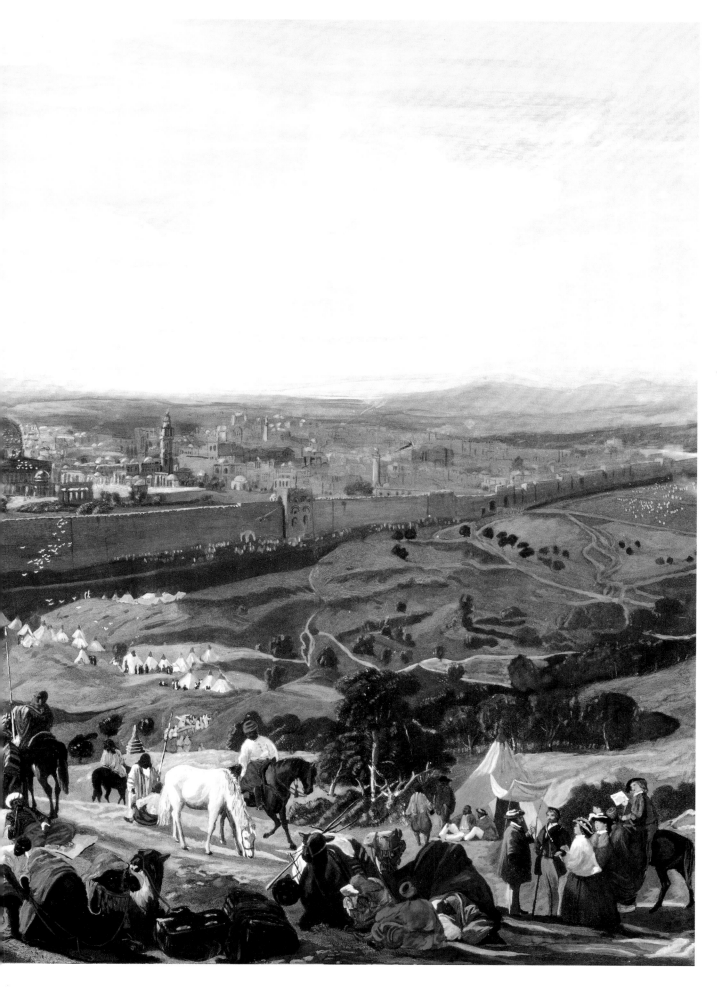

9b. Jerusalem, a
hand-coloured
engraving by
Henry Selous, 1860

∼ 7 ∼

SALT, Henry (1780-1827)

Henry Salt, a portrait painter by training, first travelled to Egypt between 1802 and 1806 in the service of George Annesley, Viscount Valentia. Appointed British Consul-General in Egypt in 1815, Salt himself became an important collector of Egyptian antiquities. He met Burckhardt while the latter was in Egypt, and in 1816 was persuaded by him to hire Giovanni Belzoni to remove from Luxor a colossal granite bust of Rameses II, known as 'Young Memnon', which he later presented to the British Museum. Salt died of dysentery in Alexandria in 1827, three years after his wife's death from cholera. (For his portrait by Joseph Bonomi see p. 83, no. 2b).

Salt is particularly well known for his valuable plate book, *A Voyage to Abyssinia and Travels into the Interior of that Country* (1814), and also for his large lithographs of Cairo.

Portrait of John Lewis Burckhardt 1817
(Illustration p. 174)
Lithography by M. Gauci. Published 15 May 1821
27.3 x 20 cm.

Inscribed 'Sheikh Ibrahim (J. L. Burckhardt). In his Arab Bernous. Sketched at Cairo in Feb 1817 by H. Salt Esq.'

Frontispiece to Burckhardt's *Travels in Syria and the Holy Land* (1822). The Swiss-born Burckhardt (1784-1817) was a diligent student of Arabic life and language who travelled in Arabia and Egypt under the auspices of the London African Association, adopting the name Sheikh Ibrahim. He became famous as the re-discoverer of Petra in 1812, and in 1813 of the temples of Abu Simbel. His scholarship and enterprise inspired many British travellers in Egypt. Salt's portrait was done a few months before Burckhardt's death from dysentery in Cairo.

∼ 8 ∼

SEDDON, Thomas B. (1821-1856)

Seddon accompanied Holman Hunt to the Holy Land in 1853-54, and this landscape was the best-known product of the journey. It is another example of extreme pre-Raphaelite attention to detail, painted in full sunlight. Seddon, however, was not as accomplished an artist as Hunt or Madox Brown, and his colours tend to be rather livid and hard. He died in Cairo in 1856, and his works are extremely rare. It is understood that Seddon used photographs to enable him to depict the scene with such accuracy.

Jerusalem and the Valley of Jehoshaphat from the Hill of Evil Counsel 1854
(Illustration p. 78)
50 x 68.5 cm.

A recent Tate Gallery reproduction. (The original canvas, arched top 67 x 83 cm., is in the Tate Gallery, London)

∼ 9 ∼

SELOUS, Henry Courtney (active mid-19th century)

It is not known that Henry Courtney Selous ever visited the Holy Land. Most likely he utilized the work of others. The 'Jerusalem in her Fall' engraving was extensively published in print form and appeared in the *Illustrated London News* (copies of which are in the Collection).

a) **Jerusalem in her Grandeur**

b) **Jerusalem in her Fall**
(Illustration pp. 258-59)
A pair of mixed method engravings, executed by C. Mottram and later coloured by hand. G. L. Beeforth, Scarborough, and Hayward & Leggatt, London, 1860
Paper size: 74.5 x 104 cm.

Annexes

Annex 1
Guide Books

G uide books are important for understanding the state of affairs and the customs of the Holy Land and Jerusalem during the last stages of the Ottoman period. The increase in pilgrimages and travel to the Holy Land in the second half of the nineteenth century resulted in a demand for guide books. The first guide book to the Holy Land was apparently *The Way to the Holy Land*, English Pilgrim Guide, 1515. In 1825 a series of guides began to appear in London under the name of *The Modern Traveller*. The first scientific guide book was that of Baedeker in 1876.

These books were printed and published outside the Holy Land. After 1831, when Ibrahim Pasha created a period of law and order in Palestine, two printing presses were opened in Jerusalem, one by Armenians and the other by Jews. Then in 1846 the Franciscan Custody of the Holy Land opened its own printing press in Jerusalem and started printing – in Arabic – on 27 January 1847. The Franciscan Printing Press's early publications were in the fields of education and religion – and so they remain today – and it was in keeping with these goals that in 1865 they produced the first guide book to the Holy Land in the Arabic language, written by Elias Faraj Basil al-Khasrawany. In the following year came their first guide book in a European language (Italian) – *Guida del Pellegrino divoto in Terra Santa e Gerusalemme* by Franciscus Cassini de Perinaldo OFM.

Apart from historical information and geography, descriptions of routes, topography, population and interesting sites, the guide books contained details of hotels and tips to the traveller as well as descriptions of local customs and local people. They also contained detailed maps and valuable steel prints. They are therefore of considerable interest and provide important records for understanding the conditions in the Holy Land in the second half of the nineteenth century.

Some of the more valuable guide books in the collection are listed below.

THE MODERN TRAVELLER series London 1825
The Modern Traveller: A Popular Description, Geographical, Historical and Topographical of the Various Countries of the Globe – Arabia
12mo. *Illus*: A map and 3 prints.
The Arabia volume in this series, covering the Arabian peninsula, Sinai, Petra, Aqaba and (unusually) Mecca.

BAEDEKER, Karl Leipzig and London 1898
Palestine and Syria, Handbook for Travellers, Edited by Karl Baedeker
12mo. *Illus*: 20 maps, 48 plans, and a panorama of Jerusalem. 3rd edition revised and augmented
This famous guide first appeared in 1876, published by Fritz Baedeker, son of Karl Baedeker, founder of the firm and originator of the modern travel guide. Later editions were enlarged and this guide earned a lasting reputation for its wealth of accurate, authentic information, and for its lively accounts of the geography, history, religion, language, and customs of the region, practical information and detailed descriptions of the sites. Some of this material has grown obsolete – many sites have changed, some remain much the same, others have vanished. The book is thus of great historical interest for travellers, researchers, and anyone interested in the Holy Land.
The Collection also has the 5th edition (1906), and a facsimile (Jerusalem 1973) of the Jerusalem section of the 1st edition, *Jerusalem and its Surroundings*.

BAEDEKER, Karl Leipzig and London 1902
Egypt: Handbook for Travellers By Karl Baedeker
12mo. *Illus*: 23 maps, 65 plans, 59 vignettes. 5th edition
The Collection also has the 6th edition (1908) and the 8th revised edition (1929), both titled *Egypt and the Sudan*.

MEISTERMANN, Father Barnabas London 1907
New Guide to the Holy Land, With 23 Coloured Maps and 110 Plans of Towns and Monuments Either in the Text or on Flyleaves. By Father Barnabas Meistermann, O.F.M., Missionary Apostolic. Translated from the French Edition by the Order and Sanction of the Most Rev. Father Custodian of the Holy Land
12mo. Meistermann's book was extremely popular and many editions were published in several languages.

MEISTERMANN, R. P. Barnabas Firenze 1925
Guida di Terra Santa, Illustrate con 21 Carte, 14 Piante a Colori e 103 Disegni nel testo, Compilata dal R. P. Barnabas Meistermann, O.F.M., Missionario Apostolica, e Tradotta dal P. Teofilo Bellorini, O.F.M.
12mo. Italian version of a later edition of the above work.

HENDERSON, Rev. Archibald Edinburgh 1906
Palestine: Its Historical Geography with Topographical Index and Maps, By Rev. Archibald Henderson, D.D.
Small 8vo. 3rd edition; the 1st appeared in 1884

MILLER, Rev. J.W. Leicester n.d.
The Unique Guide to the Mediterranean, The Holy Land and Egypt, By Rev. J. W. Miller
Small 8vo. No date, probably late 19th C. A detailed guide, mostly on the Holy Land but including Egypt.

GARPATCH, A. Cairo 1918
A Complete Handbook to Palestine & Syria: Historical-Geographical-Political and Descriptive from 3000 BC to 1918. Compiled by A. Garpatch. Published by Kassem Meawad, Emad El Din St. Cairo Egypt
Small 8vo. 1st and only edition of this very rare guide; it was published in Cairo, which was unusual.

COOK'S HANDBOOK series London 1907
Cook's Handbook for Palestine and Syria (Lower Palestine Section), New Edition Thoroughly Revised by the Rev. J. E. Hanover and Dr. E. G. Mastermann
Small 8vo.

MACMILLAN & CO. London 1912
Guide to Palestine and Syria
12mo. *Illus*: 13 maps, 6 plans. 5th edition of this important guide. The 1st edition (1901) included Egypt; the 3rd and later editions concentrated on Palestine and Syria.

THE AMERICAN COLONY Jerusalem 1930
The American Colony Palestine Guide, by G. Olaf Matson
Small 8vo. 3rd (and possibly last) edition of this well known guide. The 1st edition, entitled *The American Colony Guide to Jerusalem and Environs*, appeared early 1900s.

⫸ Annex 2 ⫷
Techniques of Print Making

Woodcut

First devised in Germany in the late fourteenth century for fabric printing, the woodcut is the most ancient form of European pictorial print. Soft woods like pear, sycamore or beech are cut into blocks length-wise from the tree with the grain. In the fifteenth and sixteenth centuries the artist either drew directly onto the block or onto paper stuck to the block, which was then passed to the form cutter, or xylographer, who cut away the background, leaving the lines standing out in relief ready to accept the ink for printing. A screw- or lever-press, of the kind used to print letterpress, is used to print woodcuts, pressure being applied evenly from above. Great pressure is unnecessary for such surface printing and the earliest woodcuts were probably printed by hand. The convenience of being able to print woodcuts on the same press, and simultaneously with typeface, led to their extensive use as early book illustrations.

Engraving

Engraving developed as an artist's printing technique in the early years of the sixteenth century in Germany, Italy and the Netherlands, the three leading centres of artistic activity in Europe, and some of the greatest Renaissance masters experimented with the new invention.

Engraving, in common with etching, requires considerable pressure to print, and both techniques are printed on the same intaglio roller press. The plate is

prepared by dabbing it with ink, spread by a soft leather dolly.

Muslin is used to wipe the plate so that the ink is trapped in the incised lines and rubbed from the smooth, polished surface of the plate. The plate is laid on the steel bed of the press, a dampened sheet of paper on top, covered by blankets, and passed beneath the double rollers in a smooth, mangle-like action by turning a handle. The pressure squeezes the ink out of the grooves onto the paper, after which the fresh print is hung up to dry. Some impressions show central drying creases where they have hung over a line.

In copper engraving the artist cuts directly into the sheet of metal with a sharpened burin of lozenge-shaped cross-section, which cuts a V-shaped groove naturally tailing off to a point. The rough shaving of metal raised at the edges of the line, the burr, is removed with a scraper to give a sharp, clean, crisp line when printed, whose slight stiffness reflects the initial resistance of the metal.

Etching

Etchings began as an armourer's art of decoration, and for this reason the earliest etchings were made on iron and have a coarser line than those printed from the now traditional copper. Since the beginning of the twentieth century, zinc has also occasionally been used as a cheaper alternative to copper, especially for very large plates.

The word etching has its roots in the old High

German *ezzen* to eat, for the drawing is eaten, or bit-ten, into the copper plate by acid, known as the mor-dant. The artist lays a dark ground of mixed waxes, resins, gums and soot onto the copper plate, covering and completely sealing its surface. In drawing with the etching needle he removes the ground and exposes the copper beneath. When placed in a bath of nitric acid the acid attacks the copper and chemically cuts the design into the plate. The longer the plate is exposed to the acid the deeper will the lines be etched, the more ink they will hold when wiped for printing and the heavier and thicker will be the resulting intaglio printed line. Variety of tone, almost amounting to colour, can be achieved by controlling the degree of etching of different areas of the plate. The artist can stop out with varnish those areas he wishes to keep delicate while biting strong lines deeply with the acid.

Etching allows the artist to draw easily, for his nee-dle meets only the soft resistance of the wax ground. It is therefore the technique traditionally most associ-ated with artists' original printmaking; and it has the longest continuous history.

Aquatint

The principal method involves dusting an even layer of powdered resin onto the copper plate and fus-ing it in place with a gentle heat applied from beneath. The areas of the plate which do not require tone are stopped out and the plate immersed in acid. The acid can only bite the copper around and between the par-ticles of resin, which results in a fine network of lines, like miniature crazy paving. The size of the individual particles of resin, whether coarse or fine, determines the grain of the aquatint and the length of immersion in the acid, the depth or intensity of tone. Aquatint is only rarely used alone, and then mainly in the twenti-eth century. Generally it is employed in conjunction with the etched line.

In the first half of the nineteenth century, aquatint came to be most used for topographical and sporting prints, principally in England and Switzerland. It was found to be particularly suited to hand colouring with watercolour washes and thrived in relation to the English school of watercolour artists and their discov-ery of the picturesque in landscape, and the tourists' demand for views in Europe. Often the plate was inked up *à la poupée* in two colours, blue at the top and black or brown for the lower portion. This speed-ed up the process of subsequent hand colouring. The colourists worked from a model supplied by the artist. Although colourists were often women working in sweat-shop conditions, young artists such as Thomas Girtin and Joseph Turner also received early training in this fashion.

Largely for economic reasons, by the middle of the nineteenth century tinted lithography superseded aquatint for the production of topographical prints.

Lithography

Lithography, from the Greek *lithos graphos* (stone writing), is based on the chemical fact that water and grease will not mix. The traditional matrix is limestone; though today, outside of art colleges, zinc plates have almost universally replaced stones for ease of handling. The artist draws on the prepared stone with a greasy material, which as lithography developed in the nineteenth century was usually a lithographic crayon. The stone is dusted with French chalk and painted with gum-etch (gum Arabic dissolved in water with nitric acid), which increases the porosity of the undrawn areas. The seepage of the grease from the drawing into the stone makes the drawn areas non-porous. The pre-pared stone is dampened with a sponge for printing. When inked up with a roller the ink adheres only to the drawing, which has repelled the water and is rejected by the porous areas, which hold the water. The stone is printed on a laterally-moving scraper press.

Preparing lithographic stones for printing is a complex and laborious process, which is generally carried out by a professional printer working in close collaboration with the artist. Lithographic drawing allows the artist to draw on the stone as freely as on paper, and a great variety of surface effects is possi-ble, depending on the drawing material and the use of the scraper.

⟅ Annex 3 ⟆
References

Rferences are most important for a collector and should always be consulted both for studying the existing collection and also before making a valuable acquisition. There are many forms of references. First, there are catalogues of other collections or of art exhibitions, which are sometimes scholarly works and extremely valuable (see below, References for Rare books). Second, there are bibliographies. Third, there are scholarly books which contain details and photographs that greatly assist in identifying objects of relevance to the collection. Last but not least are the catalogues of museums, auction houses, booksellers, galleries, etc., which document materials and objects relevant to the collector. Knowledge is also greatly enhanced by corresponding with other collectors and exhibitors.

I have always relied on references in my quest for collecting. Consulting references is not only a professional requirement but also a complementary enjoyment to collecting. Nothing will please a collector more than ensuring, through the references, the authenticity and value of what he has acquired, or is about to acquire.

There are few reference books that deal with works of art and books on the Holy Land and Jerusalem in the Ottoman period, and some are rare and difficult to obtain. In the following section I have tried to record references that are valuable and scientifically researched, all of which are in the Collection, and tried to ignore commercial ones like auctioneers' sale catalogues (although some contain excellent references) and commercial art books.

A knowledge of prices of collectable objects is very important to a collector with limited means, and the figures realized by reputable auctioneers are appropriate references in this regard, although some variations can occur due to different editions of a book, size variations, media, bindings and condition of a painting or photograph.

References for Rare Books

Abbey, J. R., *Travel in Aquatint and Lithography 1770-1860, from the Library of J. R. Abbey*, 2 vols., San Francisco 1991

Volume 1: *World, Europe and Asia*; Volume 2: *Asia, Oceania, Antarctica, and America*

First printed and published privately at the Curwen Press, London, 1956; reprinted by Dawsons of Pall Mall, 1972; reprinted with a new frontispiece and the collotype plate in photolithography by Alan Wofsy Fine Arts, San Francisco 1991.

This bibliographical catalogue is considered a major reference on books in English, with plates in aquatint and lithography. It gives excellent references and collations. Some of the books described relate to the Levant and the Holy Land.

Hilmy, Prince Ibrahim, *The Literature of Egypt and the Sudan from the Earliest Times to the Year 1885 Inclusive*, 2 vols., London 1886

This bibliography on Egypt and the Sudan is the equivalent of the Reinhold Rohricht bibliography on Palestine (see below). It is not restricted to Egypt and the Sudan, since many of the references are relevant to the Levant. It includes printed books, periodicals and papers of learned societies, maps and charts, ancient papyri, manuscripts, drawings, etc. The copy in the Collection is a limited recent reprint of the 1990s.

Navari, Leonora, *Greece and the Levant, the Catalogue of the Henry Myron Blackmer Collection of Books and Manuscripts*, Maggs Bros. Ltd, London 1989

Folio, pp. xxiv, 448 pages, with frontispiece and 16 coloured plates.

The publication of the Henry Blackmer catalogue, in a limited edition of 300 copies, was an important event in Greek, Levantine and Holy Land studies, for never had such an extensive collection been catalogued in such detail. There are over 1900 entries, mainly of printed books but including manuscripts, photographs and drawings, many dealing with Jerusalem and the Holy Land. Every book is described with a signature collation and plate count. Physical bibliography is followed by an historical account of each book, setting it and the author in context.

The late Henry Blackmer was an American banker who settled in Athens and formed this remarkable collection on Greece and the Levant, ranging in date from the fifteenth to the nineteenth centuries. It includes many works of travel, archaeological and architectural treatises, costume books, political tracts and historical accounts of wars, battles and sieges in all the languages of the Eastern Mediterranean. The Blackmer Collection was sold by Sotheby's London in September 1989. The catalogue is a standard reference work, essential to any dealer or collector, or anyone interested in the literature of Greece, the Levant and the Holy Land.

Navari, Leonora, *The Ottoman World: The Şefik E. Atabey Collection* , London 1998

This catalogue of Şefik E. Atabey's renowned library, contains 1629 entries, listing books, manuscripts, etc., of relevance to the Ottoman Empire, many of which relate to the Levant and the Holy Land. The Şefik E. Atabey Collection was auctioned by Sotheby's in May 2002.

Rohricht, Reinhold, *Bibliotheca Geographica Palaestinae: Chronologisches Verzeichnis der von 333 bis 1878 Verfassten Literatur über das Heilige Land, mit dem Versuch einer Kartographie*, 1890

This is a most important record of books published about Palestine between AD 333 and 1878, containing references to 3,515 books. The work is in German, but titles of books are in their original languages. First published in 1890, but reprinted many times; including in 1963 and 1989 in small 8vo format (by John Trotter, the well known dealers in Judaica and Holy Land books).

References for Paintings

The notes on the artists in Chapter 5 benefited from the following reference works and catalogues:

Ben-Arieh, Yehoshua, *Painting the Holy Land in the Nineteenth Century*, Hemed Books Inc., Jerusalem 1997

Benezit, E., *Dictionnaire des Peintres, Sculpteurs, Dessinateurs et Graveurs*, nouvelle edition, 10 vols., Paris, Librairie Grund, 1976

Fine Art Society, *Eastern Encounters: Orientalist Painters in the Nineteenth Century*, London 1978

Guiterman, Helen and Llewellyn, Briony (eds.), *Roberts's Pictures of the Near East*, Barbican Art Gallery, London 1986
Catalogue of an exhibition at the Barbican Art Gallery in 1986-87.

Jordan National Gallery, *On the Banks of the Jordan: British Nineteenth Century Painters*, Amman 1986

Jullian, Philippe, *The Orientalists: European Painters of Eastern Scenes*, Oxford 1977

Llewellyn, Briony, *The Orient Observed: Images of the Middle East from the Searight Collection*, Victoria & Albert Museum, London 1989

Llewellyn, Briony, *Romantic Lebanon: The European View 1700-1900*, British-Lebanese Association, London 1986
Catalogue of Oil Paintings, Watercolours, Drawings, Prints Books exhibited at Leighton House, London.

Mallalieu, H. L., *Dictionary of British Watercolour Artists up to 1920*, London 1984

Royal Academy of Arts, *The Orientalists: Delacroix to Matisse: European Painters in North-Africa and the Middle East*, Royal Academy of Arts, London 1984

Thornton, Lynne, *The Orientalists: Painter-Travellers 1828-1908*, Paris 1983

Wood, C., *Dictionary of Victorian Painters*, 2nd edition, London 1978

References on Atlases, Maps and Views

Aviel, Yaakov, *Choice of Illustrations from Yaakov Aviel's Collection of the Holy Land*, 1984
Catalogue of Aviel's collection, which was auctioned on 19 July 1984

Laor, Eran, *Maps of the Holy Land: A Cartiobibliography of printed maps 1475-1800*, New York and Amsterdam 1986

Laor, Eran, *Undique ad Terram Sanctam*, Jerusalem 1976
Album of the cartographic exhibition from the Eran Laor Collection.

Mazar, Benjamin, *Jerusalem, The Saga of the Old City*, Universitas Publishers, Jerusalem 1954

Meyer, Hermann, *Jerusalem, Maps and Views*, Universitas Booksellers, Jerusalem 1971

Nebenzahl, Kenneth, *Maps of the Bible Lands*, Times Books, London 1986

Palestine Exploration Fund, *The World of the Bible*, London 1965
A souvenir album of the centenary exhibition of the PEF held at the Victoria & Albert Museum, London, in cooperation with the British School of Archaeology in Jerusalem.

Rubin, Rehav, *Image and Reality: Jerusalem in Maps and Views*, Jerusalem 1999

Vilnay, Zev, *The Holy Land in Old Prints and Maps*, 2nd edition, Jerusalem 1965

References on Photography

Probably the best single reference on the history of photography in the Holy Land is:

Onne, Eyal, *Photographic Heritage of the Holy Land 1839-1914*, Institute of Advanced Studies, Manchester Polytechnic, Manchester 1980

Other valuable references include:

Nissan, N. Perez, *Focus East: Early Photography in the Near East 1839-1885*, Domino Press, Jerusalem 1988

Osman, Colin, *Jerusalem Caught in Time*, Garnet Publishing Ltd., London 1998

Yeshayahu, Nir, *The Bible and the Image: The History of Photography in the Holy Land 1839-1899*, University of Pennsylvania Press, Philadelphia 1985

～ Index* ～

* Numerals in bold denote illustrations

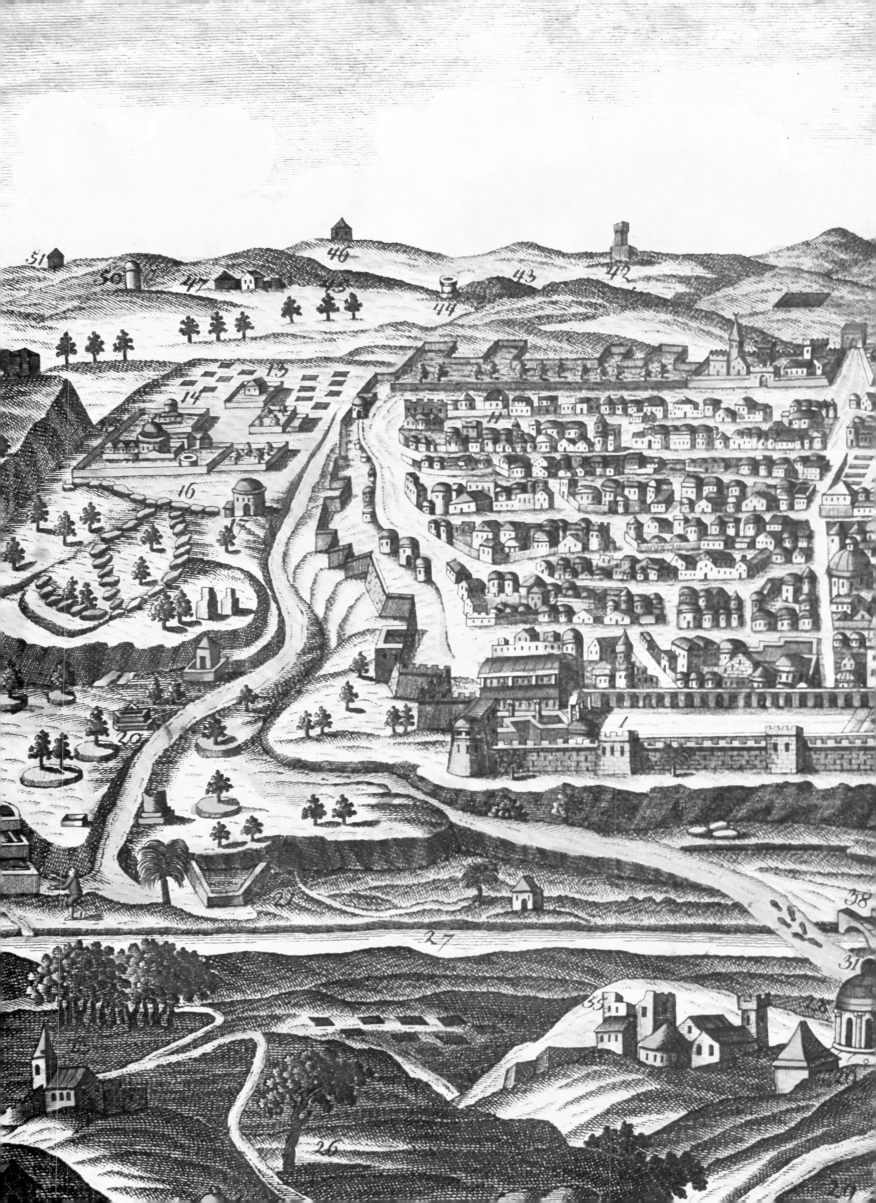